Criticizing Art

Understanding the Contemporary

THIRD EDITION

Terry Barrett

University of North Texas Professor Emeritus, The Ohio State University

CRITICIZING ART: UNDERSTANDING THE CONTEMPORARY, THIRD EDITION

Published by McGraw-Hill, a business unit of The McGraw-Hill Companies, Inc., 1221 Avenue of the Americas, New York, NY 10020. Copyright © 2012 by The McGraw-Hill Companies, Inc. All rights reserved. Previous editions © 2000 and 1994. No part of this publication may be reproduced or distributed in any form or by any means, or stored in a database or retrieval system, without the prior written consent of The McGraw-Hill Companies, Inc., including, but not limited to, in any network or other electronic storage or transmission, or broadcast for distance learning.

Some ancillaries, including electronic and print components, may not be available to customers outside the United States.

This book is printed on acid-free paper.

1234567890DOC/DOC10987654321

ISBN 978-0-07-337919-7 MHID 0-07-337919-0

Vice President & Editor-in-Chief: Michael Ryan

Vice President EDP/Central Publishing Services: Kimberly Meriwether David

Publisher: Christopher Freitag

Associate Sponsoring Editor: Betty Chen

Executive Marketing Manager: Pamela S. Cooper Senior Managing Editor: Meghan Campbell

Project Manager: Robin A. Reed

Design Coordinator: Margarite Reynolds Cover Designer: Mary-Presley Adams Photo Research: Sonia Brown

Cover Image: Mark Ryden, Dodecahedron Window (detail), digital print on canvas, 90 x 140 in., 2007.

Buyer: Laura Fuller

Media Project Manager: Sridevi Palani Compositor: Laserwords Private Limited

Typeface: 10/13 Berkeley Printer: R. R. Donnelley

All credits appearing on page or at the end of the book are considered to be an extension of the copyright page.

Library of Congress Cataloging-in-Publication Data

Barrett, Terry, 1945-

Criticizing art: understanding the contemporary / Terry Barrett.—3rd ed.

o. cm.

Includes bibliographical references and index.

ISBN 978-0-07-337919-7 (alk. paper)

1. Art criticism—United States—History—20th century. 2. Art, American—20th century. I. Title.

N7476.B38 2011 701'.18—dc22

Preface

The PRIMARY GOAL OF THIS BOOK is to bring readers inside the immensely fascinating world of contemporary art. I have written it to help readers operate more comfortably and knowledgeably within the field of contemporary art criticism in a manner as much like that of professional critics as possible. More specifically, I have written it to enable readers to write and talk about art better than they now can.

The book is built around the practices of contemporary critics writing about contemporary art. Most of the critics are American, mostly writing about American art in its multicultural plurality. Their writings have been gathered from an intentionally wide variety of publications, from newspapers and newsmagazines to international journals of art criticism. A constant supposition of the book is that diversity is healthy. Thus you will find a wide sampling of critical publications, each geared to a different audience and written in a distinct tone of voice with its own vocabulary.

The book uses the thoughts and words of dozens of critics about the works of dozens of artists. The selection of critics and artists was somewhat arbitrary. Sometimes I chose the critics I wanted to include first, and the art they wrote about was not the deciding factor. In most cases, however, I selected the artists first and then read published criticism about the art they made. The criteria I used to select the artists were also arbitrary but carefully considered: I wanted diversity of media and messages, the influences of modernity and postmodernity, ethnic variety, gender diversity, and socially activist artists as well as those more concerned with aesthetic issues.

For the first edition of this book, to help in the selection of critics and—especially—artists, I polled several friendly colleagues at Ohio State University and nationally who are knowledgeable from a variety of perspectives and professions about recent art and criticism, asking them which artists and critics should be considered for a book such as this one.² They responded with over 250 different artists and 72 critics.

I then made my final choices based on my own preferences, their recommendations, and my goal of inclusivity. The group I finally chose is broader than it would have been without my colleagues' generous advice. New choices of artists and critics come with each new edition of this book. Nevertheless, I cannot, of course, accommodate all the artists and critics working today; thus the exclusion of any particular artist or critic should not be construed as being based on a negative appraisal.

A number of years ago, the aesthetician Morris Weitz undertook a study of what critics did when they criticized literature.³ Among his conclusions were that critics engaged in one or more of four central activities: They described, interpreted, judged, and theorized. This book is organized around these categories of critical activities. The categories are sufficiently general as to provide direction without being overly specific and limiting thinking. They pertain to postmodern discourse as well as traditional aesthetics. Neither Weitz nor I, however, offer these critical activities as the steps to take in doing criticism or as a method of criticism. In this book I have derived principles of description, interpretation, and judgment from the writings of published critics and discussed aspects of theory in relation to art and criticism. If readers understand these principles, they can think independently of methods, developing their own to suit their ways of working.

Description, interpretation, judgment, and theory overlap in the writings of critics and in this book, even though separate chapters are built around each. It is difficult to write about art without describing it. Consciously and unconsciously held theories of art affect all criticism. Not all critics engage in all four activities in the same piece of writing, and some critics choose to write primarily interpretive criticism while others insist that judgment is the most important activity of criticism. I think that interpretation is the most important critical activity in that, if one fully understands a work of art, judging it becomes easy—and may not even be necessary. Judgments without interpretations, however, are irresponsive to the artwork and perhaps irresponsible to the reader.

The book is based on several other suppositions as well. First, art critics are generally and most often interested in contemporary art rather than old art. When they deal with older art in contemporary exhibitions, they are likely to discuss what that art means to present-day viewers rather than what it might have meant to the viewers in the past for whom the art was originally made.

In addition, criticism is generally positive; it puts the experience of art into language to interest and inform readers. Criticism is usually not written for the artists whose work the critic is discussing. Rather, critics are usually trying to increase the public's thoughtful appreciation of art.

Good criticism is careful and engaging argumentation that furthers dialogue about art and life; dogmatic and terse pronouncements of good or bad are antithetical to fruitful critical dialogue.

Artworks generate different interpretations, and to interpret an artwork is to generate meanings.

iv

In the process of writing criticism—that is, by carefully articulating their responses to art so they may communicate them to their readers—critics enlighten themselves about art and their own reaction to it.

Critical plurality—a variety of voices—is a welcome phenomenon of contemporary art criticism. A diversity of critical voices, even though they sometimes contradict each other, is healthy because it gives readers of criticism more to think about regarding works of art and the world from which the artworks emerged.

A plurality of critical voices may help readers find their own voices, allowing them to identify with some, disagree with others, and eventually formulate their own positions.

Viewing art and reacting to it and reading criticism and reacting to it can provide self-knowledge as well as knowledge about art.

Discussing works of art with others can bring new knowledge of others in relation to self. We do not all think alike. We can come to know others through how they think about works of art. We can disagree amicably and build peaceful communities through discourse that is respectful of the views of others.

Critics criticize criticism as well as art; criticism itself can and should be criticized.

Critical discourse is interesting in itself, as well as a contribution to knowledge about art and the world. Through this book, I hope to encourage the reader to join the discussion.

NEW TO THIS EDITION

The most substantive change in this edition is the expansion of Chapter 6, Writing and Talking about Art. The chapter now contains more examples of student writing of different types. It includes the writing of artist statements, short critical writings, personal responses to works of art, writing about one's own work, writing about peers' art, and writing about professional work. The chapter also includes an expanded discussion of and suggestions for studio critiques for readers who make art.

Chapter 3, Describing Art, and Chapter 5, Judging Art, now offer principles for each critical activity. These inclusions are consistent with principles for interpreting art in Chapter 4 of the past edition.

Throughout, artworks and information about artists have been updated; new artists have been included and introduced by way of recent writings about their work.

ACKNOWLEDGMENTS

Thanks to Lisa Pinto and Betty Chen of McGraw-Hill for the opportunity to revise this book. Thanks to the McGraw-Hill staff for their competent and cooperative work, especially Betty Chen, Meghan Campbell, Pam Cooper, Robin Reed, Laura Fuller, Margarite Reynolds, and Sonia Brown. Jan Beatty was the sponsoring editor of the first and second editions. The reviewers of my initial proposal and of subsequent drafts of the manuscript include Don Bacigalupi, University of Texas at Austin; William Bradley, The Pennsylvania State University; Liana Degirolami Cheney, University of Massachusetts at Lowell; Mark Gottsegen, University of North Carolina at Greensboro; Paul Eli Ivey, University of Arizona; David William, University of Pittsburgh; and Joseph F. Young, Arizona State University; and especially Sally McRorie, Florida State University; and Claudia Mesh, Arizona State University; Rod Miller, Hendrix College; and Elaine Slater, Wentworth Institute of Technology (reviewers for this third edition).

Thanks to my colleagues in the Department of Art Education and Art History at the University of North Texas, and Dean Robert Milnes, College of Visual Art and Design, for providing a friendly new home after my years at The Ohio State University. Thanks to the many students who have read the book and offered valuable suggestions, and to those who have allowed me to reprint their writings. Thanks especially to my wife, Susan, for her cheerful involvement, her hard work, and her continued loving support.

Contents

Preface iii Chapter 1 • About Art Criticism 1 Love and Hate 1 Critical Arrogance and Humility 3 Difficult Criticism 4 Critics and Artists 6 Critics and Audiences 8 The Diversity of Critics 10 Critics and the Art Market 12 The History of Art Criticism 14 Some Critics Past and Present 15 Giorgio Vasari 15 Denis Diderot 15 Charles Baudelaire 16 Clement Greenberg 17 Lawrence Alloway 19 Hilton Kramer 20 Lucy Lippard 21 Rosalind Krauss 22 Arlene Raven 23 Criticism: A Definition 24 Criticizing Criticism (and Critics) 27 The Value of Criticism 28

Chapter 2 • Theory and Art Criticism 30

Modernity and Postmodernity 30

Modernist Aesthetics and Criticism 33

Postmodernist Aesthetics and Criticism 39

Marxist Criticism 44

Psychoanalytic Criticism 45

Feminist Aesthetics and Criticism 47

Multiculturalist Aesthetics and Criticism 57

Postcolonialism 60

Queer Theory 62

Conclusion 63

Chapter 3 • Describing Art 65

Subject Matter 66

Medium 68

Form 70

Context 72

Painting: Leon Golub 72

Sculpture: Deborah Butterfield 77

Glass: Dale Chihuly 80

Performance Art: Laurie Anderson 84

Video: Bill Viola 87

Installations: Ann Hamilton 88

Principles of Description 90

Chapter 4 • Interpreting Art 95

Interpreting the Photographs of William Wegman 95

Interpreting the Work of Jenny Holzer 102

Interpreting the Paintings of Elizabeth Murray 112

Principles of Interpretation 119

Chapter 5 • Judging Art 127

Judging Frida Kahlo's Paintings 129

Peter Plagens 129

Hayden Herrera 132

Other Critics and Kahlo 134

viii

ix

Judging Martin Puryear's Sculptures Judging Romare Bearden's Collages 141 Examples of Negative Judgments 146 Opposite Judgments of the Same Work Appraisals, Reasons, and Criteria 149 Traditional Criteria 149 Realism 150 Expressionism 151 Formalism 153 Instrumental Uses of Art 155 Other Criteria 157 Choosing among Criteria 158 Principles for Judging Art 162 Chapter 6 • Writing and Talking about Art Writing Art Criticism 168 Choosing What to Write about 168 Describing 170 Interpreting 170 Judging 171 Considering Assumptions 172 Technicalities and Procedures of Writing 173 Selecting a Style Manual 173 **Determining Word Count** Identifying Your Audience 173 Getting Started 174 Taking Notes 175 Avoiding Plagiarism Making an Outline Writing 177 Rewriting 177 Common Errors and Writing Recommendations 178 Editing 178 Adhering to Deadlines 180 Samples of Writing 180 Writing Personal Responses 180 Writing Short Responses to Works of Art 190

Writing an Artist's Statement 195
Writing and Studio Critiques 198
Researching One's Own Art 202
Criticizing Criticism 208
Talking about Works of Art 212
Casual Conversation about Art 212
Organized Talk about Art 213
Criticizing Works in the Public Domain 214
General Recommendations for Good Group Discussions 214
Suggestions for Interactive Studio Critiques 215

Notes 219

Bibliography 232

Index 240

For Mom

CHAPTER

About Art Criticism

THIS CHAPTER IS AN OVERVIEW of contemporary art criticism. It is a cross section of a broad spectrum of current critical practice—not a careful history of art criticism in the twentieth century. It includes critics who hold varying and sometimes disagreeing points of view about a wide variety of artworks. It is a sampling of critical voices, some soft and others shrill. It samples critical writings from daily newspapers, national popular newsmagazines, regional art journals, sophisticated academic journals, and national and international art publications written in English. Some of the critics have overt political motivations that they directly identify; others leave their politics, or lack thereof, implicit. The chapter views criticism as a lively, ongoing, interesting, valuable, and complicated conversation. It—and indeed the whole book—has been written to encourage readers to join the discussion.

LOVE AND HATE

"You presumably write about works of art because you love them. I don't write out of hate. I write out of love, and that's what I think criticism should primarily be." These are the comments of Robert Rosenblum, a critic living in New York. His sentiments are echoed by other critics. Rene Ricard, a critic and poet, stated in *Artforum* that "in point of fact I'm not an art critic. I am an enthusiast. I like to drum up interest in artists who have somehow inspired me to be able to say something about their work." Of her desire to spend time with art, Rosalind Krauss, a founder of the critical journal *October*, says, "Presumably one gets involved with this rather particular, rather esoteric form of expression because one has had some kind of powerful

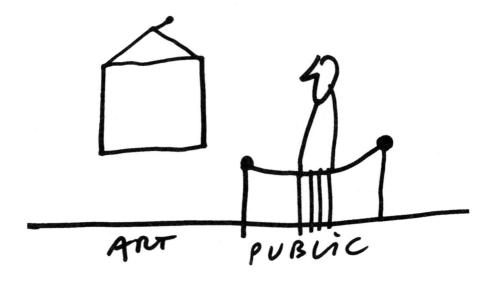

Dan Perjovschi, *Art/Public*, 2007.
Courtesy of the artist and Lombard-Freid Projects.

experience with it—and presumably this powerful experience then makes you want to go on and think about it and learn about it and write about it. But you must have at some point been ravished, been seduced, been taken in."³

These statements by these critics serve to offset the popular misconception that the criticism of art is a negative endeavor. In ordinary language, the term *criticism* does connote disapproval and fault finding: thus it is quite natural for those who lack knowledge about art criticism to associate it with negativity toward art. In aesthetic discourse, *art criticism* neither denotes nor connotes a negative activity. But unfortunately the term continues to be confusing to the public—and some, like Ricard, do not even want to be called critics. Lucy Lippard, a very prolific art critic, also distances herself from the label *critic*: "I never liked the term anyway. Its negative connotations place the writer in fundamental antagonism to artists." She and other critics do not want to be thought negative about art or antagonistic to artists because they are not. Certainly critics sometimes do make negative judgments about art (critical judgment will be thoroughly considered in Chapter 5), but most often critics' judgments are positive. As Ricard says, "Why give publicity to something you hate?" 5

The attitudes expressed in this book are positive about art and art criticism. In general, critics choose to spend their lives thinking and writing and talking about

art because they love it and see it as a valuable phenomenon in the world. Most are grateful to be professionally associated with art and art criticism. Dave Hickey says, "It's not a great living, but I have a great life. I get paid for doing what I like to do, which is to write." Critics do not always agree with the art that is made, but they enjoy thinking about it. Rosenblum summarizes their attitudes: "We just want to write about art and look at it and talk about it."

CRITICAL ARROGANCE AND HUMILITY

Sometimes critics are accused of arrogance and pomposity. They are often portrayed as snobs in popular culture. And perhaps they are. Neither critics nor artists are necessarily nice people. In one of his critical essays, Jeremy Gilbert-Rolfe reminds us that the Greeks who gave us concepts of democracy and aesthetics were slave owners. Janet Malcolm, in a lengthy, informative, and gossipy two-part series of articles about the editing of the influential critical journal *Artforum*, says that Krauss "is quick, sharp, cross, tense, bracingly derisive, fearlessly uncharitable—makes one's own 'niceness' seem somehow dreary and anachronistic. She infuses fresh life and meaning into the old phrase about not suffering fools gladly."

Many critics express humility about being critics. Peter Plagens is a critic and an artist who writes art criticism for Newsweek magazine as well as the art press. Before moving to New York some years ago, he lived and worked in California. In a humorously serious and self-revealing essay about being a critic, he admits his own vulnerability. Describing his experience of coming to New York to see whether he wanted to write for Artforum, he wrote, "Archie Bunker, driving the JFK-Midtown Carey, dines immediately on my feelings of inferiority before all New Yorkers. They know more than I do; deference seems called for at all times. The cold authority of the East is established at once, by the way the driver takes my six bucks."10 After a week in New York, he complains of the tediousness of "listening to somebody's opinion of this writer's interpretation of that critic's opinion of this artist's influence on that artist's early work."11 He questions whether "MORE DISCOURSE IS BETTER—the great unexamined assumption of the art world."12 He did decide to write for Artforum and eventually moved East. Before he did, however, he candidly admitted his insecurities in print: "I'm white, WASP, middle-class, married, with two kids and a house; I exercise reasonably, don't drink a lot, smoke mostly other people's dope, and am reasonably industrious (it's taken three days to type this). But, back here, I feel beaten down, slow, uncaring; New York brings out the spiteful recluse in me. I want coffee in the morning, basketball games on TV, the yard clean and raked, my daughter bounced on my knee, a can of beer before dinner. Chickenshit? I wonder if I've ever had a real art idea."13

Hickey writes disparagingly about what he does as an art critic, likening it to playing air guitar: "Criticism is the weakest thing you can do in writing. It is the writer's equivalent of air guitar—flurries of silent, sympathetic gestures with

nothing at their heart but the memory of the music." ¹⁴ Patricia Phillips acknowledges the difficulty she has in doing criticism: "This is a challenging time to write about art. There are so many ambient conditions that affect and influence it. Art is often so short-lived, so conditional, that viewing it is like coming to terms with a sensation, a memory or fast-flying thought. In the here-today-gone-tomorrow world of contemporaneous ideas, the critic frequently writes about an object or installation that has disappeared—extinguished like an ordinary event or a single day. Less frequently, the critic writes about art as speculation waiting for realization. The relationship between critic and subject has changed in this century. The writer does not stalk the object; subject and critic circle each other, ever-moving." ¹⁵

A. D. Coleman, one of the first and most enduring critics to take recent photography seriously, began writing photography criticism precisely because he felt he didn't understand photographs or the effect they were having on our society. He was neither a photographer nor a photography historian. At the time he began writing about photographs, he was a drama critic for *The Village Voice*. He approached photography as someone wanting to know more about it rather than as an expert. He "came to feel there might be some value to threshing out, in public and in print, some understandings of the medium's role in our lives." His was an outsider's rather than a practitioner's point of view.

Gilbert-Rolfe worries about being wrong, and even worse, influentially wrong, in his criticism: "It may be the case that your interpretation of the work is entirely wrong but conceivably so influential as to color the way in which the work is seen even by succeeding generations, so that you may in fact both be the one to recognize the importance of the work and the person responsible for consigning it to infinite misreading."¹⁷

Although critics express general enthusiasm about their profession, criticism is not always a satisfying endeavor for critics, and sometimes it can be quite lonely. Linda Burnham, who writes primarily about performance art, says that "anyone who calls him/herself a critic can look back over a very checkered career, propelled by very little encouragement from anyone." To counter any supposed power critics have over art, Hickey states, "Art changes criticism, not the other way around." Plagens, reflecting on his career as a critic and as an artist, expresses some doubt and resentment about his critical efforts: "At best, I'm seeing through the gameplaying, and it's tedious; at worst, I'm just tired of being a handmaiden to other people's work (let *those* fuckers write something about my stuff for a change)." ²⁰

DIFFICULT CRITICISM

A common complaint about critical writing is that some or much of it is too difficult to read and too hard to understand. This complaint may also be deserved. Malcolm says about Krauss's critical writing, for example, that it has "a hard-edged, dense opacity; it gives no quarter, it is utterly indifferent to the reader's contemptible little

cries for help."²¹ Writing about one of his flights to New York from Los Angeles, Plagens says, "Tried to read three issues of *Artforum* on the plane coming in, got through one part of one article before my head hurt."²²

Gilbert-Rolfe defends the difficulty of criticism based on the difficulty of art: "Art and its criticism are difficult whether one likes it or not." 23 He acknowledges that there is a general feeling that criticism should not be difficult and that some people think art "really isn't difficult at all, but is made difficult by critics in the same way that ordinary people, with good reason, often suspect that the law itself is straightforward but is made difficult by lawyers." He does not agree. He sees art as purposely challenging and difficult. For support, he quotes George Steiner, who argues that "whatever enriches the adult imagination, whatever complicates consciousness and thus corrodes the clichés of daily reflex, is a high moral act. Art is privileged, indeed obliged, to perform this act; it is the live current which splinters and regroups the frozen units of conventional feeling."24 The painter and conceptual artist Pat Steir also cherishes the difficulty and mystery of art: "The most intriguing art is art that you can't understand. It's this element, like the ungraspable thing that flies away, that attracts me, especially to new things."25 Like Steiner, Steir sees moral implications in viewing challenging art: "I always think when you see something you can't understand, it reminds you of life itself, because you can't understand life. That's why there are moments when beauty is dead and painting is dead. When you're moved by something you can't understand, it reminds you of your mortality."

Nonetheless, some critics are calling for greater clarity in critical writing. Steven Durland, in an editorial in *High Performance*, a West Coast magazine devoted to performance art, very adamantly, and with some sarcasm, calls for clear communication by critics, especially those writing criticism that is theoretical: "If you theorists out there really care about the things you are theorizing about, then *tell it. WORD*. Most people are trying to develop theories on how to pay the rent. They don't have time to figure out what someone is talking about when it requires more than a ten-year-old paperback dictionary. They don't hate theorists, they just don't have time. If you're the one with some answers about how to make things work, and you can tell it, you'll be more famous than Madonna. You won't even *need* tenure. And people will love you for it. Trust me."

In the same editorial, however, he expresses frustration as an editor in gauging exactly what kind of writing his readers want. "In the last *High Performance* reader's survey, we got approximately equal numbers of comments accusing us of being either 'too theoretical' or 'too lacking in theory.' Over 90 percent of those respondents claim to have a college degree and nearly 60 percent claim to have a graduate degree." ²⁷

As inspiration for her writing, Lucy Lippard says that she keeps a postcard over her desk that shows a little black girl holding an open book and grinning broadly. The caption on the card reads, "Forge simple words that even the children can

CRITICS AND ARTISTS

The relationship between critic and artist is certainly complex, often ambivalent. Bob Shay, a sculptor who usually works in clay, expressed his ambivalence about criticism this way:

understand."28 Although some art and its criticism may be difficult, critics should

Criticism lends credibility, so artists want their shows reviewed. I as an artist take the opposite view. I tend to be real skeptical anyway and I don't give a damn about reviews. I make art because I really get off on making art. I just love being in my studio making the stuff. It would certainly be nice if my work were to be reviewed in some major periodical, and reviewed favorably. But I don't expect it and I can't imagine ever being disappointed if it weren't reviewed. That's secondary or tertiary to why I make it. Criticism is more economic than anything else. It's like rock n' roll art. It's about that hype and be-bop and image and all that stuff. I don't think it has much to do with the real sanctity of making art in one's studio and of the merit of that art, the significance of that art.²⁹

Despite these ambivalent but primarily negative feelings toward criticism, Shay also acknowledges that sometimes criticism can be useful to him: "Criticism can be helpful if it helps me understand, to gain insights into my own work. I work intuitively. At some point I need to come back to the work and ferret out what's going on. Good criticism can help me do that. To pick out threads of continuity from one series to the next, from one piece to the next that maybe I didn't understand. Someone can give me insights, maybe new meanings of the work that I never, at least on a conscious level, intended."³⁰

Asked about the usefulness of criticism to him, Pheoris West, an African American painter, responded, "If there's an aspect of what I was trying to get across in my work, or an insight into something that was going on in my work that I didn't necessarily, consciously put in the work, but has an appropriateness, then I get something out of it." ³¹

Tim Miller, a gay performance artist, expresses what he as an artist wants of a critic: "I want the critic to ask me what the fuck I am doing if they don't get it." Miller goes on:

I want the little brat within me to listen and be open to intelligent negative criticism and not batten down the intuitive hatches when someone suggests I am not the second coming.

I want us to be able to see creative work beyond the usual Cartesian linear foodchain rat race of GOOD or BAD. This bores the shit out of me.

I want a thousand African-American, Latino, Queer and so on publications to flourish so that we encourage writers and criticism coming from our own communities because we can't wait for other folks to do it for us.

I want critics and artists and audiences to get into juicy dialogue with each other and swap baseball cards and preconceptions so that eventually we can form a more perfect union.

Do artists pay attention to criticism? Georg Heimdal, a painter, says, "Most of my time talking about art with other studio artists is through art criticism. We talk about articles we've read. We talk about issues that are on the table. We hardly ever sit down and just talk about each other's work. We don't talk about other artists' work directly as much as we talk about art criticism about those issues, and how our work or this person's work fits into those issues." 33

Susan Dallas-Swann, a sculptor working with light, says, "I read art criticism. I'll read almost anything that I see or that's presented to me. I am an avid reader. I enjoy most of it and I try to accept a broad spectrum of critical work. A critic can change someone's life and change society. It's a very powerful role if they accept it as a powerful role. It can be a negative or positive role, but it's powerful." 34

Artist Richard Roth has similar attitudes about criticism: "I read everything, for very selfish reasons, as an artist. I'll look at any picture and read anything. I think maybe there's something for me. Criticism definitely is something I read in that way and I'm always hoping. If there's work I really like that I'm too lazy to evaluate maybe this person will just say it. Like, 'Ah yes, that's right, that's why I like it.' I look at it for material. I read it to get informed and to get ideas. On a lot of levels, it works for me. I like to read it. I want to know what's going on. The art world is a big conversation and everyone wants to be part of the conversation."³⁵

Kay Willens, an installation artist—that is, an artist who makes site-specific sculptural environments—says, "The way in which criticism benefits artists is that it's possible to be fairly isolated and to not be in a community that is supportive and to be working with ideas that are not in vogue or that are not understood on a general level. And often being able to read a certain kind of criticism can be supportive in the sense that there are people out there dealing with certain kinds of ideas that are similar." ³⁶

The artist Robert Moskowitz, however, expresses a general distrust of reasoning about art:

I'm very happy to like a work of art without going through the process of finding out why. In fact, I would try *not* to intellectualize why. We might come up with some reasons as to why we like something, but I'm not sure those are the *real* reasons. They're just ideas, and superficial ones at best."³⁷ He goes on to say that "painting and sculpture are visual experiences, words are something else. I'm not interested in explaining how I feel about something. It's a gut instinct and it's nonverbal."

Perhaps many artists feel this way, but not all. Claes Oldenburg is interested in intellectually exploring his reactions: "Whatever attaches you to a work that you can't understand is only because you don't have enough information about yourself, or the work.³⁸

Although most of these artists are at least tolerant of criticism, if not positively disposed to it, other artists express much stronger reservations. Tony Labat offers several thoughts of artists about criticism in "Two Hundred Words or So I've Heard Artists Say about Criticis and Criticism":

"I don't read that stuff anyway."

"It looks like he just read the press release and took everything out of it."

"This is a good piece, good writer. I wish he would write about my work."

"He forgot to mention my name."

"This only reflects the writer."

"He didn't get it."

"It was just descriptive."

"He doesn't take a stance."

"So fucking opinionated."

"His sexual preference really shows."

"Campy shit."

"I wish we had critics for critics."

"What the hell is he talking about?"

"I just like to see my name in print."

"All those big words and says nothing."

"That was a good piece, of course he liked my stuff." ³⁹

The artists Labat quotes raise several issues, but most of the issues center on them and the critic, their work and its criticism. Their remarks, understandably, are self-centered and self-interested. There is need for a caution here, however, and a distinction. The caution is that your art professors are likely exhibiting artists who have strong negative opinions about critics and criticism because of how their work has or hasn't been attended to by these critics. It is good to be aware of one's own and others' biases. Also, criticism as practiced in the art studio is usually for the purpose of teaching better art making. Professional critics, in their writing, are not concerned with such things—art professors certainly are. Perhaps a fundamental problem between artists and critics is a difference in opinion about for whom criticism should be written.

CRITICS AND AUDIENCES

The audience for professional published criticism is *not* the artist who made the work that is being criticized. The critic's audience is a much larger public. Terry Gross does art criticism from Philadelphia on National Public Radio, often in interview format; Plagens writes for *Newsweek*; and Robert Hughes for *Time*. For any of these critics to use such large forums to reach an individual artist would be a misuse of the forums—a letter or phone call to the artist would suffice.

Critics write for readers of books, magazines, and newspapers. They slant how they write depending on whom they are writing for because they are concerned with reaching their audiences. Lucy Lippard, for example, is very concerned about

communicating to a wider range of people and would like to reach beyond the limits of the art world. She says, "As a middle-class, college-educated propagandist, I rack my brain for ways to communicate with working-class women. I've had fantasies about peddling socialist feminist art comics on Lower East Side street corners, even making it into the supermarkets."

Patrice Koelsch, a critic who, like Lippard, is also dedicated to increasing multicultural awareness in the art world, thinks what we most need in democratic communities are "living demonstrations of authentic critical inquiry." ⁴¹ Because of recent attacks on art made controversial by politicians, such as the photographs made by Robert Mapplethorpe and Andres Serrano, she thinks it especially important to demonstrate to ordinary citizens the process of thinking critically. Koelsch wants critics to enlarge the scope of their communities and audiences by writing op-ed pieces for people who do not read the art press. She exhorts critics "to practice more honest, more informed, more engaged (and engaging) criticism." To reach wider audiences, she believes, criticism has to change: "It has traditionally been a voice of authority: purportedly omniscient, objective, and capable of discerning universal truths and values." Criticism as it has been practiced "invites the reader to observe the rational processes of the properly educated, appropriately situated, implicitly privileged writer," and this is alienating to the reader and counterproductive in effecting change. She cautions her fellow critics when they write about culturally diverse art to "be aware of our own tendencies to interpret the meaning and to ascribe value to it as it satisfies our own expectations of what that work should be."

Audiences are many and varied. Some readers are artistically sophisticated, others interested but less informed. Effective critics take the knowledge of their audiences into account. As a critic publishing in a daily newspaper, Roberta Smith sees herself "constantly talking to readers in a kind of immediate way. You can say one thing one week, and another thing another week. You don't have to say everything at once. You don't have to be right all the time." Smith writes frequently for *The New York Times* and she sees what she does on a lot of levels: "It's a revelation of myself, me thinking out loud about how to look at an object, and hopefully giving other people ideas about how to look at an object, but I also hope that I get people to go out and look at art—and think about it."

About his critical writing, Robert Rosenblum says, "What you're really trying to do is to educate yourself, and educate the audience that's going to read about how you're going to educate yourself." He adds that "you like language, and you like things to see, and you try to put them together in a way that teaches what you're looking at, and you hope that this will be communicated to an audience." He assumes the position of being an educator of the interested public. He doesn't write daily or regularly for a newspaper and sees more freedom of choice in what he does as a freelance critic. He thinks Smith would have to cover everything in New York and take stances, whereas he sees himself as fortunate in being able to write about only what he is enthusiastic about.

THE DIVERSITY OF CRITICS

Critics and their backgrounds are varied. Of critics already mentioned in this chapter, some are artists, one is a poet, and some have degrees in art history. Arthur Danto, author of books on art theory and art critic for The Nation since 1984, is a professor of philosophy. Wendy Beckett, author of Contemporary Women Artists and narrator and author of a series of TV programs, is a Catholic nun living in a cloistered convent in England. 44 She writes criticism for Art Monthly and Artscribe and Catholic newspapers in England. Literary figures such as Henry James, George Bernard Shaw, John Updike, and John Ashberry have written regularly about art. David Halpern has edited a book, Writers on Art, that includes Jean-Paul Sartre writing about Tintoretto, Aldous Huxley about El Greco, Joyce Carol Oates about Winslow Homer, D. H. Lawrence about Cézanne, Gertrude Stein about Matisse, Norman Mailer about Picasso, and Hemingway about Miró. 45 The poet Charles Simic has written prose about the sculptures of Joseph Cornell. 46 Ann Beattie, author of the novels Falling in Love and Love Always, wrote a critically interpretive book about the paintings of Alex Katz. 47 Her editor, Anne Yarowsky, thought up the project. She had a Katz print in her bedroom and saw similarities between the work of the artist and that of the author; she called the two, and both agreed to do the project. 48

Today there are many critics with many voices. Rosenblum, for one, thinks this is healthy because "the power of any one person isn't all that effective."⁴⁹ He says that "back in the '50s you could count them on the fingers of one hand. Now there are armies of critics all over, so that no single voice has much authority. Everybody wants to get into the act, and does."

In the 1950s there were also few journals devoted to art criticism. Today there are many. There are regional journals, such as *New Art Examiner* out of Chicago, *Artweek* on the West Coast, *Art Paper* in Minneapolis, and *Dialogue*, published in Columbus, Ohio; national journals such as *Artnews*, *Arts Magazine*, *Art in America*, *Artforum*, and *Parachute*; and international journals including *Flash Art*, *The International Review of African American Art*, and *Art International*. There are academic journals such as *Art Journal*, published by the College Art Association, and *Exposure: The Journal of the Society for Photographic Education*. There are journals devoted to specific art forms, such as *High Performance* for performance art and *Afterimage* for film, photography, and video.

Many academic journals publish criticism of art and reviews of books about art. Art criticism is included regularly in daily newspapers in big and small cities and in magazines with national circulations such as *Vanity Fair* and *Connoisseur*, as well as *Time* and *Newsweek*. One *Newsweek* issue had four different articles about the arts: one about the Museum of Modern Art's traveling exhibition of photographs, "Pleasures and Terrors of Domestic Comfort"; another about Christo's "The Umbrellas: Joint Project for Japan and the U.S.A."; one about Richard Meier's architecture for the Gettys' new headquarters in Los Angeles; and reviews of films by John Sayles and Jodie Foster. 50

Critical publications are of many and varied ideologies, with interlocking sets of beliefs and assumptions about the world, art, and art criticism. Some political and aesthetic ideologies are obvious: The *New Criterion* positions itself to the political right, for example, and *October* positions itself to the political left. One would likely write for one or the other, not both; and the editors of one would likely pass over writers from the other. The ideological persuasions of some publications are more difficult to determine because they are embedded within the pages—informal and not clearly articulated. Informed readers and writers of criticism are aware of the political contexts in which criticism appears. ⁵¹

Critics have agendas of their own, aesthetic and political, which they sometimes state and otherwise leave implicit. When their agendas are implied but not stated, they can be determined by the art they write about and the art they don't, as well as by how they write about it. Benjamin Buchloch sees himself as a critic whose role is the "reading and rereading of art history against the official versions that we have been acquainted with. I consider that to be a crucial task for a critic and for a historian, to rewrite the official version of art history, whether it is that of the immediate present or whether it is that of the past."⁵²

Suzi Gablik is deeply troubled by her sense of the social and environmental unraveling of the world, and as an art critic she works for social change: "The art that interests me is more like an intervention, or interaction, in a real life situation, but it doesn't have the quality of social protest or political hectoring . . . it's made with a specific audience in mind, or with the audience as part of the creative process. Interactive art can actually build community." She questions the value of pluralistically championing all art: "I think the problem with a pluralist agenda, or philosophy, is that it invites yet more individualism, when for me, the need is for a new paradigm of interrelatedness and interconnection and community." Thus she favors art such as the ecological projects of Helen and Newton Harridan in San Diego, who are restoring life to polluted rivers, John Malpede and his theater group with the homeless, LAPD, and Tim Rollins and K.O.S. Hilton Kramer's critical agenda, however, is diametrically opposed to Gablik's. Kramer tries "to defend the integrity of art against the attempt to enlist it in political causes." ⁵⁴

Such a diversity and plenitude of critical writings is healthy. Critics give us much to think about concerning art in society. There is such diversity because critics are people with different backgrounds, beliefs, and attitudes about art. Throughout this book, a wide range of voices is quoted so readers may find some with which they agree and some with which they disagree. Reading criticism and reacting to it, and viewing art and reacting to it, can provide self-knowledge as well as knowledge about art. Eventually, through reflecting on art and its criticism, readers should develop their own critical voices and join the conversation.

CRITICS AND THE ART MARKET

When John Coplans was editing *Artforum* in the 1970s, he was told that when he put an artwork on the cover of the magazine, the gallery representing the artist would get a stream of phone calls inquiring about purchasing the piece. He also tells of an artist confronting him about the magazine's cover: "One day, after lunch I walk down Madison Avenue with Max Kozloff. It's spring and sunny. Suddenly a wild-looking bearded figure blocks our path shouting 'When?' It's Lucas Samaras . . . he wants to know when he is getting the cover of *Artforum*." Sometime after he was fired as editor of *Artforum* in 1977, Coplans says, at an opening at the Metropolitan Museum, Leo Castelli confessed to him that it was he who had him fired because he could not rely on his continual critical support of Castelli's gallery. Coplans's thought was this: "No wonder reviews in art magazines nowadays read like press releases."

Coplans's comment can remind us as readers to pay attention to the sources of art criticism and to be aware of the interests of the critics and the publishers of the criticism, who are supported by advertising revenue paid them by the galleries and museums whose work they criticize. Critics, for example, sometimes write essays for exhibition catalogs and are paid by museums to do so, as they should be. Because the writing is commissioned does not mean that the criticism is suspect, but one should be aware that the sponsored critic is going to be positive about the work. Knowing this, one can then read the critic and be especially attentive to the quality of the argument the critic is offering in favor of the work.

Hickey is an art critic who once owned a commercial art gallery. In an essay called "Dealing," he provides a commonsense perspective on the business of the art world, including the critic's role. He explains that when the Museum of Modern Art (MoMA) acquires work from an artist, it takes a larger risk than would a small city museum were it to acquire the same piece; and "when Leo Castelli decides to take you on as an artist, his risk is substantially greater than that of Bob's Art and Framing in West Las Vegas, should they grant you an exhibition." If a collector buys a painting from Castelli, that buyer is taking less of a risk and paying more for the painting than if the buyer had first discovered the painter and bought the painting before it was handled by Castelli. Castelli increases the value of the painting just by taking it into his gallery, and he decreases your risk of a bad investment when you buy it. However, if you wait for Castelli to find the art, you pay more for it. If you wait for reviews of that art in the art magazines, you pay more for it. If you wait longer, till after MoMA acquires the artist's work through Castelli, you pay still more. If you wait until everyone wants one, and there is only one, the price approaches infinity. "You are not paying for art. You are paying for assurance, for social confirmation of your investment, and the consequent mitigation of risk. You are paying to be sure, and assurance (or insurance, if you will) is very expensive, because risk is everything, for everybody, in the domain of art."57

Art critics play a role in the art market by increasing attention to certain art and increasing the value of that art: "The raw investment of attention, positive or negative, qualifies certain works of art as 'players' in the discourse. So, even though it may appear to you that everyone hates Jeff Koons's work, the critical point is that people take the time and effort to hate it, publicly and at length, and this investment of attention effectively endows Koons's work with more importance than the work of those artists whose work we like, but not enough to get excited about." ⁵⁸

One conclusion that can be drawn from Hickey's thoughts is that a critic needs to have integrity to be respected; and for Hickey, part of that integrity comes from the courage to take risks in offering something different from what has already been said, in public and in print. Hickey writes that critics "*must* take risks, but not just any risk, because if you are not 'right' a fair percentage of the time—which is to say, if you are not persuasive about the art on whose behalf you take risks—your efforts are inconsequential, and citizens devoted to inconsequential activities are rarely rewarded in this republic." ⁵⁹

Because critics' writings are in the public domain and because critics are part of a community called the art world, they are publicly scrutinized. For example, Peter Plagens, with characteristic wit, provided for *Artforum* baseball card profiles of Peter Schjeldahl and Jerry Saltz for the New York spring "lineup" when Schjeldahl was named art critic for *The New Yorker* and Saltz replaced him as critic for *The Village Voice*. Plagens's "Scoop" on Saltz included this: "No real holes in his swing save for a mild obsession with being up-to-date. Spouse Roberta Smith is also an art critic (*The New York Times*), so when Saltz ain't at the ballpark, he's in the gym." Of Saltz's "Weaknesses," Plagens wrote, "Few fans can recall a specific Saltz at-bat. He needs to work on his power and going to the opposite field, especially against the new cute 'n' clever slacker artists." "The Scoop" on Schjeldahl was that he "takes the occasional big cut and is certainly capable of driving the ball, but doesn't tend to go for the fences when facing blue-chip contemporary artists."

Writing art criticism is generally not a lucrative business. Only a handful of writers are likely to be able to support themselves solely by writing art criticism—perhaps those employed by national newsmagazines and major newspapers. Art magazines have relatively small circulations, are published only monthly, and are not able to provide more than supplemental income to critics. Mazagines such as *The New Yorker* and *Vanity Fair* with circulations larger than those of art magazines pay more, but only occasionally publish articles about art.

Publishers of criticism have to maintain their integrity, avoid conflicts of interest, and communicate a sense of fair play if what they print is to be read seriously. Editorial staff members consult with one another about which artists and events and venues to cover and which critics to assign to them. Selecting critics for shows is dependent on editors matching critics' expertise and interests with what the editors want to cover. Critics also suggest their own projects and seek editors'

A critic's influence on today's art market is probably much less than popularly assumed, and certainly less than Clement Greenberg's during the 1940s when he actively promoted Jackson Pollock. There are many more critics today, with expressly different and sometimes contradictory points of view; and no one of them has the singular power of Greenberg. Perhaps a well-known and respected critic who negatively reviewed the work of a new and previously unknown artist might hurt the artist's ability to sell that work in that show, especially if the review were to be printed while the show was still up, which is often not the case. Established critics, however, are not likely to bother writing about a show that they do not like by an unknown artist. Conversely, an enthusiastic review is not likely going to make an artist's career or guarantee sales of the artist's work, whether that artist is new or established.

THE HISTORY OF ART CRITICISM

According to James Elkins, writing the entry for *art criticism* for the *Dictionary of Art*, there is no reliable history of art criticism and no universally accepted definition of it.⁶¹ Some scholars of art explicitly conflate art history and art criticism, allowing no differences between the two, whereas others believe that art criticism subsumes art history.

All art history can be said to be critical in the sense that historians choose to include this work by this artist in their history while excluding that work by that artist. No art history can be said to be neutral: All facts that are included in a history depend on judgments as to whether they constitute facts at all and whether those facts are important enough to include in the history.

Nonetheless, there are books about the history of art criticism, including one by Grassi and Pepe in Italian and *History of Art Criticism*, written in 1936 by Lionello Venturi, an art historian. Grassi and Pepe begin their history with Plato, and Venturi begins his history two centuries later. Venturi begins with Xenocrates and includes Cicero and other Greeks and Romans, proceeds to the Middle Ages with St. Augustine and Thomas Aquinas and others, then through the periods of Renaissance, baroque, and neoclassical art, and on to the nineteenth and early twentieth centuries, ending with critical considerations of cubism and surrealism. Venturi and Grassi and Pepe, however, make no distinctions between art history and art criticism and few between art history, art criticism, and philosophical writing about art.

This book is not a historical treatment of art criticism past or present. It examines a cross section of art criticism as it is practiced contemporarily. It lets those who write art criticism and the criticism itself provide the definition. It concentrates

attention on a variety of critics who are writing about a variety of topics, usually pertaining to contemporary art and its exhibition, and sometimes to older art, but usually as that older art pertains to today. Following are some profiles of art critics from the past and present.

SOME CRITICS PAST AND PRESENT

Giorgio Vasari

Giorgio Vasari (1511–1574) was an Italian Renaissance painter, draftsman, architect, collector, and writer and the author of *Vite*, a two-volume work published in 1550, with over a thousand pages about architecture, sculpture, paintings, and lives of artists. ⁶³ It remains a "fundamental work of art history, the essential source for the study of the Italian Renaissance." ⁶⁴ Because of *Vite*, Vasari is recognized as the father of art history; and because *Vite* is more than a chronology of artists' biographies, Vasari is also considered fundamental in the development of art criticism, for *Vite* is a critical history in which Vasari distinguishes, in his words, "the better from the good, the excellent from the highly competent."

In Vasari's critical judgment, the art of Raphael and Michelangelo surpassed all previous art, and he measured other art against the ideal set by their art. Vasari saw Michelangelo's art as the embodiment of perfection. When Michelangelo died in 1564, Vasari faced a choice: Either art history had come to an end, or—although art had reached a climax—art history should continue to be written. (This perceived "crisis" in art in the sixteenth century seems not unlike "the end of art" in the twentieth century, or the end of the modernist tradition, which Arthur Danto identifies with Andy Warhol's *Brillo Box*, 1964, discussed in Chapter 2.) Vasari chose the explanation that artists would continue making art and that its making ought to be recorded, and he completed a second and enlarged edition of *Vite* in 1568.

Vasari thought that one ought to have knowledge of technique to be able to judge and appreciate what an artist has made. He befriended artists, including Michelangelo, and was himself a painter and illustrator. On the basis of this knowledge, he provided descriptions of the skills involved in architecture, including mosaics, vaulting, and stained glass windows; in painting; and in sculpture, including bronze casting. Vasari identified criteria by which art could be judged by all people who saw art and read what he wrote, not just other artists. Vasari based his criteria on both trained sensitivity of the eye and knowledge of technique.

Denis Diderot

Denis Diderot (1718–1784) was the French writer, critic, and philosopher who is best known for editing the *Encyclopédie* (1751–1765), an encyclopedic dictionary of arts and sciences; but he is also recognized as the pioneer of modern art

Diderot appreciated and acknowledged the difficulty of writing art criticism, and he recognized the limits of art writing, thinking it impossible to translate the essence of a painting or sculpture into language; he thought that artworks ought to be seen rather than described. Whereas the representational artist is challenged with inventing ways to depict the world that are faithful to reality, the critic has the further challenge of capturing the artist's depiction from one step further removed than the artist's. He also thought that words are insufficient to express feelings.

From 1759 to 1781, Diderot wrote about the biennial Salons organized by the Academy of Painting and Sculpture in Paris. These writings are available in four volumes, titled *Salons*.⁶⁷ They were first published in a newsletter that circulated to subscribers such as Catherine the Great of Russia and Frederick the Great of Prussia. The newsletters were not sold in Paris and thus were protected from censure by royalty and the Academy, allowing Diderot to more freely express his views.

Charles Baudelaire

Charles Baudelaire (1821–1867), a French poet and art critic, grew up with a loving interest in painting and from a young age was attacted to criticism and philosophy of art. He wrote criticism of the Salons of 1845 and 1846, the Exposition Universelle of 1855, and the Salon of 1859. He wanted his writing to be "passionate, political, and partisan."68 The tone of his writing was intemperate. He freely rejected those artists whose work he disapproved of, including Ingres, "an eloquent amateur of beauty."69 He was a man of the city and never developed an appreciation of nature in the world or in paintings. He was an advocate for art that was born of the imagination and idealism and that was capable of profoundly moving those who saw it. He found this in the art of Delacroix: "From his youth, M. Delacroix was great. Sometimes he has been more delicate, sometimes more unique, sometimes more of a painter, but he has always been great." 70 Baudelaire ranked Delacroix alongside Raphael, Michelangelo, Rembrandt, and Rubens. He admired Delacroix for his skillful technique, dramatic use of color, and imaginative and intelligent innovation. He also praised the work of Daumier, an urban artist, and admired caricature in the work of Hogarth and Goya.⁷¹

Clement Greenberg

In *The New York Times*, critic Deborah Solomon opened a story about Clement Greenberg (1909–1994) with this statement: "No American art critic has been more influential than Clement Greenberg." Greenberg, whom Solomon calls "the high priest of formalism," is perhaps best known for promoting, in the 1940s, then-unknown artists such as Robert Motherwell, Helen Frankenthaler, Morris Louis, and others. He is most famous for discovering Jackson Pollock: "Together they symbolize the romance of an era in which critics and artists believed that American painting could finally outshine the art of Paris, and they were right."⁷²

Greenberg vigorously championed abstract expressionism and created a new language for following generations of art critics. His aesthetic mission was set within a political agenda. He wanted to bring about social progress through revolutionary change, and he looked to the artistic avant-garde to lead such a revolution. For him, the early abstract expressionists were revolutionary in their courage to internally draw upon their individual consciousness. He particularly opposed what he saw as the negative effects that capitalism had on high culture, most evident in mass culture's preference for popular art and "kitsch." He thought that the artistic avant-garde ought to move to the margins of crass capitalist society and resist its degrading effects on art.

Solomon calls Greenberg the Moses of the art world, who handed down the laws of painting. The laws were formalist; that is, to Greenberg, painting should be stripped of illusion, subject matter, artists' feelings, storytelling, or anything else that distracts from the *form* of a painting. Solomon also calls him the art world's Ann Landers because he "advised, counseled and coaxed innumerable artists." He befriended them, talked with them, gave them advice on how to paint.⁷⁴

Adam Gopnik, writing about Greenberg after he had passed away, called him a "power critic" and credited him not so much with an aesthetic eye as with a powerful elbow:

The truth is that what is taken for an eye in art criticism is often something else. Sometimes an eye is really a nose, the ability to smell out quality without being able to diagnose its sources. Sometimes an eye is really a mouth, the ability to turn visual impression into a metaphor without much attention to detail. And sometimes what is called an eye is really an elbow. This was Greenberg's case. He had the ability to push his way past the people and the received opinion crowded in front of the picture and make an original judgment. His eye may have been weak, but his elbow was terrific, and, in a way, that was just as good.⁷⁵

Besides the abstract expressionists, Greenberg promoted, in the 1960s, the dry, problem-solving art of Morris Louis, Kenneth Noland, Jules Olitski, and Larry Poons that is called "field" painting. He called Olitski "the greatest living painter." ⁷⁶

Greenberg drew from the age of four, with no reinforcement from his parents.

Greenberg's criticism is controversial. Many critics today respect his contributions but now reject his strict formalism. Because his formalist conception of art is so narrow and forceful, he is often challenged. Tom Wolfe ridiculed him with sarcastic humor in *The Painted Word*. Rosalind Krauss and T. J. Clark "resent the critic for presenting art as a seamless, self-contained bubble floating high above the world of politics. Some of his practices are also questionable. He paid studio visits to artists and freely offered them advice on how to paint. This practice seems beyond the boundaries of professional criticism and raises questions about critical distance and objectivity. (Of his advice to him, however, painter Kenneth Noland says, "I would take suggestions from Clem very seriously, more seriously than from anyone else.")⁸¹ He also accepted gifts of art from those artists about whom he wrote. Such acceptance of gifts from artists by critics raises ethical issues. Greenberg left himself open to accusations of manipulating the art market for personal economic gain.

In 1947, as executor of David Smith's estate, Greenberg stripped paint from several unfinished Smith sculptures, commenting, "They looked better." After Morris Louis died in 1962, Greenberg completed a few Louis paintings by deciding where to cut off the stripes. When asked about the limits of a critic's relationship to an artist, he responded, "What you can't do is write in praise of a girlfriend." (He dated Helen Frankenthaler in the 1950s.) Such proximity and lack of boundaries between a critic and artists, their work, and the art market strain critical credibility and are rightly viewed with much more suspicion today than in Greenberg's day.

Of his critical work, Greenberg says, "You don't choose your response to art. It's given to you. You have your nerve, your *chutzpah*, and then you work hard on seeing how to tell the difference between good and bad. That's all I know."84 His opinions flow freely: Of Julian Schnabel he says, "He's not devoid of gifts, but he's minor," and later, "Roy Lichtenstein is a minor painter. The pictures look minor. When they're good they're minor, when they're bad, that's all. Schnabel can paint but his pictures are awful. David Salle is—God, he's bad."85

Greenberg died in New York City in 1994. Florence Rubenfeld wrote a biography of him in 1998, and his collected writings are available in *Clement Greenberg: The Collected Essays and Criticism.*⁸⁶

Lawrence Alloway

Lawrence Alloway (1926–1989) is probably best known for his pioneering writing about pop art—he invented the term in the late 1950s—and his early and continual critical analysis and approval of the work of such artists as Roy Lichtenstein, Robert Rauschenberg, James Rosenquist, Andy Warhol, Claes Oldenburg, Jim Dine, and Jasper Johns.⁸⁷

Alloway was born in London in 1926 and died in 1989. He held no university degrees. At the age of 17, however, he began attending evening art history classes at the University of London and then began writing art reviews for *Art News and Review*. His main interest became American art, but he continued to write about British art for *Art News and Review* and then, in the 1950s, for *Art International*. He visited the United States in 1961 and became a curator of the Solomon R. Guggenheim Museum from 1962 to 1966. At the Guggenheim, his exhibitions included William Baziotes's Memorial Exhibition, Barnett Newman's "Stations of the Cross," an exhibition of hard-edged, color-field paintings he called "Systemic Painting," and the work of Jean Dubuffet. He accepted a teaching position at the State University of New York at Stony Brook in 1968, where he taught a course in twentieth-century art as a professor of art history until 1981. He was a contributing editor of *Artforum* from 1971 to 1976 and also wrote art criticism on a regular basis for *The Nation* from 1968 to 1981.

Alloway's several books include *American Pop Art*, *Topics in American Art since* 1945, and *Roy Lichtenstein*, and he is represented in Donald Kuspit's prestigious series of anthologies of critics' writings with *Network: Art and the Complex Present*. Some particularly important articles by Alloway are "The Expanding and Disappearing Work of Art," "The Uses and Limits of Art Criticism," "Women's Art in the Seventies," and "Women's Art and the Failure of Art Criticism." 88

Unlike Clement Greenberg, who tried to separate and elevate art from daily life, Alloway sought connections between art and society: "I never thought that art could be isolated from the rest of culture." Alloway appreciated the diversity of art and rejected Greenberg's insistence on abstraction in art as restrictive. He also objected to art criticism that was isolated from larger cultural considerations. He stressed the inclusion of underrepresented art for critical attention, especially works by African American, Puerto Rican, and women artists, insisting that art criticism consider all types of art.

When interpreting art, Alloway was interested in "the interaction of the artist's intention and the spectator's interpretation." He considered the social origin of the artist, the artist's ideological sources, and the conceptual development apparent in the artist's work. He also drew upon statements about the work by other

artists and critics and freely used the artist's own statements when interpreting his or her work. However, he believed "the function of the audience is to determine the meaning of the work when it is out of the artist's hands." Alloway believed that "it goes against all one's experience of art to presume that exhaustive interpretation is possible," and he stressed that flexibility of interpretation "is preferable to dogmatic avowals of singular meaning and absolute standards." When he was judging art, Alloway's primary criterion was the art's communicative impact. He championed much of women's art, for example, because it addressed "the social experience of women."

Hilton Kramer

Hilton Kramer (1928-) wrote art criticism for The New York Times from 1965 to 1982, when he left the paper and founded New Criterion magazine. He wrote weekly criticism for the New York Observer and publishes in Commentary. In a review of Kramer's collected essays, The Triumph of Modernism: The Art World, 1987–2005,91 Anthony Iulius writes that Kramer continues to think exactly the way he did twenty years ago.⁹² Suzi Gablik refers to Kramer as a hard-hitting conservative critic who speaks with the force of a typhoon and describes him as an "unyielding, capital M Modernist, who believes in aesthetic autonomy as crucial to art's values; a wellhoned, universal cannon defined by quality; the prototypical model of the artist as a genius struggling against society; and a vision-generated, vision-centered paradigm for art."93 Each of these characteristics is being challenged in the art world today. Postmodernism is at odds with modernism. Contemporary critics generally do not separate art from the rest of human endeavors nor aesthetic values from moral values; the criterion of "quality" is suspected by many as an excuse for upholding the dominance of a straight white male aesthetic; universal lists of masterpieces are often heavily weighted with Western works and devalue the art of diverse cultures; notions of genius have generally given way to belief in the influence of other art and artists on what any individual artist makes; and much art being made currently is based on social knowledge rather than exclusively on an aesthetic vision.

Kramer, however, is resolute in opposing any politicization of art, and he resists art that is aimed toward social and cultural change. For Kramer, art is at its best when it serves only itself and not some other purpose. He believes the only problems that art can and should be solving are aesthetic ones. Kramer asserts that the only moral imperative in art is to live up to one's highest abilities to make art. He holds onto formalist criteria, and he believes in what he calls an "ethos of innovation"—that is, the concept that innovation should be a primary force in the artmaking process.

About Kramer, David Ross, director of the Whitney Museum, said, "Hilton Kramer is a tremendously gifted, neoconservative critic who hasn't liked any new art in, probably, thirty years, and whose taste in things old I tend to appreciate. I wish

he would open his mind up to look at the things that are being made today and recognize the qualities in them, but I fear he never will." Whereas critic Lucy Lippard admires feminists, activists, and artists of color such as Adrian Piper, Leon Golub, Nancy Spero, May Stevens, Hans Haacke, Amalia Mesa-Bains, and Suzanne Lacy, Kramer favors painters and admires Richard Diebenkorn, Helen Frankenthaler, Bill Jensen, 95 Henri Matisse, Jackson Pollock, Christopher Wilmarth, and Alex Katz. 96

Kramer entered criticism accidentally. As an undergraduate he studied literature and philosophy. He became very interested in the Boston Museum's collection of Indian and Indonesian art and is self-taught in art history, a subject he sometimes teaches. He studied comparative literature and philosophy in graduate school at Columbia, was going to be an English professor, and was writing literary criticism; but he wrote an article about art criticism for *Partisan Review* in 1953, got more offers to write art criticism, became editor of *Arts Magazine* in the late 1950s, and in 1965 accepted an invitation to be the art critic for *The New York Times*. He is the author of *The Twilight of the Intellectuals: Culture and Politics in the Era of the Cold War* and *Abstract Art: A Cultural History* and has published his collected writings in *The Age of the Avant-Garde: An Art Chronicle of 1956–1972* and *The Revenge of the Philistines: Art and Culture, 1972–1984.* He refers to today's art writing as "academic twaddle, commercial hype, or political mystification." ⁹⁸

Lucy Lippard

Lucy Lippard (1937–) has written many books, including *Mixed Blessings* and *On the Beaten Track*. ⁹⁹ *Mixed Blessings* was a seven-year project that began in Central America, took her to the Caribbean and then to all of Latin America, and finally ended up in North America. The book is exclusively about artists of color, hundreds from around the United States, most of whom are not well known and all of whom are socially opposed to the status quo. About Lippard's book, Meyer Raphael Rubinstein predicts that "this prolegomenon to the art of a future American culture may possibly turn out to be the most important book by an American art critic since the appearance of Clement Greenberg's *Art and Culture*." ¹⁰⁰

Not all critics, however, are as pleased as Rubinstein with Lippard's writing. Hilton Kramer has dismissed her criticism as "straightout political propaganda." ¹⁰¹ This is probably one of the few points on which Kramer and Lippard agree, however. Lippard embraces the label *propagandist*. In "Some Propaganda for Propaganda," she writes, "The goal of feminist propaganda is to spread the word and provide the organizational structures through which all women can resist the patriarchal propaganda that denigrates and controls us even when we *know* what we are doing." ¹⁰² She argues that people in power want to keep a distinction between propaganda and art: "There are very effective pressures in the artworld to keep the two separate, to make artists see political concern and aesthetic quality as mutually exclusive and basically incompatible; to make us see our commitment to social change as a result

Lippard sees herself in partnership with socially oppositional artists, whose work, too, is often dismissed by the term *propaganda*. She wants to reclaim *propaganda* as a positive term and equates it with *education*. She believes that critical neutrality is a myth, that all critics are partisan, and that her approach is merely more honest than those of critics who claim to be removed from special interests.

Rosalind Krauss

Rosalind Krauss (1941–), art historian and critic and prolific writer, is the author of Terminal Iron Works, based on her dissertation on David Smith, Passages in Modern Sculpture, The Originality of the Avant-Garde and Other Modernist Myths, Bachelors, The Optical Unconscious, The Picasso Papers, Voyage on the North Sea: Art in the Age of the Post-Medium Condition, and Perpetual Inventory. She is coauthor with Hal Foster, Yve-Alain Bois, and Benjamin Buchloh of a major historical survey of recent art, Art since 1900: Modernism, Antimodernism, Postmodernism.¹⁰⁵

In her early professional career, Krauss wrote criticism for *Art International, Art in America*, and *Artforum* with prominent colleagues Annette Michelson, Barbara Rose, and Michael Fried. She was committed to minimal art. In 1976 she and Michelson founded the highly intellectual critical journal *October*, a quarterly with the subheadings Art / Theory / Criticism / Politics, which was influenced by French theory and is still published. It is free of ads for galleries and the concomitant appearance of conflict of economic dishonesty; in contrast, *Artforum* was open to suspicion of "selling" covers to promote artists of galleries that advertised in *Artforum*.

Krauss's intellectual influence brought Bulloch and Bois from Europe to New York City. As a professor of modern art history, Krauss advised the doctoral dissertations of Hal Foster, Buchloh, and Douglas Crimp, important critics writing today. All of these critics, in turn, have protégés teaching art history and writing art criticism and theory.

Krauss and her associates base their writings on solid formal analysis of works of art. Krauss was early influenced by Clement Greenberg and his formalism. She broke with Greenberg, in part, because of his alteration of Smith's sculpture after the artist's death. She and her colleagues shied away from poetic, subjective criticism supported by Harold Rosenberg, and that of poet and critic Frank O'Hara, for example. Krauss's formalism is influenced by French theorists such as Maurice Merleau-Ponty, Ferdinand de Saussure, Jacques Lacan, Jacques Derrida, Georges Bataille, and Roland Barthes. Her references to these authors, in her philosophical art criticism and through her curatorial work, helped bring French thought to the forefront of much of the critical discourse of our time, as discussed in Chapter 2 on theory and art criticism.

Arlene Raven

Arlene Raven (1944–2006) titled a collection of her critical writings *Crossing Over: Feminism and Art of Social Concern.*¹⁰⁶ The book is another in the series by master art critics edited by Donald Kuspit. Raven crossed over from art history to write about the social and aesthetic avant-garde: "Crossing over is the journey into new territory of hundreds of American artists inspired by feminism and the possibility of social change." Kuspit admires Raven's "tone of anguished intensity" concerning women's issues expressed through art.

Raven said of her work, "I have discussed the social issues of our day, from U.S. foreign policy to aging, with the art which seeks to address them." 108 She sought out art "in the service of a cause greater than its own aesthetic objectness" and art that wants "to affect, inspire, and educate to action as well as to please." Artists she has chosen to write about include Leslie Labowitz, Betye Saar, Miriam Schapiro, Annie Sprinkle, Faith Wilding, Harmony Hammond, Judy Chicago, Mary Daly, Mary Beth Edelson, Cheri Gaulke, and Suzanne Lacy. The topics she wrote about include violence in art, pornography, women's roles in the home, bulimia, rape, ritual and the occult in women's performance art, the healing power of art, and housework. She used popular culture in her writing, referring, for example, to Archie Bunker in the TV show All in the Family when writing about women's art of the 1970s. She has also written about Lily Tomlin. She freely played with writing style, sometimes using her own voice and sometimes the voices of many other people, collaged together in different typefaces in the same article. She was published in Arts, Women's Review of Books, The Village Voice, New Art Examiner, and High Performance.

Raven held both an M.F.A. and a Ph.D. In the early 1970s, as an art historian, she worked with Judy Chicago and Miriam Schapiro for the Feminist Art Program at California Institute of the Arts. With Chicago and Sheila de Bretteville, she created an independent school for women in the arts, the Feminist Studio Workshop, and The Woman's Building, a public center for women's culture. She also founded and edited *Chrysalis*, a magazine of women's culture. She returned to New York in 1983: "My purpose today is to bring my perspective about the work and thought of artists committed to personal freedom and social justice to an art audience and the general reader, and thus to participate in creating change." 109

In his preface to her anthology, Kuspit says that "the assumption of art's healing power is implicit in the best feminist art, which seeks to heal women wounded psychically—and sometimes physically—by patriarchal society." Raven was the victim of a rape. The attack took place one week before she visited Los Angeles in 1972 to help in the preparation of *Ablutions*, a performance piece under the direction of Judy Chicago. Part of the piece was an audiotape of women telling their experiences of rape. "I participated in a process of feminist art which is based on uncovering, speaking, expressing, making public the experience of women." 111

Thirteen years later she accepted an offer to write the catalog for RAPE, an exhibition at The Ohio State University in Columbus, on the subject of rape by twenty women artists. In a revealing essay, she admits her personal anxieties about the project: "I don't want to board the plane to Columbus. I'll say I'm sick. . . . From one conversation to another I remained raw and opened to their 'stories' and my own brutal experience thirteen years ago, the pivot which hinged my understanding of my life until then and motivated every action since. . . . I never have been able to read more than a few sentences about rape. I leave the theatre or turn off the television at the hint of a rape scene. . . . Healing. Never healed." 112

CRITICISM: A DEFINITION

Despite all these differing views of criticism by critics, defining criticism is easier than defining art. A definition will eventually be stipulated here based on what critics do and say they do. A. D. Coleman defines criticism as "the intersecting of images with words," adding that "I merely look closely at and into all sorts of photographic images and attempt to pinpoint in words what they provoke me to feel and think and understand." Donald Kuspit thinks of criticism similarly. Why do "we respond to this artist's image of a Madonna and child rather than that artist's image? Why do we like a certain texture and not another texture?" He goes on to say that "it's part of the critic's task, perhaps his most difficult task, to try to articulate the effects that the work of art induces in us, these very complicated subjective states."

Dore Ashton says that her passion as a critic is to "understand what attracts me, what moves me." About his writing of criticism Hickey says, "I see the object. I translate that seeing into vision. I encode that vision into language, and append whatever speculations and special pleadings I deem appropriate to the occasion." Roberta Smith says that sometimes her criticism is "just like pointing at things. . . . One of the best parts of it is that occasionally, maybe more than occasionally, you get to write about things that haven't been written about yet, new paintings by new artists you know, or new work by artists who aren't known." 117

Alloway defined the art critic's function as "the description, interpretation, and evaluation of new art." He stressed the new: "The subject of art criticism is new art or at least recent art. It is usually the first written response." He understood art criticism to be short-term art history and objective information available at the moment. It is "the closeness in time of the critical text and the making of the work of art which gives art criticism its special flavor." He distinguished between the roles of historians and critics: "Though critics enjoy the art of the past, their publications on it are less likely to be decisive than those of art historians." Alloway particularly stressed the importance of description, wanting to maintain a balance between describing and the act of evaluation. For him the critic's function is "description and open-mindedness rather than premature evaluation and narrow specialization," and he wanted to stay away from saying "good and bad." 119

Robert Pincus-Witten, past editor of *Artforum* and currently writing for *Flash Art*, agrees with the necessity of dealing with the new: "I see the critical task as being essentially that of pointing to the new . . . the real issue at hand is not new modes of criticism but what happened to painting and sculpture during the last few years." He thinks it essential to empathize with the artist: "The recognition of the new must coexist with an intense empathy with the artist—so much so as to oblige the critic to adopt the artist's experience as a personal burden, a commonweal, a common cause if necessary. The critic imaginatively must be the artist." His chosen mode of expression is chronicling, journaling—"recording what one is thinking or feeling." 122

Critics differ on the importance of judging art. As we have seen, Alloway and others minimize judgment. Greenberg asserts that "the first obligation of an art critic is to deliver value judgments." He is quite insistent on the point: "You can't get around without value judgments. People who don't make value judgments are dullards. Having an opinion is central to being interesting—unless you're a child." Roberta Smith concurs, if less adamantly: "You have to write about what you think. Opinion is more important, or equally as important, as description." ¹²⁴ She adds that "you also define yourself as a critic in terms of what you don't like."

Joanna Frueh speaks eloquently for the need for intuition in criticism:

Art criticism, like other disciplines that privilege the intellect, is generally deprived of the spontaneous knowing of intuition—of knowledge derived from the senses, and experience as well as the mind. Nerves connect throughout the body, conduct sensations, bits of knowledge to the brain. Blood pumping to and from the heart flows everywhere inside us. Knowing is being alive, wholly, not just intellectually. It is a recognition of human being, the intelligence of the body. The intellectual may feel enslaved in matter. If only she could escape from the body. But the mind will not fly unless we embrace the body as a path to freedom. 125

She asserts the value of and need for feminist thinking in art criticism:

System and hierarchy. They withhold (information). Everything in its place. Discuss an artist's work chronologically. Picasso was more influential than Braque. "Straight" thinking. Feminist thinking is the curves, bends, angles, and irregularities of thought, departures from prescribed patterns of art historical logic. To be "straight" is to be upright-erect-phallic-virtuous-heterosexual, but feminists turn away from the straight and narrow. Deviants without their heads on straight. Logocentrism produces enclosure, tight arguments. It sews up the fabric(ations) of discourse. Feminists with loose tongues embroider, patch new and worn pieces together, re-fabricate. 126

Arthur Danto agrees with Baudelaire that criticism should be "partial, passionate, political." Danto rails against the no-nos of orthodox modernist art criticism: "Don't talk about subject matter or the artist's life and times; don't use impressionistic language or describe how a work makes you feel; do give an exhaustive account

of the work's physical details; *do* pass judgment on its aesthetic quality and historical importance." He likes to talk about subject matter and he thinks it's time for art to be about something besides itself.

Critics sometimes predict future directions in art. In a review of a recent exhibition of the surrealist André Breton, Peter Plagens foresees the future: "Already there are signs of neosurrealism creeping into the art world. . . . So far, the new style has been a little timid. But don't be surprised if, with a little boost from the end-of-the-century Zeitgeist, surrealism makes a serious comeback." 128

From these samplings of what critics say about what they do, it is apparent that criticism is many things to many critics. They have different conceptions of what they are about and place different emphases on what criticism should be. But we can draw some generalizations: Criticism is usually written. It is for an audience. It is not usually for the artist. It comes in many forms, from daily newspapers to scholarly books. Critics are enthusiastic about art. They describe and interpret art. They differ on the importance of making judgments. The intuitive response is important to some. Many admit that they are in a constant state of learning when they write criticism. Criticism is concerned about recent art, for the most part. Critics tend to be passionate about art, and they attempt to be persuasive about their views of art.

Others besides critics offer conceptions of criticism. Edmund Feldman, an historian and art educator who has written much about criticism, calls it "informed talk about art." Marcia Eaton, an aesthetician, says that criticism "invites people to pay attention to special things." Critics "point to things that can be perceived and at the same time *direct* our perception," and when criticism is good, "we go on to see for ourselves; we continue on our own."

Criticism should result in "enlightened cherishing." ¹³¹ This is a compound concept of Harry Broudy's, a philosopher of education who advocates education about art. "Enlightened cherishing" acknowledges thought and feeling without dichotomizing the two.

Morris Weitz (1916–1981), the aesthetician best known for his "open concept of art," in which he maintains that art cannot be defined because it is an ever-changing phenomenon, defined criticism as "a form of studied discourse about works of art. It is a use of language designed to facilitate and enrich the understanding of art." Weitz's definition is embraced in this book but is supplemented with more current theorists, who stress more broadly that critics also produce meaning about culture in general. Criticism is language about art that is thoughtful and thoughtout, for the purpose of increasing understanding and appreciation of art and its role in society. Weitz conducted extensive research on what critics say they do and what they actually do. He concluded that critics do one or more of the four activities of describing art, interpreting art, judging it, and theorizing about art. This book is built around these activities, with chapters about each. The four activities are specific enough to provide structure and not too limiting to be exclusive of

any critical practice. They also remind us that criticism is considerably more than passing judgments on works of art. Weitz goes so far as to claim that judgment is neither a necessary nor sufficient part of criticism; that is, one can write criticism without passing judgment, and if one only passes judgment, that mere judgment is less than criticism.

This book presents judgment as an important part of criticism, but not the most important. That distinction lies with interpretation. Usually a thorough interpretation, which necessarily includes description, will imply a judgment. A judgment without benefit of interpretation is irresponsive to a work of art and probably irresponsible. Recall Clement Greenberg's one-line dismissals of artists quoted earlier. As they were stated and quoted, his comments are conclusions, not arguments. Although such one-line dismissals or one-line pronouncements of greatness are frequently made in casual conversations about art, and in Greenberg's case, are from an interview, such pronouncements, made by prominent critics, artists, or professors, are the worst kind of criticism—unless they are developed into fuller arguments. Andy Grundberg, former photography critic for *The New York Times*, puts the point well: "Criticism's task is to make arguments, not pronouncements." 133

CRITICIZING CRITICISM (AND CRITICS)

As we have already seen, critics do not always agree with one another. Sometimes they disagree quite harshly. John Coplans, founding editor of Artforum, recalls, "When I was editor of Artforum, I had half a dozen editors on my board. They were always quarrelling with each other. They all hated each other. They were strong people, all academically very well trained, all extremely knowledgeable, the most experienced writers and critics in America." 134 His editors were the prominent and influential critics Lawrence Alloway, Max Kozloff, Rosalind Krauss, Annette Michelson, and Robert Pincus-Witten. Rosalind Krauss also recalls those days: She remembers having "stupid arguments" with Lawrence Alloway, that Max Kozloff "was always very busy being superior—I could never understand why." 135 Referring to current times, Krauss lambasts critic Tom McEvilley of Artforum as "a very stupid writer. I think he's pretentious and awful. . . . I have never been able to finish a piece by McEvilley. He seems to be another Donald Kuspit. He's a slightly better writer than Donald Kuspit. But his lessons on Plato and things like that—they drive me crazy. I think, God! And I just can't stand it."136 Coplans, however, calls McEvilley "first rate, absolutely first rate." 137

The preceding comments are mostly critics criticizing critics. Some, of course, are *ad hominem* and logically fallacious because they are directed at the person rather than at the individual critic's writings. When they act more responsibly, critics criticize criticism, rather than the people writing criticism. Often such criticism is positive. In his general preface to the anthologies of art critics (including Dennis Adrian, Dore Ashton, Nicolas Calas, Joseph Masheck, Peter Plagens, Arlene Raven,

and Robert Pincus-Witten), Donald Kuspit calls them "master art critics" because they provide sophisticated treatments of complex art. He praises their independence in their points of view and their self-consciousness about their art criticism. He admires their passion, their reason, and their lack of dogmatism: "They sting us into consciousness."

In her review of an Arthur Danto book, Marina Vaizey, art critic for the *Sunday Times of London*, praises him for being able to make the reader and the essayist "feel, see and, above all, think" and to describe "the sheer captivating sensuality of a particular work." ¹³⁸ Her criteria for good criticism include literary merit, judgments made in a setting that is more than local, and insights that have a relevant vitality that goes beyond the short time span implied by publication in a periodical of current comment.

The aesthetician Marcia Eaton praises the literary criticism of H. C. Goddard because she finds him to be a "superb pointer" and teacher who shows us how to contemplate and scrutinize art in ways that will produce delight. ¹³⁹ He does not have to distort the text to get us to see things hidden in it. He does not try to force his views. He expresses humility and readiness for exchange of insights. He is a good inviter.

Thus Kuspit and Eaton offer criteria for good criticism: sophisticated treatment of art, critical independence, self-consciousness of the critical process, passionate reasoning, lack of dogmatism, delightful insights without distortion of the work of art, humility. Kay Larson, critic for *New York* magazine, adds fairness to the artist as a criterion. Hard Mark Stevens tries to avoid "nastiness" when criticizing art and regrets the times he has been sarcastic in print. He thinks critics should be "honest in their judgment, clear in their writing, straightforward in their argument, and unpretentious in their manner." For him, good criticism is like good conversation—"direct, fresh, personal, incomplete."

Criticism itself, then, can and should be criticized. Indeed, most critics consider what they write as incomplete; that is, what they write is not the final word, especially when it is about new work. Instead, they feel they are contributing to an ongoing conversation about new art. Their comments are not unleashed speculations; they are carefully considered points of view—but they are views always open to revision.

THE VALUE OF CRITICISM

"The total burden of aesthetic communication is not wholly on the artist." When Harry Broudy wrote this in 1951, he was addressing viewers rather than professional critics, but the thought serves us well here. Critics do not believe the cliché that "art speaks for itself." They willfully and enthusiastically accept the burden of artistic communication with the artist. They work for viewers of art and those members of society who want to think critically about the times and conditions in which

we live. Critics, like artists, produce meanings, but they use the pages of magazines rather than swatches of canvas. Critics, like artists, have aesthetic and ethical values that they promote through their writing. When critics do their work well, they increase their readers' understanding and appreciation of the art they write about, the political and intellectual milieu in which it is made, and its possible effects on the world.

The artist Chuck Close said, "Once you get rid of the normal baggage you carry in looking at art, things happen: you find yourself liking what you hated a while ago." Critics help audiences do this. Marcia Siegel, author of several books of dance criticism, says that the process of writing criticism helps *her* appreciate the artwork more: "Very often it turns out that as I write about something, it gets better. It's not that I'm so enthusiastic that I make it better, but that in writing, because the words are an instrument of thinking, I can often get deeper into a choreographer's thoughts or processes and see more logic, more reason." The process of doing criticism is beneficial to the one who does it. The purpose of this book is to encourage the reader to engage in the criticism of art.

Theory and Art Criticism

The art and criticism of any age are affected by and, in turn, affect aesthetic theory. In recent times criticism has revolved around debates concerning modernism and postmodernism. The chapter is mostly about postmodernism, art, and criticism, but postmodernism makes sense in relation to modernism. Artistic modernism, or modern art, arose from within cultural modernity, a much larger and longer-lived phenomenon. Thus the chapter first broadly sketches the Age of Modernity and contrasts it to postmodernity, explains the aesthetic theory of modernism, and makes postmodernist art criticism more understandable through extended examples of critics and artists influenced by and influencing postmodernist theories of art.

MODERNITY AND POSTMODERNITY

We are in an age referred to by many as postmodernity. Postmodernity, according to some, has already replaced modernity and, according to others, lives alongside it. The Age of Modernity is the epoch that began with the Enlightenment (about 1687 to 1789) and that, through such intellectual leaders as Isaac Newton, championed a belief in the potential of science to save the world. The age is also characterized intellectually by the discourses of philosophers such as René Descartes (1596–1650) and, later, Immanuel Kant (1724–1804), who believed that through reason scholars could establish a foundation of universal truths. Political leaders of modernity also championed reason as the source of progress in social change, believing that reason can produce a just and egalitarian social order. Such beliefs fed

the American and French democratic revolutions. Modernity proceeds through the Declaration of Independence, the French Revolution, the First and Second World Wars, into our own day.

The major movements and events of modernity are democracy, capitalism, industrialization, science, and urbanization, and its rallying flags are freedom and the individual. Scholars of postmodernity Steven Best and Douglas Keller define modernization as a term "denoting those processes of individualization, secularization, industrialization, cultural differentiation, commodification, urbanization, bureaucratization, and rationalization which together have constituted the modern world."

Not all theorists agree that modernity is dead or even that it is outmoded, but most postmodernists do. Still others say that we are already beyond postmodernism. For example, Chika Okeke-Agulu, a specialist in contemporary African art, asserts that globalization of contemporary art has rendered distinctions between postmodernist and other discourses irrelevant. Some scholars use the term *postmodern* descriptively; others use it prescriptively to urge the formation of new theories to deal with new times.

Scholars critical of modernity cite the suffering and misery of peasants under monarchies and the later oppression of workers under capitalist industrialization; the exclusion of women from the public sphere; and the colonization of other lands by imperialists and, ultimately, the destruction of indigenous peoples. Some social critics also claim that modernity leads to social practices and institutions that legitimate domination and control by a powerful few over the weak many, even though modernists promise equality and liberation of all people. Karl Marx, Sigmund Freud, and their followers have undermined modernists' belief in the ability of reason to find truth by demonstrating that forces below the surface of society and psychological forces not bound by reason are powerful shapers of society and individuals.

Proponents of postmodernity say we have been living in the Age of Postmodernity for about two decades, and some symbolically date its birth to the student riots in Paris in 1968, during which students, with the support of prominent scholars, demanded radical changes in a very rigid, closed, and elitist European university system. Proponents characterize the age as a period of rapidly evolving and spreading technological developments that are producing a new social order requiring new concepts and theories. There is no unified theory of postmodernity. In fact, several different theories and theoretical directions, some of which conflict with others, are lumped together under the term. However, the following generalities can be made apparent.

Whereas modernity is influenced by the rationalism of René Descartes, Immanuel Kant, and others, postmodernity is influenced by philosophers such as Friedrich Nietzsche, Martin Heidegger, Ludwig Wittgenstein, John Dewey, and, more recently, Jacques Derrida and Richard Rorty. All of these thinkers are skeptical about the modernist belief that theory can mirror reality. Instead they embrace a much more cautious and limited perspective on truth and knowledge, stressing that facts are

simply interpretations, that truth is not absolute but merely the construct of individuals and groups, and that all knowledge is mediated by culture and language. Whereas modernists believe they can discover unified and coherent foundations of truth that are universally true and applicable, postmodernists accept the limitations of multiple views, fragmentation, and indeterminacy. Postmodernists also reject the modernist notion that the individual is a unified rational being. Descartes's dictum, "I think therefore I am," and, more recently, Jean-Paul Sartre's existentialist claim that the individual is free and undetermined place the individual at the center of the universe. Postmodernists instead remove the individual from the center and claim that the self is merely an effect of language, social relations, and the unconscious; they downplay the ability of the individual to effect change or be creative.

These generalizations about modernity and postmodernity are derived mainly from Best and Keller, who also provide clear and detailed summaries of two important strands of theory contributing to postmodernity that will be briefly examined here: structuralism and poststructuralism. Structuralism emerged in France after World War II, heavily influenced by the earlier semiotic theory of linguist Ferdinand de Saussure. De Saussure identified language as a system of signs consisting of signifiers (words) and signified (concepts) that are arbitrarily linked to each other in a way that is designated by the culture. Structuralists attempt to explain phenomena by identifying hidden systems. They believe that no phenomenon can be explained in isolation from other phenomena. They differ from previous scholars who explained things through historical sequences of events. Structuralists such as Claude Lévi-Strauss used linguistic analysis in anthropology; Jacques Lacan developed structuralist psychoanalysis; and Louis Althusser promoted a structuralist Marxism. These structuralists in their varied disciplines sought to discover unconscious codes or rules that underlie phenomena. They sought to make visible systems that were previously invisible. They, like modernists, strove for objectivity, coherence, and rigor and claimed scientific status for their theories, which they believed purge mere subjective evaluations.

Poststructuralists—most influentially Jacques Derrida, Michel Foucault, Jean-François Lyotard, and Roland Barthes—attack the structuralists for their scientific pretensions, their search for universal truth, and their belief in an unchanging human nature. Both the structuralists and the poststructuralists reject the idea of the autonomous subject, insisting that no one can live outside of history; but post-structuralists especially emphasize the arbitrariness of all signs. They stress that language, culture, and society are arbitrary and conventionally agreed upon rather than natural. Poststructuralists use historical strategies to explain how consciousness, signs, and societies are historically and geographically dependent. Poststructuralists also collapse the boundaries between philosophy, literary theory, and social theory. Postmodernists build on the semiotic projects of Barthes and others, who study the systems of signs in societies and who generally assume that language, signs, images, and signifying systems organize the psyche, society, and everyday life.

Poststructuralists believe Marx's emphasis on the power of economic relations is too dogmatic and limited as an explanation of historical and social development and seek to identify multiple forms of power and domination. In the political arena, according to Best and Keller, most poststructuralists find Marxism to be obsolete and oppressive and no longer relevant for the postmodern era; instead they advocate radical democracy.³

There is considerably more to postmodernist theory, but it is much beyond the scope of this chapter, which deals more specifically with modernism and postmodernism in art and art criticism. Modernism, modernity, postmodernism, and postmodernity are all interdependent, and a study of any one will help explain the others.

Postmodernism in art follows modernism or lives alongside it—many artists and critics continue the modernist tradition. Postmodernists, however, reject modernism. Postmodernism is more complicated than modernism and, because in large part it is a denunciation of modernism, the former cannot be adequately understood without an understanding of the latter. Thus, this chapter continues with a comparison of the two and then looks at the multiple influences on the encompassing, cumbersome, and influential ideological phenomenon called postmodernism and examines how it is affecting art and its criticism.

MODERNIST AESTHETICS AND CRITICISM

Artistic modernism is more recent than philosophical modernity. Artistic modernism began during the middle or the end of the nineteenth century or during the 1880s—depending on which scholar is consulted. Robert Atkins, for example, dates modernism "roughly from the 1860s through the 1970s" and writes that the term is used to identify both the styles and the ideologies of the art produced during those years. ⁴ Although modernism is now old and perhaps over, it was once new and very progressive, bringing a new art for a new age.

Modernism emerged amid the social and political revolution sweeping Europe. Western European culture was becoming more urban and less rural, industrial rather than agrarian. The importance of organized religion in the daily lives of people was diminishing, while secularism grew. Because the old system of artistic patronage had ended, artists were free to choose their own content. Their art no longer needed to glorify the wealthy individuals and powerful institutions of church and state that had previously commissioned their paintings and sculptures. Because it was unlikely that their art would flourish in the new capitalist art market, artists felt free to experiment and made highly personal art. The slogan of the era, "art for the sake of art," is apt.

Modernists signified their allegiance to the new by referring to themselves as "avant-garde," thinking they were ahead of their time and beyond historical limitations. Modern artists were especially rebellious against restrictions put on previous

artists by the art academies of the 1700s, and many avant-garde artists rebelled against the dominance of the art salons and their conservative juries in the late 1800s. Modern artists were generally critical of the status quo and frequently challenged middle-class values.

Premodernist Jacques Louis David painted scenes from the French Revolution, and Francisco de Goya depicted Napoleon's invasion of Spain. Modernists Gustave Courbet and Edouard Manet turned their easels away from nobility and wealth to paint ordinary life around them. The impressionists and postimpressionists abandoned historical subject matter and also turned away from the realism and illusionism artists had been refining in the West since the Renaissance.

Some modernists, such as the futurists in Italy during the 1920s, celebrated in their work the new technology, especially speed, while others, such as the constructivists in the Soviet Union, embraced scientific models of thinking. The abstractionists Wassily Kandinsky and Piet Mondrian embraced spiritualism to offset the secularism of the modern era. Paul Gaugin, and later Pablo Picasso, sought solace and inspiration in non-Western cultures, while Paul Klee and Joan Miró "employed childlike imagery that embodies the yearning to escape adulthood and all its responsibilities."⁵

In 1770 philosopher Immanuel Kant laid the philosophic foundation for artistic modernism, and for the formalism that grew up in the 1930s. Kant developed a theory of aesthetic response which held that viewers could and should arrive at similar interpretations and judgments of an artwork if they experienced the work in and of itself. When viewing art, people should put themselves in a suprastate of sensory awareness, give up their personal interests and associational responses, and consider art independently of any purpose or utility other than the aesthetic. An aesthetic judgment should be neither personal nor relative. The viewer should rise above time, place, and personal idiosyncrasies, reaching aesthetic judgment of art with which all reasonable people would agree. In 1913 Edward Bullough, an aesthetician, added the concept of "psychic distancing," reinforcing Kant's idea that the viewer should contemplate a work of art with detachment.⁶

In the 1920s the theory of modernism received a big boost from two British critics, Clive Bell and Roger Fry, who introduced what is now known in art theory as formalism. Formalism and modernism are inextricably linked, although the former is an outgrowth of the latter. Bell and Fry sought to ignore as irrelevant the artist's intent in making a work of art and any social or ideological function the artist may have wanted the work to have. Instead the "significant form" of the artwork was what was to be exclusively attended to. Critic Robert Atkins credits Bell and Fry's critical purpose as being responsible, at least in part, for the early-twentieth-century interest in Japanese prints and Oceanic and African artifacts. Their critical method of attending to art was meant to allow a cross-cultural interpretation and evaluation of any art from any place or any time. Form was paramount, and attention to other aspects of the work—such as its subject matter or narrative content or uses

in rituals or references to the ordinary world—were considered distractions and, worse, detriments to a proper consideration of the art.

During the 1930s, in the area of literary criticism, T. S. Eliot, I. A. Richards, and other writers developed "New Criticism," a formalist approach to literature that paralleled formalism in art. They wanted considerably more interpretive emphasis placed on the work itself—on the poem rather than the poet, for instance—and they wanted it to be analyzed according to its use of language, imagery, and metaphor. They were attempting to correct the then-current practice of critics placing too much emphasis on information outside of a literary work—for example, on a poet's biography and particular psychology, rather than on the actual text.

After World War II, formalism became extremely important in the United States because of the work of Clement Greenberg, the most influential American critic of this century. With formalist principles, Greenberg championed the abstract expressionism of Mark Rothko, Willem De Kooning, and Jackson Pollock in the mid-1940s through the 1950s. Greenberg particularly championed the work of Pollock, and the artist and critic in tandem are generally credited with moving the center of the high art world from Paris to New York. While regionalist painters such as Thomas Hart Benton and Grant Wood were painting the American scene, and while social realists depicted class struggles, the abstract expressionists championed the existential ideal of individual freedom and committed themselves to psychic selfexpression through abstraction. Shape, size, structure, scale, and composition were of utmost importance, and styles evolved out of enthusiasm for particular properties of paint. Abstract expressionism gets much of its effect "from how paint in various thicknesses, applied by a variety of means, behaves differently and affects the finished work in different ways. Blobs of paint mean something different from drips or thin veils."8

With the backing of Greenberg and, later, fellow critic Harold Rosenberg, abstract expressionists and color-field painters and hard-edge abstractionists flattened their paintings under the formalist principle that painting is two-dimensional by nature and that it ought not attempt three-dimensional illusions. Rosenberg declared that "a painting is not a picture of a thing; it's the thing itself." He wanted artists "just TO PAINT." Barnett Newman, who painted huge minimally abstract paintings in the 1950s, wrote that the canvas should not be a "space in which to reproduce, re-design, analyze or express," and he rejected "props and crutches that evoke associations, and resisted the impediments of memory, association, nostalgia, legend, myth." Frank Stella wrote, "My painting is based on the fact that only what can be seen there *is* there." Minimalists, with their emphasis on reducing painting and sculpture to its bare essentials, were heavily influenced by the work of Newman, Ad Reinhardt, and David Smith. Atkins credits minimalism with being the first internationally significant art movement pioneered by American-born artists. 12

During the 1960s, historian and critic Michael Fried wrote extensively about formalism, concentrating especially on minimalist sculptors. However, as social

forces in the 1960s sought to obliterate social boundaries, so art movements erased aesthetic boundaries. Joseph Beuys, the German process artist, was claiming that everyone was an artist, while Andy Warhol was claiming that everything was art. Movements such as pop art eventually rendered formalism ineffective. Warhol's renditions of Brillo boxes and Campbell's soup cans demanded social and cultural interpretations rather than meditations on the significance of their form. Pop art also relied on everyday life, a subject that was anathema to formalists, and pop artists such as Roy Lichtenstein used comic book imagery to make art with important narrative content, a concept that formalists wanted banished from painting. Pop artists erased the boundaries between high art and low art, and between an elite and a popular audience, by placing their versions of comic strips, soup cans, and cheeseburgers in galleries and art museums.

Criticism of modernism, its slogan of "art for art's sake," and its push toward minimal abstraction was growing. Tom Wolfe attempted to discredit Greenberg and Rosenberg and their abstract and minimalist movements with sarcastic wit in his entertaining short book *The Painted Word*. Wolfe mocked as a trivial idea the formalists' insistence on the "flatness" of a canvas. In 1982 Wolfe wrote *From Bauhaus to Our House*, this time concentrating on the glass box architecture of modernism. In the book Wolfe sarcastically dismisses the architectural principles and buildings of Mies Van Der Rohe, Le Corbusier, and the Bauhaus school of pre–World War II Germany, which had immigrated to the United States. Wolfe's book about architecture followed another influential critique of modernist architecture by Charles Jencks, *The Language of Post-Modern Architecture*. Is Jencks pointed out that the utopian dreams of architects like Le Corbusier resulted in sterile skyscrapers and condemned public housing projects. Jencks called for a new architectural style based on eclecticism and popular appeal.

Arthur Danto credits Warhol with bringing about "the end of art." ¹⁶ By the phrase "the end of art," Danto refers to the logical end of a certain strain of art, namely modernism. Danto describes modernism as an internally driven sequence of "erasures" that took place over decades and ended in 1964 with the exhibition of Warhol's *Brillo Box*. According to Danto, the history of modernism since 1900 is "a history of the dismantling of a concept of art which had been evolving for over half a millennium. Art did not have to be beautiful; it need make no effort to furnish the eye with an array of sensations equivalent to what the real world would furnish it with; need not have a pictorial subject; need not deploy its forms in pictorial space; need not be the magical product of the artist's touch."

Many others agree that the history of modernism is a history of "erasures." Modernist artists took apart the foundations of all that was special in previous art making. They abandoned beauty as the ideal of art—Picasso's Cubist rendering of women in *Les Demoiselles d'Avignon*, 1907. They dropped subject matter as essential—Jackson Pollock's "drip paintings." They stopped rendering three-dimensional forms on two-dimensional surfaces—Franz Kline's *Mahoning*, 1956, an

approximately $6' \times 8'$ oil on canvas, black-on-white linear abstraction. They eliminated the artist's touch—Don Judd's *Untitled*, 1967, consisting of eight cubes, made by commercial fabricators, of steel and car paint. They eliminated the need to have an art object itself—for conceptual artists of the mid-1960s and 1970s, the idea was more important than the finished work; John Baldessari, for example, exhibited only the documentation of a conceptual piece he made by placing the letters C-A-L-I-F-O-R-N-I-A in the actual landscape according to where these letters appeared on a map of California. They eliminated the need to have an artwork be different from ordinary objects—soft sculptures of hamburgers and fries by Claes Oldenburg, and Andy Warhol's *Brillo Box*, 1964.

Danto specifically credits the *Brillo Box* with the end of modernism because with it Warhol made the "philosophical" statement that one could no longer tell the difference between an ordinary object and an art object just by looking at it. To know that Warhol's *Brillo Box* was art and a Brillo box in the grocery store was not, one had to know something of the history of art, the history of the "erasures" that led to Warhol's ultimate erasure (or the death of art). One had to participate in a "conceptual atmosphere" and be familiar with some of the "discourse of reasons" afloat in an "art world."

Despite Danto's proclamation of the end of art, there obviously were and are many artists, with much energy, still making art; but it is the art of a new "pluralism" rather than art made under the dictates of mainstream modernism. Danto sees "the end of art" as a liberation: "Once art had ended, you could be an abstractionist, a realist, an allegorist, a metaphysical painter, a surrealist, a landscapist, or a painter of still lifes and nudes. You could be a decorative artist, a literary artist, an anecdotalist, a religious painter, a pornographer. Everything was permitted since nothing was historically mandated." 18

This is roughly the way that Danto and other mainstream critics and aestheticians see the history of modern art. One art scholar may judge some artists to be major influences; another may see these same artists as less important. Fried, for instance, stresses the importance of minimalist sculptors such as Judd and Robert Morris, while Danto finds the pop artists, especially Warhol, to be most influential.

Others, notably Douglas Crimp, write a different history of modernism, arguing that its demise was brought about by the invention of photography. Photography allowed the mechanical reproduction of images, including art images, thus eventually stripping away from the work of art its properties of uniqueness, originality, and location or place of origin. In reproduction, the artwork can be studied in libraries and living rooms. In reproduction, the artwork can be enlarged, cropped, and recombined with other artworks and images. That the artwork once was "original and authentic" is considered much less important. What is considered important by Crimp and others is that any artwork made in any place in the world at any time can now be seen over and over again in myriad contexts.

The significance of the reproducibility of artworks by photographic means was first noted by Walter Benjamin in the 1930s. Benjamin was a member of the Frankfurt School, which also included Theodore Adorno, Herbert Marcuse, and other European scholars fleeing Hitler. These scholars, and more recently Jürgen Habermas, developed what is known as *critical theory*, a form of neo-Marxism that challenges dominant capitalist ideology, practice, and culture. Habermas particularly supports art that contributes to critical social discourse. Marxists accept modernism's search for foundational truths but are generally hostile to artistic modernism's separation of art from life. The "neo" in neo-Marxism is a rejection of the strict and unwavering historical determinism and belief in the collapse of capitalism that Marxists once held. Currently most Marxists accept the influence of culture on history and the ability of people to affect the future.

In postmodernist terms, Danto's and other writers' renditions of modernism are thought of as "stories." According to Derrida, all explanations of the world, including scientific explanations, are merely stories or "discourses" fabricated by people. Derrida holds that we never get to reality, only to what we say about reality. There is no truth; there is only discourse. Nevertheless, Danto's theory is compelling. It may be only discourse, or a story—but it may be a true story; certainly it is one to remember. It is convincing and makes sense of myriad stylistic changes that have taken place in art over the past 100 years, making these changes seem logical and linear. Like all stories, however, it draws our attention to certain characters and events and ignores thousands of other people who could have become major or minor characters. Danto's story of modernism is set in Paris and New York; the rest of the world would be distracting. Danto's story ignores all aesthetic traditions except those of Western Europe and the United States. It is a story about modern Western culture, and it overlooks artists and artworks that do not fit its plot. Frida Kahlo is not a character in this story, nor is Romare Bearden. The art of most women is omitted, as is the work of artists of color, and indeed anyone who was making art with intentions different from those cited by mainstream critics and aestheticians.

In reviewing Sister Wendy Beckett's ten-part television series, "The Story of Painting," art critic Eleanor Heartney shows how Sister Wendy's approach to art is "thoroughly canonical" (focusing on those Western masters one would expect in a typical art appreciation course) and "thoroughly conventional"—that is, modernist: "Sister Wendy tends to focus on single works, offering spicy details about the artist's life or the story depicted. She appears untouched by contemporary art history's efforts to deconstruct and recontextualize art. In her commentaries, cataclysmic historic events, social upheavals, technological and economic revolutions remain securely in the background, while questions of artistic influence and aesthetic philosophy are only slightly acknowledged. Instead, each artist stands essentially alone, a heroic defender of the realm of individual freedom." 19

We might have inherited a different history of art than modernism (others are currently being written). But we didn't. We inherited modernism as a very

influential, and limited, explanation of art of the past century. The predominant characteristics of modernism are an optimism regarding technology; a belief in the uniqueness of the individual, creativity, originality, and artistic genius; a respect for the original and authentic work of art and the masterpiece; a favoring of abstract modes of expression over narrative, historical, or political content in art; a disdain for kitsch in culture and a general disdain for middle-class sensibilities and values; and an awareness of the art market.

POSTMODERNIST AESTHETICS AND CRITICISM

Postmodernists set themselves apart from all or most modernist beliefs, attitudes, and commitments. They present the art world with diverse aesthetic forms that break with modernism; examples include the architecture of Robert Venturi and Philip Johnson; the radical musical practices of John Cage; the novels of Thomas Pynchon; films like *Blue Velvet*; performances like Laurie Anderson's; use of electronic signage by Jenny Holzer; Barbara Kruger's use of the linguist strategies of commercial advertising to make socially oppositional art in popular culture; "grazing" cable television with a remote control; and "spin doctors" positioning their presidential candidates in a positive way.

Sherrie Levine is considered a preeminent postmodernist visual artist, and through an examination of one of her works we can gain entry into the morass of postmodernist theories of art. Levine is most famous for "appropriating" artworks from the past, most often so-called masterpieces by such white male modernist artists as the European painter Piet Mondrian and American photographers Walker Evans and Edward Weston (one of the most influential mentors of modernist art photography). Levine copied ("appropriated") Evans's photograph and exhibited it as her own work of art under the title *After Walker Evans #7*, 1981. The very act of appropriating or borrowing or plagiarizing or stealing is a postmodernist strategy that flouts the modernists' reverence for originality.

According to Philip Yenawine, former educator at the Museum of Modern Art in New York, originality for Levine has to do with raising an issue rather than with inventing a new image. Her attitude, and that of other postmodernists, "assumes that originality is impossible, anyway, given that there is nothing new under the sun. Therefore, invention and uniqueness are no longer essential in making art. Originality might, in their terms, be an egoistic grasping for individual recognition in a world that is ever more needful of the opposite—cooperation and integration." Postmodernists remind us that the notion of originality is absent in most traditions of art, in the West and throughout the world. Throughout time most cultures felt no need to identify artists personally, even if they were especially gifted.

About Levine's *After Walker Evans* #7, Yenawine further explains that this image, reproduced here, is five or six generations of printing away from its original negative and exaggerates the by-products of reproduction: intensified whites and blacks

Sherrie Levine, *After Walker Evans #7*, 1990. Black and white photograph, $14" \times 11"$. Courtesy of Sherrie Levine and Marian Goodman Gallery.

and loss of subtle gradations from light to dark. We might look at this as distortion, but Yenawine examines it for the things gained and interprets the most basic gain to be access because this particular image might have otherwise been unknown to us. Yenawine's point reinforces Crimp's, and Benjamin's before his, that the invention of photography has created havoc for modernism. The original photograph or any artwork is not important. The reproduction brings the image to millions of us who otherwise would not see it at all because we would not travel to wherever Evans's photograph might hang. Levine scorns originality in her defiant and blatant copying.

Another quality that Yenawine finds more obvious in the reproduction than in the original is "pathos." Because Levine's reproduction has diminished the original photograph's fine print qualities, it encourages us to concentrate on the subject matter of the image. Evans's photograph is part of the large documentary project of photographing poverty in America that took place during the Depression. While doing this, Evans always gave great attention to compositional issues that are diminished in Levine's reproduction. Yenawine writes that "by reducing the formal perfection, we have left, then, something that is more a document of what Evans started with, perhaps made even more touching because of the heavy contrasts of black and white, the general dirtiness of the image itself. While we might be satisfied to see Evans's original image as a still life, here we are urged to wonder about the life of the person who sits in the chair." Thus Levine's *After Walker Evans #7* can be seen to illustrate other principles of postmodernism—namely, that art ought not be separated from life, that art can and should refer to things other than art, and that art can and should be about more than its own form.

By using a camera to rephotograph a photograph, Levine is also eschewing the reverence previously given to painting, always considered the essential medium of modernism, even though minimalist sculptors attempted to challenge the primacy of paint on canvas.

By selecting the work of male artists, Levine questions the place of women in the history of art. By copying certain subjects of male artists, such as a photograph by Edward Weston of his son Brett Weston as a nude young boy, she also questions the role of the artist's gender when the audience views the work: If the nude torso of a young boy had been made by a woman artist, the implications would have been different than they are. The issue of gender and representation is a larger issue that will be explored in the following pages as we consider the role of feminist theory in postmodernism.

As should be expected, not everyone is enamored with appropriations such as those by Levine. In one biting rejection, Mario Cutajar dismisses the practices of Levine and fellow postmodernists like Jeff Koons, who appropriates crass three-dimensional commercial artifacts such as bunnies, has them made into stainless steel replicas, and exhibits them as high-art sculptures, and like David Salle, the painter who freely and frequently paints others' imagery into his own.

While acknowledging objections like those of Cutajar and others, with this example of a postmodernist work of art by Levine and fleeting references to the work of Koons and Salle, we can begin to draw some meaningful generalizations about the differences between postmodernist art and modernist art. Postmodernists do not merely follow modernists chronologically but also critique them. Modernists throw off the past and strive for individual innovations in their art making; postmodernists are generally content to borrow from the past and are challenged by putting old information into new contexts. Critics and theorists who support modernism ignore the art of artists who are not working within the sanctioned theory of modernism. Postmodernist critics and artists embrace a much wider array of art-making activities and projects. Modernists attempt to be pure in their use of a medium; postmodernists tend to be eclectic regarding media and freely gather imagery, techniques, and inspiration from a wide variety of sources, much of it from popular culture. Modernists generally disdain popular culture. Although modernists are often enthusiastic about the times during which they work, they think themselves and their art apart from and above the ordinary events of their day. Postmodernists are skeptical and critical of their times; and, as we shall soon see when we deal with activist art, some postmodernist artists are socially and politically active. Modernists believe in the possibility of universal communication; postmodernists do not.

Whereas modernists search for universals, postmodernists identify differences. Difference, according to Cornel West, is concerned with issues of "exterminism, empire, class, race, gender, sexual orientation, age, nation, nature, region."²³ According to West, a new cultural politics of difference is determined to "trash the monolithic and homogeneous in the name of diversity, multiplicity and heterogeneity; to reject the abstract, general and universal in light of the concrete, specific and particular; and to historicize, contextualize and pluralize by highlighting the contingent, provisional, variable, tentative, shifting, and changing."

In an article called "Beyond Universalism in Art Criticism," Karen Hamblen provides an overview of problems inherent in beliefs in the possibility of universal communication through art. ²⁴ She explains that most scholars no longer believe that art objects can communicate without viewers having access to knowledge about the times in which they were made and the places in which they originated. Most critics no longer believe that they can interpret, let alone judge, art from societies other than their own without considerable anthropological knowledge of those societies. Most critics now believe that artworks possess characteristics and meanings based on their sociocultural contexts and acknowledge that artworks have been

interpreted differently in various times and places. Critics are now likely to consider personality differences, socioeconomic backgrounds, genders, and religious affiliations of artists and their audiences, whereas modernist critics are much more likely to concentrate solely on the art object itself and believe that they can gain consensual agreement about their individual responses.

With the influence of postmodernism, critics are much more attuned to viewers of art and how they respond to it, and they prize variable understandings of the same work of art. Wanda May, along with Hamblen, both scholars of art education, asserts that the postmodernist goal is to "keep things open, to demystify the realities we create." The rigid categories of modernism "tend to make us more static than we are or wish to be." May adds that a postmodern work is "evocative rather than didactic, inviting possibilities rather than closure." Craig Owens, drawing on the work of Barthes, explains a postmodern distinction between considering literature, or any work of art, as either *work* or *text*: "Singular and univocal, the work is an object produced by an author; whereas the text is a permutational field of citations and correspondences, in which multiple voices blend and clash." This is an important distinction and marks a big difference between newer and older kinds of criticism: Most contemporary critics and all postmodernist critics hold that an artwork is indeed a text written by many people, providing viewers with many possible readings.

Lucy Lippard gives a clear and strong objection to the tendency of modernists to withdraw from the world and ordinary viewers in their art making: "God forbid, the [Modernist] taboo seems to be saying, that the content of art be accessible to its audience. And God forbid that content mean something in social terms. Because if it did, that audience might expand, and art itself might escape from the ivory tower, from the clutches of the ruling/corporate class that releases and interprets it to the rest of the world." She rails against what she calls the still-current modernist taboo against what modernists derogatorily refer to as "literary art," which encompasses virtually all art with political intentions. Critics and artists still influenced by modernism are likely to denigrate social art as too "obvious, heavy handed, crowd pleasing, sloganeering." Lippard berates modernists for rejecting dada, surrealism, social realism, pop art, conceptual art, performance art, video art, and all art with social concerns.

Barbara Kruger, a postmodernist artist who appropriates and alters photographs and adds her own texts, is also a published critic who rejects the modernists' fixation with distinguishing, in a hierarchical manner, high culture from low culture. The title of her article is telling: "What's High, What's Low—and Who Cares?" In the article she denounces such categories in general for their false authority, pat answers, and easy systems. She defends her rejection of distinctions between high and low art by arguing that art "can be defined as the ability, through visual, verbal, gestural, and musical means, to objectify one's experience in the world: to show and tell through a kind of eloquent shorthand how it feels to be alive. And of course

a work of art can also be a potential commodity, a vessel of financial speculation and exchange. But doesn't popular culture have the ability to do some of the same things: to encapsulate in a gesture, a laugh, a terrific melodic hook, a powerful narrative, the same tenuously evocative moments, the same fugitive visions?" In a related thought about modernism's penchant for dogmatic statements and distinctions, Robert Storr writes, "Indeed if postmodernism means anything, it is an end to terminal arguments and the historical mystifications and omissions necessary to maintaining millennial beliefs of all kinds." ²⁹

Harold Pearse, a Canadian scholar of art education, succinctly draws significant distinctions among premodern, modern, and postmodern tendencies, and his thoughts summarize this section: "By dispossessing itself of the *premodern* tendency to repress human creativity to avoid usurping the supremacy of a divine creator, and the *modern* tendency to over-emphasize the originative power of the autonomous individual, the *postmodern* imagination can explore alternative modes of inventing alternative modes of existence." Pearse explains that the model of the modernist image of the artist as a productive inventor has been replaced by that of *the bricoleur*, or collagist, who finds and rearranges fragments of meaning. The postmodern artist is the "postman delivering multiple images and signs which he has not created and over which he has no control."

MARXIST CRITICISM

Marxist critics hold that artists and artworks express what is invisible or below the surface, sometimes unknown to the artist, and Marxism runs through aspects of both modernism and postmodernism. Karl Marx (1818–1883) sees realities beneath the surface of what appears to be "the real." Marxist critics assert that artworks are not independent and autonomous but are highly influenced (some say determined) by the society in which they are produced. Marxist critics look at how the social constructions and relations influence the ways artworks are made and received. Art and its study are not disembodied or disinterested; the production and apprehension of art are socially dynamic and relevant.

Marx attributes transformative powers to art. Art can merely be a symptom of society, mirroring it; but works of art can also reveal how we view the world, and aid us in changing it by producing an awareness of others in the larger social sphere, thus reducing individual alienation. Marxists, among others, insist that we seriously consider the role of social and historical context in how we interpret works of art.³¹

"Critical theory," originally associated with the Frankfurt School, derives from Marx and Sigmund Freud and others who exercise a "hermeneutics of suspicion," or generally wariness about interpretation and understanding. They see all claims to truth as being highly influenced by power and vested interests. Neo-Marxist theory investigates how the meaning and authority of one's communication are affected by class and gender, and where one stands geographically or within an institution. Art

Culture does not emerge from the free creative expression of social agents, but is constructed in commodity form by an alliance of the state and private corporations. It signals the complete rationalization of the emancipatory powers of creativity, where creativity is converted into standardized mass-produced products and reduced to basic formulaic patterns of taste. This commercialized culture engenders intellectual passivity and docility, which themselves are the conditions needed for authoritarian politics to reign.³²

PSYCHOANALYTIC CRITICISM

Psychoanalytic theory is a vast domain of knowledge that cuts across and through other theories of art. Sigmund Freud (1856–1939) has a conceptual affinity with Marx in that both see realities beneath the surface of what appears to be reality. Michael Hatt and Charlotte Klonk identify two ideas fundamental to all psychoanalytic theories: "First, psychoanalysis declares that our mental life is not the same as our conscious life. As well as our consciousness, with its faculties of reason and imagination, thinking and wondering, our minds have an unconscious." Freudian theory maintains that our unconscious is formed from repressed mental events in childhood, especially sexual longings. We banish many sexual longings from consciousness to an unconscious where they are retained and to which we have no direct access. "The nature of the repressed material alerts us to the second key principle: that sexual impulses are central to the human psyche and, hence, human behavior." 33

Psychoanalytic theories generally assert that artists express what is buried within their subconscious minds and that works of art give us knowledge of artists as making subjects and of viewers as viewing subjects. Freud defines psychoanalysis as consisting of three aspects: (1) a discipline focusing on the unconscious, (2) a therapeutic method for treating nervous disorders, and (3) research on aspects of culture, including art history, literature, and philosophy. Freud proposed that all is not as it seems, and that people can be seen as "texts." The unconscious and repression are two interrelated concepts that work dynamically as the basis of Freud's psychoanalytic theory. The repressed is part of the unconscious. Repression occurs when an instinct from the unconscious arises but is deemed by the conscious to be dangerous, threatening, destabilizing, or socially taboo. His intellectual legacy in the humanities is immense, and many of his ideas find current thinking in art criticism.

The more recent psychoanalytic theory of Jacques Lacan (1901–1981) is very influential in postmodernist theory and was brought to art criticism largely through feminist critics. Lacan reworks Freudian developmental theory to account for the biological becoming human, asserting that language and ideology influence the formation of the biological being's identity. Language precedes consciousness, and it directs and mediates one's desires. The child's entry into language marks its transition from merely biological to human.

The subject is dependent on three interdependent and inseparable "orders": the symbolic, the imaginary, and the real. The ego or conscious self is not biologically determined, nor is it autonomous. The subject becomes an "I" only when it enters the Symbolic order, which is constituted by preexisting language and by desire that is caused by the child's separation from its mother, and also by the father's interference in the relationship of the child and its mother. Language and the father signify prohibition and authority.

The order of the imaginary is a mix of "self as other" and "self and other." Lacan's famous "mirror stage" is part of the imaginary. In the imaginary order, during the mirror stage of development, the child between the age of six and eighteen months becomes aware of itself as an image. It recognizes itself in a mirror; it identifies with its own image as a whole but also experiences its uncoordinated body as fragmented. The mirror stage constitutes a sense of alienation: Lacan writes, "To know oneself through an external image is to be defined through self-alienation."

Lacan's theory of "the gaze" is particularly compelling for many critics and artists. The gaze reveals to Lacan a split between eye and sight. There is asymmetry in the relation between the sight of the self and the gaze of the thing looking back. As Lacan writes, "You never look at me from the place from which I see you." Lacan looks to art to understand how we represent ourselves in relation to desire. He challenges us to view art with two tasks: (1) recognize our own desire in looking, and (2) listen, read, and interpret the "text," not the "author." Lacan pleads, "Please give more attention to the text rather than to the psychology of the author."

The Museo de Arte Contemporáneo de Castilla y León in Spain applies psychoanalytic theory to interpret the work of Paul Pfeiffer, a contemporary American artist digitally distorting video images of cultural icons such as basketball stars (see Color Plate 1). The icons promise redemption and transcendence, but Pfeiffer eliminates their identities

to express himself with their absence and through it. The erasure of the iconic body is predominant in his work. At first glance, when we no longer feel captivated by the omnipresence of that iconic image, what is manifested is an unexpected moment, of anxiety and doubt, as a mirror reflecting our own loss. We become part of the erased, absent image. Instead of captivatingly observing the icon, as viewers we look directly at the crowd watching the game in the sports stadium. At the same time, then, the spectator sees the very act of seeing. By "erasing" the icon Pfeiffer is therefore seeking to erase us, perhaps to liberate our identity and push us into the shapeless plural background of the crowd. ³⁵

FEMINIST AESTHETICS AND CRITICISM

Q. "Who are the Guerrilla Girls?"

A. "We're a bunch of anonymous females who take the names of dead women artists as pseudonyms and appear in public wearing gorilla masks. We have produced posters, stickers, books, printed projects, and actions that expose sexism and racism in politics, the art world, film, and the culture at large. We use humor to convey information, provoke discussion, and show that feminists can be funny. We wear gorilla masks to focus on the issues rather than our personalities. Dubbing ourselves the conscience of culture, we declare ourselves feminist counterparts to the mostly male tradition of anonymous do-gooders like Robin Hood, Batman, and the Lone Ranger. Our work has been passed around the world by kindred spirits whom we are proud to have as supporters. It has also appeared in *The New York Times, The Nation, Bitch*, and *Bust*; on TV and radio, including NPR, the BBC, and CBC; and in countless art and feminist texts. The mystery surrounding our identities has attracted attention. We could be anyone; we are everywhere."—The Guerrilla Girls, 2010

This statement is quoted from the Guerrilla Girls' Web site. ³⁶ The Guerrilla Girls established themselves in New York City in 1985 when some of their members noticed that a 1985 Museum of Modern Art in New York City exhibition, "An International Survey of Painting and Sculpture," included only 13 women in the exhibition that featured 169 artists. They are known for posters ("Do women have to be naked to get into the Metropolitan Museum?" posted on city buses in 1989), books (Confessions of the Guerrilla Girls, 1995; The Guerrilla Girls Bedside Companion to the History of Western Art, 1998; Bitches, Bimbos and Ballbreakers, the Guerrilla Girls Guide to Female Stereotypes, 2003; The Guerrilla Girls Art Museum Activity Book, 2005; and The Hysterical Herstory of Hysteria and How It Was Cured from Ancient Times until Now, 2010), billboards, appearances, and creative forms of culture jamming that expose discrimination in the art world.

Their first work was putting up posters on the streets of New York City decrying the gender imbalance of artists represented in museums. They expanded their activism to include racial imbalance, the film industry ("The Anatomically Correct Oscar: He's white and male, just like the guys who win!"), popular culture, and gender stereotyping, while they continue to focus on corruption in the art world ("A curator shall not exhibit an Artist, or the Artists of a Dealer, with whom he/she has had a sexual relationship, unless such liaison is explicitly stated on a wall label 8 inches from the exhibited work.") Women's groups have taken action to confront social injustice worldwide in Bosnia, Brazil, Cyprus, Europe, India, Mexico, and Serbia.

Describing the political work of the Guerrilla Girls is a good way to introduce the major contributions of feminism to current art theory. The history of feminism is older than some of us may realize: Mary Wollstonecraft wrote A Vindication of the Rights of Women in 1792, and Virginia Woolf wrote A Room of One's Own in 1929, both of which address women's self-definition and their material disadvantages. In the nineteenth and early twentieth centuries, women campaigned for women's

THE ADVANTAGES OF BEING A WOMAN ARTIST:

- Working without the pressures of success.
- •Not having to be in shows with men.
- •Having an escape from the art world in your 4 free-lance jobs.
- •Knowing your career might pick up after you are eighty.
- •Being reassured that whatever kind of art you make it will be labeled feminine.
- Not being stuck in a tenured teaching position.
- •Seeing your ideas live on in the work of others.
- •Having the opportunity to choose between career and motherhood.
- Not having to choke on those big cigars or paint in Italian suits.
- •Having more time to work after your mate dumps you for someone younger.
- •Being included in revised versions of art history.
- •Not having to undergo the embarrassment of being called a genius.
- •Getting your picture in art magazines wearing a gorilla suit.

A PUBLIC SERVICE MESSAGE FROM GUERRILLA GIRLS CONSCIENCE OF THE ARTWORLD

5 3 2 La GUARDIA PLACE, #237 NY, NY 10012

Guerrilla Girls, *The Advantages of Being a Woman Artist*. Courtesy of the Guerrilla Girls, NY.

legal rights, including voting rights, property rights, workplace rights, reproductive rights, protection of women and girls from domestic violence, and against misogyny and gender-specific discrimination. Simone de Beauvoir published *The Second Sex* in 1949; Betty Friedan's *The Feminine Mystique* came out in 1963, Kate Millet's *Sexual Politics* in 1970, and Germaine Greer's *The Female Eunuch* in 1971. Gloria Steinem founded Ms. magazine in 1972, about forty years ago.

Feminist aesthetician Hilde Hein offers this caution to any summary of feminism: "Feminism is nothing if not complex." Most would agree with Hilde Hein's assertion. Much of the complexity underlying feminist discourse revolves around two different positions: one which asserts that there are important differences between the two sexes, sometimes referred to as "biological feminism," "essentialism," or "gynesis," and another, called "gender theory," which asserts that differences between men and women are cultural, not biological. According to aesthetician Anita Silvers, "Gynesis claims that certain properties of works of art are the natural expressions and representations of women"; whereas "gender theory denies that there is a female nature—psychological phenomenological, biological, or otherwise—that is independent of the accidents of race, class, and custom." These two themes run through the following review of feminism in the art world.

Hein provides a brief historical overview of feminist art in Great Britain and the United States, recalling that Helen Frankenthaler and Bridget Riley in the 1950s and 1960s enjoyed great prominence in the art world, but their content was not feminist because it neither addressed the historical condition of women nor looked like art made by women. Until the end of the 1960s, most women artists sought to "de-gender" their art to compete within the male-dominated mainstream. By the 1960s the counterculture no longer considered the mainstream to be ideologically neutral, and feminists recognized that the art system and art history had institutionalized sexism. Feminist artists such as Miriam Schapiro, Judy Chicago, and Nancy Spero exhumed women artists ignored in the past, and feminist historians began writing "revisionist" art histories to include the women artists who had been ignored. Many feminists dismissed the distinction between the crafts and high art as a male distinction, especially because women traditionally made craft items. Feminist artists in the 1970s began including decoration in their art. Other feminists produced autobiographical works in many media as well as cathartic, ritualized performances such as Mary Beth Edelson's Memorials to the 9,000,000 Women Burned as Witches in the Christian Era. During the 1980s some feminist art took a conceptual bent—for example, Cindy Sherman's photographic investigations of female role playing in culture and Barbara Kruger's evocations of cultural domination through the graphic vocabulary of advertising. Feminist principles have currently become widely accepted; and in opposition to the purity and exclusivity of modernism, feminists are calling for an expansive, pluralistic approach to art making, including the use of narrative, autobiography, decoration, ritual, and craft-as-art. Hein writes that feminists' acceptance of popular culture helped to catalyze the development of postmodernism.

Hein's caution about the complexity of feminism and her brief historical overview provide an introduction to feminist art and criticism. Kristin Congdon and Elizabeth Garber, two art educators applying feminist views to the teaching of art criticism at all levels, provide further overviews. Their summary positions, given here, are supplemented and amplified by the work of other scholars of feminism, male and female.

Congdon summarizes recent feminism this way: "In the past twenty-five to thirty years the feminist movement has functioned to increase discussions about women's art and women artists. Dialogue centers on one or more of the following issues: (1) the recognition and establishment of women's art history; (2) the existence of gender differentiated approaches to artistic processes, products, and aesthetic response; and (3) the development of non-hierarchical approaches to understanding and appreciating art." 39

Garber offers four important distinctions. The first, and most important, is between sex and gender: "Sex is the biological trait we are born with: We are either male or female. Gender, on the other hand, is learned through socialization. Feminine and masculine traits are associated with gender, e.g., boys *learn*, through

social expectations and modeling, to assert themselves and not to cry, while girls *learn* to express their emotions and to nurture others." Congdon offers these examples of gender expectations: "While men are expected to excel in a particular arena, women are conditioned to be adequate in many areas. Boys learn independence, competition, and organizational skills whereas girls focus on relationships with others which involve intimacy and a greater effort toward peaceful interchange and compromise." (See Barbara Kruger, Untitled, We don't need another hero, 1986.)

Feminist theory is built on gender distinctions. Gender is a primary factor in how we perceive the world and understand art, but gender has been overlooked for centuries by aestheticians and critics who would want us to believe that we can approach art and experience neutrally. Some forty years ago, Simone de Beauvoir observed that "one is not born a woman; one becomes one"—she then went on to show how woman has been constructed as "Man's Other."

Garber's second premise is that feminist theory is instrumental. That is, it works to change the way things are. It arises from the social and political goals of the women's movement. It seeks to alleviate the oppression of women. Garber asserts that "not all women artists are feminists; feminism is a chosen position." In Hein's words, "one becomes a feminist by declaration—not by birth or chance or out of habit." Hein goes on to explain that "contrary to a commonly held belief, feminism comes no more naturally to women than to men. Women are normally socialized to experience the world in accordance with male determined categories. Knowing themselves to be female, they nevertheless understand what that means in male terms, unless they explicitly take an oppositional stand and declare their right to self-determination." Feminist critics reject the notion that aesthetics and politics can be independent of one another. Some critics, however, still maintain that there should be a separation between art and politics. Hilton Kramer proclaims that feminism "tells us nothing about the qualities one should be studying in a work of art."42 Hein counters the assertion that overtly political representations have no place in art by arguing that such critics "are failing to grasp the charge implicit in the feminist art that 'conventional' art is equally political, the politics being cast in that 'neutral' or masculinist mode that appears invisible." Despite objections such as Kramer's, most agree that a separation between art and politics is narrow and naive and obstructionist to intelligent critical discourse.

Third, according to Garber, "Feminist and feminine are not interchangeable terms. Feminine is a term assigned to women that connotes socially determined qualities of women such as delicacy and gentleness (these qualities are often assumed to be innate and to transcend historical eras) or inherent qualities such as generally smaller physiques than those of men." Feminism should always be understood as a political commitment to bring about change in a specific historical moment and to meet special needs that the lives of women dictate. Certainly not all women artists are feminists in their work. Hein reminds us of the work of Riley and Frankenthaler,

Barbara Kruger, "Untitled" (We don't need another hero), 1987. Photographic silkscreen/vinyl, $90" \times 117"$.

© Barbara Kruger. MBG#4189. Courtesy of Mary Boone Gallery, New York.

and Edward Gomez reminds us of the work of Susan Rothenberg and Jennifer Bartlett, two very successful contemporary painters in whose work gender has not been an explicit issue.⁴³

Garber's fourth premise is similar to Hein's caution about the complexity of feminism. Garber agrees with those who hold that feminism is not a fixed set of principles or a single position or approach to understanding, but a varied philosophy that continues to evolve. Rosalind Coward emphatically makes a similar point: "Feminism can never be the product of the identity of women's experiences and interests—there is no such unity. Feminism must always be the alignment of women in a political movement with particular political aims and objectives. It is a grouping unified by its political interests, not its common experiences." Hein also holds that feminists have not found a body of truths or a central dogma, but she credits feminists with reframing the questions. The list of problems feminists have abandoned as misguided are "the characterization of aesthetic 'disinterest,' the distinction between various art forms, as well as differences between craft and art, high and popular art, useful and decorative arts, the sublime and the beautiful,

originality, and many puzzles that have to do with the cognitive versus the affective nature of aesthetic experience." This last point rejects splitting emotion from cognition, holding that they are essentially interrelated. Almost everyone agrees that the old problems, the older questions, *are* outmoded and counterproductive to intelligent and inclusive criticism.

After making these general distinctions, Garber explicates the major themes and issues of feminism, beginning with a question often raised about whether there is a distinctive "female aesthetic" or a "female sensibility." She explains that feminists have taken different positions on this matter. Lucy Lippard identified qualities that distinguish women's art making from that of men's as "a central focus (often 'empty,' often circular or oval), parabolic baglike forms, obsessive line and detail, veiled strata, tactile or sensuous surfaces and forms, associative fragmentation, autobiographical emphasis." Lippard says these qualities are found more often in the work of women than of men. She cites as examples Georgia O'Keeffe's flowers with their vortices, Frida Kahlo's autobiographical paintings, and Miriam Schapiro's detailed pattern and decoration paintings of kimonos and houses. Lippard also speculated that she as a woman brings a different sensibility to looking at art: "I know that a certain kind of fragmentation, certain rhythms, are wholly sensible to me even if I can't analyze them."

The search for female sensibility as a universal quality of women's art was more important in the 1970s than it is now. Some feminists argue that the insistence on a female sensibility reinforces characteristics socially assigned to the sexes and perpetuates too simple a dichotomy of opposites between male and female. Claims of a female sensibility circumscribe what and who women can be, and many feminists strongly reject limiting conceptions of women to any particular quality. Lippard abandoned her previous beliefs about female sensibility in 1984. Arlene Raven, however, defended the search, saying that a female sensibility was consciously introduced as the antithesis to imagery sanctioned by art history canons that related men's experiences and values as better than women's. Garber thinks such disagreements among feminists are healthy and can lead to "varieties of feminist aesthetics that represent chosen positions in the fight to end social, economic, intellectual, and spiritual oppression of women or that deconstruct stereotypic ideas about women's sensibilities."

Feminism in the French tradition, as theorized by Helene Cixous, Luce Irgaray, and Julia Kristeva, is concerned with theories of "the body" and feminine writing, writing from the body (*écriture féminine*) as subverting male authority. They offer feminine writing in opposition to traditional "phalocentric" writing and philosophy. Their writings tend toward the effusive and metaphorical, and have informed artworks and exhibitions centered on the body.

Congdon argues that women have shared experiences that are binding: "Women are bound together by shared experiences which often include childbirth and childraising and major responsibilities for homemaking and food preparation. They are also bound together by oppression. It *does* make a difference to women as a cultural

group that one out of every three females in the United States is raped, that one out of every two wives is abused by her husband, that one out of every four female children is sexually abused; and that eighty percent of women who work outside of the home say that they have been sexually harassed on the job." She also argues that "everyone suffers from sexism. An oppressor may reap some benefits from an unjust position but that same oppressor must guard, continue to fight for, justify and distort reality in order to maintain the status quo. Energy expended in such negative ways is energy not spent in positive development."

Feminist scholars of art education also advocate explicit inclusions of women artists in art curricula for all ages of learners. For example, Georgia Collins and Renee Sandell argue that doing so "will (1) encourage the interest of female students by providing them with like-sex role models, opportunities for increased pride and self-esteem, and the excitement of discovering a lost heritage; (2) provide all students with a more complete, complex, and provocative picture of artistic activity and achievement in our culture; (3) prepare more realistically those students headed for art careers in which they will find themselves competing with artists of both sexes; and (4) stimulate critical thinking with regard to the status and values attached to various art activities in our culture."

Divisions in the movement, however, arose over issues of class and race, with black feminists, including Alice Walker, Angela Davis, and bell hooks, asserting that class oppression and racism were being overlooked by a largely white and economically privileged feminist movement. Postcolonial feminists argue that racial, class, and ethnic oppression, more than sexism, are primary forces of patriarchy. They react against what they see as universalizing tendencies in Western feminism and lack of sufficient attention to women's experiences across cultures. Wangechi Mutu (see Color Plate 2), for example, is both an artist and anthropologist who draws on the storytelling traditions of her native Kenya, depicting imaginary female figures using a range of materials, including magazine pictures, ink, paint, glitter, and fur on Mylar. Her work is about issues of African identity, cultural hybridity, and women's roles. Lucy Lippard recalls Hulleah Tsinhnahjinnie, a Navajo/Creek/Seminole photographer, bitterly commenting, "While my mother and aunt were cleaning houses of white women, those women were developing their theories of feminism." 46

As noted earlier, postmodernist critics reject the notion that an art object can communicate universally across time and space. Feminists also reject universal criteria as merely the tastes and values of a small segment of the population—usually male, white, and artistically and socially elite. Feminists ask why subjects of war are valued over mother-and-child or flower paintings. In Chapter 3 there is a discussion of how Deborah Butterfield was pleased that her renditions of horses were peaceful, as opposed to the warlike horses often rendered by male artists. Feminists also ask why quilting is called a "minor art." Congdon suggests that quilts have been unappreciated because they were made by women, just as jazz was underrated for so

Congdon cites several feminist scholars who argue that women think and act differently in the art world than their male counterparts. Carol Gilligan has found that that which is masculine tends to separate and that which is feminine tends to connect, and such attitudes have much to do with how men and women solve problems and define the world. Cheatham and Mary Claire Powell found that many of the women artists they studied "did not have as a characteristic goal the need to get to the top in a competitive isolated manner but to use art as a way of connecting to all things and creating more fulfilling lives." Sandra Langer claims that male artists strive to create the perfect art object, while "a woman centered perspective replaces the dubious object and its mechanistic overtones with the more exciting and rewarding concept of experimentation. The right to fail, to be human, to keep on trying and growing is fundamental to feminism itself." Congdon cites others who argue that a woman's perspective can be noncompetitive, subjective, and bonding. Joanna Frueh studied art history texts and found their language to be associated with war, revolution, and conquest, in contrast to noncompetitive thinking: "Artists destroy pernicious styles, they engage in campaigns, skirmishes, military exercises, battles and conquests. We read about assaults, attacks, invasions and confrontations as well as rebels and revolutionaries." In contrast to this, feminist art criticism can be connective, inclusive, and nonhierarchical. Some feminist critics are quite content with their political and cultural actions to open doors and raise more questions than they answer.

Garber considers how feminist theory has contributed to our understanding of how viewers respond to images. She and other feminists credit John Berger, the British neo-Marxist critic, with identifying the "male gaze" in his book and television programs, Ways of Seeing. 47 Berger's thesis is that the many nude paintings of women in Western art are made for the enjoyment of the male. The woman subject is presented as passive and available. Man is always assumed to be the ideal spectator, and the pictured woman is designed to flatter him. Man is the surveyor, woman the oppressively surveyed, reduced to an object of aesthetic contemplation and thereby dehumanized. Jean-Paul Sartre, the existentialist philosopher, earlier made an observation very similar to Berger's about the male gaze. He wrote that the perceived object, aware of herself perceived, finds herself coerced to self-awareness as through the eyes of another, thus ceasing to be herself. 48 Images of women circulating in fine art and, especially, in popular films and advertisements provide what feminists call "paradigm scenarios" that shape our emotions, inform our ideas, and influence our actions. Images of women, positive and negative, help to construct and reinforce our emotional patterns and influence our worldly actions toward women and attitudes about them.

Hein characterizes the objectionable depictions of women in the high-art tradition:

Along with loving and caressive exploration of women in intimate detail, they have been used to represent considerable violence toward and abuse of women. The grand tradition is full of rapes, abductions, mutilations, and hateful degradation of women. But these have not been authentic from a woman's perspective. By and large, they have been viewed through the lascivious, sentimental, or punitive eye of a man. Feminist artists face the challenge of recasting these same experiences as they are undergone by women, so as to reveal an aspect of them that has been ignored. In doing so, they expose both the politics and the gender bias of traditional art and risk rejection of their own work on the ground that it is not art within that traditional definition. What is distinctive to feminist art, then, is not that it is "about" women, but that it is so in a way that is new, albeit using the same instruments as before.

Griselda Pollock names some of the images of women within popular culture that feminists are contesting—"the dumb blonde, *femme fatale*, homely housewife, devoted mother, and so forth, which were judged in a vocabulary of absolutes: right or wrong, good or bad, true or false, traditional or progressive, positive or objectifying."⁴⁹ Pollock semiotically deconstructs a printed advertisement of how women are constructed. A high-gloss, airbrushed glamour photograph of a female model is carefully composed, constructed, and selected from many shots and printed for mass circulation. With its carefully selected female body and lack of realized surroundings, the ad has a tradition and evokes a "reality effect" for its appeal to fantasy. She argues that color, focus, texture, printing procedures, and airbrushing all constitute signifying elements that must be scrupulously decoded.

Jan Zita Grover considers representations of lesbians in the popular culture, asking, "Which representation has greater authority for you: the wanton woman in Victoria's Secret underwear or leather in *On Our Backs* or the jockettes in photographs of GAA softball players printed in a local bar guide or gay newspaper? Any of these? All? None?" 50 She explains that "pulp paperbacks make explicit allusion to butch—femme dichotomies: what were popularly conceived as 'male' traits are attributed to one partner (short hair, tailored clothes, piercing stare, wiry, boyish build, dominating position above and behind partner), while the other is commonly depicted as exaggeratedly feminine (*en deshabille*—peignoir, brassiere or slip, frilly underpants—long hair, modestly downcast glance)." She asserts that "most of the social and sexual differences encoded in these illustrations say more about male illustrators'/editors'/readers' concerns with imposing marks of gender difference on the objects of their desire than they do about lesbian lives."

The topic of pornography has been a subject of heated debates, especially in the 1970s and 1980s. Antipornography feminists rallied with the slogan "Pornography is theory behind rape." They argue that pornography degrades women, exploits them during the performance of pornography and later in its distribution, and contributes to attitudes complicit with rape and sexual harassment. Other feminists, however,

Grover asks an important second question, "not simply about which cultural institution's representation has authority or resonance or credibility, but *for whom*. For the Moral Majorian seeking proof for his contempt; for a parent of a gay seeking evidence that gay lives can be (almost) happy, (almost) normal; for a gay person living a closeted or isolated life, eager for evidence that others of her or his sex, class, race, sexual preference exist as openly gay; for a concerned straight person attempting to understand—to see—something about a gay friend's culture; for a gay or straight fantasy, turn-on, turn-off, daydream, nightmare."

Hein, Pollock, Grover, and other feminist, postmodernist, and—as we shall next see—multiculturalist and post colonialist writers try to deconstruct such images of the woman as the sexual object displayed in paint on canvases in museums and as the "dumb blonde" and "butch" portrayed in popular culture. Feminists and postmodernists in general see all images as part of discourse. They insist that images are not natural, but because they have been constructed so artfully and so often and are in such wide circulation, they falsely appear to be natural and true representations of how women are; thus they very much need to be deconstructed, taken apart, dismantled. Much current politically engaged art and criticism purposely make problematic that which we take for granted and try to make explicit that which is implicit and hidden in language and images.

Judith Butler's postmodern feminism argues that gender is constructed through language. She both draws on and critiques the thought of Simone de Beauvoir, Michel Foucault, and Jacques Lacan. She criticizes the distinction between biological sex and socially constructed gender. In *Gender Trouble* she argues that gender is performative, that there is no one cause for women's subordination and no single approach to alleviating it. She seeks to collapse the distinctions between nature and culture that permeate the summary of feminism offered here.

Garber offers these further clarifying generalizations about feminism in contemporary art practice and theory.⁵¹ Feminists are generally but not necessarily postmodernists. Feminists draw on various theories and methodologies, such as psychoanalytic, semiotic, deconstructionist, and neo-Marxist, for political purposes to help them meet their social goals. Feminism is part of a broader political movement aimed at widespread social changes that affect women and other Others—people of color, lesbians and gays, poor, and elderly. Last and very important, because of their social and political goals, feminists often emphasize lived experiences. Even when feminist scholars write theoretically and their work seems removed from lived experience, they, in fact, are often building bridges from theory to experience.

In looking back during the first decade of the twentieth century on feminism that she was and is part of, Lippard writes, "And of course we were *never* all that

cohesive. Definitions of feminist art were always passionately contested. It was one of our strengths that there was never a single unified feminism." However, she believes there was and is a "feminist culture [that] entails a basic set of values common to socialist, radical, lesbian and various other brands of feminisms," and among these she includes "raising consciousness, inviting dialogue, and transforming culture . . . feminist culture is a value system, a revolutionary strategy, a way of life." 52

MULTICULTURALIST AESTHETICS AND CRITICISM

Fred Wilson is an artist who deals with museums and the ways they represent, fail to represent, and misrepresent racial and ethnic minorities. Wilson was born of African American and Native American parents. In 1992 Wilson organized an exhibition titled "Mining the Museum" at the Maryland Historical Society in Baltimore. In a *New York Times* review, Michael Kimmelman describes Wilson's exhibition as a critique of museums, writing that Wilson's installation "not only evokes the experiences of blacks and Indians in Maryland; it also suggests how those experiences have routinely been ignored, obscured or otherwise misrepresented at places like this one." ⁵³

Among the finely crafted and polished silver vessels that one would expect to see in a section of a historical museum labeled "Metalwork 1830–1880," Wilson placed steel shackles crudely forged and hammered for slaves. In a typical display of antique Victorian furniture, including a chair with the logo of the Baltimore Equitable Society, Wilson placed a whipping post. The museum has several oil paintings of locally famous and prosperous landowners with unnamed slaves in the background. Wilson researched one of the paintings, tracked down the identities of the pictured slaves, and then wrote their names in very large print on the gallery wall next to the painting. For another painting of wealthy white men, Wilson shone spotlights on the anonymous slaves in the painting and added audiotapes that pretended to speak what the slaves were thinking. With biting and effective humor that subverts the original function of glorifying the ruling class, Wilson renamed another painting *Frederick Serving Fruit*, to shift its meaning to a young black boy who is shown serving his white master, the subject whom the painter intended to honor.

Kimmelman credits Wilson's work with bearing witness to injustice and writes that it reminds the visitors, once again, of the subjectivity of historical truth, precisely in an institution that assumes itself to be a dispenser of historical information. Based on Wilson's exhibition, museum educators prepared materials that asked visitors to consider any object in the museum by asking these questions, none of which would have been asked of an art object during the reign of modernism:

For whom was it created? For whom does it exist? Who is represented? Who is doing the telling? The hearing?⁵⁴

These are provocative questions, especially because, as Karen Hamblen notes in a scholarly critique of the art museum, "one comes to a museum to appreciate, not to question." When viewing art in a museum setting, we are not usually asking serious questions about why certain objects have been selected, who made these choices, why, who is best served by the choices, and which objects were *not* selected and why. Hamblen rightly argues that it is necessary to see our choices as proceeding from particular viewpoints, whether consciously held or not, that are themselves embedded in political motivations. The Guerrilla Girls and WAC ask us to raise the same questions, as has Foucault.

Wilson's gut-wrenching juxtapositions challenge the notion that appreciation is the proper attitude to hold in a museum when he confronts us with shackles next to teapots and whipping posts next to armoires. Hamblen asks us to question the selection process involved in the collecting, preserving, and exhibiting of objects in museums, pointing out, as has Wilson, that such decisions have a problematic, political dimension that we have ignored too often and for too long. Hamblen notes that objects, by being placed in an art museum, automatically and instantly receive "an apolitical patina." The historical and ideological origins of art objects and artifacts are obscured and their chosenness is forgotten. We wrongly receive them as if they have an unquestionable correctness, a givenness, and we leave them with a sense of "that's the way things should be."

Whereas modernist approaches to society tended to trust reason to bring about emancipation and social progress, postmodernists see these attempts resulting in reductionist policies regarding differences among peoples and their oppression. Feminists, postmodernists, and multiculturalists recognize the plural nature of society and work politically for plurality, diversity, and individuality rather than conformity and sameness. Postmodernist critics and artists in a pluralistic American society are asserting in words and artworks that there are many repertoires of knowledge, several traditions, and different shapes of consciousness-despite the fact that, as Hamblen points out, only certain modes of consciousness are given institutional credence. Other traditions continue to exist alongside the traditions of the dominant culture but without the benefit of institutional sanctions. In museums and through art world discourse, particular and selected types of aesthetic knowledge and traditions are presented as correct. Rarely are these representative of the broad base of aesthetic preferences in a pluralistic society. Within a pluralistic democracy, diversity of expression, unpopular viewpoints, and minority rights are supposed to be protected and respected. Critics, scholars, and artists working to increase multiculturalist sensibilities are fighting the assumption that the Western European tradition of male superiority is of greater value than other traditions.

Hachivi Edgar Heap of Birds uses some postmodernist strategies similar to Wilson's, often taking his work directly to the streets. Like Wilson, Heap of Birds returns to what critic Mason Riddle calls "musty record books" for historical information that the dominant culture would like to suppress. In a 1990 piece about government

property along the Mississippi River in downtown Minneapolis, Heap of Birds erected forty white aluminum signs with the names in blood red of forty Dakota Indians—first in Dakota, then in English—who were hanged after the 1862 United States—Dakota war. Thirty-eight of the execution orders were signed by President Abraham Lincoln, two by President Andrew Jackson. Riddle reports that some Minnesotans attacked the piece, and she argues that their responses "reveal not only how fearful of (real) history many white people are, but also how powerful the piece is." ⁵⁶

In San Jose, California, Heap of Birds displayed a transit poster on the outside of a bus with these words:

SYPHILIS SMALLPOX FORCED BAPTISMS MISSION GIFTS ENDING NATIVE LIVES

About his work and that of other artists who have been kept on the fringes of the art world, critic Meyer Rubinstein writes, "They are not using art to get a message across, rather, the getting across of the message is their art." Since 1982 Heap of Birds has used abstract paintings; pastels on paper; ink on paper; and public works in the form of billboards, posters, and the Spectacolor Light billboard in Times Square in New York City. Heap of Birds received training in the traditions of his tribal elders on the Cheyenne Arapaho Reservation in Oklahoma and has also pursued graduate studies in the United States and Great Britain.

About his use of traditional media—oil, pastels, and ink—for pieces that hang on gallery walls, critic Lydia Matthews writes that he "subverts any attempt to characterize this Native American artist as noble spirit, dangerous savage, or ravaged victim. Instead, Heap of Birds represents himself as a complex and fully dimensional individual working as an artist within a tribal community." ⁵⁸

Born in British Columbia to Swiss and Dane-zaa parents, Brian Jungen transforms ubiquitous and sometimes racist consumer items into inventive sculptural forms that link his First Nations heritage to issues of cultural identity. As a result of his Aboriginal–Swiss identity, he is as well versed in Dane-zaa family stories as he is in Western art history. His work dismantles conventional social stereotypes, such as the reduction of native peoples to mascots for U.S. sports teams, by altering sporting goods and thereby opening up new spaces of engagement. He looks beyond the surface of everyday objects to extract more explicit meanings that begin to expose the roots of a social consciousness. Referencing the carving of trees into northwest coastal totem poles, he has inscribed the words "first nation, second nature" into a baseball bat, injecting "disorder into modernity's notions of order by transforming materials" by creating new prototypes for new understandings of global culture.⁵⁹

David Bailey is a scholar working in England who uses semiotics and poststructuralist theories to critique how minorities, especially black people, are abusively

misrepresented in the popular press through stereotypical representations. He writes that the stereotype "is commonly used to push people whom we do not value into still further subordinate positions. As soon as we think of people or groups whom we value, it is much harder to image them as stereotypical." Bailey identifies three elements of a stereotype: fragmentation defines the whole group by one small aspect ("Blacks are inherently criminal"); objectification places the group outside of what is considered normal (the black as exotic athlete); name substitution (nigger, kike, spic, yip, fag, gimp) demeans the group. Bailey tells us that stereotypes, like other forms of discourse, are not natural or inevitable; rather, they are socially constructed to serve the interests of the dominant group. Using techniques of psychoanalytic criticism, he explains that the notion that blacks are exotic reinforces the position of white domination through the psychological constructs of otherness and difference and a combination of desire and fascination. Blacks pose a threat to white society, yet within this fear is a desire and fascination with the physical, textural, and sexual physique of the black subject's body.

Bailey contrasts two examples of media representations of Asians in British newspapers. An Air Lanka advertisement in a supplement of a London Sunday newspaper uses a color photograph of natives paddling long boats, with an inset of a female Asian model gazing at the reader with an inviting smile. The ad's copy is "A taste of paradise to Sri Lanka. Be dazzled with the people of Paradise." Bailey contrasts this ad with the paper's headline for a news story, "Asians still flooding in," about Asians and British immigration laws. Bailey identifies ambivalence in these two representations. First he identifies a sociopsychological fear of the Asian subject, an extreme xenophobia, fear, and contempt for strangers and foreigners "flooding the country." In the ad, however, Bailey identifies a desire for and fascination with Asian culture embedded within mythologies of exotic food ("a taste of paradise") and submissive women (the model's gaze, "be dazzled with the people"). Bailey concludes that "the logic of racist ideologies is such that it can naturalize representations and make it seem all right for the 'English' to go to Asia and flood it with a neo-colonialist mentality, yet it is not all right for Asians to come to this country (except to do low paid manual jobs)."

By means of his analyses of these Asian representations, Bailey presents another example of how words and pictures are not neutral. The power of words and images can be wielded only by those who have access to the means of representation and reproduction. This stereotypical imagery depends on the people who constructed the ad and the headline—those who are part of or heavily influenced by the dominant culture and who reinforce racial stereotypes and contribute to the construction of demeaned "others."

POSTCOLONIALISM

Postcolonialism is a multidisciplinary area of study that began in the 1980s, achieved prominence in the 1990s, and continues today. It is closely aligned with and overlaps multiculturalism. Postcolonial critics investigate the cultural situations of

peoples or nations that have been or are under the imperialist territorial control of a colonizing power. Their interests include considerations of processes of colonization and decolonization, and how these historical events influence art made by both the colonized and the colonizer. The theory applies to representations of anyone made "other" by imperialist discourse.

Colonialism is the social assertion by a dominant power over an indigenous people based on the colonizer's belief in its own unique superiority that gives it the right to dominate indigenous people politically and culturally, and to take control of their raw materials and land. Colonizing mechanisms do not cease to end when territorial control ceases, and critics seek to understand the continuing influences of domination and subordination in works of art made under the influence of colonization. The colonizers' ways of domination meet subversive means of resistance in works of art as well as in behaviors. Such resistance in works of art is a topic for postcolonial art criticism.

Most influential of postcolonialists is Edward Said (1935–2003), a Palestinian born in Jerusalem whose family fled to Egypt. Said lived in Lebanon and Jordan before immigrating to the United States, where he spent his career as a professor of literature at Columbia University publishing important and politically engaging work for Palestinian independence and human rights. His academic and political work focus on how white Europeans and North Americans fail to understand differences between Western and non-Western cultures.

In his groundbreaking 1978 book *Orientalism*, Said addresses questions of colonization by the West: How are colonized cultures represented, what is the power of such representations in controlling cultures, and what is the discourse by which colonizers and the colonized construct their subject positions? Said defines "Orientalism" as Western discourse about the East that establishes the oppressor—oppressed relationship within colonial discourse. The Orient, for Said, is an "imaginative geography" mapped by discourse, including imagery, and the mapping occurs through binary racist oppositions between what is said to be "Oriental" and its inferiority to the "Occidental" or the West. The West constructs "Orientals" as a homogeneous population without individual faces, and identifies all members of the group by a few negative stereotypes.

While colonial discourse oppresses the colonized subject, it simultaneously affects the colonizer: "European" is constructed in part by how it is not "Oriental." Such debased depictions by imperialists of the colonized are constructed in visual representations. To counteract "Oriental" constructions, postcolonial critics seek to resist totalizing identity constructions of colonized individuals. Postcolonial critics also try to resist Eurocentrism that privileges the West and marginalizes the rest. Postcolonialism in art criticism challenges looking "disinterestedly" at art within museums that we have previously viewed as innocent institutions. Rather, we should examine objects in museums and their roles in light of social and political discourse. We ought also to police imperial means of obtaining such objects from cultures.⁶¹

QUEER THEORY

The work of Michel Foucault, the late French historian of ideas (he did not want to be known as a *philosopher* because the term implies a search for foundational truths), is an important influence on postmodernist criticism and particularly on gay activist art and criticism. Foucault's major contribution has been to show the authority and power of discourse—language and other representations—in general, and especially how discourse constructs gender and represents sexuality. Foucault warns that those in power assume the self-appointed task of upholding reason for and revealing truth to those who they think are unable to see for themselves and who are not allowed to speak for themselves. Language can be descriptive, explanatory, controlling, legitimating, prescribing, and affiliating. Argument and reason can and have been used to silence and control others, and an unyielding insistence on rational discourse can silence or diminish those who think differently.⁶³

Gay activist artists and critics are deriving strategies to use in their radical political activities from postmodernist theories such as Foucault's. A new generation of gay activists calls itself queer, not lesbian, gay, or bisexual. The name queer is meant to confront both those who would have gays disappear into mainstream society through assimilation and any oppressors of gays. Lisa Duggan, in an article she aptly titles "Making It Perfectly Queer," explains that many gay militants have rejected "the liberal value of privacy and the appeal to tolerance which dominate the agendas of more mainstream gay organizations. Instead, they emphasize publicity and self-assertion; confrontation and direct action top their list of tactical options; the rhetoric of difference replaces the more assimilationist liberal emphasis on similarity to other groups."64 The new politic poses anger instead of civility, flamboyance instead of respectability. Louise Sloan wants a "queer community of men, women, transsexuals, gay males, lesbians, bisexuals, straight men and women, African Americans, Native Americans, people who can see and/or walk and people who cannot, welfare recipients, trust fund recipients, wage earners, Democrats, Republicans, and anarchists that might be able to teach the world how to get along."65 These and other writers have taken their theoretical direction, in part, from Michel Foucault, who convincingly demonstrated that homosexuality, indeed all sexuality, is socially constructed. That is, sexuality is something that we ourselves create.

New "queer theories" reject the humanly made dyad of the homosexual/ heterosexual, with its valuing of the latter and condemnation of the former. Douglas Crimp, an influential critic and activist, writes that "the significance of so-called appropriation art, in which the artist forgoes the claim to original creation by appropriating already-existing images and objects, has been to show that the 'unique' individual is a kind of fiction, that our very selves are socially and historically determined through preexisting images, discourses, and events." 66 One strategy emerging from the theory is, as noted earlier, to reclaim offensive words like *queer* and *dyke* that have made people feel perverse, odd, outcast, different, and deviant and to make the terms positive and confrontational. The names that recent activist groups have invented for themselves exemplify this point: ACT UP (The AIDS Coalition to Unleash Power), the Silence = Death Project, Gran Fury, Queer Nation, DIVA TV (Damned Interfering Video Activist Television), and LAPIT (Lesbian Activists Producing Interesting Television).

Gay activist artists confronting the crisis of AIDS have been quick to use the artistic strategies of postmodernism, freely appropriating the styles of other postmodernist artists such as Jenny Holzer, Barbara Kruger, and Hans Haacke. Crimp makes no apology for derivative and unoriginal work by "guerrilla graphic designers." Instead he argues that "the aesthetic values of the traditional art world are of little consequence to AIDS activists. What counts in activist art is its propaganda effect; stealing the procedures of other artists is part of the plan—if it works, we use it." In contrast to modernist criteria, Crimp writes, gay activist artists don't claim invention of their style or the techniques; they want others to use their graphics as well as make their own.

Like ACT UP, Survival Research Laboratories (SRL) is an activist collective of postmodernist artists who mount spectacles of remote-controlled machine violence as a means to protest aspects of the dominant culture they find oppressive. For a machine that was to be covered with Bibles and designed to self-destruct in flames, SRL solicited donations for Bibles, saying, "Bibles can always be obtained for free from hotels, church organizations, libraries, the Gideon Society, thrift stores and your parents' house." One of the artists described the planned performance as "the ultimate nightmare for the right wing religious male" and said it was designed to get at a whole range of issues such as population control, child pornography, the role of women in male-dominated culture, and, "of course, the biblical angle of the misuse of the Bible by reactionaries."

CONCLUSION

As would be expected, not everyone in the art world is equally enthusiastic about postmodernist ideas, feminism, and multiculturalism, all of their proponents, and their activist contingencies. Some scholars hold that there is a major fund of knowledge that all Americans should learn if they are to be considered culturally literate

Smith defends what has come to be called "the canon"—namely those mostly Western artworks selected by some scholars as masterworks that ought to be studied by all who wish to be culturally literate: "What cannot be argued away is the existence of great art and the fact that it is great because it magnificently transfigures the commonplace. The criteria of greatness, moreover, are no mystery. They are incomparable artistic (technical) finesse, extraordinary capacity to provide high degrees of aesthetic gratification, and stature, the latter term implying the significant human values masterworks individually express."

Opponents of the canon generally consider it much too narrow in scope and hold it to be legitimating only certain types of art, while implicitly denigrating other types. Arguments of this sort often raise issues about the word and concept of *quality*: "What is in question is the way the word is used to compare, select and sort out art and artists. Some people in the art world claim that the word is simply a pretext for preserving the authority of the heterosexual white male." Those on the right of the political and aesthetic spectrum tend to embrace the word *quality*, and those on the left to disdain it as a term used to exclude art. Despite opposition, a widening of the canon of what artworks ought to be considered seriously should be supported.

Artists and critics are informed by and contribute to the thought of their times. The many examples of uses of modernist and postmodernist strategies by critics and artists given in this chapter are offered to make art and criticism, in all their complexity, clearer. No one-to-one correspondences between a theory and an artwork or a theory and a piece of art criticism are given, however—that would be too much of an oversimplification. This book is influenced by postmodernists' beliefs that an artwork does not have a single meaning and that multiple interpretations are beneficial. Thus throughout this book many critics are quoted about the work of a single artist. Some of the critics are modernist in their approaches to art, others are postmodernist, and many eclectically draw from both. Usually the theories of art that influence critics are embedded within their written comments. Careful readers can accept the challenge of identifying the critics' theoretical suppositions in their criticism. The more perspectives we can gain on a work of art, the richer and deeper will be our experience of that work.

Describing Art

A LTHOUGH A POPULAR MISCONCEPTION about art criticism is that it is primarily judgmental and negative in tone, in actuality, most of the words written by critics are descriptive and interpretive rather than judgmental, and positive in tone. Critics seek to provide readers with information about artworks, and describing these artworks, many of which will not be seen by their readers, is one of their major activities. *Describing* is a kind of verbal pointing a critic does so that features of a work of art will be noticed and appreciated. Descriptions are rarely evaluatively neutral: If a reader looks closely at a critic's descriptions, the reader can infer the critic's approval or disapproval of the work being described. Written descriptions are also heavily inflected by what the critic thinks the work is about.

As a mental process, description is a means of gathering information about the work; then the critic sorts the information (which can be substantial), writes distilled descriptions for readers, and formulates interpretations and judgments of the work. If the critic's descriptive information is inaccurate or woefully incomplete, any ensuing interpretation or judgment is suspect.

With careful observation, descriptive information can be gathered from within the work—"internal information." For teaching purposes, internal descriptive information is sometimes grouped under three topics: subject matter, medium, and form. These are defined with examples in the following sections.

Critics also provide descriptive information about aspects not visible in the work—that is, contextual information such as facts about the artist or the times in which the art was made. This is "external information," and examples of this are given as well.

SUBJECT MATTER

Subject matter refers to the people, objects, places, and events in a work of art. Art writer Astrid Mania describes sculptures by Mona Hatoum: "An oversized kitchen grater as a *Daybed* (2008) whose sharp surface would strip the goose pimples from your flesh; a folding cheese grater as a metal room divider with nastily jagged openings (*Paravent*, 2008) or household sceneries fenced off by wires that connect different objects and electrify them (*Homebound*, 2000): Mona Hatoum subjects commonplace objects to a transformation that lends them an unsettling or threatening air." The writer evocatively describes the objects in the chilly mood they exhibit. The writer wants to give the reader her reactions to the work as well an objective description.

Another writer raises these rhetorical interpretive questions about Hatoum's subject matter of kitchen utensils, but does not answer them, leaving them for us to ponder: "Such a terrifying kitchen if encountered in a dream would portend . . . what? An all-powerful and angry mother? Hatoum's beleaguered homeland, Palestine? An ambivalence toward notions of home or homeland? The fear of a life of domestic drudgery? The bitterness of a nurturer to the object of her nurturance?"²

Doug Harvey describes the characters that inhabit Mark Ryden's paintings (see Color Plate 3): "Pastel bunnies, dollies, bees, monkeys, elephants, and baby deer cohabit with pasty centipedes, fetuses, mutant Abe Lincolns, mandrake roots, slabs of meat, and naked, big-eyed prepubescents. The elaborate frames, often hand-carved to Ryden's specifications, add to the paintings' stately Victorian theatricality." He adds that these creatures drip with "creepy nostalgia and oedipal content." 3

In a broadcast radio review, Gary Faigin says, "Ryden commands our attention as a craftsman and visionary of the first order. Very few contemporary artists of any stripe have his command of the vocabulary of representation, and his singular world of not-so-innocent juveniles and stuffed animals cavorting in vaguely anachronistic landscapes has an astounding presence."

When introducing a Ryden exhibit of 2007 called "The Tree Show," Holly Myers writes, "This body of work is clearly sympathetic to her [nature's] plight and attentive to the concerns of her [nature's] kind. This body of work is filled with wood nymphs: creatures of virginal demeanor and a cool, canny gaze whose movements

Mona Hatoum, *Dormiente*, 2008. Mild steel, 10 5/8" \times 90 1/2" \times 39 3/8" (/27 \times 230 \times 100 cm). Photo by Jason Mandella. Courtesy of Alexander and Bonin Gallery, New York.

suggest a state of harmony with the Arcadian landscape in which they roam." She calls Ryden's painting *Allegory of the Four Elements* "one of the most enchanting works the artist has yet produced" and describes the subject matter: "four of these nymphs gather around a tree stump with an air of ethereal poise, as if holding the energetic currents of the world in balance." ⁵

These writers name subject matter in Ryden's paintings—bunnies, dollies, bees, monkeys, elephants, and baby deer—but they use different descriptors to give readers vivid mental images and to evoke feelings they think are appropriate in response to Ryden's work. For example, they write that the creatures drip with "creepy nostalgia and oedipal content," and wood nymphs have a "virginal demeanor and a cool, canny gaze" in "an air of ethereal poise." Description, interpretation, and judgment overlap. To assert that Ryden's paintings have "oedipal content" is to interpret them. Calling the characters "creepy" is interpreting and may be a judgment of them.

When describing works of art that are nonobjective, without people, places, or events, and composed of color, shape, texture, and other elements with no

MEDIUM

Some artists choose to limit their use of media to one primary medium, such as oil on canvas. Other artists employ many different media throughout their careers, sometimes using mixed media in one work of art.

Olafur Eliasson is a contemporary Danish-Icelandic artist who uses many media, as exemplified in a retrospective exhibition at the Museum of Modern Art in New York, which also traveled to Dallas. In a review of the exhibition in *The New Yorker* magazine, Peter Schjeldahl refers to the artist as an "inventor and engineer of minimalist spectacle" and mentions "an electric fan swaying on a cord from the ceiling of the atrium, rooms awash in different kinds of peculiarly colored light, a wall of exotic (and odorous) moss, a curtain of falling water optically immobilized by stroboscopic flashes" Schjeldahl describes the effect of the electric fan, *Ventilator*, as "a witty finesse of the MOMA atrium's space-splurging grandiosity. Propelling around on a course dramatically varied by ambient air currents—at some moments a vicious zoom, at others an indecisive hovering—the fan becomes an economical point of fascination that makes the space feel designed for nothing else."

In an overview of feminist art, Lucy Lippard admits to her long obsession with the medium of collage, "a layered, cumulative mode" that is effective in women's political art:

From Hannah Hoch to the Guerrilla Girls to Barbara Kruger to Deborah Bright, collage or montage has always been a particularly effective medium for political art. Humorous and hard-hitting, it can bring separate realities together in endlessly different ways. Collage or montage, though it was first exploited by modernism, is also the core strategy of postmodernism. It represents a dialogic approach. Collage is about shifting relationships, juxtaposition and superimposition, gluing and ungluing. It's an aesthetic that willfully takes apart what is or is supposed to be and rearranges it in ways that suggest what could be. Collage makes something of contradictions. It contains the possibility of visual puns, accessible contrasts, and irony. It's also the medium of surprise, which can shake us out of our stupors.

Importantly, both critics do not merely mention the media used by artists they are writing about, but especially consider to what purpose the media are used.

Referring to another artist, David Cateforis writes about the "sheer physical power" of Anselm Kiefer's paintings—"covering entire walls, their surfaces clotted

Olafur Eliasson, *Ventilator*, 1997. Altered fan, wire, cable. Dimensions variable. Installation view at Museum of Modern Art, New York. Collections of Peter Norton and Eileen Harris Norton, Santa Monica, CA. © 1997 Olafur Eliasson. Photo by Studio Olafur Eliasson.

Waldemar Januszczak is especially effective in describing Kiefer's medium and how it affects the viewer: "Kiefer's large fields of scorched earth—his most-often-recurring image—look like slabs of blasted heath itself, danced over by devils, driven over by panzers, tortured by the weather, then screwed to the wall. They seem plowed as much as painted. Many of the furrows have straw embedded in them. Some are visibly blackened with a welding torch. Others have things attached to them—bits of old farm equipment, sheets of lead, charred fence posts, mysterious numbers."

When critics write about medium, they also refer to subject matter and the form or composition of the work. More important, they express how the artist's use of medium and form affects our reactions to the artwork. When Frances Colpitt describes a seascape made by Anselm Kiefer in 2004, she describes the painting's form in relation to its subject matter and how it affects it. The critic writes about *Aschenblume (Ash Flower)* this way, giving us an evocative description that matches what we can see in the painting:

Above a dark roiling sea floats an ominous black cloud stained, inkblot-like, onto the canvas. A brilliant, vaguely impressionist light glows from between the cloud and the distant horizon line. Lowering the horizon to the center from its normally high placement in his work, Kiefer mitigates some of the tension and instability, if not the foreboding quality, that are typical of his earlier paintings. While the cloud conjures up thoughts of brewing storms or apocalyptic explosions, a lead grid, recalling a mulioned window, is placed on top of the cloud and establishes a sense of flatness in an otherwise illusionistic painting. ¹⁰

FORM

All works of art have form, whether realistic or abstract, representational or non-representational, meticulously planned or achieved spontaneously. When critics discuss the form of a work of art, they provide information about how the artist presents subject matter (or excludes it) by means of a chosen medium. They tell of the artwork's composition, arrangement, and visual construction. "Formal elements" of a work of art may include dot, line, shape, light and value, color, texture, mass, space, and volume. How formal elements are used is often referred to as "principles of design," and these include scale, proportion, unity

within variety, repetition and rhythm, balance, directional force, emphasis, and subordination.

The following paragraph is an example of a description of a large work on canvas, *Requiem*, by David Anthony García, written to accompany a reproduction of the work in an exhibition catalog (see Color Plate 4). The description is quoted here in full because its authors carefully consider the work's form—its colors and contrast, focal point, size, surface, center point, and so forth—in relation to the work's subject matter and cultural references, in ways that direct us to think about the work's meaning. The paragraph is largely a formal analysis, but the authors describe its formal elements and principles in relation to its possible meaning:

This multimedia, multidimensional, expressionistic piece shocks us with its high color and design contrasts. Bright vertical pointed oranges draw us into the focal point of this large-scale work, which engages our attention and calls for serious thought or meditation, somewhat like an Eastern mandala. Because the canvas itself has been overstretched, the resulting work displays an uneven surface that dips in the four cardinal directions and then rises to a peak at the center. The dead center point protrudes outward like a promontory. Reinforcing the pointed orange vectors are dark brown and earthen-colored flamelike designs that upon closer inspection are revealed to be hundreds of faces or totemic masks in various states of emotion, perhaps representing souls trapped in purgatory. To the right of center is a representation of the individual's physical life. A face looks out on earth and sky. A man in repose on a hilly landscape, his face ashen, indicates the end of his physical journey. A skull rests below him, symbolizing the return of the body to the earth. The left side of the work also shows a face looking in the opposite direction at a web or net above which is a cloud-filled sky. A faint shadow of a baby floats beneath the web. Bisecting the piece is a cardiogram that is flat on either side of the work, with increasing impulses closer to the center. Thick green vines intertwine on both sides of the orange, suggesting that the spiritual and physical worlds are connected, despite a temporary separation. Finally, at the outer bounds of the central area the canvas has been built up with the addition of bodies of actual fossilized scorpions and seeds. The overall theme of this work, emphasized by its title, Requiem, is obviously a ceremony of recognition of the life of one individual. This one individual's requiem attains symphonic proportions: it is played out on a grand scale by the artful deployment of line, color, patterns (including patterns of faces), and the addition of organic materials and an icon of medical technology. 11

Descriptions of form alone, without references to and inferences about meaning, are insufficient. In the following pages, more extended examples of descriptive writing are provided to continue examination of the important critical activity of describing works of art.

CONTEXT

Every artwork is located and seen within a physical context. That context may be a white wall in a room of a commercial gallery, the foyer of the Museum of Modern Art, a public civic space such as an urban billboard, the natural wilderness, or in the studio of the artist who has made the piece. Where a piece is located and seen affects reactions to it.

Knowledge about an artwork, who made it, when, for which audiences, and for what purposes is contextual knowledge that informs viewing a work. Sue Coe is an artist who has frequently published drawings, prints, and paintings in publications as editorial content for The New York Times, Time, and The New Yorker. She also publishes independent books and exhibits and sells work through a gallery representative. She has long been an advocate of human rights, making work about racial, class, and gender inequities.

She also works to promote the rights of animals, including the books *Dead Meat*, which examines animal lives on factory farms, Pit's Letter about abandoned dogs, and cruelties of the sheep industry in Sheep of Fools. "Elephants We Must Never Forget" (2008) is, according to its press release, "the first exhibition ever to document the plight of circus animals . . . long exploited for their entertainment value."

Her images alone are illustrative of exploitation, but their impact increases with knowledge about what is being pictured, and that it has happened in real life. In the exhibition a sequence of eleven works tells the story of Topsy, an elephant electrocuted at Coney Island as publicity for Thomas Edison's electric company. Her gallery representative offers this comprehensive justification of her work with animals as a challenge to the centuries-old dichotomy between animals and humans, nature and culture (see Color Plate 5):

The belief that humans, created in God's image, are different from and superior to other creatures is deeply rooted in the Judeo-Christian tradition. The Biblical Book of Genesis granted man dominion over animals, and ever since. Western men have attempted to tame and control nature. That which was deemed wild, whether embodied in an animal, an unsettled frontier, an alien society, or closer to home, the female sex, had to be conquered and subdued. The culture/nature dichotomy was the underlying rationale for imperialism, colonialism, slavery, and the subjugation of anyone or anything judged less civilized than the European white male. In a worldview characterized by a division between "us" and "them," animals were the consummate "other." Within this context, elephants exemplify both the near decimation of a specific wild species and the broader exploitation of colonial Africa and Asia. 12

PAINTING: LEON GOLUB

Leon Golub, born in 1922, passed away in 2004 at the age of 82. After serving in World War II as a cartographer, he began studying art history and then decided to paint, and he earned an MFA degree from the Art Institute of Chicago in 1950. He

In an obituary for Golub in *Artforum* magazine, Gerald Marzorati, editor of *The New York Times Magazine* and author of a book about Golub, *A Painter of Darkness*, wrote, "We won't soon have the comfort of calling his paintings dated." Marzorati says that the world caught up with Golub just months before he died in August 2004 when, in April 2004, photographs of American soldiers abusing Iraqi detainees in the Abu Ghraib prison outside of Baghdad were released to the public. These photographs, according to Marzorati, "horrified the world, Golub included, no doubt but they couldn't have taken him by surprise. He'd already *conjured* them with paint, slowly teasing pictures of abuse, torture, and degradation" in different series of paintings referring to torturers, mercenaries, and others perpetuating political cruelty "with casual viciousness and terrifying vacancy. . . . No one had ever painted their kind until Golub did."¹³

In his obituary for The New York Times, art critic Holland Cotter describes Golub as "an American painter of expressionistic, heroic-scale figures that reflect dire modern political conditions." Cotter offers a chronology of a series of paintings beginning with Golub's paintings of "single, frontal figures that seem to belong to a mythical race of shamans or kings." In the 1960s he produced a series called "Gigantomachies" of wresting figures based on classical Greek and Roman art: Cotter observes that "there was nothing idealized about them. Half abstract, they suggested knots of raw gristle and blood." In the "Assassins" series Golub exchanged modern figures for classical figures in pictures of Western soldiers attacking Asian civilians. These paintings are in direct reference and opposition to the Vietnam War. His "Mercenaries" series of the 1980s "focused on military and paramilitary violence, suggesting that this had become a global condition." In the 1990s Golub made paintings of skeletons and snarling dogs that had "apocalyptical tones." In the mid-1990s he began adding text to his paintings, continuing this practice in his last years, such as Bite Your Tongue, 2001 (Color Plate 6). Cotter offers this conclusive summative interpretation of Golub's work: "His subject was Man with a capital M—as a symbol and spiritual ambition, often irrational and destructive."14

In an obituary for Golub in *Art in America*, Raphael Rubinstein describes the artist as "best known for his epically scaled paintings depicting scenes of torture and political repression." Rubinstein offers us important contextual information, explaining that in the 1950s Golub "sought to develop a figurative approach that responded to the existential and political conditions" of the times following the Holocaust. Importantly, "Golub articulated his dissatisfaction with art that, in his view, placed aesthetics above ethics." His figurative painting of political content was a move away from the current work of the time, abstract expressionism. Rubinstein interpretively identifies Golub's main theme as "men and power." Rubinstein echoes Marzorati's claim about Golub's continued relevance in light of Abu Ghraib and newer revelations of Americans' use of abuse and torture in Iraq.

Critics writing at the time Golub made the paintings agree and reinforce what Marzorati, Cotter, and Rubinstein wrote after the artist's death. David Cateforis writes about Golub's pictorial protests to the Vietnam War, "He painted three enormous pictures of Vietnam, striving for absolute objectivity by drawing his images of men, uniforms, and weapons from news photos and military handbooks. In the first two canvases, he pictured American soldiers firing on Vietnamese civilians. In the third, he depicted the soldiers at rest, their victims lying at their feet. With these gigantic protest paintings—the largest of them 40 feet wide—Golub established himself as one of the most ambitious and uncompromising politically engaged artists of our time." ¹⁶

Coauthors Ed Hill and Suzanne Bloom summarize the subject of Golub's work as "inquiries into the realms of power and abuse." In a feature-length article in *Artforum*, Rosetta Brooks also offers another summary view: "For the past 30 or so years Golub's art has confronted hidden episodes and unspeakable acts of horror that foment beneath the surface of our mediated reality." 18

Like Cateforis, who noted that Golub obtains his subject matter directly from news photographs and military handbooks, critics Robert Berlind and Rosetta Brooks describe Golub's strategy for rendering his subject matter. Berlind writes, "Golub has always made use of preexisting imagery," and Brooks writes that, because of this, "we feel as if we've seen these images before—but where, we're not sure. In a sense, this is imagery to which the media denies us access." Both critics then go on to make interpretive points about these descriptive facts. Berlind: "Indeed, the origins of his imagery in the public domain constitute one implicit level of social critique, for we are shown that all of this already exists, not only on the fringes of our global power, but at home, within our domestic visual environment." Brooks: "In a media-controlled universe, the disturbing familiarity of Golub's images asserts our sense of history as a dynamic of universal forgetting."

Critics selectively describe all that can be described based on what they interpret to be important. That is, all kinds of facts and figures could be mentioned, especially when talking about art based on historical events; for this reason, critics are purposely selective about what they detail and what they omit.

Pamela Hammond calls a recent show of four Golub paintings a "grisly exhibition." Of one of the paintings, she writes, "*The Prisoner* shows figures emerging from a sooty, crosshatch haze. Fuzzy blocks of light glare from the surface, coming at us like spotlights. One of a pair of criminals fixes his steely stare on us; a gun lengthens his right arm; a holstered hip twists towards us. The other turns his head away, grimacing ambiguously." In a different review of the same exhibition, Ben Marks describes the subject matter of another of the paintings:

75

Prisoners (III) is a scene of two men pulling a blue suited prisoner by his hair, presumably for interrogation and torture. One man holds an Uzi and stares straight at us. His green eyes and red lips are the only other colors in this piece, which is otherwise painted entirely in hues of brown, beige, charcoal, and white. The other man looks forward, intent on completing this task, which he neither seems to enjoy nor find particularly troubling. There is a "just doing my job" quality to the proceedings that makes the viewer nervous. The whole scene feels like the memory of a bad dream, recalled through a haze of paint and sweat as if we had just bolted upright, wrenched from our otherwise peaceful middle-of-the-night slumber.²¹

In these two quotations by Hammond and Marks are examples of compelling descriptions of an artist's subject matter. The critics draw us in by their use of descriptive language. When Hill and Bloom describe the sphinx in *Yellow Sphinx* (1988), they do not simply say, "There's a sphinx"—rather, they fashion this compelling description of it: "The hybrid monster rears up heraldically, its two feet supporting a massive lion's body and man's head; the beast's torso is turned away from us, while its face is seen in left profile against a large expanse of acrid yellow."

Several critics comment on the ambiguity of Golub's subject matter. Robert Storr writes that Golub paints "the ubiquity and humanity of the 'inhuman." 22 Marks observes that Golub does not allow us specificity regarding who is being depicted: "The nominal source for this particular group of paintings is the Middle East, giving the subjects an indeterminate ethnicity. Their generally non-Caucasian facial features remove any easy, stereotypical relationships of oppressor and oppressed we might want to lapse into." Brooks pays particular attention to the victims in Golub's paintings: "Frequently, the victims in a Golub painting, rather than their torturers, are 'masked,' either literally or figuratively. Their flesh is reduced to anonymous lumps of pigment. Their bodies appear as fragmented, partial, or dislocated representations, the mere pretext for a game performed on them by interrogators. It is the latter, striking their poses as they enjoy their private joke, who command our attention. The horror of *Interrogation II* (1981), for example, is generated by the smiling faces of the mercenaries turning to the onlooker, flashing their grins automatically as the camera button clicks." Hammond comments that with his use of referential ambiguity, Golub "pulls you into an open-ended narrative, forcing you to create your own version of the circumstances."

As readers already familiar with Golub's paintings or as viewers standing in front of them, we may feel that writing such descriptions of the subject matter is easy and automatic: We simply look at the paintings and describe what we see. But these descriptions of the visual are inventions when they are made verbally. Critics find words and shape phrases to accurately and passionately tell about the work and engage the reader with it. Their descriptions are discoveries that offer us insights into the work by means of carefully crafted language. Hammond writes of a criminal's "steely stare." Rather than saying he holds a gun, she writes that "a gun lengthens his right arm; a holstered hip twists towards us." In describing formal aspects of

the works, Marks doesn't just list the colors, but also notices and notes that the man with the Uzi has green eyes and that his green eyes and red lips differ in color from the rest of the painting. Marks's description of the feeling of a scene being that of "a bad dream, recalled through a haze of paint and sweat" is good, inventive descriptive writing, as is Brooks's description of how Golub posed the mercenaries so that they are "turning to the onlooker, flashing their grins automatically as the camera button clicks."

There is general agreement among critics that Golub's works are powerful, and the critics we have quoted so far are particularly drawn to describing his subject matter. Margaret Moorman attributes the power of a series of sphinx paintings Golub made in the late 1980s to their form rather than their subject matter: "The four large paintings here are powerful, but their power derives almost entirely from their formal qualities-their size, their scraped and scumbled surfaces, their awkward but compelling compositions, their vivid color."23 Robert Storr is puzzled by the meaning of the sphinxes and says they "ask self-addressed riddles, ones which they do not, perhaps cannot, answer." Instead of attempting more of an interpretation than this, he offers descriptions. He particularly is impressed with Golub's use of color in these paintings: "The mutant men and beasts of his most recent work pace and gesture in a brilliant radioactive haze as if before the cameras of a highbudget film production." He adds that "the grating brilliance of Golub's tints and the extreme tactility of his usually abraded surfaces contrast sharply with the way in which the depicted forms seem to diffuse into the etiolated matrix of strokes, so that his pictures acquire a disturbing cinematic or video-screen effect." Cateforis also writes about how Golub handles paint: "He renders his figures in a harsh, acrid. illustrational mode, laying on the paint thickly, then dissolving it and scraping it down with a meat cleaver. The eroded colors and surfaces of Golub's paintings are raw, dry, and irritated, setting us on edge, increasing our discomfort."

Rosetta Brooks eloquently describes a series of Golub's paintings called "Night Scenes" (1988–1989), particularly attending to their formal qualities. She writes that they "place us squarely in the realm of television imagery where the color blue dominates the canvas" and that "one searches these dark yet luminous surfaces for clues with the alert vigilance with which one concentrates on discerning the outlines of figures in the street to distinguish a mugger from a passerby. But it is the paintings themselves that are threatening; danger is suggested everywhere in that everything seems OK on the surface. These are not the sinister corners of Golub's earlier interrogation rooms. Yet the near monochromes of high-tech spectral blues create a similar atmosphere; a strange glow pervades the fragmentary scenes with the relentless evenness of an electric lightbulb."

In a review of prints by Golub, Robert Berlind describes some of Golub's technique and then infers meaning based on his description of the artist's process: "The surface of the print is made by scratching and abrading the stone so that the figures emerge as much out of a negativity, a rubbing out, as by an additive process of

drawing. Golub's work process becomes metaphor, and the damaged facture establishes the psychological and emotional ambience of these wraithlike personae." He adds that Golub's "perversely sweet palette plays off against the harshness of surface and emotional content."

Berlind reviewed a later exhibition of Golub's work, from the late 1990s, and characterized them: "massive complaints about the inevitability of pain, aging, indignity and death, they are not easy to swallow." He praises them: "These are no mere illustrations but complex paintings whose retinal impact, astute composition, and subtly shifting descriptive language are crucial to their effect." ²⁴

Although the critics here are all positive in their descriptions of how Golub formally presents his subjects in the media of paint and ink, one critic expresses reservations. Joshua Decter writes, "The career of Leon Golub has been characterized by a problematic tension between the commitment to a tradition of abstract expressionist painting and an engagement with certain 'radical' or 'left-wing' politics organized within the cultural sphere." He goes on to say that "an awkward tension was produced between the monumentality of the painting (which referred explicitly to the scale and design of Clyfford Still and others) and the threatening images of violent acts about to commence or recently enacted." Decter concludes by saying that he is disappointed that "the content of Golub's paintings are being eradicated and diffused by a seeming dedication to the 'beautifying' requirements of the market-place." Thus Decter agrees with the other critics on how Golub's paintings look, but he disagrees when he judges the effects of the paintings. Here we have a clear agreement about description and a disagreement about interpretation and judgment.

SCULPTURE: DEBORAH BUTTERFIELD

Following are several descriptions, some quite eloquent, of sculptures by Deborah Butterfield (see Color Plate 7). The critics writing about her works seem to enjoy writing about it. They are particularly impressed with the way she handles minimal materials—sticks and mud, discarded metal—to evoke a strong presence of horses. Deborah Yellin, for example, writes that she is a "virtuoso" in the way she handles steel because of the remarkable sense of volume and detail she creates.²⁶ Yellin says that Butterfield is totally in control of her subject matter and materials and that she is a master in capturing the essence of her highly individual animals. Yellin goes on to specifically describe Butterfield's adeptness with scraps of metal: "Steel provides an ideal structure for these pieces, since it is skeletal at times, roundly solid at others, and often elegantly curvilinear. In her seemingly effortless manipulation of scrap metal, Butterfield is able to capture the sense of suspended movement of her subjects." Donna Brookman is also impressed with Butterfield's use of her chosen medium: "The forms have a vivid materiality and abstract beauty. All three horses are made with colorful and corroded pieces of scrap metal-old drums, pipes, and fencing that remain undisguised even as they are transformed."27

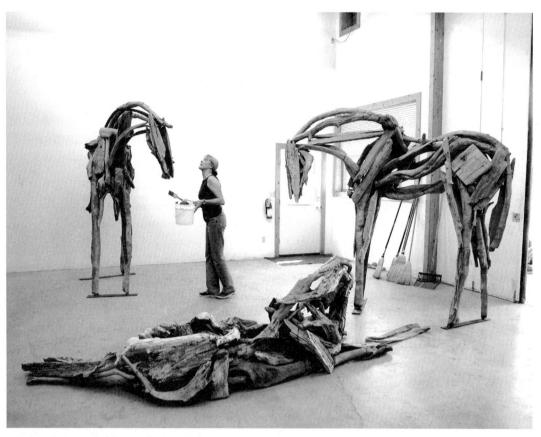

Deborah Butterfield, Installation, 2009.

Art © Deborah Butterfield/Licensed by VAGA, New York, NY.

To back up her contention that Butterfield has a commanding knowledge of her subject matter, Yellin adds the biographical information that Butterfield rides and schools her own horses: "So lifelike are her animals that they appear on the brink of movement, yet the twisted, crumpled, discarded metal that they are made of totally belies such fluidity." The animals communicate their individual character through "the tilt of a head, the swing of a tail, the bend of a knee."

When attending to works of art, critics draw on their own knowledge of life as well as their knowledge of art. Critic Richard Martin, like the artist, is apparently knowledgeable about horses. He writes that "in the language of horse trainers, there is an expression that a horse 'fills the eye,' meaning that he or she is good to look at with fine proportions."28 He goes on to describe the artist's sculpted horses with anatomical detail: "Butterfield realizes the essential anatomy of the horse. The crest can be elegantly maintained in a long sweep of rusted metals; withers may be reinforced by a skin of steel; a metal spur may stand up as the dock of the horse; and the juncture of two pieces of metal may serve as the hock on the horse's leg." Martin admires Butterfield's sculptures because her "examination of the horse is as passionate as the philosopher's and as engaged as the rider's." He adds, "When the line of the back is continuous and strong and the hunk of metal falls to the point of hip and an adjunct piece of metal forms the gaskin on two upper legs, there is no doubt of the presence of the horse."

Critics writing about Butterfield's works seem to delight in describing their form. Martin, for example, provides us with this description: "Another standing horse pokes its head forward and draws its neck down in an aerial and ethereal elegance generated by loose structure, whereas the barrel of the horse and its hindquarters are densely described in an impacted lattice of twisted metals even including parts of a child's tricycle incorporated below the loins." Of a show of Butterfield's horses in Chicago, Kathryn Hixson writes, "The familiar Butterfield abstractions of the equine are compelling presences, looming larger than life, defined by delicately open fragmented shells of linear abstraction." ²⁹

Butterfield's work also inspires critics to examine and write about their feelings in viewing it. Hixson attends to the form of the sculptures and then moves into the emotions the sculpted horses evoke: "Adeptly controlling her formal elements, Butterfield constructs lace-like structures—crisscrossing twigs and branches, sometimes incorporating crumpled strips of metal—that become astute representations of emotionally expressive postures of this domesticated animal—as demure partner, vanquished other, and unself-conscious being." Martin also writes of the emotion in the sculptures, specifically attending here to Butterfield's reclining rather than standing horses: "In the reclining horses, Butterfield creates both sympathy and eroticism. The awkward distribution of weight, the knowledge of a delicate equilibrium required to lift the recumbent horse to an upright position, and the implication of birth, nurture, and death give these horses a particular poignancy." He adds that the supine horses are "seductive in the sense that we assuredly want to cuddle with them, but they are comforting in their generation of the blissful repose that is the horse's tranquil equivalent of real life." Of one piece, Brookman writes, "The hollow torso of this horse, with no visible supporting structure, emphasizes its vulnerable, weak quality," and she adds that Butterfield "vividly conveys the spirit of the horse, with all of its connotations of power, grace, and sexuality, yet simultaneously makes her creatures appear elusive and threatened." Yellin says that Butterfield's horses exude an aura of pastoral calm but that the weathered and beaten metal of which they are made also suggests their mortality.

Comparing and contrasting works of art is a common and useful critical strategy. Two critics compare and contrast Butterfield's horses with other depictions of horses throughout the history of art. In his review, Martin mentions the painted horses of Géricault, Bonheur, and Stubbs; the horses in the Broadway production of *Equus* and the Hollywood films *Black Beauty* and *My Friend Flicka*; as well as the Trojan Horse. Marcia Tucker, in an interview with the artist, has Butterfield herself reflect on how her horses differ from those of other artists: "My work started out

GLASS: DALE CHIHULY

This is a clinically accurate description of one of Chihuly's artworks: "Davy's Gray Sea Form Set with Black Wrap Lips. American, designed and made by Dale Chihuly with Kate Elliott and other glassblowers, probably at Pilchuck Center, Seattle, 1985. Glass, clear greyish tinted, with coloured glass inclusions; an eight part assemblage consisting of one large 'container' in the shape of a wavy-edged shell with six smaller forms of varying dimensions and shapes nesting inside the other and a small sphere. Marks: CHIHULY 1985 incised on base of the largest. 24.7 cm. long. C.111 & A-G-1987." This type of description attempts scientific objectivity. It is written anonymously, conveying the impression that it is objective and without bias. It is not, however, considered critical writing or art criticism; it is a catalog entry for a historical archive. Although it contains important descriptive data, it is not the type of descriptive writing we usually find in art criticism. Descriptive writing of this type would be deadly to read; descriptive critical writing tends to be more engaging to draw the reader's attention.

Andrea DiNoto, writing for Connoisseur magazine, offers more typically lively descriptive information about Dale Chihuly and other artists who have recently taken up the medium of glass: "The work is virtually brand new—no piece is more than twenty years old—and the concept is revolutionary: glass as an art medium, not for elegant factory-made tableware or accessories, but for sculpture and even 'painting' that is designed and executed by studio artists."32 Her descriptions overlap with the catalog information, but she is aware of herself as a writer and of her audience. Readers of Connoisseur include potential investors, and DiNoto, with an appeal to authority, informs them that curators of the Metropolitan Museum of Art and the Smithsonian "admire not only the technical virtuosity of these young, mostly American artists but also the stunning variety of form and color that glass allows in its alchemical partnership with light." She describes the range of capabilities of glass from "blown glass sculptures that exploit the sensual quality of the material to cold-worked prismatic forms that express its optical perfection. Between these two poles are whimsical assemblages, massive cast pieces, flat panels." She also states that Dale Chihuly "is generally considered the most charismatic of the glass artists working today, and one of the most creative."

DiNoto then indirectly introduces a question of value: Is this new glass work good? Behind this question lurks a larger one: Is it art or (merely) craft? "Distinguishing between the good, bad, and ugly is not always easy, because glass objects

tend to have an immediate superficial appeal." She cites criteria offered by Paul Gardner, a curator at the Smithsonian: rarity, technical excellence, and beauty. Gardner suggests that glass collectors take glassblowing courses, as he did, to understand the medium. He expresses his enthusiasm concerning "the idea of transparency and light and thickness and permanence and quickness—It's glorious."

Robert Silberman, writing for *Art in America*, also raises questions of value, more directly than DiNoto: "With glass, only a fine line separates 'works of art' from *objets d'art*; as the work of lesser artists too often demonstrates, the opposite of functionalism is often a merely decorative formalism—what might be called the Glorified Paperweight Syndrome." He asserts that "a separation remains in force among museums, galleries, and collectors between *glass work* and *art work*" and goes on to say that "it still remains unclear whether even the most successful of the established artists, such as Littleton and Chihuly, should be thought of as good artists, or good (for) glass artists."

In a review of a 1981 exhibition by Chihuly in New York City, however, Gene Baro asserts that, in this exhibition, there is "no condescending distinction between fine and decorative arts." He asserts that this exhibition "must be among the most creatively inventive and technically challenging to be seen this season in New York. Thought of as plastic expression, Chihuly's forms have an organic integrity missing from most sculpture. Assessed for their variety of interacting colors and textures, they challenge the illusionism of current painting. As small objects, they achieve generosity of scale, even a certain monumentality. And they are beautifully made, with a rare refinement that speaks absolutely of the essential characteristics of the glass medium."

Clearly these critics are raising questions of value and of theory rather than description. The critics acknowledge that some glass art, especially that of Dale Chihuly, is very appealing, but ask about its value as *art*. The theoretical questions are these: Is glass work art or craft? Is there a meaningful or useful distinction between what is termed *art* and what is called *craft*? These are questions of judgment and theory, which are discussed in later chapters. Nevertheless, judgment and theory do influence how one understands a thing (interpretation) and how one describes it. Conversely, how one describes something depends on how one understands it and values it. Because of these unresolved issues in the case of glass, the following critics writing about it struggle with describing, and defining, its properties as an art form.

Silberman describes the art form this way: "There is undeniably something special about glass as a medium. Its purity, fragility, and hardness, combined with its ability to flow, hold color, and exist in states ranging from the transparent to the opaque, make it almost fatally attractive." Calling it "almost fatally attractive" indicates his continuing skepticism. In *Artweek*, Ron Glowen describes the medium this way: "Glass is a visually seductive and glamorous material. The hot glass process—with its mesmerizing mix of fascination and danger, rigorous physical discipline and showman's flair, teamwork and timing—adds greatly to its allure. No one has exploited this more than Chihuly." 35

Glowen also describes the history of the "studio glass movement," which, he explains, began in this country in 1962 when Harvey Littleton designed and built a small glassblowing furnace at The Toledo Art Museum in Ohio. Chihuly is a student of Littleton's. Chihuly founded the Pilchuck Glass Center in 1971 in northern Washington State, and he travels and teaches extensively, producing almost half his pieces in other artists' studios. Glowen recounts that Larry Bell manufactured glass cubes in Los Angeles in 1965 and that, in the 1970s, when Italo Scanga incorporated "crafted" glass into "fine art" installations, glass art was assigned dual traditional (craft) and avant-garde (art) roles. In the tone of his writing, Glowen expresses discomfort with implied distinctions between art and craft.

Because the movement is new, many of the critics writing about Chihuly describe the techniques he and others use. Linda Norden writes in *Arts Magazine* of "Chihuly's continuing commitment to the exploitation of properties unique to hot glass and the glassblowing process." She describes glassblowing as "an elaborately choreographed tug-of-war between the artist (blowing, spinning, rolling, etc.) and gravity" and is impressed by the tremendous kinetic energy inherent in glassmaking—far from the familiar associations of glass with fragility and preciousness. She relates that Chihuly favors spontaneity but does produce watercolor sketches before blowing. She also explains that by blowing tough soda-lime glass into a mold with interior ridges, Chihuly pushes glass to new extremes of thinness. By corrugating the glass, he provides increased structural stability, and thus he can allow close inspection of his pieces, further refuting the fragility and preciousness usually associated with glass.

David Bourdon writes that "obviously reveling in the elasticity of his molten medium, Chihuly emerges as a red-hot virtuoso who exalts the craft of glassblowing into an uncharted new realm of artistic significance." In describing the clusters of bowls Chihuly is well known for, Bourdon describes how the artist achieves a line of color around the edges of bowls, or lip wraps: "The lip wraps are lengths of glass rod—often about the thickness of a line of extruded toothpaste—affixed to the rims of the bowls. Visually, they function like colored contour lines." Bourdon also explains that to overcome the size limits feasible with blown glass, Chihuly clusters related forms to augment the scale of his pieces.

Marilyn Iinkl describes the technique Chihuly used to make a series of vessels in response to his love of Navajo blankets. She explains that he makes flat drawings out of thin glass threads pulled from Kugler color rods. They are assembled by hand and fabricated with a propane torch. Molten glass is placed on the drawing and blown into the cylinder shape. "The motifs wrap the cylinders as the blankets wrapped the Indians." About these same pieces, Penelope Hunter-Stiebel writes, "The resulting heavy, nonfunctional vessels speak of the precision of textiles and the freedom of abstract painting."

Chihuly produced a series of vessels he calls the Pilchuck Basket series. Norden informs us that these were inspired by Tacoma Indian baskets of Chihuly's native

02

Northwest. She says that, with these glass pieces, it is evident that Chihuly favors asymmetry and distortion as well as delicacy and spontaneity. Some of the forms are "nearly two feet in diameter; the slouching and distended bubbles were decidedly glass in their thinness and shiny translucence, but still very much baskets in their tendency toward ambers, burnt orange, straw, and slate brown coloring." Hunter-Stiebel writes that, in making these baskets, Chihuly "flirts constantly with their destruction, allowing varying degrees of collapse." She adds that "the baskets form families, nestling within each other or in near proximity as if seeking shelter in their vulnerability."

Bourdon provides some engaging descriptive writing about Chihuly's wall-mounted clusters of blown bowls, referring to them as "flamboyant corsages"—"four or five bowl-like shapes with outward-flaring sides and crimped or crinkled rims, clustered like bunches of fantastic flowers." He writes that these glass reliefs command attention "both for the sheer gorgeousness of their undulating forms and for the spectacular manner in which they seem to spill into the room." He calls their shapes "biomorphic" and writes that their "intricate and ornate edges seem all but alive with potential movement." He informs us that the bowls are generally wider than they are deep, sometimes flattened like platters. He describes the forms as abstract but nature-based, reminiscent of spiraling forms and coiled growths in marine creatures such as sea anemones or mollusk shells: "The undulating sides, swirling lips, and progressively spaced stripes suggest they may have been shaped by eddying water or gusts of wind. Though the scalloped edges are in fact stationary, their apparent fluidity hints at potential movement, like the swaying bodies of organisms responding to tidal changes."

Peggy Moorman is drawn to Chihuly's use of color and provides some lively descriptive writing about it. She says that his colors are "so vital they seemed fresh from the fire." She continues, "Chihuly's colors range from raw and gaudy, with an orangy yellow as bright as jewelweed, to the subtle, dusky red of a certain species of starfish that lives in the cold tidal pools of the northern Pacific coast of Washington, where the artist lives and works." She describes a particular "milky cerulean blue that glows through orange, ochre, and rust" and writes of "shamelessly gorgeous colorations and his rash and fluid distortions." She continues, "Chihuly's laminated colors produce an effect like that of a seashell—he makes the interior of each piece a single smooth color, which glows from behind a speckled, variegated exterior the way a cowrie's pale inside is set off by its brindled back."

In a comprehensive critical overview of Chihuly's work, written as an introductory essay for an exhibition catalog, Barbara Rose moves beyond earlier craft versus art considerations, and opens her writing with these declarative assertions:

The greatest living master of the ancient medium of glass, Dale Chihuly has breathed new life into a traditional art form, ensuring its future by creating a third-millennium fine-art expression for an artisanal form invented before the first millennium began.

This is a unique accomplishment, which is the result of the unusual mix of talents, risk taking, experimentation, organization, and social interaction that characterizes this visionary artist. Chihuly has the perceptive blend of precision and nonchalance, control and nerve, not only to find new solutions, but also to conceptualize new problems. His obsession with technical innovation, together with a healthy respect for the achievement of past masters, permits him to make a singular contribution to his chosen medium.⁴¹

Thus she opens her essay with a judgment of value, referring to Chihuly as "the greatest living master" of glass; accepts his use of glass as "fine-art expression"; and talks about the personal qualities of the artist that have aided him in his accomplishments—namely his "unusual mix of talents, risk taking, experimentation, organization, and social interaction." In the rest of her essay, she elaborates on the themes she introduces in the paragraph: historical developments of glass, the overlap of Chihuly's artistic concerns with painters and sculptors of his time, his technical innovations, and his unique collaborative work with glassmakers in traditional glass centers around the world. (See Color Plate 8.)

PERFORMANCE ART: LAURIE ANDERSON

The difference between describing glass objects and describing the performance art of a living person is enormous. In reviewing a performance by Laurie Anderson in 1986, John Howell, in *Artforum*, describes her costumes over the years: In the early 1970s she wore "a white minimalist/hippie gown"; in the late 1970s, "punkish sci-fi suits"; and in the mid-1980s, at the time of his review, "all out glitz" in a gold lamé suit, bright green shirt, silver tie, and red shoes. ⁴² "This glittering concert character, like all pop personas, has changed clothing to update her assumed role, that of symbolic stand-in for the collective unconsciousness of the moment."

Howell credits Anderson with continuing (for more than ten years at the time he was writing) "to refine a small vocabulary of rich ideas that seems to be capable of infinite development." He describes the performance he is writing about as a "talking electronic-blues performance" that shows "subtle changes in her trademark formula of musical monologues accompanied by elaborate mixed media visual imagery and quirky props." He also describes the lyrics as "the further adventures of her staple wide-eyed 'I,' the Anderson who sees funny things, has peculiar thoughts, dreams a lot (the word 'dream' occurs in most of her song sketches), and who comments in a *faux naif* manner on the comic absurdity of it all." Howell typifies Anderson as a lyric poet rather than a systematic analyst and admires the variety, clarity, and sheer drama of her audiovisual pieces. He also mentions problems with the performance—namely, the starting and stopping of brief pieces—and wonders whether their meanings contain small insights or large theories.

In a 1990 review of Anderson's *Empty Places*, Ann-Sargeant Wooster, writing in *High Performance*, a magazine devoted to performance art, provides some historical

perspective on Laurie Anderson. Wooster writes that "she has come a long way from the time in the early '70s when she used to play the violin on street corners wearing ice skates embedded in a block of ice and the performance was over when the ice melted." Wooster also declares that Anderson now "defines performance art." The critic places Anderson in the tradition of American storytelling with O'Henry, Jack Kerouac, and Bruce Springsteen. She goes on to identify a frequent theme of Anderson's as "loneliness and the alienation rendered by our modern technological world."

Wooster describes the setting for Anderson's musical performance: "Anderson's singing was accompanied by abstract black and white films that looked like scratch-board drawings. Walls of images that included footage of passing subway cars were stretched and pulled into space until they became electronic billboards mirroring the ceaseless mobility of the onlooker rather than advertising a product."

A considerable portion of Wooster's review concerns Anderson's music, and here it is as much music criticism as it is art criticism. She writes of Anderson's "elegiac mood" and the music's "quality of mourning." She describes the "lush opulence" formed by Anderson's "electronic tableaux" when she surrounds herself onstage with the accoutrements of high technology. She describes Anderson's voice in earlier performances as "gravelly," especially because of the artist's use of a "vocoder." Wooster also informs us that Anderson has been taking voice lessons, and the critic now characterizes her voice as lighter and more pleasant, similar to that of Joni Mitchell or Syd Straw. The critic thinks Anderson has replaced her former "androgynous persona" with a more feminine stage presence that corresponds more closely to her new voice. She describes Anderson's music as content-laden, in a singsong, talking manner.

Wooster expresses gratitude for audio recordings: "As the beauty of live performance soon vanishes from memory as does its flaws . . . we can think of the importance of records for performance artists of all kinds. Anderson's songs from *Empty Places* linger on in a stronger and more haunting way in the form of her favorite, democratic object, a record."

Commenting on her live performances, the art editors of *The New Yorker* magazine write in 2007 that "Laurie Anderson's performances are not the multimedia events that they used to be, but they do hit on a variety of levels. Her small group (usually a trio, though her husband, Lou Reed, has been known to sit in) creates a blend of keyboard, synthesizer, violin, and guitar sounds, sometimes rhythmic, sometimes breaking through the strictures of time signatures and achieving a meditative euphoria." The writers conclude, "The most arresting instrument in the band is Anderson's voice. Often, she's not singing so much as speaking in pitch, every word precisely presented, offering lyrics that are epigrammatic, politically and culturally astute, funny, and cosmic." 44

When interviewed by Deborah Solomon of *The New York Times* and asked if she was worrying about "aging and wrinkles," Anderson replied, "Not really. I think some prunish people look pretty good. I am more worried about turning into a

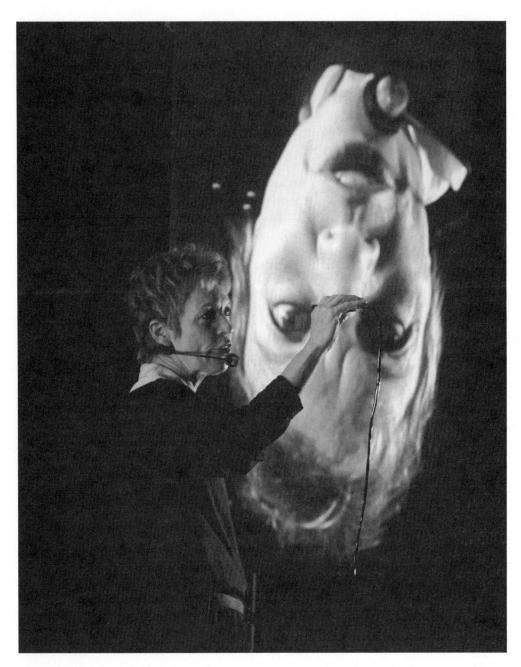

Laurie Anderson in performance, 2007.
Photo by Kevin Kennefick Photography, Williamstown, MA.

schlump rather than a prune. A schlump is someone who doesn't care about anything and who is just protecting their own turf, which is getting smaller and more meaningless, and then they disappear."⁴⁵

VIDEO: BILL VIOLA

Following are different descriptive accounts of installations by video artist Bill Viola. The first is the artist's own descriptive summary of a plot of one of his videos; the second is a critic's description of viewer's reactions to a Viola piece installed in a public civic site; and the third is a critic's description of her own reactions to another of Viola's works.

Emergence (see Color Plate 9) is a high-definition video commissioned by the J. Paul Getty Museum that resembles a painting because it is framed, is hung on a wall, and moves so slowly that if one passes it by quickly, it might not be recognized as a moving image. It is played continuously, with a single running time of about twelve minutes. Viola offers this descriptive account of the plot of *Emergence* (2002):

Two women are seen sitting on either side of a marble cistern in a small courtyard. They wait patiently in silence, only occasionally acknowledging each other's presence. Time becomes suspended and indeterminate, the purpose and destination of their actions unknown. Their vigil is suddenly interrupted by a premonition. The younger woman abruptly turns and stares at the cistern. She watches in disbelief as a young man's head appears, and then his body rises up, spilling water over the sides and out onto the base and the courtyard floor.

The cascading water catches the older woman's attention, and she turns to witness the miraculous event. She stands up, drawn by the young man's rising presence. The younger woman grasps his arm and caresses it as if greeting a lost lover. When the young man's pale body reaches its fullest extension, he totters and falls. The older woman catches him in her arms, and with the help of the younger woman, they struggle to lower him gently to the ground. Lying prone and lifeless, he is covered by a cloth. Cradling his head on her knees, the older woman finally breaks down in tears as the younger woman, overcome with emotion, tenderly embraces his body. 46

Michael Duncan, a freelance critic in Los Angeles, wrote about *The Crossing*, one of Viola's best-known pieces, in a feature article in *Art in America* about a midcareer survey of Viola's work at the Whitney Museum. When he saw the piece, it was installed in an empty mezzanine level of the Grand Central Market in downtown Los Angeles: "It mesmerized passersby with its cathartic display of the power of water and fire. . . . On a rainy Sunday, families toting fresh tortillas, fish, onions, and carrots stood there for the work's duration, astounded by the physical power of the elements. In the dark recesses of the space, a steady leak of rainwater, courtesy of El Niño, added a touch of realism to the experience. . . . No one—especially in Southern California—needs a gallery guide or wall of text to tell them that fire, water, earth, and air can be overwhelming, annihilating forces. Viola presents excesses of water and flame that inspire a pure state of awe and wonder." 47

"Buried Secrets" (1995) is so disturbing that its images and associations still float into my consciousness the way the disturbing parts of dreams resurface unbidden, reminding one of anxieties, unresolved conflicts, deep fears.

I walked through the installation rather quickly thinking I'd "gotten it," like the punch-line of a joke, only to realize later that I had felt far too uncomfortable to linger, as if I too had shut my eyes to something I hadn't wanted too know.

Figuring out why I found this exhibition so painful led me to confront my own secret fears, angers, and feelings of failure. Bound by fear, lost in a forest of choices, guilt-ridden, trapped inside myself, and explosively alone, I know the confusion of the abandoned friend in *The Greeting*: it all cuts much too close to the bone, as Viola's work so often does. 48

The artist's account of his own work is a mostly straightforward description of what one would see or, perhaps more accurately, what Viola would want one to see, including some interpretive suggestions. Duncan's account gives us a critic's impressions of how *The Crossing*, installed in a public shopping space, affected viewers who saw it. The viewers were grocery shoppers, but they stopped and watched the entire piece and were filled with awe and wonder at Viola's use of the elements—even though they know them well as residents of Southern California, who frequently experience fires, floods, mudslides, and earthquakes. Boyle articulates her own experiences with Viola's works and her feelings of fear while watching and later while reflecting upon the works. These three approaches provide us with different descriptive options, each of which could be pursued with more length or which could be combined in one piece of writing.

INSTALLATIONS: ANN HAMILTON

A writer for *The New York Times*, Annette Grant, asks this question of her readers to introduce *corpus*, an installation by Ann Hamilton (see Color Plate 10): "Let's say you have a room roughly the size of a football field. It's also three stories high and lined with two tiers of closely spaced windows containing 3,380 panes of glass. And you'd like to show art in it. What would you do?" The question is appropriate because Hamilton is known for making site-specific installations in various media that respond to and interact with exact locations for a specific period of time.

Grant's answers for her readers are consistent with information provided by MASS MoCA on its Web site. The institution commissioned the piece for its largest space, a space that was originally filled from 1874 to 1938 with rooms for dyeing raw cotton for the fabric industry. The director of the art venue describes his experiences with Hamilton's works and with *corpus*: "Being in one of her evocative installations engages all the senses: they are experiential, immersive, kinesthetic, and, in this case, grand, liturgical without liturgy." ⁵⁰

MASS MoCA provides this description and overview of corpus:

Hamilton animated the volume of the space with sound, light, and millions of sheets of paper that fell from the ceiling over the course of the ten-month installation. Hamilton engaged the space by introducing three elements into the main gallery. First, in the rafters high above the gallery floor, she placed 40 pneumatic mechanisms that lifted and released single sheets of translucent onionskin paper. The machines moved at the pace of breathing, inhaling to pick up the paper from a stack, exhaling to drop it. Second, 24 horn-shaped speakers slowly descended from and ascended to the rafters to meet the paper on the floor. One voice was present in each of the downward-facing speakers, and the 24 voices often spoke in unison. As the speakers lowered, they formed a central aisle that disappeared as they moved upward. Finally, every pane of glass in the gallery's several hundred windows was covered with red or magenta silk organza. The light filtering through these windows provided the only illumination in the space, suffusing it in color. The combination of the light filtering through the windows, the implied aisle in the long nave-like gallery, and the voices speaking together suggested the intense, almost otherworldly experience of being in a great cathedral. ⁵¹

Grant offers descriptive details of six aspects of corpus: the room, the staff, the paper droppers, the speakers, the second chamber, and the balcony. Regarding the staff, Grant informs us that forty-five people worked on the installation, including the artist and eleven students, who cut pieces of silk and affixed them by hand to 3,380 panes of glass. During the life of corpus, forty specially built machines dropped about five million pieces of onionskin stationery, one at a time and at irregular intervals, until the papers were shin deep, at which point the papers were swept up and recycled. Hamilton chose the paper "by sucking samples to her mouth and then releasing them until she found the right weight and texture." Twenty-four cone-shaped speakers lowered from overhead beams to kiss the top of the papers in fifteen-minute cycles and then rose back to the ceiling. Each speaker contained one voice reading material composed by Hamilton. The second chamber behind the huge room "is in twilight." Speakers playing music "whirl and rotate just overhead like fluttering bats." The balcony overlooking the huge room provides benches made from beams removed from the factory during its renovation. Grant concludes her article with a quote on MASS MoCA's Web site.

In its conclusion for *corpus*, MASS MoCA describes unifying elements of Hamilton's installations:

Each of Hamilton's installation works is responsive to a particular architectural space, and each requires a performance from the artist and the audience. But whether virtually clearing a space of everything but its own and the viewer's presence or working with a host of media that may include video, audio, photographs, sculptures, live performers, animals, and plants, Hamilton's poetic installations offer tangible, poetic correlatives to a site. Her sensory environments are a duration, a process, and an accumulation of presences. With each, Hamilton invites viewers to actively experience those moments when knowledge is absorbed, particular moments are felt, and collective memories are retrieved.⁵²

The descriptions of *corpus* provided here are derived from MASS MoCA's Web site and from an article consistent with information from the sponsoring institution, which in turn, most likely relied on Hamilton's articulations about her own work. Thus we are assured that the descriptions are suitably accurate according to the institution that commissioned the work, and parallel experiences the artist intends for viewers of *corpus*. Grant uses these sources of information and confirms them with her own experience of the installation. Press releases and sponsors' Web sites are good sources of descriptive information; but be aware that they also shape ensuing discourse about work being described.

In describing Hamilton's installations, critics need to refer to specific spaces and times because Hamilton's pieces are site-specific—planned around and made for an exact location—and meant to last for a specific period of time. Sarah Rogers also points out that Hamilton's projects are "site specific not only in formal configurations but in associative references to the context of their sites." The materials she uses are often from the region in which her installations are built, and the references in her pieces are often in response to local history and recent occurrences.

PRINCIPLES OF DESCRIPTION

The following principles for describing art are offered as a summary of the important general points of this chapter. This set of principles is meant to be open-ended and nondogmatic. It serves as a guide to describing works of art.

Description is criticism. Description is not a prelude to criticism—it is criticism. Description is both necessary and sufficient to art criticism. That is, all art criticism most likely contains some descriptive information; otherwise we would not know what the critic was writing about. Some art criticism is primarily descriptive, offering facts and observations about an artwork. That is, critical writing that is primarily descriptive can be an enlightening and informative contribution to critical discourse. Not all criticism needs to include an explicit interpretation of an artwork's meaning. Not all criticism needs to pass a judgment of worth on a work of art in order to be considered "criticism."

Description is an essential element of criticism. Accurate descriptions of a work of art are fundamental to any ensuing interpretation (what the work might mean) or judgment (how the work is valued) of the work. Faulty or inaccurate descriptions will likely lead to faulty and unreliable interpretations. Similarly, if an object is described inaccurately, and then a judgment is made on the basis of that inaccurate description, the ensuing judgment will be suspect.

Descriptions are factual. Critical descriptions ought to be based on facts, such as the medium of which the artwork is made, its size, information about the artist who made it, and the time in which it was made. In theory, descriptions are said to be true or false, accurate or inaccurate. That is, when a critic makes a descriptive claim about a painting—points to something in it and names it—we should be able

91

to see it and agree (or disagree) with the critic's observation. Description is said to deal with facts, and it does. However, all facts are dependent on theory, and all descriptions are interwoven with interpretation and evaluation.

Factual descriptions depend on interpretive and evaluative decisions. Critics want to persuade their readers to see a work as they do. If they are enthusiastic, they try to communicate their enthusiasm through their choice of descriptors and how they put them together in a sentence, a paragraph, and an article. The descriptions quoted in this chapter depend on how the critic understands the piece of art.

Critics could attempt to write descriptions in a painstaking way so as not to reveal their preferences and biases; such an exercise in critical writing might be valuable in learning to write descriptively and to identify value-laden descriptions. Critics' descriptions, however, are rarely value-neutral because critics are writing persuasively. When a critic approves or disapproves of a work of art, this approval or disapproval often comes through in the critic's descriptions of the work.

Descriptions are lively. When critics describe, they often do so quite passionately. Recall these descriptors of Chihuly 's work: "flamboyant corsages," "clustered like bunches of fantastic flowers," "sheer gorgeousness," and "the spectacular manner in which they seem to spill into the room." Critics write to be read, and they must capture their readers' attention and engage their readers' imaginations. If Golub's work frightens them, they want us to experience the chill: "The whole scene feels like the memory of a bad dream, recalled through a haze of paint and sweat as if we had just bolted upright, wrenched from our otherwise peaceful middle-of-the-night slumber."

Description is a data-gathering process. Describing everything you can about a work of art is a good way to begin thinking about the work. "What do I see?" is a good starting question. "What do I know about this work of art?" is another. When you gather such descriptive data, everything matters. Facts about artist, title, medium, size, date, and place of presentation are important descriptive information. It is better, in this stage, to collect too much information rather than too little.

Description is a data-reporting process. Description is a process of both gathering information and reporting the information that is known about a work or seen in the work. Because there is so much potential descriptive information to report, relevance is the criterion for inclusions and exclusions. That is, critics may describe a lot in their data-gathering stage, but then report only the descriptive information that they think is most relevant to the points they are making about the work.

Describe subject matter. Anselm Kiefer's paintings often use the subject matter of burned fields. In good descriptive writing, however, they are not just burned fields; they are "large fields of scorched earth that look like slabs of blasted heath itself, danced over by devils, driven over by panzers, tortured by the weather, then screwed to the wall." Deborah Butterfield's subject matter is horses, but it is also "the tilt of a head, the swing of a tail, the bend of a knee." This is insightful and engaging descriptive writing.

When a critic writes, "Beginning with a series of performances, which incorporated his own body in sculptures as an abstract element, Charles Ray's works have always concerned themselves with what has been termed the *mind/body problem*," ⁵⁴ the critic is adding a reference to theory underlying the description of the work—namely "the mind/body problem." Critics need to decide whether their audiences will know about such references, and if not, explicate them.

Describe medium. The medium can be oil on canvas, but it can also be wax, or—more interestingly—"smelly beeswax," or costuming, but not just a costume, but rather "a white minimalist/hippie gown" and "punkish sci-fi suits" and "all out glitz." When writing about the performances of Laurie Anderson, art critics had to come up with terms for her music and wrote of her "elegiac mood," a "quality of mourning," and "lush opulence."

Describe form. In a discussion of form, the elements of dot, line, shape, light and value, color, texture, mass, space, and volume were mentioned. This list is useful in learning to notice details in a work of art. However, in professional critical description, color is not merely the name of a hue, but rather it becomes "a high-tech spectral blue" or a "perversely sweet palette." A good critic does not simply describe one of Golub's canvases as dark; rather, she writes, "One searches these dark yet luminous surfaces for clues with the alert vigilance with which one concentrates on discerning the outlines of figures in the street to distinguish a mugger from a passerby." In lively critical language, texture becomes "laying on the paint thickly, then dissolving it and scraping it down with a meat cleaver. The eroded colors and surfaces of Golub's paintings are raw, dry, and irritated, setting us on edge, increasing our discomfort." And paint is not simply acrylic; it is "splattered, splotched, and squiggled acrylic."

Describe context. Description can beneficially include information about the work's presentational environment—that is, where and how it is physically present. Is it a work in process, or a completed work on a pedestal in a gallery?

Biographical and sociocultural information can be helpful in orienting viewers to new work. For example, "Chris Ofili is one of the so-called Young British Artists. Of Nigerian descent, he grew up in Manchester, England, and now lives in Trinidad. This background contextualizes the trans-cultural working methods of the Turner Prize winner, who combines elements from different cultural areas, including African, East European and Pacific folk culture, European art, and the pictorial traditions of India." This description makes assumptions of readers—namely that they are already familiar with a group of artists referred to as the "Young British Artists" and the Turner Prize, a prestigious prize of international import given to a young British artist. Critics try to determine what knowledge their readers have or might need.

The work's ideological context is also important: What is the work's historical context, its intellectual influences, its politics? For example, critics have directly linked Leon Golub's later work to the war in Iraq and specifically the abuses of

prisoners in Abu Ghraib prison. Similarly, Golub was politically opposed to such abuses. This, too, needs to be told to the reader if the reader would not otherwise know.

Similarly, a critic introduces new work this way: "In 2008, the Studio Museum of Harlem hosted Kehinde Wiley's one-man show 'The World Stage: Africa, Lagos—Dakar.' In this exhibition Wiley brings his passion for portraiture to a global scale by temporarily setting up studios in Lagos, Dakar, and many other African cities. The show included paintings like *Three Wise Men Greeting Entry into Logos* (2008), where three black males are posing as a traditional sculpture of postcolonial African art, and a group of more straightforward portraits such as *Mame Ngagne* (2007) in which young black men are depicted against a background of brightly colored fabrics. 'The World Stage,' a wider project that was taken by Wiley to China, Lagos, Dakar, Mumbai, Sri Lanka, and now Israel, is an artistic enterprise that allows the artist to confront himself and his African roots with different cultures and traditions." ⁵⁶

External information is a source of description. Critics describe what they see in a work of art and also what they know about the artist or the times in which the art was made. The critics describing Chihuly's work felt a need to provide a history of the glass art movement. Critics usually know a lot about the artists whose work they are writing about, and they offer this knowledge to their readers. Sometimes critics need to do research in libraries to find external information that will enable them to better write about an artist or exhibition. To prepare for an interview with Anselm Kiefer, because of the many literary references in his paintings, Waldemar Januszczak tells of "scampering from the librettos of Wagner to the musings of Heidegger, from Nietzsche to Jung, from the short stories of Balzac to the epistles of Eusebius of Caesarea, from Goethe to William L. Shirer, from image to image, from quote to quote, in a kind of marvelously addictive game of Nontrivial Pursuit."

Information about art and artists is endless, however, and the ultimate test for the critic deciding whether to include or exclude such descriptive information is relevance: Will this information help or hinder an understanding of the art and the flow of the article?

Description, interpretation, and evaluation are interdependent activities. Although we can talk about descriptive information as isolated phenomena, it is not. How one describes a work of art depends on how one understands it and also on how one values it. There are no facts without theories, and there are no descriptions without interpretations. For example, the critic presents descriptive information in the first sentence, and includes interpretive information in the second. "Wangechi Mutu's collages of women's bodies, plant-like or animal-like elements, and intertwined abstract patterns initially captivate the viewer with their opulent, exuberant colors, but on closer inspection, they real twisted postures, grotesque contortions, and anatomic obscenities. The female body—what is projected onto it and how it is represented—is at the center of Mutu's oeuvre." Describing plants,

colors, and patterns is insufficient without knowing about the artist's ideological concern with "the female body."

Descriptions and interpretations are meaningfully circular. Describing what one sees is dependent on how one understands what is seen. We describe, and then interpret, or give meaning to what we describe, which often leads us to notice and describe something else, and then to infer an understanding or interpretation. To read (and understand) a sentence, one must know each word in the sentence; but each word's meaning is dependent on what the other words in the sentence mean. The meaning of a word is not fixed or static, but dependent on the context of the sentence, and the sentence's context in a larger text. This phenomenon of describing and interpreting is sometimes referred to as "the hermeneutic circle." It applies to describing elements of art as well as words in a text.

Descriptions are based on relevance to a larger idea. Descriptions can be infinitely detailed. To describe *everything* about a work of art would be tedious to write and to read. Critics select what they tell about a work of art depending on their larger idea of what it means to them or to how and why they value it. Critics have a purpose when they offer descriptions of work to readers; they usually have a bigger idea in mind than merely reporting on what they see.

Interpreting Art

NTERPRETATION IS THE MOST IMPORTANT activity of criticism and probably the most complex. This chapter is built around critics' interpretations of the work of three contemporary artists: William Wegman, an artist who makes photographs, videotapes, and paintings; Jenny Holzer, who works with language; and Elizabeth Murray, a painter. The purpose of the chapter is to help readers understand what interpreting an artwork entails, to explore different strategies of interpretation used by critics, to examine the similarities and differences of a variety of interpretations of the same work, and, ultimately and most importantly, to derive principles of interpretation that will enable readers to read interpretations more intelligently and help them formulate their own interpretations of works of art. A number of such principles are derived from the criticism samples that follow, and then they are listed and defined in the final section.

INTERPRETING THE PHOTOGRAPHS OF WILLIAM WEGMAN

In *Art in America* in 2007, art historian and writer Roni Feinstein writes, "The ambience of a William Wegman exhibition is unlike any other. Adults and children of all ages gather, laughter rings out, and the atmosphere is unusually animated. No artist of our time better bridges the gap between art world audiences and the general public than William Wegman."

The chapter begins with William Wegman because his work challenges the very value of interpreting art. Wegman's work is so accessible it seems to make attempts at interpretation unnecessary. Although the work is in virtually every important museum collection in the world, he and his videotapes and photographs have been

on Sesame Street, Jay Leno's The Tonight Show, Late Show with David Letterman, and Saturday Night Live. Wegman's photographs of his dogs have been on the covers of such diverse magazines as Avalanche, Artforum, Camera Arts, and Sotheby's auction catalog. He and the dogs have been featured in People magazine and in a human interest story for Valentine's Day in The New York Times.² Some of Wegman's work is undeniably cute, including photographs of adorable puppies that are preserved in museum collections but also are available on calendars, note cards, and T-shirts. Does art that is so easily enjoyed by the public need interpretation? Do such interpretive endeavors yield worthwhile insights? These are the questions to be answered in this section.

William Wegman paints, draws, photographs, and makes videotapes. Although this section concentrates on interpretations of his Polaroid photographs, it also touches on his other media. Critics writing about Wegman's work often include biographical information about him and his dogs. It is generally true that modern critics offer more contextual information about artists and how their work evolved than did critics of fifty years ago, who wanted to focus primarily, if not exclusively, on the artwork itself. Nevertheless, contemporary critics seem particularly interested in Wegman's life. They may sense in his work a relationship between him and his dogs that makes them want to know more about the lives of both, or his work may make them especially curious about the person creating the work. In any event, the biographical information given here is condensed from articles by Michael Gross, Elaine Louie, and Brooks Adams.³

William Wegman lives in New York City's Chelsea in a building that was formerly a warehouse. He also spends time in a home on a lake in Maine. Wegman lives with his Weimaraners. The dogs have a couch with separate dog beds on it in the bedroom and a dog run of dirt and concrete. They freely roam the space. Louie writes that Wegman plays with them frequently and that the dogs and William "simply adore each other."

Gross writes that "Wegman has survived the Vietnam-era draft, a first brush with fame, a risky dalliance with cocaine and Old Crow, and even his seemingly inescapable association with charismatic canines, to reach, at his maturity, a career peak." Wegman grew up in a working-class environment in Holyoke, Massachusetts, drawing pictures as a child. He attended Massachusetts College of Art and graduated with a BFA in 1965, later earning an MFA from the University of Illinois at Champaign—Urbana in sculpture and performance art. As a student, he was friendly with photo-conceptualist Robert Cumming and shared studio space with painter Neil Jenney. He considers his mentors to be Ed Ruscha, Bruce Nauman, and John Baldessari. Artist Robert Kushner designed costumes for Man Ray, Wegman's first dog. Ruscha is pictured with Fay Ray in *Sworded* (1987).

Wegman got his first and most famous dog, Man Ray, in 1970, as a puppy. He considered naming him "Bauhaus" but then settled on "Man Ray," the name of the famous dadaist who made photographs. The dog Man Ray died of cancer in 1981

97

at 11 years, 8 months. About Man Ray, Louie quotes Wegman saying, "I could do him as a dog, a man, a sculpture, a character, a bat, a frog, an elephant, an Airedale, a dinosaur, a poodle. I never got tired of him." Wegman spent three years without a dog after Man Ray died. In 1984 he got another Weimaraner, but it was stolen; a third died of a virus. He got Fay Ray in 1985 and named her after the actress in the original *King Kong* movie.

Of Weimaraners, Wegman says they have a lap-dog sensibility with hunting and pointing capabilities and that they are very good at holding a pose. As models, they have the added advantageous characteristic of not drooling. They like to work, and they pester Wegman when he is painting canvases rather than photographing them. Wegman goes to dog shows, and he frequents thrift shops in search of such items as fake leopard coats, mink jackets, brocade robes, and satin and lace wedding gowns.

In 1978, when Wegman was invited by the Polaroid corporation to its studio in Boston, he began making large $20^\circ\times24^\circ$ instant color photographs on Polacolor film of Man Ray. Wegman has now been using the camera for over thirty years. The camera and studio cost about \$1,500 a day, and the prints are about \$100 each and take eighty-five seconds to develop. On a typical day, he shoots about sixty frames, of which about five will be usable. He employs a camera technician, a film handler, and a lighting specialist.

In 1982 Wegman published *Man's Best Friend*, a book dedicated to Man Ray the artist and Man Ray the dog, with a brief introduction by Laurance Wieder.⁴ In 1990 he published a catalog of his touring retrospective exhibition of videotapes, photographs, drawings, and paintings. Martin Kunz, Peter Weiermair, Alain Sayag, and Peter Schjeldahl wrote essays for the catalog.⁵ Such catalogs, especially of retrospective exhibitions, are generally a summary of current thinking about the work in the exhibition. They are written by critics or scholars sympathetic to the work. (It would be strange to commission someone to write a catalog essay who disapproved of the art in the catalog.) These critical writings about Wegman are played off the essays in the book and catalog because these sources are sanctioned thinking about Wegman's work.

Kunz's writing is succinct and his essay brief. In that sense, it is like Wegman's work. Of Wegman's videotapes, Kunz writes in his introduction that Wegman's productions "stood out against the early works of video art by others, which were characterized by an a esthetic of consciously extended duration and artificially constructed boredom." In this brief statement, Kunz is assuming an audience knowledgeable about conceptual art of the 1970s. Although he does not provide examples to back up his claim, one example is the following: Andy Warhol's *Sleep*, an eighthour film of a person sleeping, shot and shown in real time. All of Wegman's early videotapes are shot in real time, in black and white, with one camera, and without cuts, and all play out a single idea. They are all very short, some as brief as thirty seconds, others only as long as two minutes. They are all funny and entertaining. They are anything but the "consciously extended duration and artificially constructed

Peter Weiermair reinforces Kunz's art about art interpretation. Writing about Wegman's photographs of the early 1970s, Weiermair says, "Wegman created these single shots, diptychs, and series during the period when Minimal, Conceptual, and Process art, for which the photograph was an important means to record events in time and space, were flourishing. No importance was placed on style and composition, or other aesthetic values of art photography. But if on the one hand Wegman came from the circle of Minimalism and Conceptual Art, on the other hand he made fun of their seriousness, their ideology of reduction, and above all, their lack of humor." 6

Other critics concur that Wegman has a penchant for making witty comments about the art of others with his own. Craig Owens wrote that Wegman's photographs in the 1970s parodied the work of Serra and the sculpture of Robert Morris, as well as the serial and systemic art of Carl Andre, Mel Bochner, and Sol LeWitt. Robert Fleck considers Wegman's videos and photographs of Man Ray "a high point of body art" and credits the 1980s Polaroids with "one of the most surprising solutions in 'conceptual sculpture."

D. A. Robbins states that Wegman's drawings have been largely ignored by critics because of "their difficult conceptual nature." (See Funney/Strange.) Kevin Costello links Wegman to dada: "Wegman is assuredly a conceptualist—a point of view in contemporary art where the idea, the concept underlying the visual documentation, has equal or more importance than the object, painting, or photograph itself. . . . His art presents complex redirections to the viewer, not only to the image of the dogs or paintings but also to the highbrow seriousness of much of art as history, which under the worst circumstances is presented with a preciousness which stands in the way of the truly human sensibility that art addresses and reflects." ¹⁰

Wegman seems to agree with these interpreters. Robbins quotes Wegman about his graduate education: "I rebelled against what I was supposed to be thinking about at that time, having to read Wittgenstein and Levi-Strauss." He goes on to say that he didn't want to be a dilettante philosopher and thought Robert Smithson, the sculptor of earthworks, was being a dilettante scientist when he wrote about art. Once he left the university environment, Wegman says, he drifted back to what was more immediate: explicitly autobiographical subject matter, simple domestic scenes, household objects, menus, grammar school, the world of men and women, cats and dogs.

Weiermair interprets Wegman's early black- and-white photographs as being about the medium of photography itself: "Wegman starts with the supposition that our consciousness is partly controlled by the medium of photography as a system of symbols, and that we have internalized this medium. We always assume that photographs do not lie and tend to identify photographic reality with truth. Many artists of the 1960s and 70s have examined this topic and have scrutinized the medium with the medium itself. The photograph is a shadow of reality; light makes its existence possible."

William Wegman, Funney/Strange, 1982.

© William Wegman.

Craig Owens interprets Man Ray's passive and submissive modeling to be a parody of fashion photography, with Wegman substituting the dog for the woman. 11 Owens also posits that Wegman's work exhibits a "deliberate refusal of mastery." Owens interprets this refusal of mastery to be an important theme of Wegman's works. He writes that they speak of failure more often than success and of intention thwarted rather than realized—especially the videotapes of Wegman trying unsuccessfully to impose his will on Man Ray, at the expense of the dog. Owens's is a psychoanalytic interpretation: The narcissistic ego attempts to assimilate, to appropriate, to master the Other, and Wegman's work refuses such mastery over an Other. Owens continues, "When we laugh at Man Ray's foiling of Wegman's designs, we are also acknowledging the possibility, indeed the necessity, of another, non-narcissistic mode of relating to the Other—one based not on the denial of difference, but upon its recognition. Thus, inscribed within the *social* space in which both Bakhtin and Freud situate laughter, Wegman's refusal of mastery is ultimately political in its implications." Here Owens is drawing upon a large interpretive framework of psychoanalytic theory to make sense of Wegman's tapes of Man Ray.

Jean-Michel Roy also reads psychological content in Wegman's Polaroids and asks, "Where does the real power of these shots come from? What sets them above and beyond the tradition of animal art to which they are often linked? The photographs' force seems to come from the original and complex manner in which they twist the roles of master and dog—evoking a consciousness and resigned sense of the fundamental powerlessness, which appear a reflection of the human condition." He argues that "posing is a subordination of the gaze of the self to another, an offering of one's self to the viewer," and that "Wegman is imposing an attitude that is at odds with their fundamental animal nature, at least in principle. He forces them with his master's authority to play human, to mimic beings imbued with consciousness and desire."

D. A. Robbins writes of the mystery of the Man Ray Polaroids, and Weiermair, citing and agreeing with this interpretation, writes, "Looking through the photographs one is struck by Man Ray's muteness, his final unknowableness; Man Ray *referred* to personality. His silence placed him at the center of the camera's (and the artist's, and our own) search for meaning. Our erotic desire to know, to recognize and make contact with the charged presence of life, is at once massaged by Man Ray's nobility and thwarted by his non-human inarticulation."

Weiermair claims that the most important feature of Wegman's approach in the Polaroid prints "resides in the tension between the perfection of the technical process being employed (Polaroid photography in a room) and the grotesque or humorous nature of the playlet that is being portrayed." He writes that the frozen beauty of the Polaroid prints have all the formal qualities of commercially produced pictures: "The object is seen frontally, the colors have that saturated and brilliant look that advertisers are so fond of; not one detail, not one aspect of the object that has been photographed eludes us. And it is this tension between the formal beauty of the photograph and the makeshift character of the arrangement that forms the basis of Wegman's approach." (See Color Plate 11.)

Weiermair interprets many of the Polaroids to be playing off advertising photography: "By appropriating the dominant language, the language of advertising, for his own purpose, he claims the right to treat serious subjects in a lighthearted way, subjects that include death, boredom, solitude, and what Michel Nuridsany has called the 'generalized derision of the world." Robbins offers a parallel interpretation:

"The manipulator of the media is by extension the manipulator of the audience; in this way Wegman associates himself with authority, with the generators and controllers of information, in order to make transparent the mechanisms by which power manipulates us."

In the opening paragraph of her review of a major retrospective exhibition of Wegman's (2006–2007), Roberta Smith, in *The New York Times*, writes that the exhibition "simultaneously confirms why Mr. Wegman hasn't always received the respect he deserves and why he deserves it. The short explanation—on both counts—is that he has been too innovatively funny for too long and on too many levels (visual, verbal, commercial, and arty) for people to see the serious artist behind the inveterate joker. He's also been funny in too many mediums for his achievement to be easily grasped." The exhibition is called "Funney/Strange," the title of one of his drawings from 1982. Smith's comments about Wegman being misunderstood echo the same comment, quoted earlier, that D. A. Robbins made in 1984 when referring to Wegman's early drawings and their difficult conceptual nature. At the end of her review, Smith states that Wegman's "profundity sneaks up on you." 13

Although all these critics offer interpretations of Wegman's work, they also acknowledge that they do not fully understand it and that it is not fully understandable. Jerry Saltz writes that "in each medium [photography, video, drawing, and painting] the meaning is never preciously located or emphatically stated. Everyday objects and situations are examined and turned topsy-turvy and inside out. A snake-pit of references, jokes, and off-handed intentions lie in wait ready to ambush the unsuspecting viewer. Somehow Wegman subverts the familiar without becoming pedantic or didactic. All of this combines to produce an often inexplicable but palpable aesthetic pleasure in the work." 14

What conclusions can be drawn from these interpretive writings about the work of William Wegman? First and probably most importantly, Wegman's seemingly transparent and definitely humorous work has sustained considerable interpretation by a number of critics. The themes in his work identified by these critics are those of antimastery of one ego over another and antimastery concerning aesthetic technique in the early videotapes and black- and-white photographs. The critics see his later color Polaroid work as being very masterful aesthetically. They interpret the work to be mysterious and to be about the mystery of the Other. They all interpret the work to be art commentary about art and photography and interpret the Polaroids as photographs about fashion and advertising photography. Thus even art that can be enjoyed on *The Tonight Show* can be interpreted seriously by professional critics.

Any artwork can both generate and tolerate multiple conjectures about its meaning. Wegman's work is a good example of this principle. Wegman's art readily sustains the interest of children seeing it on *Sesame Street* and of psychoanalytic critics giving it much deeper readings. Viewers of David Letterman's *Late Show* enjoy Wegman's videotapes and photographs, and so do readers of *Artforum*. The meanings

of Wegman's works are not merely discoverable, as in an archaeological sense; they are also generated by active, engaged, and articulate viewers.

None of these critics claim to fully understand Wegman's work. Their admissions lend support to another principle: No single interpretation will exhaust the meaning discoverable in a work of art.

All the critics enjoy the humor of Wegman's art. Saltz writes, "Having been a funny video artist and a funny photographer, William Wegman has now turned out to be a very funny painter, a fact that does not diminish the seriousness or the importance of his work one iota." Although they differ in their interpretations of the humor, they all see the work as being much more than funny, much more than one-line jokes. Jeremy Gilbert-Rolfe's statements about criticism in general are very apt here when applied to Wegman's work: "In criticism one is often being serious about things which are by definition not serious. Works, that is to say, which are seriously not serious and difficult by not being difficult." ¹⁵

There are several interpretations here by several critics, all of them mutually reinforcing, none of them contradictory. Different interpretations are beneficial because they expand our knowledge and appreciation of art.

Owens and Robbins base their interpretations of Wegman's work on psychoanalytic theory. From them, another principle emerges: Interpretations of art are often based on a larger worldview.

The following sections about the works of Jenny Holzer and Elizabeth Murray test and expand on the generalizations found in the interpretations of Wegman's work. Here are some immediate generalizations: Art is interpretable, even if it seems very straightforward. Art can be understood from several different points of view and with different levels of understanding, from naive to sophisticated. Interpretations further thinking about art. No single interpretation exhausts the meaning of a work of art. Several interpretations enrich the understanding of a single body of work. There are many ways to interpret art. Some of these ways involve theories from other areas, such as psychoanalytic theory.

INTERPRETING THE WORK OF JENNY HOLZER

Some of Holzer's works contain a phrase, others brief essays, usually of her own writing. She shows the texts in a variety of formats and media, including posters, etched bronze plaques, decals, billboards, LED (light-emitting diode) electronic signboards, T-shirts, baseball caps, rubber stamps, pencil logos, stickers pasted to phone booths and parking meters, embossed metal signs similar to "no parking" signs, the Sony JumboTRON video scoreboard in San Francisco's Candlestick Park during a baseball game, the Maiden Spectacolor Board in London's Picadilly Circus, the 800-square-foot Spectacolor Board in Times Square in New York, the marquee of Caesar's Palace in Las Vegas, baggage turnstiles at the Las Vegas airport, various marquees on city streets, the outside of train cars in Hamburg (in German), the

103

cable music video channel MTV, granite bench etchings, silver bands engraved with fragments of text wrapped around human bones, xenon lamp projections onto exterior walls of public buildings at night in the United States and internationally, large text paintings of government documents about the Iraq war, as well as sophisticated sculptural installations with electronic words delivered with precision and a range of speed and pattern in art galleries and museums (see Color Plate 12).

Nick Obourn in *Art in America* summarizes: "For over thirty years, Jenny Holzer's art has plumbed the relationship between didactic text and other visual conduits for language." The critic is referring to Holzer's traveling exhibition (2009–2010), "Jenny Holzer: Protect Protect," when it was on view at the Whitney. Educators at the Museum of Contemporary Art in Chicago introduced the same exhibition this way: "For more than thirty years, Jenny Holzer's work has paired text and installation to examine emotional and societal realities. Her choice of forms and media brings a sensate experience to the contradictory voices, opinions, and attitudes that shape everyday life."

Twenty years before this retrospective, two critics found too little to interpret in Holzer's work. Jeremy Gilbert-Rolfe dismissed her art as "arid and trivial" and went on to say, "The pieties of Jenny Holzer, expensively produced slogans offered as works of art, while directly comparable to the fatuous pieties of Mao Tse-Tung or the Ayatollah Khomeni, completely fail to generate anything like a new thought. What they do instead is exactly what the slogans of the Maoists or of Islamic fundamentalists do, which is to pretend that difficult ideas can be reduced to simple formulations." Robert Hughes holds a similar position regarding her art. He calls it "limpidly pedestrian" work that makes no demands on the viewer, and in *Time* magazine he writes, "Holzer is the modern version—rewired, subsidized, eagerly collected, but still recognizable—of those American maidens who, a century ago, passed their hours stitching improving texts as samplers: THOU GOD SEEST ME, ABC, XYZ. The main differences are that instead of using biblical texts, Holzer writes her own, and that instead of using needle and thread, she inscribes them in LEDs and marble." 19

Peter Plagens, Hughes's counterpart at *Newsweek*, holds Holzer in much higher esteem than does Hughes. Plagens reviewed the work she showed in the 44th Venice Biennale, which he refers to as the oldest and most prestigious international art exposition. He explains that the United States chose its own representative, that a solo turn in Venice is practically an Oscar, and further that "her spectacular display of deadpan *Truisms*, blazing across rows of LED signs, and her Roman-letter *Laments*, carved into marble floors and benches, was awarded the grand prize for the best national pavilion." He finds Holzer's work to be full of poignancy because of its mix of personal confession and huge spectacle. He also thinks that "it's simply a visual knockout. The effect is like looking out from the center of the carousel on Saturday night and still being able to read all the neon signs."

Although at this point the discussion is a bit ahead of itself-dealing as much with the topic of judgment as with interpretation—some important and relevant points can be made immediately based on these conflicting examples. First, there was critical consensus regarding the work of William Wegman, but there is no consensus concerning the work of Holzer. Thus it is clear that critics sometimes disagree. Interpretations of Wegman's work varied, with some critics seeing more meaning in the work than others. The critics also used different interpretive strategies, but their conclusions were in general agreement. With interpretations of Holzer's work, however, there are clear disagreements, both about the value of the work and what it means. Gilbert-Rolfe and Hughes interpret the work to mean nothing; they see empty pieties that cause little reflective thought and have no merit. Precisely because Gilbert-Rolfe and Hughes interpret the work to be not worth interpreting, they judgmentally dismiss it. Michael Brenson calls it "thin." 21 Thus the ability of artworks to generate interesting interpretations is a criterion of judgment for some critics. In these examples interpretations and judgments are intertwined. Because there are conflicting interpretations, interesting and difficult questions about interpretive correctness arise. Namely, are all interpretations, even those by professional critics, correct even when they are contradictory? Are some interpretations better than others? How should one decide among competing interpretations? How should interpretations themselves be judged? These questions are addressed in the final section of this chapter.

In a human interest story about the artist, Candace Bridgewater writes that Holzer "combines harsh political statements, environmental and social concerns, intense personal feelings, and poignant observations with elements of poetry. Her works instruct, baffle, electrify, and sometimes offend her readers." Grace Glueck writes that Holzer "hatches messages that range from deadpanned aphorisms to dark meditations about the human condition, embosses them on plaques, engraves them on marble and granite benches or sarcophagus lids and—with skilled technological choreography—sets them prancing in dazzles of colored light." She identifies Holzer's issues as "nuclear holocaust, AIDS, the environment, feminism, the poor, the power of big business, and big government."

Jenny Holzer was born in Gallipolis, Ohio, grew up in Lancaster, Ohio, and graduated from Ohio University with a BFA in art in 1972. At the Rhode Island School of Art and Design she made abstract paintings influenced by those of Mark Rothko and Morris Louis. She incorporated some writing in her paintings. In 1977, as a member of the Whitney Museum's Independent Study Program, she read Marx, psychology, social and cultural theory, criticism, and feminism. Holzer's work became exclusively verbal when she made her *Truisms*, or "mock-clichés," as she calls them. "I started the work as a parody, the Great Ideas of the Western World in a nutshell." Several of the *Truisms* follow, in alphabetical order, as Holzer presents them.²⁵

IT'S A GIFT TO THE WORLD NOT TO HAVE BABIES

IT'S BETTER TO BE A GOOD PERSON THAN A FAMOUS PERSON

IT'S BETTER TO BE LONELY THAN TO BE WITH INFERIOR PEOPLE

IT'S BETTER TO BE NAIVE THAN JADED

IT'S BETTER TO STUDY THE LIVING FACT THAN TO ANALYZE HISTORY

IT'S CRITICAL TO HAVE AN ACTIVE FANTASY LIFE

IT'S GOOD TO GIVE EXTRA MONEY TO CHARITY

IT'S IMPORTANT TO STAY CLEAN ON ALL LEVELS

IT'S IMPOSSIBLE TO RECONCILE YOUR HEART AND HEAD

IT'S JUST AN ACCIDENT YOUR PARENTS ARE YOUR PARENTS

IT'S NOT GOOD TO HOLD TOO MANY ABSOLUTES

IT'S NOT GOOD TO OPERATE ON CREDIT

IT'S VITAL TO LIVE IN HARMONY WITH NATURE

JUST BELIEVING SOMETHING CAN MAKE IT HAPPEN

KEEP SOMETHING IN RESERVE FOR EMERGENCIES

KILLING IS UNAVOIDABLE BUT IS NOTHING TO BE PROUD OF

KNOWING YOURSELF LETS YOU UNDERSTAND OTHERS

KNOWLEDGE SHOULD BE ADVANCED AT ALL COSTS

LABOR IS A LIFE-DESTROYING ACTIVITY

LACK OF CHARISMA CAN BE FATAL

LEARN THINGS FROM THE GROUND UP

LEARN TO TRUST YOUR OWN EYES

LEISURE TIME IS A GIGANTIC SMOKE SCREEN

LETTING GO IS THE HARDEST THING TO DO

LISTEN WHEN YOUR BODY TALKS

LOOKING BACK IS THE FIRST SIGN OF AGING AND DECAY

LOVING ANIMALS IS A SUBSTITUTE ACTIVITY

LOW EXPECTATIONS ARE GOOD PROTECTION

MANUAL LABOR CAN BE REFRESHING AND WHOLESOME

MEN ARE NOT MONOGAMOUS BY NATURE

MODERATION KILLS THE SPIRIT

MONEY CREATES TASTE

MONOMANIA IS A PREREQUISITE OF SUCCESS

MORALS ARE FOR LITTLE PEOPLE

MOST PEOPLE ARE NOT FIT TO RULE THEMSELVES

MOSTLY YOU SHOULD MIND YOUR OWN BUSINESS

MOTHERS SHOULDN'T MAKE TOO MANY SACRIFICES

In an exhibition catalog, Diane Waldman informs us that Holzer set the *Truisms* first in Futura Bold Italic and then in Times Roman Bold type.²⁶ When Holzer first made the *Truisms*, she put forty to sixty on a page, alphabetically, with black letters on white paper. The *Truisms* are statements fashioned by Holzer but presented

Ann Goldstein describes the *Truisms* this way: "Comprised of alphabetically ordered one-line statements, these logical, often disquieting, proclamations are presented in uppercase italics that project the authority of reason. The messages absorb and emulate a variety of viewpoints, both masculine and feminine, across the political spectrum." Glueck typifies the *Truisms* as "pithy to platitudinous" and notes that they variously embody roles of "the feminist militant, the callous Yuppie, the sage buckeye, and the psychobabbler." About the *Truisms*, Plagens writes that "her straight-faced declarations range from naive anarchism ('Any surplus is immoral') to the visceral discoveries of motherhood ('I am indifferent to myself but not to my child')."

Hal Foster has offered a more complete interpretation of the *Truisms* than the other critics. In a feature article that appeared in *Art in America* in 1982, early in Holzer's career, Foster too sees the artist's work as "the babble of social discourse," but he takes his interpretation of her work considerably further.²⁸ In the article, he compares the work of Holzer with that of Barbara Kruger, an artist using similar strategies but with language and photographs. Foster bases his interpretation of Kruger's and Holzer's work on the semiotic theories of Roland Barthes, the late French scholar who devoted his career to the study of sign systems and how they function in society. Barthes is particularly impressed with the power of language. For Barthes, and for Foster's interpretation, language is legislation. To utter a discourse is not to communicate; it is to subjugate. Language is quite simply controlling.

Foster notes that the *Truisms* seem to offer information, but they are mostly opinions, beliefs, and biases—conflicted and cogent by turns, they intend everything and nothing, and they result in "verbal anarchy in the streets." He makes the further points that Holzer's images are as likely to derive from the media as from art history and that their context is as likely to be the street wall as an exhibition space. According to Foster, Holzer is a manipulator of signs more than a maker of art objects, and her pieces turn the viewers into active readers of messages more than contemplators of the aesthetic. He says that few of us are able to accept the status of art as a social sign entangled with other such signs and that this entangling is the very operation of Holzer's art. He thinks of her antecedents as conceptual artists Joseph Kosuth, Lawrence Weiner, Douglas Huebler, and John Baldessari and site-specific artists Daniel Buren, Michael Asher, and Dan Graham.

Very importantly, he sees her work with language to be critical rather than accepting. She treats languages simultaneously "as targets and as weapons." Foster relates that others also see her work as a weapon and that an installation of *Truisms* at a

Marine Midland Bank in Lower Manhattan was canceled after one week because bank officials disagreed with the credit truism, "It's not good to operate on credit." Foster argues that in her work we see not only how language subjects us but also how we may disarm it. He understands her *Truisms* to place in contradiction ideological structures that are usually kept apart; they present truths in conflict and imply that under each truth lies a contradiction. In the *Truisms*, discourses of all sorts collide. Proverbs clash against political slogans. Holzer places her reader in the midst of open ideological warfare, but oddly, Foster argues, the result is a feeling of release rather than entrapment. That is, he argues, she exposes coercive languages that are usually hidden, and when they are exposed, they look ridiculous. Thus the *Truisms* rob language of its power to compel and offer their viewers freedom rather than coercion.

Whereas the other critics consider Holzer's *Truisms* a morass of conflicting statements, Foster does not. If the *Truisms* were only to show that all truths are arbitrary, subjective, and equal even when they contradict each other, we would be rather helpless and our world rather hopeless. But Foster interprets the *Truisms* more optimistically. He sees them as a way out of the abyss that language seems to create because the *Truisms* express a larger, simple truth—namely that "truth is created through contradiction. Only through contradiction can one construct a self that is not entirely subjected." To Foster, the *Truisms* suggest dialectical reasoning—truth, countertruth, new truth—and thus, for him, the *Truisms* do not merely state a problem but also provide a solution.

Holzer followed her *Truisms* with a series of *Inflammatory Essays* written at the same time as the *Truisms*, between 1979 and 1982. The essays are more assaultive than the *Truisms*. Foster says that they heat up and expand the *Truisms*:

DON'T TALK DOWN TO ME. DON'T BE POLITE TO ME, DON'T TRY TO MAKE ME FEEL NICE. DON'T RELAX. I'LL CUT THE SMILE OFF YOUR FACE. YOU THINK I DON'T KNOW WHAT'S GOING ON. YOU THINK I'M AFRAID TO REACT. THE JOKE'S ON YOU. I'M BIDING MY TIME, LOOKING FOR THE SPOT. YOU THINK NO ONE CAN REACH YOU, NO ONE CAN HAVE WHAT YOU HAVE. I'VE BEEN PLANNING WHILE YOU'RE PLAYING. I'VE BEEN SAVING WHILE YOU'RE SPENDING. THE GAME IS ALMOST OVER SO IT'S TIME YOU ACKNOWLEDGE ME. DO YOU WANT TO FALL NOT EVER KNOWING WHO TOOK YOU?

Goldstein refers to these essays as "a series of incendiary paragraphs—proclamations of righteousness, the tactics of terrorism, power of change, leadership, revolution, hatred, fear, freedom." She informs us that Holzer produced these paragraphs as

posters or texts in publications. In them, she addressed recognizable, common issues, and "their authoritative, aggressive, violent tone and poetry unnerve the viewer/ reader." Waldman tells us that the *Inflammatory Essays* are set in Times Roman Bold. Each essay is one hundred words long, divided into twenty lines in the same square size. They exhort the viewer to action. Foster interprets the essays to be more concerned with the force of language than with its truth. He continues with his semiotic reading of them. For him, they show that some voices insinuate; others demand. The essays show how language, truth, force, and power can pervert one another.

In his article, Foster interprets one more of Holzer's early pieces, *The Living Series*, for which the artist made embossed metal signs (like "no parking" signs) and cast bronze plaques. One says this: "The mouth is interesting because it is one of those places where the dry outside moves toward the slippery inside." Foster claims that with these pieces Holzer distorts the officialese that is really our social discourse of efficacy and etiquette. He enjoys how Holzer beguiles officialdom by using the plaque, which is the form of administrative truth: It commemorates a place or celebrates a man and thereby exalts a piece of property as the very presence of history. He interprets Holzer's signs and plaques as foiling such markings. Rather than present a public place, they may pose a subversive private one, or rather than announce "George Washington Slept Here," they may offer this: "It takes a while before you can step over inert bodies and go ahead with what you were wanting to do."

The artist first used *Truisms* on LED signs and then created *The Survival Series* between 1983 and 1985 for the signs. Waldman thinks of the signs as "eminently suited to the device of repetition which Holzer often uses with her swift, accessible consumerist language to persuade the viewer effectively." Glueck quotes Holzer as saying that with *The Survival Series* she "switched from being everyone to being myself." This series was not limited to electronic signs. She pasted the following silver offset lithographed sticker, $2\frac{1}{2}$ " \times 3", made in 1983, on a garbage can lid in New York City: "When there is no safe place to sleep you're tired from walking all day and exhausted from the night because it's twice as dangerous then."

In 1986 Holzer introduced *Under a Rock*. Of these pieces, Waldman writes, "In *Under a Rock* a commentator is watching horrific events and describing them as they happen, still in a relatively objective tone." This is one of them: "Blood goes in the tube because you want to fuck. Pumping does not murder but feels like it. You lose your worrying mind. You want to die and kill and wake like silk to do it again." Holzer etched texts such as this one into stone benches and sarcophagi and also put them on electronic signboards. Waldman credits the juxtaposition of stone and electronics with creating "a somber mood of contemplation with an intense and jarring physical presence." Waldman thinks that with these pieces Holzer is continuing her advocacy of social and political issues but that her expression is more individual and pensive. Another critic, Holland Cotter, offered this interpretation of *Under a Rock*: "Written in a pungent, often poeticized and syntactically episodic prose (that

occasionally simulates the idiomatic peculiarities of bad translation), they speak in an accusatory direct address that is sometimes obscene, sometimes high-flown, always angry."²⁹ Cotter expresses concern that the text just quoted might be read as an excitement to sexual violence rather than as a critique of it.

Holzer followed *Under a Rock* with *Laments*, which she first showed in 1987. Of these, Waldman writes, "The Laments series expresses Holzer's social and political concerns in more explicit terms than those of her earlier works; here her message is more complex, and she speaks now of broader, more universal themes. The language of the individual signs and sarcophagi retains its formidable clarity and directness but achieves a texture and nuance, an elegiac quality that is new to the work." This is one of the *Laments*:

I WANT TO LIVE IN A SILVER WRAPPER. I WILL SEE WHOOPING ROCKS FLY. I WILL ICE ON MY BLACK SIDE AND STEAM ON MY OTHER WHEN I FLOAT BY SUNS. I WANT TO LICK FOOD FROM THE CEILING. I AM AFRAID TO STAY ON THE EARTH. **FATHER HAS CARRIED ME** THIS FAR ONLY TO HAVE ME BURN AT THE EDGE OF SPACE. **FACTS STAY IN YOUR MIND** UNTIL THEY RUIN IT. THE TRUTH IS PEOPLE ARE PUSHED AROUND BY TWO MEN WHO MOVE ALL THE **BODIES ON EARTH INTO** PATTERNS THAT PLEASE THEM. THE PATTERNS SPELL OH NO NO NO **BUT IT DOES NO GOOD** TO WRITE SYMBOLS. YOU HAVE TO DO THE RIGHT ACTS WITH YOUR **BODY. I SEE SPACE AND IT** LOOKS LIKE NOTHING AND I WANT IT AROUND ME.

Because Holzer was chosen as the American representative to the prestigious Venice Biennale, several critics examine in what way her work is "American." Brenson sees her as "An Ohio-born artist rising from the mean streets of New York." He also interprets her art to be "democratic work" in that it is "a repository for the voices of ordinary men and women around the country. Many opinions, feelings, and ideas are invited into her work, and they are allowed to settle there without fear of exclusion or judgment. Her work fits America's view of itself as a melting pot in which everything and everyone eventually gains a place." He also states that she is "decidedly unpretentious." Bridgewater refers to Holzer's "terse Midwesternisms," and Glueck sees her as American in her "ease with technology, her nonelitist approach, her impatience with tradition, and her wish to reach multitudes." Waldman states that Holzer, like Duchamp and Warhol, borrows freely from mass culture, addresses originality and the value of the artist's hand in making art, contrasting the impersonal common objects, billboards and signs, with a message that is personal and sincere.

Holzer's exhibition "Protect Protect" (2009–2010) contains three major bodies of work: "Redaction Paintings," "Lustmord," and "Electronic Signs." The "Redaction Paintings" are text and official graphic items that include autopsy reports of detainees in the Middle East, government correspondence concerning interrogation of detainees, finger- and handprints of soldiers accused of war crimes, and maps from a PowerPoint presentation by the military's central command to the White House. Information has been previously blackened by government censors during the declassification process. Most of the paintings are monochromatic, oil on linen, often black on white, and unadorned; they look like enlarged photocopies, which is their source. Joan Simon reminds us, "These paintings bear the particulars of documented if intentionally secret abuses of governmental power that Holzer had in mind very early on and which she flagged in more generalized phrasing as daily mottos on a host of items. . . . ABUSE OF POWER COMES AS NO SURPRISE." 30

Lustmord translated from German means rape-slaying or sex-murder. Lustmord is also the title of a Holzer essay about the atrocities of war in former Yugoslavia, when women and girls were targeted. Holzer wrote some of the texts on human bodies and photographed the words. She also presented fragments of the text on silver bands wrapped around human bones and set on a table. The texts are written from three points of view: perpetrator, victim, and witness.

"Electronic Signs" include *Truisms* and *Inflammatory Essays* and more recent texts displayed as sculptural electronic signs, some of which repel and others which

111

soothe depending on her choice of colors and pacing of the scrolling texts. Nick Obourn interprets Holzer's signs as "co-opting technology to disseminate her ideas while warning against its inexorable march." He concludes, "Her work enchants as it provokes, lulling us with lights and action even as we are unsettled by the words they illuminate." ³¹

So what can be immediately concluded from these interpretive writings about the work of Jenny Holzer? This section began with quotes from critics who dismissed the work, claiming that it did not have enough substance to merit interpretation. Other critics, most notably Foster and Waldman, however, found much to interpret in the work. Thus there is the immediate problem of conflicting, indeed contradicting, interpretations of the same body of work by credible, professional critics. Based on the wealth of thought that Foster and the other critics derived from Holzer's work, it seems that Gilbert-Rolfe and Hughes were premature in their dismissive judgments. Unfortunately readers are unable to learn much about their negative views of Holzer because these critics refuse to treat her work seriously and are content to dismiss it. If they took the time to develop more elaborate arguments for why the work is empty, they would give their readers more to think about, and ultimately readers might even agree with their positions.

Critics can and do disagree with one another, even when interpreting the same body of work. They might agree with one another's descriptions of the work but vary greatly in their interpretations and judgments of it. This leaves the reader of criticism with the problem of negotiating these differences. Interpretations are not so much right or wrong as they are enlightening, insightful, useful, or—contrarily—unenlightening, misguided, incomprehensible, or perhaps unaccountable to the facts. Critics who without elaboration dismiss Holzer's work do not add to the knowledge of and insight into her work, and in this sense, other critics' interpretations are better. When critics dismiss work without discussing it or their reasons for dismissing it, they may well have ideological or political reasons—they may be saying this kind of work is not worth my (or your) time. Such curtly dismissive criticism, however, is simply unenlightening.

Many of the critics included biographical information, stressing Holzer's midwestern influences; many also examined the way in which her work is or isn't American. Art does not arise in a vacuum. It is influenced to a greater or lesser degree by the artist's cultural milieu. Whether to include such information depends on its relevance: If the information extends and deepens an interpretation, it is beneficial and should be included.

The critics are also attentive to how Holzer's work has changed, and they document the changes and attempt to make sense of them. They are very aware of and eager to relate to their readers the specific history of any work. This is another form of contextual, historical information that critics consider important in deciphering meaning in art.

INTERPRETING THE PAINTINGS OF ELIZABETH MURRAY

In an exhibition catalog accompanying one of the last and most joyous exhibitions of Elizabeth Murray paintings while she was alive (see Color Plate 13), Francine Prose writes, "Looking at Elizabeth Murray's work provides so much interest and pleasure that it helps us forget the increasingly dangerous circles in which we seem to be spinning. Jittering, exploding, jumping off the walls, her paintings still find the time and space to extend a hand and help us over the most important boundary that art can lead us across—that is, the border between being here, confined in our bodies and minds, and being set free from all of that: being somewhere else completely." 32

Roberta Smith, writing in *The New York Times* in 2007, refers to Elizabeth Murray as "a New York painter who reshaped Modernist abstraction into a high-spirited, cartoon-based language of form whose subjects included domestic life, relationships, and the nature of painting itself." Smith continues, "Her semi-abstract shapes resolved into bouncing coffee cups, flying tables, or Gumby-like silhouettes with attenuated arms and legs that careened across surfaces like thin, unfurling ribbons." The overall effect, according to Smith, "was of some inchoate yet invigorating crises of the heart or hearth, as intimated by titles like 'More Than You Know,' 'Quake Shoe,' and 'What Is Love?'" Smith wrote these reflections in 2007, the year Murray died of lung cancer.³³

In the early 1990s Deborah Solomon wrote a feature article about Elizabeth Murray for *The New York Times Magazine*.³⁴ In it, the critic gives a more complete overview of Murray's career. Her article provides a basis for establishing interpretive themes and strategies and a basis of comparison to other critics' writings. In preparing for her feature, Solomon may have read some or all of the other critics cited here. She bases her story on studio visits with the artist and provides the additional point of view of the artist.

Solomon relates that Murray lived in a loft in lower Manhattan and that her studio was long, bright, and in the front of her living space. "Brushes in all sizes and crumpled tubes of oil paint are heaped on wooden carts, and the air is thick with their greasy scent. A miniature easel, complete with a picture by one of the artist's children, stands in a corner." Solomon may mention the snapshot of the artist's child early in her article because she eventually interprets Murray's paintings to be, in significant part, about home life. Throughout the article she provides other biographical information about the artist. Murray was "modest and unassuming," was soft spoken, wore no makeup, and had frizzy gray hair. She was born in Chicago in 1940 into an Irish-Catholic family. She earned a BA from the Art Institute of Chicago and attended graduate school at Mills College in Oakland, California. Solomon

Solomon also tells us early in her article that the artist had postcard reproductions of favorite paintings near her table, including several of Cézanne's. The critic eventually introduces art historical references as a second important interpretive theme of Murray's paintings.

Solomon writes a lively descriptive and interpretive summary of the artist's work: "A Murray painting is easy to recognize. More often than not, it consists of a big canvas loaded up with forms and colors that bounce off one another in an anarchic, ebullient way." Although the paintings seem abstract, "they are full of references to human figures, rooms, and conversations. Narratives quickly present themselves. The pictures can suggest squabbling children, for instance, or a woman sitting alone at a table, feeling edgy. But usually their meanings aren't so literal and their protagonists aren't people but personable shapes and objects: Cracked cups, chubby paintbrushes, and overturned tables (with legs that can vehemently kick) are among the artist's favorite motifs" and "vibrant, eccentrically shaped canvases in which giant coffee cups and flying tables put a homey spin on vanguard art." Solomon also writes that "one of the hallmarks of a Murray painting is that it looks clunky and even awkward, yet is layered with subtle psychological meanings." She interprets Murray's essential theme to be interiors through which she gets at "life's frayed, dangling ends."

Solomon explains Murray's process of creating her elaborately three-dimensional canvases. The artist made a pencil sketch and then fashioned a clay model of the shaped canvas she wanted, and assistants built the stretcher out of plywood and stretched the canvas over it. Murray said that she painted not knowing what would go onto the shapes of the canvas. The critic quotes the artist saying, "I want my paintings to be like wild things that just burst out of the zoo." It usually took about two months for Murray to complete a painting, and she usually went through a period of hating the painting before she resolved it and was then excited about it.

In addition to the mention of Cézanne reproductions in the artist's studio, the critic writes that Murray's "work recapitulates great moments in 20th-century art. Cubism's splintered planes, Fauvism's jazzy colors, Surrealism's droopy biomorphic shapes, the heroic scale of Abstract Expressionism—it's all there in a Murray painting." The critic also posits what is not there in the painting: "Unlike most other art stars of the 1980s, Murray isn't interested in art that cleverly comments on its own limitations. Her work isn't ironic. It doesn't turn art history into a joke. It's not about gender politics. And it doesn't try to demonstrate that painting is being swallowed up by the media. Rather, it uses an admittedly postmodern apparatus—the shaped and sculpted canvas—to posit an old-fashioned (and even corny) belief in the pleasure of paint." Solomon argues further that Murray does not "appropriate" and mock the past; rather, she shows how the past can still speak to us today.

Solomon relies heavily on art theory to develop her interpretation of Murray's work. The critic understands the history of twentieth-century theory, mainly modernism and postmodernism, and explains how Murray uniquely negotiates between the two. Her reference to the "high and low crowd" refers to those debating the merits or lack of merit in making a distinction between fine art and popular art. Such discussion was raised by an exhibition organized by the Museum of Modern Art, "High and Low: Modern Art and Popular Culture." Generally, modernists maintain a strong dichotomy between fine art and kitsch; postmodernists find such a distinction elitist and reject it. Regardless, theory and interpretation are clearly linked in general, and here theory is specifically related to interpretations of Murray's paintings. The role of theory in criticism and in modernism and postmodernism is explored more fully in Chapter 2.

Other critics pick up, reinforce, and expand on Solomon's interpretive arguments. None refute or contradict those arguments. All the critics writing about Murray seem challenged to find inventive language with which to describe and encapsulate the spirit of her work. The following summary statements from different critics are examples of good, lively, interpretive writing about art.

Robert Hughes writes that "for her, art is about dreaming and free association, the goofy insecurity of objects that sidle through the looking glass of a tactile sensibility and peek out, transformed, on the other side."35 Jude Schwendenwien writes in the New Art Examiner about Murray's "cakey paint" and states that "the topsyturvy arrangement of biomorphic-shaped canvases suggests jigsaw puzzle pieces waiting to be reunited."36 Robert Storr writes about Murray's "saturated hues, jutting and twisting elements of relief" and says that "a general imagistic tumult of swollen shapes, household objects, and writhing limbs typifies the direct, at times almost overwhelming address of her work."37 He also writes about the dark palette she employs and her anxious touch, and the increasingly complex skeleton and tense musculature of her shaped canvases. He continues, "At once gut-turning and thrilling, her images vibrate optically with the stresses she has learned to place upon her canvases. . . . Dimpling and splitting at the seams like overinflated Mae Wests, jackknifing across the wall like collapsing lawn chairs, and separating into thick strands like pizza dough." Storr also writes of arcing bars and bulbous shapes, a washing-machine tumble of elements, her rowdy and cartoony vocabulary, and a picture's Silly Putty surface; he concludes that Murray is unafraid of making a mess and that when using paint she takes "fervent interest in all the elemental states, from liquid to solid, that this miraculous muck can assume."

115

Ken Johnson, writing in *Arts Magazine* about a 1987 show of Murray's paintings, offers this summary paragraph: "The new paintings look like huge slabs of clay. The waxy rich painterly surfaces suggest not the delicate thinness of paint on canvas, but, rather, the visible part of a fleshy solidity. You feel as though you could dig your fingers inches deep into the paint and pull out heavy handfuls of it."³⁸ He also writes of two kinds of shapes, amorphous and rectangular, which are "stretched like Silly Putty by a pair of giant hands . . . the normally static rectangle seems to be buffeted by a languid breeze, drooping like a wet sheet on a clothesline, corners flapping this way and that." He terms the paintings "hyperactive" and compares them to a clinically manic person acting out uncontrollable impulses. Whether the paintings are angry, gloomy, or gleeful, Murray shows her excitement with the process without bringing the paintings to "finicky completion."

In addition to these general interpretive remarks, Johnson offers some specific interpretations of a few individual paintings. These are quoted here because they are clear examples of sexual interpretations. Johnson interprets a 1987 painting to be "dream symbolism of sexual intercourse":

Consider *My Manhattan*, the central image of which represents an encounter between a monumental teacup full of orange liquid and a hugely swollen, weirdly flexible spoon. The cup, seen from overhead, is precisely outlined but cubistically skewed, its structure jauntily raked, its mouth a vast circle filled with the hot drink. The spoon's structure, by contrast, is at once turgid and unnaturally fluid. Along the picture's top edge looms its bulbous handle which narrows to a serpentine tube winding in a clockwise spiral around the picture's right edge to enter the cup from below. It ends, not as the broad concavity of a normal spoon, but rather, as a sort of knob with a canvas-penetrating hole in it. From the point where the spoon splashes the liquid, giant orange droplets shoot out of the cup.

In a following paragraph, he offers this further evidence for his interpretation: "the rippling contour of the picture's edge, the three-dimensional table limbs attached onto each side like embracing arms and legs, the splay-legged table collapsing under the weight of the cup, and the pervasive, mistily harmonious blue ambience around the hot center. It all adds up to an allegory of perceptual dissolution in sexual ecstasy." In *Chaotic Lip* (1987) he sees a reference to menstruation; in *Pompeii* (1987) he says, "a phallically overinflated spoon volcanically ejaculates a massive, seminal drop." Nancy Grimes, writing in *Art News*, is also exuberant in her critical expression about Murray's paintings and also sees some sexual implications in the work. She writes that Murray has allowed painting "to get wet again, to roll around in pigment, humor, narrative, and sex." "39"

Like Solomon, other critics also give interpretive emphasis to the importance of Murray's deliberate inclusion of the domestic into her semi-abstract paintings. Janet Kutner writes in *Artnews*, "Murray continues to base her imagery on ordinary still-life, household, and studio items such as cups and saucers, tables and chairs,

Elizabeth Murray, My Manhattan, 1987. Oil on canvas, 83 $1/4" \times 107" \times 16"$.

© The Murray-Holman Family Trust, Courtesy of Pace Gallery.

paintbrushes and palettes; on punctuation marks such as commas and exclamation points; and on variations of cartoon characters including Tweety Bird, Popeye, and Gumby."⁴⁰ She also observes that Murray's "signature shapes, whether household objects or punctuation marks, refuse to give up their identity no matter how greatly she distorts them."

Gregory Galligan, in *Arts Magazine*, is very explicit in his interpretation of the "domestic presence" in Murray's paintings and gives it his primary interpretive attention in his review of her work.⁴¹ He specifically mentions Murray's recurring use of the table, "which rears up like a horse on its two hind legs. This is a ghastly, near ghostly presence, which Murray would return to time and again over the following years." He asks of this "demonic presence," with its four legs twisting grotesquely toward the spectator, if they are "striving to stamp upon one's limbs, or to wrap around one's torso in a suffocating squeeze?" He asks of another comic and cartoonlike reference, "What could be the meaning of an outburst of crimson

Color Plate 1 Paul Pfeiffer, Four Horsemen of the Apocalypse (28), 2007. Digital C-print on fugiflex, $48'' \times 60''$. Courtesy of Paul Pfeiffer.

Color Plate 2
Wangechi Mutu, *In Killing Fields Sweet Butterfly Ascend,* 2003. Ink, collage, contact paper on mylar.
Photo by Gene Ogami. Courtesy of the artist and Susanne Vielmetter Los Angeles Projects.

Color Plate 3

Mark Ryden, *Allegory of the Four Elements*, 2006.

© Mark Ryden. Courtesy of Paul Kasmin Gallery and Porterhouse Fine Art Editions, Inc.

Color Plate 4

David Anthony Garcia, *Requiem - In Memory of Anthony Martinez*, 2004.

© David Anthony Garcia. Photo by Craig Smith, Courtesy Arizona State University Hispanic Research Center.

Color Plate 5
Sue Coe, *The Jangaweed*, 2008.
© 2008 Sue Coe. Courtesy Galerie St. Etienne, New York.

Color Plate 6
Leon Golub, *Bite Your Tongue*, 2001.
Art © Estate of Leon Golub/Licensed by VAGA, New York, NY.

Color Plate 7

Deborah Butterfield, *Untitled (red)*, 2008.

Art © Deborah Butterfield/Licensed by VAGA, New York, NY.

Color Plate 8

Dale Chihuly, *Black Lime Soft Cylinder with Golden Lip Wrap*, 2006. Glass, 18" x 23" x 18".

© Dale Chihuly. Photo by Teresa N. Rishel.

Color Plate 9

Bill Viola, *Emergence*, 2002. Color High-Definition video rear projection on screen mounted on wall in dark room. Projected image size: 200 x 200 cm; room dimensions vairable.

Commissioned by the J. Paul Getty Museum. Photo by Kira Perov. Courtesy of Bill Viola.

Color Plate 10 Ann Hamilton, *corpus*, 2003.

MASS MoCA, December 13, 2003 – October 17, 2004. North Adams, Massachusetts. Photo by Thibault Jeanson. Courtesy Ann Hamilton Studio.

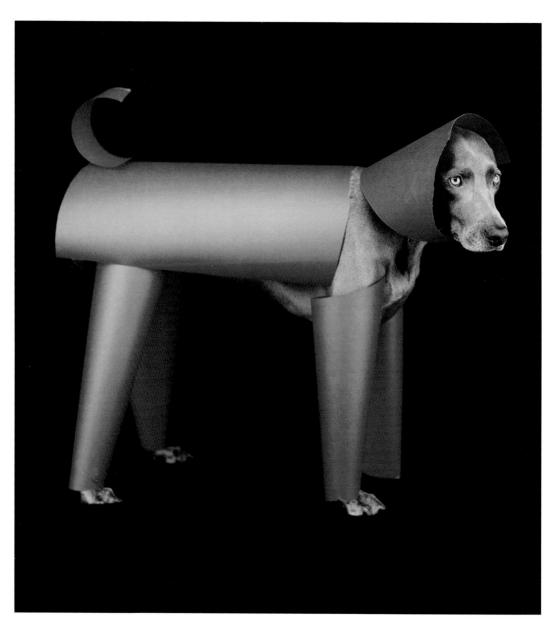

Color Plate 11 William Wegman, *Red Toy,* 2006. © William Wegman.

Color Plate 12
Jenny Holzer, *Purple*, 2009.
© 2010 Jenny Holzer, member Artists Rights Society (ARS), New York.

Color Plate 13
Elizabeth Murray, *Bop*, 2002–2003. Oil on canvas, 9' x 10" x 10 1/2".

© The Murray-Holman Family Trust. Photo by Ellen Page Wilson. Courtesy of Pace Gallery.

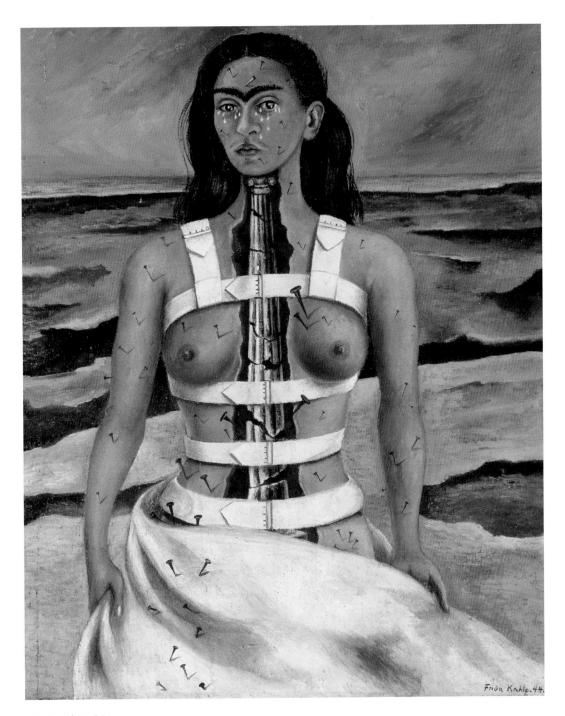

Color Plate 14 Frida Kahlo, *The Broken Column,* 1944.

© 2010 Banco de México Diego Rivera Frida Kahlo Mueums Trust, Mexico, D.F/Artists Rights Society (ARS), New York. Schalkwijk / Art Resource, NY.

Color Plate 15
Romare Bearden, *Patchwork Quilt*, 1970. Cut-and-pasted cloth and paper with synthetic paint on composition board, 35 3/4" x 47 7/8".

Art © Romare Bearden Foundation/Licensed by VAGA, New York, NY. Blanchette Rockefeller Fund. (573.1970). The Museum of Modern Art, New York, NY. Digital Image © The Museum of Modern Art/Licensed by SCALA/Art Resource, NY.

Color Plate 16
Agnes Martin, *Untitled #18*, 1995. Acrylic and graphite on canvas, 60" x 60" (152.4 x 152.4 cm).
© 2010 Agnes Martin/Artists Rights Society (ARS), New York. Photo by Ellen Page Wilson. Courtesy of Pace Gallery.

Color Plate 17

Janet Fish, Nan's Kitchen, 2004. Oil on canvas, 60" x 60".

Art © Janet Fish/Licensed by VAGA, New York, NY. Private Collection, Photo Courtesy DC Moore Gallery, NY.

tears, which are discharged from a metallic-colored tube the dumb shape of a car muffler?"

Galligan interprets Murray's paintings to provide "equivocal truths about daily life; in one sense such truths are mundane and harmless, and in another they are extraordinary and unpredictably aggressive." For him, her sculptural images of stout coffee cups, plump paintbrushes, floating kitchen chairs, and twisted dining tables with legs like rubber are symbols both familiar and fantastic. "They are symbols of everyday domestic routine and yet near-sacred idols of some secret, spiritual meditation. Like an autistic child who seems to commune with the most mundane kitchen utensils, Murray celebrates the domestic world with a spasmic, attractive sense of humor."

Interpretations of her work are not limited to discussions of the domestic and psychological implications of the ordinary; they also discuss Murray's bold experimentation with form based on the artist's solid knowledge of art history. Grimes, for instance, praises Murray's ability "to fuse monumental scale and manic formal invention with a chatty intimacy and rigorous attention to tradition." Similarly, Johnson writes that Murray's paintings "are a collision between the worlds of Bosch and Disney," and, most importantly, he interpretively asserts that "a formalist reading will get only half of what Murray's art is about." That is, Johnson is arguing, if one attended only to all the formalist inventions that Murray has achieved, one would have half an understanding of her work.

Also like Solomon, other critics find Murray's knowledge of and references to art history important. In her article, Solomon noted cubism, fauvism, surrealism, and abstract expressionism. In his review, Johnson interprets Murray's paintings with the help of references to Picasso, Kandinsky, Miró, Gorky, de Kooning, Kline, antiminimalism, Jennifer Bartlett, Susan Rothenberg, Nicholas Africano, Joel Shapiro, and the schools of New Image and Bad Painting. Storr writes that "with Matisse, Murray shares an exquisite sensitivity to the erotics of color; with Davis, a robust instinct for the sheer materiality of paint. For the former, pleasure was totally available to the eye; for the latter it was all pulse and pressure." Galligan interprets Murray's work to be referring to the past while it simultaneously points out directions for future developments in art. He states that "with a keen sense of art history, Murray integrates the past with pure, unbridled innovation." He also credits her with "a synthesis of a cartoonlike funkiness, and expressionistic angst, and an almost Cubist ordering of her impressions." Grimes writes that Murray has learned the formalist lessons of the 1960s and has incorporated them with the desire for autobiographical work of the 1980s.

Just as the critics interpret her work to be not only about domestic issues—although they make it clear that her work importantly refers to real life—so do they also interpret her work to be about other art, but not exclusively. They think it significant that her art refers both to life and to the history of art. Storr expresses the idea this way: "Consistent with this emotional urgency and sensory immediacy, her

118

formal intuitions always resonate with existential as opposed to merely art historical significance, and like all psychic experiences they deepen with duration." That is, if her art were merely full of art historical references and not about real-life situations, it would be much less than it actually is. Some art of the past—modernist art, for example—was primarily about itself and other art and purposely divorced from daily living. Some art is exclusively or primarily about social life and demonstrates little reference to or knowledge of the history of art. According to these critics, though, Murray's is referential both to life and to art.

Murray made paintings in which she refers to her dying mother. Robert Storr writes about one of these, *Can You Hear Me*? (1984), without knowing Murray's intended reference: "*Can You Hear Me*?, whose title amplifies a perfectly ordinary query into an edgy plea, features a small ghostly head from which emanate a pair of swelling armlike shapes painted a chill blue tinged with acid yellow, and a single inflated exclamation-point form painted red and acid green. The face is a direct reference to the contorted visage of the figure in Edvard Munch's *The Scream*, while the monstrous blue extensions are something we have not seen before; or rather something we have never seen in a form at once so abstract and so visceral." Thus he comes close to the artist's stated intent and private references, although he is not aware of the specific reference.

Finally, regarding interpreting Murray's paintings, critics also write about what Murray doesn't do in relation to art history and to her fellow artists. Solomon interprets what Murray's work is *not* about—namely, it is not ironic (but direct), it is not about its own limitations (as is much postmodern art), and it is not about gender politics. Hughes writes that "Murray is not a 'feminist artist' in any ideological sense, but her work, like that of Louise Bourgeois or Lee Krasner, gives a powerful sense of womanly experience: Forms enfold one another, signaling an ambient sense of protection and sexual comfort—an imagery of nurture, plainly felt and directly expressed, whose totem is the Kleinian breast rather than the Freudian phallus." Storr agrees with Hughes on this point, but says it differently: "Indeed, while Murray is neither doing 'woman's work' nor making avowedly 'feminist' art, the situations presented and emotions evinced by her pictures reflect a decidedly female perspective." A point that should be made here concerns relevance. Murray's paintings are not about many things, but how they are or are not about feminism is relevant for the critics to consider because of the social context of the period during which the paintings were made. Feminism was a force in the world and the art world in the 1980s, Murray was painting in the 1980s, and she was a woman dealing with subjects in the home. Whether her work is feminist or feminine is a relevant and interesting topic for critics and readers to consider interpretively.

When drawing conclusions about the interpretations of Wegman's work, the discussion claimed that all art is influenced by other art and that some art is about other art. These themes are particularly true of interpretations of Murray's work.

The critics cited have generally agreed in their interpretations of Murray's work but have different emphases. Johnson, for example, employed a sexually interpretive strategy to decipher Murray's paintings. He offered a sexual interpretation and then provided explicit evidence, based on what he had noticed and pointed out in the paintings. Johnson's is a clear example of an interpretive argument. Interpretations are arguments based on evidence that may be drawn from within and without the artwork itself.

Although others did not also use this interpretive strategy, Johnson's argument is nevertheless reasonable. These differences among critics support another generalization—namely, different interpretations of the same work can broaden and deepen understanding of the work.

In the next section, several principles of interpretation are presented that derive from the various interpretations of the work of Wegman, Holzer, and Murray, and from a few other examples.

PRINCIPLES OF INTERPRETATION

Artworks have "aboutness" and demand interpretation. This is the fundamental principle on which this chapter depends. It is basic and readily accepted by critics and aestheticians, but it is sometimes disputed by artists, an occasional art professor, and, more frequently, art students who hold that "art speaks for itself" or "you can't talk about art." All the examples of interpretations in this chapter disprove the latter position. Even art that seems readily understandable, such as Wegman's, can and does sustain interesting interpretations that would not readily emerge from merely viewing the work. That art is always *about* something is also a principle around which whole books have been written—Nelson Goodman's *Languages of Art* and Arthur Danto's *Transfiguration of the Commonplace*, ⁴² for example. Briefly, this principle holds that a work of art is an expressive object made by a person and that, unlike a tree or a rock, for example, it is always about something. Thus, unlike trees or rocks, artworks call for interpretations. Art critic Thomas McEvilley offers us many topics to consider when interpreting an artwork:

Thirteen Ways of Looking at a Blackbird

- Content that arises from the aspect of the artwork that is understood as representational.
- 2. Content arising from verbal supplements supplied by the artist.
- 3. Content arising from the genre or medium of the artwork.
- 4. Content arising from the material of which the artwork is made.
- 5. Content arising from the scale of the artwork.
- $6. \ \ Content\ arising\ from\ the\ temporary\ duration\ of\ the\ artwork.$
- 7. Content arising from the context of the work.
- 8. Content arising from the work's relationship with art history.

- 9. Content that accrues to the work as it progressively reveals its destiny through persisting in time.
- 10. Content arising from participation in a specific iconographic tradition.
- 11. Content arising directly from the formal properties of the work.
- 12. Content arising from attitudinal gestures (wit, irony, parody, and so on) that may appear as qualifiers of any of the categories already mentioned.
- Content rooted in biological or physiological responses, or in cognitive awareness of them.⁴³

Interpretations are persuasive arguments. This principle might better be written as two separate ones: Interpretations are arguments, and critics attempt to be persuasive. Because critics attempt to be persuasive, their interpretations rarely jump out as logical arguments with premises leading to a conclusion. One clear example of an interpretive argument is Ken Johnson's argument concerning what he sees as the sexual content of Murray's paintings. He argues that My Manhattan is a painting full of symbols referring to sexual intercourse. His evidence is a list of persuasive descriptions of aspects of the painting. He notes a cup and a hugely swollen, weirdly flexible spoon. He writes that the spoon is turgid and unnaturally fluid. The spoon's handle is serpentine and winds around the canvas's edge and enters the cup from below. The spoon's handle does not end as on a normal spoon with a broad end, but rather it turns into a knob with a hole in it. The knob penetrates an actual hole in the shaped canvas. At the point where the spoon splashes the liquid in the cup, giant droplets shoot out from the cup.

If Johnson's interpretation were put into a logical argument, his descriptions of the painting would be his premises leading to his conclusion that the painting is about sexual intercourse. Criticism, however, is persuasive rhetoric. That is, the critic would like the readers to see a work of art the way the critic sees it. And there is more than one way to be persuasive about an interpretation. One could put forth a formally logical argument, with premises and a conclusion—a syllogism, for instance. Critics, however, are much more likely to be persuasive by putting their evidence in the form of lively writing, using colorful terms in carefully wrought phrases, to engage the reader with the critic's perception and understanding so that eventually the reader will be likely to think, "Yes, I see what you mean. Yes, I agree with the way you see it." The well-written summary paragraphs in the discussion of Murray's paintings are good examples of such persuasive critical writing. Critics do rely on evidence in their interpretations, evidence from observations made about the artwork or from information about the world and the artist. But they present their interpretations not as logical arguments, but as persuasive literary essays. Interpretations can and should, then, be analyzed as arguments to see if they are persuasive because of both the evidence they present and the language in which they are written.

Some interpretations are better than others. This principle defends against the often heard objection "That's just your interpretation," by which is usually meant that no one interpretation is better than any other, and further, that no interpretation is more certain than any other. On the contrary, all interpretations are not equal. Some interpretations are better argued, better grounded with evidence, and therefore more reasonable, more certain, and more acceptable than others. Some interpretations are not very good at all because they are too subjective, are too narrow, don't account sufficiently for what is in the artwork, are irrelevant to the artwork, don't account for the context in which the artwork was made, or simply don't make sense.

Good interpretations of art tell more about the artwork than they tell about the critic. Good interpretations clearly pertain to the work of art. Critics come to a work of art with a history, knowledge, beliefs, and biases that do, should, and must affect how they see a work of art. All interpretations reveal something about the critic. But a critic should show the reader that her or his interpretation applies to what we all can perceive in and about the art object. This principle guards against interpretations that are too subjective—that is, that tell us more about the critic than about the art.

None of the interpretations quoted in this chapter are too subjective. However, it is easy to imagine an interpretation that tells us more about the interpreter than the artwork. Naive viewers of art sometimes offer subjective information about artworks. For example, if shown Wegman's photographs of dogs, young children might tell about their pets at home and how they once dressed up their pets. These remarks would inform us about the children and their pets and not about Wegman's photographs of Man Ray and Fay Ray. Their remarks would be true, might be insightful, and probably would be amusing, but they would not be directly informative about Wegman's work.

If we cannot relate the critic's interpretation to the work of art, the interpretation may be too subjective. If it is, it will not be enlightening about the object, will not be valuable as an interpretation of the artwork, and hence should not be considered a good interpretation.

Feelings are guides to interpretations. Amid this discussion about reasons and evidence and convincing, persuasive arguments and the desirability of objectivity over subjectivity in interpreting art, we may lose sight of the fact that feelings are important to understanding art. A person's ability to respond to a work of art is emotional as well as intellectual, from the gut and heart as well as from the head. The dichotomous distinction between thought and feeling is false; on the contrary, thought and feeling are irrevocably intertwined.

If a critic has a gut feeling or strong emotional response, it is important that he or she articulate this in language so the readers can share the critic's feelings. It is also important that the critic relate the feeling to what is in the artwork. A feeling that is not referred back to the artwork may be or may be seen to be irrelevant. The

There can be different, competing, and contradictory interpretations of the same artwork. This principle acknowledges that an artwork may generate many good and different interpretations. Interpretations may also compete with each other, encouraging the reader to choose between them, especially if they are contradictory.

This principle also encourages a diversity of interpretations from a number of viewers and from a number of points of view. It values an artwork as a rich repository of expression that allows for a rich variety of response. Amid the many interpretations of the art of Wegman, Holzer, and Murray, one critic has noted something that another has overlooked or has not mentioned. One critic has presented an interpretation that contributes to another critic's previous interpretation. These enrich our understanding of a work of art. They also enrich our appreciation of the responding human mind.

Despite this appreciation of diversity, it may not be logically possible for one to hold all interpretations about the artwork if those interpretations are mutually exclusive or contradictory. We ran into such a situation with interpretations of Holzer's work. Some critics said there was nothing to interpret; others found much to interpret. We could not logically hold both positions simultaneously. We could, however, sympathetically understand contradictory interpretations if we understood the beliefs of the critic, or in ordinary language, understood where the critic was coming from.

Interpretations are often based on a worldview and a theory of art. We all move through the world with a more or less articulated set of assumptions about existence and art, and it is through these that we interpret everything. Some critics have a more finely articulated and consistent worldview and aesthetic theory, based on a study of philosophy or psychology, for example, than others. They may operate on the basis of psychoanalytic theory or offer neo-Marxian critiques of all works of art they encounter. This chapter includes a psychoanalytic interpretation of Wegman's work, a semiotic interpretation of Holzer's work, and a sexual interpretation of Murray's paintings. Sometimes critics make their basic assumptions explicit; more often, however, they leave them implicit. Once the critic's worldview is identified, by either the critic or the reader, we need to make a choice. We can accept the worldview and the interpretation; we can accept the worldview but disagree with how it is applied to the artwork or reject the general worldview but accept the specific interpretation it yields.

Interpretations are not so much absolutely right, but more or less reasonable, convincing, enlightening, and informative. This principle holds that there is no one true interpretation of an artwork and that good interpretations are not so much "right" as they are compelling, original, insightful, and so forth.

Interpretations can be judged by coherence, correspondence, and inclusiveness. A good interpretation should be a coherent statement in itself and should correspond to the artwork. Coherence is an autonomous and internal criterion. We can judge whether an interpretation is coherent without seeing the artwork. Either the argument makes sense or it doesn't. Correspondence is an external criterion that asks whether the interpretation fits the artwork. A coherent interpretation may not sufficiently correspond to the work being interpreted. For instance, regarding Wegman's humorous videotapes and Polaroids of dogs, Robbins interprets them as angry and argues that Wegman employs humor that masks the artist's genuinely subversive aims. This interpretation is coherent, but does it correspond to the pictures? Are you, the reader, convinced that Wegman is an angry radical who wants to subvert society? This principle also protects against interpretations that tend toward unleashed speculation by asking them to adhere to what is actually in the artwork.

The demand for inclusiveness ensures that everything in a specific work is attended to, or that everything in a body of work is accounted for. If an interpretation omits mention of an aspect of an artwork, that interpretation is suspect. If an interpretation *could* have accounted for that aspect, it is not as flawed as if the interpretation *could not* have done so. The critics in this chapter and throughout the book usually discuss several of an artist's works, not just one. When interpreting Wegman's work, for example, they deal with his early videotapes as well as his later Polaroid photographs; they try to account for both and for the changes that have taken place in his art making. It is risky to arrive at a confident interpretation of one piece of art without knowing something of an artist's other works.

An artwork is not necessarily about what the artist wanted it to be about. Minor White, the photographer and photography teacher, once commented that photographers frequently photograph better than they know. He was cautioning about paying too much attention to what photographers said about their own work. Because of his experience in leading many photography workshops, he felt that photographers' works were often much different from what the photographers thought them to be—and better than they knew them to be. Thus he minimized the importance of the artists' interpretations of their own work.

We can probably all agree that the meaning of an artwork should not be limited to the artist's intent. Its meaning might be much broader than even the artist knows. The critics of some of Murray's paintings were quite able to derive relevant meaning from the paintings even though they were unaware she was referring to her dying mother. They correctly saw the paintings as more generally about dying and loss. It is reasonable that these paintings not be limited to the artist's specific reference.

Adrian Piper is one artist who agrees that she cannot control the effects of her works on viewers: "I recognize fully and live by the principle that once the work leaves my studio, I cannot control the effects it has. . . . I can make projections about how I think the work is going to be understood. But in the end I can't be in someone else's skin. I cannot bring their history to the viewing situation."⁴⁴

An artist's interpretation of his or her own work of art (if the artist has one and expresses it) is only one interpretation among many, and it is not necessarily more accurate or more acceptable just because it is the artist's. Some artists are quite articulate and speak and write insightfully about their work; others do not. Still others choose not to discuss the meaning of their work, not wanting their art to be limited by their own views of it.

This important principle actively places the responsibility of interpretation squarely on the shoulders of the viewer, not on the artist.

A critic ought not be the spokesperson for the artist. This is to say that the critic should do much more than transcribe what artists say about their work. It demands that critics criticize.

Interpretations ought to present the work in its best rather than its weakest light. This principle is in the spirit of fair play, generosity of spirit, and respect for intellectual rigor. A critic's dismissal of an artist's work is a contrary example of this principle.

The objects of interpretations are artworks, not artists. In casual conversation about art, it is artists who are often interpreted and judged rather than the work they make. In criticism, however, it should be the objects that are interpreted (and judged), not the people who made the objects. This principle does not exclude biographical information. Over and over again, the critics quoted here have mentioned the lives of the artists. This biographical information, however, is ultimately meant to provide insight into the work. That Elizabeth Murray wears no makeup and has graying hair may be interesting to the reader wanting to know about her, but facts about her training, for example, are more relevant to understanding her work.

Biographical information reminds us that art does not emerge apart from a social environment. The critics of Holzer's work, for example, discussed her midwestern upbringing and how it is reflected in her artwork. In a few sentences in *Artnews*, critic Curtia James provides a good example of how biographical information can be interpretively informative. Regarding a sculptural installation by Beverly Buchanan, "Buchanan's *Shack South: Inside and Out* was a full-size shack patched together out of cedar, pine, tine, and cardboard. Buchanan is from Athens, Georgia. As a child she traveled with her father, a professor of agriculture who documented the lives of black farmers. She saw many shacks like this and perceived how each inhabitant put his or her own stamp, or imprint, on the dwelling, an imprint that identified the individual in the community. Buchanan's loving ability to capture that individual imprint made *Shack South* an image of humble nobility." 46

There is a caution, however, concerning what might be called biographical determinism. Artists should not be limited to their pasts; nor should one argue that if someone is of this race or that gender or this historical background, then their art must be about such and such.

All art is in part about the world in which it emerged. Donald Kuspit reinforced this principle when he discussed his study of psychoanalysis and its effect on his criticism: "I began to feel that the artist is not exempt from life. There is no way out from seeing art as a reflection or meditation or a comment on life. I became interested in the process, including the artist's life. I became interested in how art reflected the artist's life as well as how it reflected life issues, or existential issues with which we are all involved."47 Another critic, Pamela Hammond, reminds critics of the importance of this principle, especially when interpreting the art of artists from a different culture. When she writes about the sculpture of ten Japanese artists showing in America, she informs us that traditional Japanese art does not recognize "sculpture" in and of itself. When interpreting the massive, shaped timbers of Chuichi Fujii, she informs us that Japanese tradition teaches that material possesses a life force equivalent to that of a human and that "the dualistic Judeo-Christian view that nature defers to man opposes the belief of Eastern cultures rooted in the harmonious coexistence of man and nature, life and death, good and evil."48 The critic's knowledge of traditional Japanese aesthetics informs her interpretation and our understanding of the work.

All art is in part about other art. The critics quoted in this chapter noted over and over again the artists who influenced Wegman, Holzer, and Murray; they also discussed whose art the works of these artists could be commenting on. Art does not emerge within a vacuum. Artists generally are aware of the work of other artists, and often they are especially aware of the work of certain artists. Even naive artists, or artists who have not been trained in university art departments or academies of art, are aware of and influenced by the visual representations in their societies. This principle asserts that all art can be interpreted, at least in part, by how it is influenced by other art and, further, that in many cases, some art is specifically about other art.

Wegman's art, for example, has been interpreted by several critics as being funny in response to other art being serious. Holzer's art has been characterized as being different from much other art because it is much more concerned with the political world than the art world. Murray's work has been interpreted as being about both the history of art and the trials of daily living. Art can be about life, about art, and about both. An important guide to interpreting any artwork is to see how it relates to and directly or indirectly comments on other art.

No single interpretation is exhaustive of the meaning of an artwork. This chapter has provided numerous examples of this principle: the many interpretations of the same works of art. Each interpretation provides subtle nuances or bold alternatives for understanding. According to this principle, one comprehensive but exhaustive interpretation is not a goal of interpretation.

Interpretation is ultimately a communal endeavor, and the community is ultimately self-corrective. This is an optimistic view of the art world and scholar-ship that holds that critics and historians and other serious interpreters will eventually correct less-than-adequate interpretations and eventually come up with better interpretations. This happens in the short run and the long run. Essays in exhibition catalogs of contemporary art can be seen as compilations by scholarly critics of the best thinking about an artist's work to that point. An exhibition catalog of an historical retrospective of a deceased artist is a compilation of the best thinking about that artist's work to that point. Such a historical interpretation would give more plausible interpretations and reject less informative ones.

In the short run, interpretations might be nearsighted. This principle asserts that eventually, however, these narrow interpretations will be broadened. Feminist revisionist accounts of historical art made by women are a case in point. Scholars for years and for centuries have ignored the art of many women, and it is only now, through work begun by feminist historians, that the historical record is being repaired. This is a good example of the scholarly community correcting its own mistakes, however belatedly. Chapter 5 expands on this notion with the example of Frida Kahlo, whose work is now being given more serious consideration than when she was living and making the work.

Good interpretations invite us to see for ourselves and to continue on our own.⁴⁹ This principle follows the previous one as psychological motivation for getting involved with meaning in art. It might also serve as a goal for interpreters: Be friendly to readers by drawing them in and engaging them in conversation, rather than halting discussion with dogmatic pronouncements.

Judging Art

The following two statements by two different writers about two groups of works of art are very similar. Jens Astoff writes, "Walton Ford's works are technically brilliant and visually spectacular." Roberta Smith writes, "Kristin Baker's paintings strike the eyes with a harsh and dazzling newness." They both seem like positive judgments, but they are not. If we read more from each author, we find that Astoff's statement is indeed a positive judgment set within the context of the book 100 Contemporary Artists, which implies that the selected artists are the 100 best

R. Crumb, *The Book of Genesis Illustrated*, detail. New York: Norton, 2009. From GENESIS: Translation and Commentary, translated by Robert Alter. Copyright © 1996 by

Robert Alter. Used by permission of W.W. Norton & Company, Inc.

The Mexican sculptor and conceptualist, forty-seven years old, is easily the best artist to have emerged on the era's global biennial circuit—a milieu whose chaotic demands for theatrical pizzazz and political virtue had wrecked innumerable promising talents. The Museum of Modern Art show confirms that Orozco is, in fact, the one artist of his ilk and time who stands up to really rigorous scrutiny—incidentally rejuvenating art history as a going concern—and justifies the effort by being delightful.³

All three of these quotations are examples of judgments. All three of the judgments, as quoted without benefit of their fuller contexts, are primarily descriptive observations and assertions of value without benefit of the critics' fuller arguments, which are not quoted here. Readers want clear judgments, but they also want reasons for those judgments.

In a longer quotation about a work of art, R. Crumb's *The Book of Genesis Illustrated*, Jeet Heer provides a clear positive judgment with explicit reasons for that judgment:

Among its many riches, Genesis is a book about bodies, a book where men and women constantly grapple with one another, where a servant swears an oath by putting his hand under his master's thigh, where even angels are threatened with sexual violation. Crumb has long been the preeminent cartoonist of the body. His women are notoriously full-figured, with ample butts and protruding nipples (a motif he uses in this book). But more significantly, the bodies he draws—whether they are quivering or standing still, dancing or drooping—have a visceral impact few artists can match. That's why he was the perfect cartoonist to illustrate the Book of Genesis, a fitting capstone to a great career.⁴

In Heer's argued view, Crumb is the "perfect cartoonist" for reasons stated within this quote—it's a book about bodies grappling, and Crumb is the preeminent cartoonist of the body; his illustrations have "visceral impact." Earlier in his review, Heer offers more reasons for his positive judgment: "The characters in Genesis have no internal lives: We see them speak and act, with little sense of their motivations." When God speaks "we can only guess at how the words were received." Heer credits Crumb with a major "interpretive act" with "reaction shots." The Biblical text is silent about the reactions of its characters, and Crumb provides them with passion and compassion.

Heer also imbeds his judgment with criteria, or general standards, for making them. Unlike other comic book versions of the Bible that are sanitized of such shocking events as incest, homosexual rape, seduction, murder, and the slaughter

of people and animals, Crumb is faithful to the complete text of Genesis. Heer's criterion is one of exactness. Another of his criteria is the "heightened feelings" the artist evokes.

This chapter examines the critical activities involved in judging works of art. It proceeds similarly to Chapter 4, on interpreting art, because the two sets of activities are much alike although their results are different. Making interpretations and judgments are both acts of making decisions, providing reasons and evidence for those decisions, and formulating arguments for one's conclusions. When critics interpret works of art, they seek to determine what the works are about. When critics judge works of art, they seek to determine how good the work is or isn't and why and by what criteria. Judgments of art, like interpretations, are not so much right or wrong as they are convincing or unconvincing.

In this chapter, the art of Frida Kahlo, Martin Puryear, and Romare Bearden is examined in light of how critics have judged it. Any number of artists and their critics could have been chosen, and the selection of these three artists is somewhat arbitrary. They were chosen because they make interesting art and because they represent a diversity of ages, races, ethnicities, and genders. They are three artists of color: two African American men and a Mexican woman. Puryear is professionally young; Kahlo has been long deceased but her work is enjoying renewed interest; Bearden recently passed away, and his work is in retrospective exhibition. Two of the artists work in two dimensions, and the third in three dimensions. Consistent with previous chapters, this one examines judgments from many critics, not all of whom agree with one another. The chapter then discusses criteria for judging art and related concerns.

JUDGING FRIDA KAHLO'S PAINTINGS

Peter Plagens

In "Frida on Our Minds" in *Newsweek*, Peter Plagens provides an overview of who the artist is, what she accomplished, and how she is being received today.⁵ As is typical of Plagens's writing, his review is entertaining, skeptical, at times sarcastic, and occasionally iconoclastic. This section begins by analyzing his review and then comparing it to Hayden Herrera's writings about Kahlo. Herrera has written a biography and several articles about Kahlo and has curated an exhibition of Kahlo's work. Herrera provides a good contrast to Plagens because she is unyielding in her devotion to Kahlo. Next the views of other critics are examined, and finally some conclusions are reached about critics' judgments of Kahlo's art.

The subheading of Plagens's review is "With a record sale at Christie's and a biography that keeps selling, the late Mexican painter ranks with the greats. Do we need a movie with Madonna?" The review is two pages long, consists of eight paragraphs, and is accompanied by a black-and-white photograph of Frida Kahlo and Diego Rivera captioned "Rivera and Kahlo in 1939, in a moment of calm between

the pain and other lovers." Two color reproductions of Kahlo's paintings accompany the review, *Two Nudes in a Forest* and *Self-Portrait*. The former depicts two nude females in a landscape; one woman holds the other in her lap and caresses her hair. The latter painting is captioned "the \$1.65 million self-portrait." Anyone browsing through the weekly newsmagazine and scanning these two pages has already gotten a lot of information from these journalistic teases: The artist is important, she is deceased, she is Mexican, her work is selling for record amounts, her recently published biography is very popular, Madonna wants to play her part in a movie, and she and Rivera were troubled lovers.

In the first paragraph of the review, Plagens establishes the undeniable economic value of Kahlo's paintings. He remarks that the record prices in auctions for her paintings are particularly impressive because they were obtained during a recession that was felt especially in the art market. In addition, the record \$1.65 million sale price was for a painting by a Latin American artist. The self-portrait will be shown in Mexico, where her work was declared "national patrimony," which means that it cannot permanently leave the country.

In his second paragraph, Plagens details the popularity of the artist herself: There is a PBS television documentary, a Mexican feature film of her life, and the possibility of a Hollywood film with Robert De Niro and Madonna.—eventually released in 2002 as *Frida* starring Salma Hayek and directed by Julie Taymor. Madonna visited a high school boyfriend of Kahlo to find out more about her. Plagens quotes Madonna as saying that Kahlo "is my obsession and my inspiration." Plagens relates that Hayden Herrera's 1983 biography of the artist has sold about 100,000 copies and sarcastically calls it "the reigning sisterhood-solidarity gift of choice." In this paragraph, Plagens uses sarcasm again when he refers to the interest in Kahlo as "a highbrow version of the Elvis phenomenon," and he coins the summary term "Fridamania" to characterize her current popularity.

Plagens's third paragraph is a jumble of thoughts and information. In the lead sentence he states that good art is often bought for bad reasons, such as status or investment, and that bad art is often bought with the good intention of enjoying the way it looks. He doesn't follow these observations with implications or conclusions about Kahlo's work but asserts that judging Kahlo's art is particularly difficult because of the "saga" of her life. Her life story "strikes about every emotionally correct nerve in the contemporary art world": She was a "faux-naïf surrealist who specialized in confessional self-portraits"; her father was German Jewish, her mother Mexican; as an adult she lived in the shadow of Diego Rivera, the famous muralist. Plagens recounts that Rivera was "gross (300 pounds)" and abused Kahlo emotionally, even seducing her younger sister. He writes that Kahlo was bisexual and "retaliated" with affairs of her own, including some with Rivera's female lovers and one with Leon Trotsky.

The fourth paragraph has the subhead "brief career." In it Plagens details the "grisly accident" Kahlo suffered when she was a teenager. He relates that a streetcar

hit a bus she was riding, and a handrail entered her abdomen and exited through her vagina. She was semicrippled, endured many operations, had several unsuccessful pregnancies, was in constant pain, for which she took drugs and drank alcohol, and, according to Plagens, was possibly an alcoholic. She was politically conscious, changing the date of her birthday so it would coincide with the start of the 1910 Mexican revolution, and she had a hammer and sickle flag draped over her casket. Plagens writes that, unlike Georgia O'Keeffe or Louise Nevelson, "who may have been one of Rivera's apprentice-lovers," Kahlo did not make it into the coffee table books while she was still alive. But today "she is as close to a martyr as ever turns up on Park Avenue."

In the fifth paragraph, about halfway through the review, Plagens returns to the question that is the major and organizing theme of the review: "But are the paintings that good?" As if to protect himself before giving his own less than enthusiastic judgments, he first quotes an "83-year-old feminist" in the art world who declines to refer to Kahlo as a "genius" or to her paintings as "masterpieces." Plagens writes that "in general, Kahlo's paintings were better than Rivera's," but here he is referring to Rivera's easel paintings, not his murals, for which Rivera is most revered. For Plagens, "the best Kahlos exude a spiritual intensity inextricably bound to genuine visual invention and technical adroitness." Then comes the "but": According to Plagens, most of the audience's "infatuation" with Kahlo comes from the stories in her pictures—that is, *not* from the "spiritual intensity" or "genuine visual invention and technical adroitness." The best ones "have a shock-simpatico feel that makes you suspect the presence of a psychologist coaching her to draw all the terrible things that the world and Diego did to her." He calls her "a feminist equivalent to Van Gogh," which seems a great compliment until he goes on to say that Van Gogh's tragic life caused his paintings to be "overvalued too."

In the next paragraph Plagens offers his explanation for why we are in the midst of what he calls "Frida fever": Today's art world is more interested in artists than their art; Kahlo was a dramatic woman who wore native Mexican costumes; this is a time of revisionist history, during which, according to a male art historian whom Plagens quotes, "almost any woman who ever touched a brush is being systematically studied"; and much art by contemporary women is "as awash in argumentative autobiography as Kahlo's ever was." He also quotes Herrera's biography of Kahlo and the biographer's assertion that Kahlo did not engage in surrealism to escape life, as did the European surrealists; rather, she came to terms with reality through her art. Plagens sarcastically states that this is the "culturally correct" thing for her to have done.

His final two paragraphs are subheaded "too passionate." In the first of them, he admonishes Kahlo for her political activism—she painted a portrait of Stalin, in her diary she expressed solidarity with the Soviets, she and her husband were members of the Communist party, and they invited Trotsky to Mexico as part of a plot for his assassination. Herrera denies the last claim. Plagens also blames her "fans" for

Finally, Plagens raises more concerns about what he calls "Fridaphilia" by claiming, without further explanation, that Mexicans are less enthusiastic about her popularity than Americans because they fear that the art of an essentially inwardly directed Mexican artist is being hyped by Americans. He concludes that "the line between exhibitionism and exhibition is razor thin these days," and "for better or worse. Frida Kahlo is the woman of the hour."

Hayden Herrera

In an article appearing on the first page of the arts section in a Sunday edition of *The* New York Times, Hayden Herrera gives her answers to "Why Frida Kahlo Speaks to the 90's." Her article appeared about eight months earlier than Plagens's review in Newsweek and is about three times as long. It may well be that Plagens read Herrera's article when preparing his own because the two articles share many of the same facts. Plagens refers to Herrera's biography of Kahlo, and a major part of his review addresses why the artist is resonant with the times. Plagens's is a skeptical view; Herrera's is completely positive. In her opening paragraph, she writes that Frida Kahlo "has captivated everyone from scholars writing dissertations to Chicano muralists, fashion designers, feminists, artists, and homosexuals. According to Sassy, a magazine for teenage girls, she is one of 20 women of this century that American girls most admire." Herrera tells us that Kahlo is the subject of books, films, theater pieces, and dance performances and that revisionist historians and postmodernists have gotten her into university curricula. Whereas Plagens derides Kahlo's popular acclaim, Herrera boasts that Kahlo is an "international cult figure" and that Kahlo buttons are available, as well as posters, postcards, T-shirts, comic books, jewelry, and even a Kahlo mask and a framed self-portrait into which a silver sacred heart has been inserted.

Herrera explains that Kahlo had only two one-person exhibitions in her lifetime; she lists where her work is currently being shown internationally and tells of its success at auctions. She mentions three different Hollywood projects under way, the most spectacular involving Madonna, who wants to play Kahlo. She relates that Madonna has bought two of Kahlo's paintings, one of which is *My Birth*, a bloody depiction of childbirth. Herrera praises this particular picture, which she says must have been shocking in its time and in its place of origin: "As a marginalized voice—a woman, an invalid, a Mexican, and the wife of one of the most famous painters in the world—Kahlo had the freedom to break rules."

Herrera interprets Kahlo's chief subject to be her pain—pain from the accident and thirty-five surgical operations; pain at not being able to bear children; and pain from her turbulent marriage of twenty-five years to Rivera, "who deceived her

133

often—even with her favorite sister" and who divorced her once for a year. Herrera praises Kahlo's use of her pain as her content: "All women, indeed, anyone who has experienced loss or rejection in love, can empathize with the misery Frida expressed in her self-portraits with broken hearts." And further, "Kahlo's autobiography in paint is exemplary. . . . For people preoccupied with psychological health, fearful of AIDS, and appalled by drug abuse, the gritty strength with which she endured her illness is salutary. Although her paintings record specific moments in her life, all who look at them feel that Frida is speaking directly to them." So although Plagens is disapproving of the "shock-simpatico feel" of Kahlo's paintings, Herrera praises her for showing her self-discovery and self-disclosure and for sharing the private facets of her living. Herrera argues that Kahlo's portraits "go beyond petty self-absorption. . . . When she displays her wounds we immediately know that those wounds stand for all human suffering. She is thus a kind of secular saint. People look at her image and find strength." In his review, Plagens derides Kahlo as a "martyr"; in hers, Herrera praises Kahlo as a "saint."

Herrera values Kahlo for overcoming the limitations of her culture: "Although she lived in a conservative, male-dominated culture and in the heyday of muralism when a woman making small, highly personal easel paintings could not win much respect, she valued her idiosyncratic talent." She continues, "Frida never competed with nor deferred to Rivera. . . . She was fiercely independent as an artist, and her paintings could not be more different from his."

Herrera makes the further point that when Kahlo painted women, she presented them much differently from the way in which male artists paint women: "When Kahlo painted herself, she did not see a passive repository of a man's gaze; she saw an active perceiver, the female painter scrutinizing her own being, and that included her sexual being." In support of Kahlo's feminism, Herrera quotes the painter Miriam Schapiro: "Frida is a real feminist artist in the sense that during a period of history when the accepted modes of truth were truth seen through men's eyes, she gave us truth seen through the eyes of woman. She painted the kinds of agonies women in particular suffer, and she had the capacity both to be feminine and to function with an iron will that we associate with masculinity." Herrera also admires as liberating Kahlo's unconventional approach to sexuality, arguing that she did not hide her bisexuality—she quotes Kahlo as saying that she delighted in Diego's marvelous breasts—and that she ignored the repressive forces of Mexico's Roman Catholic conservatism and "swore like a mariachi." Herrera likes that Kahlo wore men's clothing and that in her paintings she emphasized her mustache.

Herrera also credits Kahlo with being ahead of her times by embracing with pride her Mexican heritage and for denouncing racism. She relates a story about Kahlo and Henry Ford, a known anti-Semite. During a formal dinner to which she was invited, Kahlo turned to him and said, "Mr. Ford, are you Jewish?" Thus, although Plagens derides what he calls Kahlo's "cultural correctness," Herrera argues that Kahlo and her work were positive forces in repressed and repressive societies of the past and of today.

Both Plagens and Herrera credit Kahlo with being ahead of her time and in sync with ours, but Plagens suspects contemporary art world thinking of being "emotionally and culturally correct" for its "reigning sisterhood-solidarity," overvalued art, supposed excesses of feminist revisionism, and women's art "awash in argumentative autobiography."

Herrera is pleased with the popularity Kahlo has achieved some thirty years after her death, but Plagens faults Kahlo's audience for its uncritical heroine worship. He also faults the art market for economically overvaluing her work. Herrera implies that the prices are deserved and that, because of Kahlo's life and how she expressed it in her paintings, her work speaks to contemporary viewers of all kinds, especially women, people with AIDS, and others on the margins of society—and that these people find it salutary. Plagens asserts that just because people like it doesn't mean that it is good.

In his arguments, Plagens employs inventive and effectively sarcastic terms and phrases such as "Fridamania," "feminist equivalent of Van Gogh," "Frida fever," and "Fridaphilia." He gives examples of her popularity, such as the proposed movie starring Madonna, and provides statistics concerning what he considers to be the economic inflation of her art. He quotes supporters of his views, especially women—one whom he identifies as an "83-year-old feminist"—as being knowledgeable and authoritative. Herrera uses the same facts of Kahlo's popularity as evidence of support of her status of greatness. Herrera, too, quotes others in defense of the artist. Herrera offers reasons why people identify with the work and why they admire it. Plagens implies people who like it are being duped.

Other Critics and Kahlo

Joyce Kozloff, writing in 1978 in *Art in America*, seems to agree with some of Plagens's assessments: "This is not an even body of work. Kahlo's early paintings are charming, but the allegorical symbolism can be simplistic. The late works, mostly still-lifes painted while she was very ill, reveal a slackening of touch and concentration. But the work of the middle period is exquisitely crafted, intense, and concise in imagery." Unlike Plagens and like Herrera, though, Kozloff embraces Kahlo's use of her suffering and her feminism: "Her suffering can be seen as a metaphor for

135

the oppression of women, and she is exemplary in having dealt openly with taboo female subject matter at a time and place where there was no precedent."

Kay Larson wonders why it took so long for Kahlo to be recognized. She answers that question with "her race, her sex, her subjects, and her proximity to Rivera" and complains that "if an artist of Kahlo's stature remained invisible for so long, how many others might there be?" Larson praises Kahlo for copying "no particular style, not Rivera's, not folk art, not Mexican peasant art, and certainly not Surrealism." 8

Michael Newman reviewed Kahlo's work by comparing it with the photography of Tina Modotti, with which it was shown in a New York City gallery. Both artists are Mexican and political, and, like Kahlo, Modotti was also intimately involved with a prominent male artist—Edward Weston. Newman also praises Kahlo for her break with the artistic tradition of her times: "Both artists were women, both of them were influenced by radical tendencies in Mexico, and both were politically active; each developed her aesthetic influence under the shadow of a well-known male artist with whom she had an emotional relationship; and both challenged the dominant traditions of high art from a marginal position."

In addition, Newman compares Kahlo's and Cindy Sherman's self-portraits. He argues that both women assume roles, but Sherman's portraits are mass-media stereotypes—passive, masochistic images for the male gaze. Kahlo's portraits suggest an autoeroticism, perhaps linked to her bisexuality—portrayals of herself for herself. In this, he argues, Kahlo significantly alters how the female body is presented within the Western tradition of representation. That is, Kahlo is a woman making images of herself for herself, not for a man, not for an oppressive male gaze.

Kozloff writes about the emotional force of Kahlo's paintings: "Even though I was already familiar with Kahlo's work I again felt a shock in confronting it. The extreme smallness of the paintings was disconcerting, somehow contradicting their power and expressiveness, setting up an uneasy dialogue between fierceness and vulnerability." Jeff Spurrier notes the contrasting emotions he felt when passing from Rivera's paintings to Kahlo's at the Dolores Olmedo collection of Mexican art, saying that it was "like going from Charles Dickens to Emily Dickinson, grand to specific, the popular to the personal. Moving from Rivera's jazzy black-dancer series to Kahlo's *The Broken Column* (see Color Plate 14) is like stepping out of a warm tropical rain into a bone-chilling blizzard of pain." 10

Many critics identify personally with Kahlo's paintings. Georgina Valverde, for instance, offers a detailed description of *The Broken Column*: "We see a suffering Frida commanding the picture plane. She delicately holds a white drape, which gives her an air of martyrdom. Her body cracks open below the chin to reveal a crumbling Ionic column in place of the spine. Sharp nails of different sizes pierce her flesh, penetrating just enough to stay in place but having no other apparent purpose than to exacerbate the torture. . . . Her tears stream down freely, but her expression is unmoved. She seems to be saying, 'I am this decaying body. My suffering is as infinite as the horizon line. But I am something more, something enduring

Of particular interest regarding judgments of Kahlo's work is the intermingling of biographical facts with these judgments. Even a permanent exhibition of her work mixes the two: Her birthplace and home in Coyoacán, on the southeastern edge of Mexico City, is now the museum for her paintings. Few critics fail to give biographical information when writing about her paintings. They find her life fascinating. Meyer Raphael Rubinstein, for example, in an article in *Arts Magazine*, quotes a Kahlo letter about being in Paris with its art crowd: "You have no idea the kinds of bitches these people are. They make me vomit. . . . They sit for hours on the 'cafes' warming their precious behinds, and talk without stopping about 'culture' 'art' 'revolution' and so on and so forth thinking themselves gods of the world . . . shit and only shit is what they are." 12

Angela Carter writes lovingly of how "Frida Kahlo loved to paint her face. She painted it constantly, from the first moment she began seriously to paint when she was sixteen up till the time of her death some thirty years later. Again and again, her face, with the beautiful bones, the hairy upper lip, and batwing eyebrows that meet in the middle." 13 Carter also interprets Kahlo's hair as a metaphor in her life. "If wild, flowing hair is associated with sensuality and abandon, then note how the hair of Frida Kahlo, the most sensual of painters, hangs in disorder down her back only when she depicts herself in great pain, or as a child." Carter relates that Kahlo cut off her hair after she divorced Rivera for a year in 1940 and then grew it back and plaited it. Carter, like Herrera, argues that Kahlo's paintings emerged directly and irrevocably from her life: "Her work as a painter came out of that accident; she painted in order to pass the time during the lengthy period of recovery nobody ever really expected. . . . The accident and its physical consequences not only made her start to paint, they gave her something to paint about. Her pain." Carter, like Herrera, praises Kahlo for her choice of self as subject matter, for overcoming pain through art, for her suffering, for revealing herself, for being a woman.

Serge Fauchereau, however, calls such biographical information "extrapictorial." He writes that "most of her strengths are extrapictorial; her work moves us, intrigues us, but we don't look to it for the formal qualities that one discovers in a Tamayo or even a Mérida." He writes that "her friends, lovers, infirmities, abortions, and obsessions are part of the subject of practically all her paintings" and that "ordinarily, all this would not necessarily relate to the artist's work, yet in the case of Kahlo one cannot overlook it, since her art is openly autobiographical."

Most of the critics quoted here who value Kahlo's work do not seem to have intellectual difficulty in meshing Kahlo's art and biography, but Plagens, and probably others, are uneasy with such a merge. These latter would rather keep biographical information from interfering with aesthetic judgment. This was certainly the

137

old position held by formalists, who wanted the viewer to concentrate solely on the work itself, particularly its formal properties, and not be distracted by factors they considered extra-aesthetic and therefore irrelevant to art. Recent critics, however, tend to ignore or disdain the separation of biography and social context from critical judgments. (This specific issue is examined more carefully in Chapter 2, on theory.) In summary, then, critics such as Plagens and Herrera may agree on facts but disagree on the value of those facts. Plagens and Herrera have similar descriptions and interpretations of Kahlo's work, but they disagree about its worth—perhaps because they hold different criteria. Plagens, for example, favors formal invention over emotionally gripping narratives in paint. That critics disagree about the same art is healthy if it causes viewers and readers to think through the issues and draw their own conclusions. Different judgments offer us different lenses through which we may view art.

About ten years after Plagens's derision of overenthusiastic "fans" of Kahlo, Peter Schjeldahl acknowledges that he is "nearly a cultist, myself." After seeing her retrospective at the Walker Art Center in 2007, he writes, "much that is hurt and disappointed in me feels allayed, and almost healed, when I am in the spell of her art." Her self-portraits reassure him of two things: "First, that things are worse than I know, and second, that they're all right." He argues, "Kahlo's eminence wobbles unless her work holds up," and asserts that "Kahlo is among the winnowed elect of twentieth-century painters who will never be absent for long from the mental museums of future artists." ¹⁵

JUDGING MARTIN PURYEAR'S SCULPTURES

Robert Hughes, in *Time* magazine, writes that for an artist like Puryear, "Beauty without cliché is a supreme goal, and there is probably none around who exemplifies this shift better than the sculptor Martin Puryear." ¹⁶

There is general agreement that Martin Puryear makes wonderful sculptures. Neal Menzies writes, "Were this the Middle Ages, he might be called the Master of the Forms Which Evoke Feelings." Ann Lee Morgan writes that "like the best art of the twentieth century, his is a vibrant meditation on what art can be." Kenneth Baker writes that Martin Puryear's "situates itself like no other contemporary art." In *Art in America*, Nancy Princenthal calls him "one of the leading contemporary interpreters of form." Carole Calo, in *Arts Magazine*, claims that he is "one of the most exciting and influential sculptors working today." Peter Schjeldahl writes, "Coming upon sculptures by Martin Puryear is always an arresting pleasure." Donald Kuspit refers to Puryear's work as "extraordinary sculptures." What reasons do these critics give for their judgments?

Hughes explains that twenty years ago, beauty was often looked down on in the art world as mere decoration; but in art, things go "in and out of focus." Sculptors value craft, but many sculptors, especially minimalists, hired fabricators. "But the

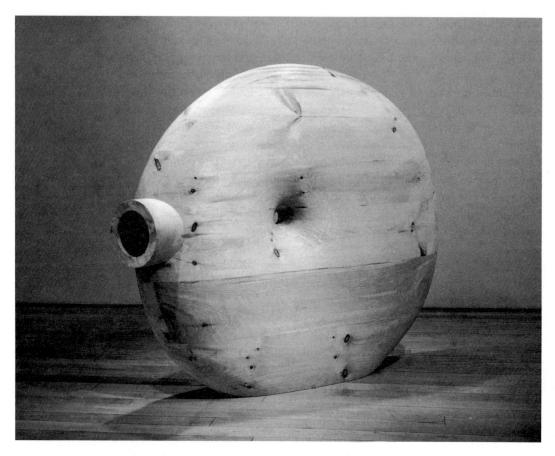

Martin Puryear, *Deadeye*, 2002. Pine, 58 $1/4'' \times 68 \ 1/16'' \times 13 \ 3/8''$. © Martin Puryear, Courtesy of Donald Young Gallery.

special intensity of Puryear's work comes from doing everything himself, mainly in wood (though tar, mud, and wire figure in his repertoire). Through the action of the shaping hand on wood, he brings forth a poetry of material substance that is unique in today's America."²⁴

Suzanne Hudson writes in *Artforum* that "Puryear's work is almost perfect. Yet he also advises that the almost is what matters." To her it is important this his craft is not perfectly fabricated. It is rather, "blue collar," "retaining the handmade." He has an "ethic of making—its relation to manual labor, class, and craft as well as to folk technology (basket weaving, tent and yurt construction, and so on). Even his woods are functional—pine, spruce, hemlock, ash, and fir—and not rosewood or walnut, which are comparatively baroque."²⁵

Menzies rates Puryear's sculptures so highly because they present "a variety of emotional states that range from lightheartedly playful to dangerously sinister and forms and meanings from the past with sophistication and elegance, investing each synthesis with his own civilized and passionate sensibility—an introspective self-sufficiency entwined with a romantic attraction to the unknowable, to feeling, and to nature." Calo admires Puryear's work because he "is an independent talent who values his own individuality and refuses to conform to what is considered 'in' and marketable. His increasing national recognition attests to the ability of talent, skill, integrity, and vision to override fashion."

Calo, eloquently and with impassioned writing, sums up her thoughts about

serious." Morgan backs her praise with her observations that Puryear "recharges

Calo, eloquently and with impassioned writing, sums up her thoughts about the appeal of his work this way: "Martin Puryear's evocative objects appeal to our frazzled spirits. In sculptures that resolve dichotomies, yet present paradoxes, there is a tension that insistently reminds us of the complexity of being. As Puryear reintegrates human experience, nature, and a primal life force, we become aware of the impoverishment of our modern lives. A universal consciousness that extends beyond chronological, geographic, or socioeconomic boundaries is expressed in objects which fuse art historical awareness, primitive allusions, and technical sophistication. With quiet conviction Martin Puryear reconciles the disparate fragments of modern existence with the timeless texture of being, instilling in us a longing for a sense of connectedness and wholeness."

These evaluations of Puryear's work are clearly favorable and enthusiastic, yet they are somewhat vague: Kuspit, for example, refers to Puryear's vessels as "having some of mystery (a heart of darkness, as it were) . . . in their shapes, which, however familiar, have something odd about them having to do with their appendages, holes, and lines."26 If one read these judgments without visual memories or reproductions of Puryear's work, one would probably not be able to imagine what his works look like. This is partially so because his work is so different from that of other sculptors, and critics writing about him acknowledge this directly or allude to it, as in the preceding quotations. His work shows "what art can be," not what it has been. He is "independent" and he refuses to conform to what is considered "in." Princenthal states that his work has "surprising variety," which affirms that it is difficult to write accurate generalizations about it. Schjeldahl writes, "A typical Puryear is as tensed and silent as a held breath. Its form may seem more the idea of its materials than of its maker. . . . Puryear shows how to matter in the world: be interested and thereby, perhaps, interesting, as often and for as long as you can."²⁷ One of the problems of writing about any new and different work is that the critic has to invent ways to write about it.

Sculpture (and performance art) is perhaps difficult to present in writing because reproductions of sculpture are even less adequate than reproductions of paintings or photographs, for instance. In most reproductions of the latter, we lose size and scale, and usually color is distorted; in reproductions of sculpture, however, we also lose the all-important third dimension.

The critics' judgments of Puryear's sculpture might also be vague because critics see it as powerful but mysterious. They hesitate to, or can't, pin it down in

Each of the critics who writes about his work describes and interprets it as well as evaluating it. In an *Artforum* review of a Puryear show, Colin Westerbeck is complimentary of the work but is primarily descriptive and interpretive. He draws an interesting inference about some of Puryear's hutlike pieces from observations about the artist's personality: "From his reticence in interviews and his obvious shyness on public occasions, it is clear that Puryear is a very private person. Several pieces looked as if they were attempts to build a refuge for himself, a hiding place, an interior space large enough for only one man." ²⁸

Most critics writing about Puryear's work mention one or more of his three major sources of inspiration: other art, other cultures, and nature. They relate his work to the minimalist sculpture of the past but quickly point out how Puryear's work is different from minimalism. Morgan states that Puryear rejects minimalism's disavowal of the expressive self. Calo states that Puryear's sculptures are influenced by an awareness of minimalism, but that, unlike minimalism, they are "imbued with interiority," and that, unlike with minimalism, "there is an underlying sense of the human gesture in his work." Princenthal relates his work to that of sculptors Arp, Brancusi, Noguchi, and Bourgeois, but she too talks about how his work is different from that of artists who may have influenced him: "Puryear's accomplishment is to keep such sources in constant, allusive play with other, non-Western references, all the while asserting his own highly idiosyncratic sense of sculptural form."

One non-Western reference Princenthal is referring to is African. She and other critics writing about Puryear usually tell the reader that the artist is an African American and that he worked in the Peace Corps from 1964 to 1966 in Sierra Leone, Africa. She also writes of his firsthand experiences with tribal art and credits these for the "eerie, almost shamanistic sense of presence that emanates from" his work. Princenthal notes that he did a series of installations dedicated to Jim Beckwourth, an African American frontiersman, and an installation inspired by the yurt, the domed and portable shelter used by nomadic Mongols. Others speak more generally about his references to ritual function. Judith Russi Kirshner, for instance, writes in *Artforum* that "his objects, which connote ritual function but of course have none, communicate through the very intensity of their making." Calo writes of his "raw primal objects," his "primitive allusions," and his interest in "communal or tribal ritual and patterns of behavior."

Critics also point out Puryear's surprising unification of African and Scandinavian cultural influences. The artist has long had an interest in woodcraft and has

141

studied woodworking techniques, both in furniture making and in shipbuilding, from craftsmen in Africa and northern Europe, as well as America. Ann Morgan relates his work to both culture and nature: "He recharges forms and meanings from the past with sophistication and elegance, investing each synthesis with his own civilized and passionate sensibility—an introspective self-sufficiency entwined with a romantic attraction to the unknowable, to feeling, and to nature."

Calo mixes her interpretation of Puryear's work with praise for it. She identifies his themes as "change, mobility, survival, captivity, and communal or tribal ritual and patterns of behavior." For her, his forms are "highly evocative and distinctive." She attributes the formal and emotional tension in his work to his fusing of opposites into meaningful wholes: raw primal objects and sophisticated craftsmanship; an ever-present dialogue between open and closed, linear and massive forms; his simultaneous investigation of interiority and exteriority; a reconciliation of such diverse materials as wire mesh, tar, oak, steel, and wire. Princenthal also observes Puryear's unification of seeming opposites: "A tension runs through Puryear's work between the insinuatingly graceful and the unabashedly awkward." Menzies writes that Puryear evokes "a variety of emotional states that range from lightheartedly playful to dangerously sinister and serious."

In general, these critics praise Puryear's work for its inventiveness with materials, for its successful mixture of bizarre forms, for its workmanship, which exhibits great skill but stops short of fastidiousness, and for the evocative presence his pieces have. Importantly and significantly, they praise Puryear's sense of form but also enjoy the works' references to life and to other cultures. Thus, for them, Puryear's art works on formal grounds, but its content is not limited to art about art.

Kahlo's art is very specific and Puryear's is vague. Those who like Puryear's work are likely to be comfortable with ambiguity. Different art evokes different reactions and calls into play different criteria.

JUDGING ROMARE BEARDEN'S COLLAGES

Joanne Gabbin, a scholar of African American literature and an author, has written a lovely passage about a woman lying on a bed in a collage, *Patchwork Quilt*, made by Romare Bearden in 1970 (see Color Plate 15).

She represents continuity. Her figure dominates the collage with bold darkness. Shades of black, brown, tan, and red suggest her diverse heritage and her beauty. She is Africa, rooted in the fertile soil of Egypt and Ethiopia, her feet replicating those that graced the burial vaults of the great pyramids. Her torso is stiff and shapely like that of a Ghanaian fertility doll. She is Antilles with her breast ripe to suckle generations of slaves who would endure ocean passage, slavery, and repressive conditions. She is the intense, blues-tinged elegance of America, bowed yet unbent. Her face resembles an African mask in its angularity, softened only by the rose bandanna that circles her head. She is in the past and the present.³⁰

Gabbin's remarks are very descriptive and interpretive, yet it is clear by her choice of descriptors that she greatly admires the collage. In fact, this quotation is taken from a two-page "Appreciation" of Bearden in a book of art history. It is a tribute to him by a fellow African American written after his death. Bearden died at age 75 on March 12, 1988. In her brief essay, Gabbin provides much biographical data about the artist. She informs her readers that Bearden was born in 1914 and that he grew up in Harlem during the Harlem Renaissance. She writes that jazz musicians Duke Ellington, Fats Waller, Earl Hines, Count Basie, Ella Fitzgerald, and Cab Calloway influenced the spontaneity and rhythms in the collages Bearden made of remembered performances by these renowned musicians. She also informs us that because of childhood sojourns to Charlotte, North Carolina, and his connections with the people of surrounding Mecklenburg County, he is rooted in southern black culture. She praises Bearden's "spirited originality" and relates that he studied with George Grosz, that he knew Constantin Brancusi and Georges Braque, and that he also studied at the Sorbonne in Paris, where he explored French impressionism. She writes that he knew traditional Chinese painting; seventeenth-century Dutch genre painting, from which he learned about representing interior space; and African tribal sculpture; as well as cubism, surrealism, and the social realism of Diego Rivera.

In another tribute to Bearden published shortly after his death, Michael Brenson, in The New York Times, wrote about Bearden that "in his hands, water, paste, paper become instruments of an orchestra, threads in a novel."31 He also writes that "Bearden was a grand intimist, an improviser who knew all the rules, a virtuoso collagist for whom cutting, tearing, daubing, and pasting were both an interior journey and a narrative adventure. His work is spontaneous and hieratic, rigorous and sensual." However, Brenson faults some of Bearden's work, especially his larger pieces, in size as well as theme—"When he set out to make epic statements, the results could be anecdotal." But he goes on to say that Bearden was a master when he worked on a smaller scale and with personal experience: "No postwar artist poured more epic feeling into intimate content and scale." He adds that "the collages have a voluptuous immediacy." Brenson also praises the consistent growth and unified development of Bearden's work at a time in American art when a rapid change of styles was being rewarded: "His art grew freer, wiser, more poignant in a way that is rare in postwar American art, where the demand for newness and change has pressured artists into defining personal evolution as continually re-creating themselves from scratch." Brenson writes that Bearden's culture always remained important to his work, even at a time when the art world was hostile to narrative, to "memory and place, and preferring art that challenges conventions." Brenson likes the fact that Bearden went against the art world by keeping his work intensely personal. He writes that Bearden chose to depict New York City jazz clubs and family gatherings in the rural South—"the artist as bard whose duty is to give voice to members of the human comedy who cannot always speak for themselves." About women, whom Brenson gives some biographical information about Bearden not mentioned by Gabbin. He was born in the rural South. He played baseball. He wrote songs and studied jazz, literature, and art. He began making collages when he was fifty. He was involved in the civil rights movement and the black artists movement. He was in sympathy with Native Americans because of childhood experiences on a Cherokee reservation in Mecklenburg County, North Carolina. Brenson claims that Bearden remained an outsider in the art world even though his art was well recognized and that in the 1960s his collages on social themes and black history began to reach a wide audience.

Peter Plagens reviewed a large retrospective show of 140 of Bearden's works that traveled to Chicago, Los Angeles, Atlanta, Pittsburgh, and Washington, D.C. Plagens praises his work: Bearden "found not only a perfect match of subject (urban life in Harlem and memories of its rural Southern roots) and medium (collage). He also discovered a working method with which he could distill sentiment into real beauty. In Bearden's best work, the color sense is every bit as fine-tuned as Josef Albers's (and a lot less lablike) and the composition is as tight as that of Stuart Davis, whom Bearden admired."³² He goes on to write that Bearden used "ingeniously incongruous figure fragments" and "blazing reds and subtle grays" with "surgeon's scissor cuts." Plagens says that "Bearden could hold together a bigger straight collage than just about anyone else, with the probable exception of late Matisse. Moreover, with his chromatic shards, Bearden constructed a visual narrative of the black American experience that is finally the equal of the same epic tale told in music and literature." Plagens concludes his review by writing that Bearden's collages are "a major statement in American art."

Plagens acknowledges that Bearden never made it into the big history books as did his peers, such as Jackson Pollock and Yves Kline. He agrees with the authors of the exhibition's catalog that Bearden's being black was "a likely factor." But the main reason was his style: "Bearden was simply out of step during the heyday of gargantuan abstract painting (the largest picture he ever made was a parlor-size $60^{\circ} \times 56^{\circ}$)."

Plagens notes still other biographical facts. Bearden studied math at New York University. Bessye, his mother, was an editor of the *Chicago Defender* and played host to such prominent people as W. E. B. Du Bois, Paul Robeson, and Langston Hughes. Bearden was a jazz musician, and Billy Eckstine recorded the tune "Sea Breeze," which Bearden wrote. In addition to being a musician, we learn from Margaret Moorman, Bearden was also a fine writer. In an article about the artist, she quotes Bearden's friend Barrie Stavis, a playwright, saying that "Romie was a brilliant writer. Had he elected to write rather than paint, he would have left a legacy in writing as important and universal as the legacy he left us in paintings and collages." Plagens informs us that Bearden was a social realist for a while,

painted "pretty cubism" for a while, and went to Paris when abstract expressionism came in. He lived above the Apollo Theatre in Harlem in the early 1950s and, according to Plagens, took up "a mild, Zen-ified version" of abstraction. He was awakened by the civil rights movement of the early 1960s and founded Spiral, a black artists' group.

Elizabeth Alexander, in a review of Myron Schwartzman's biography of Bearden, provides a one-sentence summary of Bearden's subject matter: "His iconography was magically commonplace: trains seen through doorways, roosters, doves, saxophones, trumpets, washtubs, clouds." She also informs us that the family of Bearden's wife owned a home in St. Martin, the Caribbean, and claims that that landscape influenced him, as did the tiger lilies of South Carolina. She also writes that "the artist was a clever man, analytical and incredibly well-read, humble without being the least bit self-effacing." ³⁴

Nina ffrench-frazier writes that Bearden's collages, "made from vividly colored paper cutouts and reading, like glowing Persian tapestries, as flat brilliant patterns and multiple intersecting planes, are peopled by two-dimensional, silhouetted, allegorical, masked beings identified by emblematic attributes." ³⁵

In a feature article in Artforum, Schwartzman interprets Bearden as absorbing the legacy of the cubists, Matisse, and Mondrian but transforming "the legacy into a Southern idiom, always stressing the ceremonial dimension in Southern life which gives it universality."36 In addition to the influence of European artists, Schwartzman also writes, Bearden's "work stems from a creative conflict with an enormous range of predecessors: Dutch, French, Italian, Mexican, Japanese, Chinese, and African." In a further interpretive statement, the critic writes that "as a meditative human being, Bearden wishes to preserve the uniqueness of his own experience, and, by extension, part of America's experience, from demolition by modern technology and the pace of life it dictates." Schwartzman relates that in the 1960s Bearden painted his own papers before pasting them down on hard masonite and writes about two sets of artworks Bearden produced in the 1970s, "Of the Blues," a series of collages, and "Of the Blues/Second Chorus," a series of oils-on-paper, or monoprints. The critic tells us that the novelist Albert Murray wrote the catalog introduction for "Of the Blues" and virtually all of the titles of individual pieces in both exhibitions. About these works, Schwartzman writes that Bearden "was coming to exploit the possibilities of collage as an improvisational medium in a way that allowed him to unite a freer, more open approach to the canvas with his very subject matter, blues improvisation." The critic concludes by praising Bearden because "he has simply continued to grow by resynthesizing all his past work with each new modulation in style." Ellen Lee Klein reinforces this view in her review of a show late in the artist's life: "There seems to be a new kind of exuberance and an intensified richness in his palette and in his freely combined and applied media. This is an enchanting and personal show which reveals the kind of liberation that comes with maturity and experience."37

145

In the mid-1980s, the Detroit Institute of Art commissioned Bearden to produce a huge mosaic for its centennial. He made *Quilting Time*. Critic Davira Taragin found the mosaic medium and theme to be well matched: "It echoes the piecing together of the colourful bits of fabric while continuing the collage technique of building forms from small pieces of paper called tesserae. The juxtaposition of colour and line and the recurring themes of music and women make this piece a culmination of the artist's work over the past forty years." Taragin's positive judgment of one of Bearden's large and monumental works goes against reservations Brenson and Plagens express regarding those large works. Nonetheless, Bearden's collages do attract the most critical attention. About them, Nancy Princenthal writes that although Bearden painted for thirty years before making collages, "the agility with which Bearden handles collage is undiminished; like his dauntless approach to sentimentality, his control of cut and torn paper recalls Matisse. So does his fluent use of saturated color." 39

Mildred Lane, a curator at the Kemper Museum of Contemporary Art, which owns some of Bearden's works, writes that collage is "a particularly well-suited means of responding to and representing the simultaneity of difference within everyday life . . . a means to bridge the gap between art and life." She argues that Bearden used collage as a strategy to "register deconstruct issues of race and identity" in Bearden's life in America. He always emphasized "the composite aspects of African American life as an amalgamation of disparate elements," refusing to oversimplify and reduce racial identity to something essential and fixed. Bearden's use of collage allowed him "to mediate among a Western tradition of art he so greatly admired, contemporary popular culture, and the politics of multiethnic and racially divided American society in which he lived."

In summary, critics evaluating an artist's work sometimes attempt to decide which particular pieces of an artist's whole body of work are the best. The critics evaluating Bearden's works who are cited here all agree that Bearden made good art, and they give reasons for their assessments; some then go on to argue that his collages are better than his paintings. Many of these critics provide biographical information about Bearden, and some claim that he could have been a successful musician and playwright. Some draw connections between the art of jazz and Bearden's art of collage. The critics also relate Bearden's urban and country experiences and discuss how he embodied aspects of both urban and rural situations in his work. Some praise him for capturing the black southern experience and its rural roots, and others praise him for finding the pulse of the black urban experience. With the help of biographical information, these critics formed interpretations of his work, and on the basis of their understanding of it, they went on to praise it. Thus description, interpretation, and evaluation are meshed in these examples of critical writings about Bearden.

Some critics followed the progression of Bearden's style and concluded that he kept refining his vision, staying within a style and resisting what may have been

David Salle, *Childhood*, 1998. Oil on linen, $96'' \times 118''$. Art © David Salle/Licensed by VAGA, New York, NY.

a temptation to change styles radically, because his more economically successful counterparts in the art world at the time were being rewarded for such radical stylistic changes. Thus his consistency is praised, especially in comparison to other artists of his time.

EXAMPLES OF NEGATIVE JUDGMENTS

The judgments of most critics examined so far in this chapter have been generally positive or have held only a few reservations. The following judgments are primarily negative and offer us other interesting examples to consider. They revolve around the paintings of David Salle. In a feature in *Art in America* on the painter, Eleanor Heartney disapproves of Salle's paintings because she sees them as sexist:

The images of men in Salle's paintings "tend to embody the sphere of action, decision making amid societal constraint denied women. There are images of matadors (conquest and domination of brute animal force effected with the sexually charged sabre); iconic profiles of Abraham Lincoln (frequently positioned suggestively over portions of a female body, perhaps as comment upon our culture's discomfort with the idea that public figures have private lives); bone-weary workers or fist-waving agitators; and assorted pop-culture or otherwise clichéd male characters including Santa Claus, Donald Duck, and Christopher Columbus." She also faults him for depicting Third World women as "Other" in a *National Geographic* style.⁴¹

Heartney is not alone in rejecting Salle's paintings as sexist, and these other critics are more blunt in their rejections. David Rimanelli, in a review in Artforum of Salle's work, wrote that "a woman artist I know likened a visit to a David Salle exhibition to a gang bang."42 Rimanelli characterizes Salle's work as "his trademark girlie pinup images" and "the flagrant beaver shots we have come to expect." The critic continues, "He makes fools of them [women] putting them through their paces as circus entertainers assembled for his amusement." Rimanelli offers the psychological conclusion that Salle's work is about "overcoming a desperate sense of masculine inadequacy by showing women—uh, excuse me, girls—as helpless and hopeless." In an earlier review in Flash Art, Laura Cottingham writes a two-paragraph dismissal of Salle's paintings. In the first, she faults them on formal grounds—"his assemblage technique is reductive of itself" and his work exhibits an "utter lack of draftsmanship."43 Then, like these other critics, she also rejects the sexism of the work, writing that he has a "mundane proclivity for sado-masochistic trappings. A crotch-intensive perspective holds Salle's eye most emphatically: panel by panel of female figures, fetishized by posture or prop, create the dominant motif. Salle seems to insist on a distinctively male heterosexual dialogue in painting: why else the repetitive assault."

Just when it seems there may be a comfortable consensus among critics about Salle's sexism, however, Robert Storr offers an objection. Writing in the same magazine and the same issue as Heartney, Storr claims "the issues raised by David Salle's work cannot be reduced to the question of its representation of women." He argues that "the real object of Salle's contempt is not so much women and blacks per se as it is anyone who would insist that the subject represented might in some way have a proprietary interest in their representation, or anyone who would presume to invest in pictures any residual belief in the intrinsic identity of sign and meaning." Heartney forcefully objects with a series of rhetorical questions whose answers are implicit: "Does an ostensible refusal to embrace legible meaning ultimately become a moral issue? Can and should decisively sexual subject matter be rendered in a manner that is free not only of judgment but even of any implied value system? Does the reproduction of imagery which objectifies women serve to expose, or does it rather exploit, female subjugation within a patriarchal society? Is deconstruction of matter without some form of reconstruction enough?"

OPPOSITE JUDGMENTS OF THE SAME WORK

In The New Criterion, a journal founded and edited by Hilton Kramer as a vehicle for conservative writing about the arts, Jed Perl rejects a show he has not seen, only read about: "I have been rather horrified to read about Vito Acconci's recent work—some oversized brassieres that double as seating units, at the Barbara Gladstone Gallery-in articles where these contraptions are discussed as if they were part of a distinguished tradition. All traditions are not equal."45 So, in an effectively rhetorical fashion, Perl writes that he is "horrified" about Acconci's work, and horrified that it is even being seriously considered by critics. It is below him and his sense of artistic tradition, and, although he has not even bothered to see the show, he feels comfortable dismissing it in print because of his ideological stance toward art. A. M. Homes has seen the show, however, and she writes about it very positively in Artforum: "Mammoth plaster, canvas, and steel-cable reinforced structures, Vito Acconci's four Adjustable Wall Bra pieces, 1990–1991, spanned the gallery with the sensual grace of a garment flung across the room to land half on the floor, half against the wall, bent, twisted, and possibly still warm." 46 She refers to the "hysterical proportions" of the sculpted bras that she describes as being fitted with lights, seats, video, and the sound of music or a woman breathing. She praises Acconci for always challenging himself, his gallery spaces, and the viewers of his work. She likes that he "returns to the personal, the sexual, and the taboo." She argues that he expands the associations of the bra as it has been reinvented in tandem with shifts in society's attitudes toward women's bodies. He creates a home for the body. She further writes, "On a recent afternoon, I snuggled into one, watched cartoons on the monitor, and thought 'This is the life.' This would be the life, if only the cups had more padding. But even the discomfort is in keeping with Acconci's dialectic. Of course the seats are not comfortable; why would they be? Who ever heard of a comfy brassiere, a comfortable house, or a comfortable life for that matter?"

Perl's writing may be effective in that he may encourage others to adopt his point of view and discourage others from seriously considering this work of Acconci's, but it is not acceptable criticism. It is too dismissive. It is a pronouncement rather than an argument. It does not enlighten readers about the art in question. A reasoned

APPRAISALS, REASONS, AND CRITERIA

Complete critical judgments are composed of appraisals of the work in question, reasons for the appraisal, and criteria on which the appraisals and reasons are based. "Ratings, reasons, and rules" is another way of thinking about appraisals, reasons, and criteria.⁴⁷ In the preceding section, Perl offers a clear appraisal (or rating) of Acconci's new sculpture: It's not worth his time. He does not, however, give us the reasons or criteria (rules) for this appraisal, although if we were to examine his whole article, his reasons and criteria would probably emerge. Rimanelli, also quoted earlier, disapproves of David Salle's paintings; his appraisal is clearly negative. His reasons for his negative appraisal are that Salle paints "girlie pinup images" and "flagrant beaver shots" and that "he makes fools" of women by representing them as "hopeless and helpless." Although Rimanelli does not state his criteria explicitly, we can easily infer that he believes art that depicts women should not degrade them. Several critics quoted earlier in the chapter wrote clear and complete positive judgments of Martin Puryear's sculptures. Neal Menzies praises Puryear's sculptures because they present "a variety of emotional states that range from lightheartedly playful to dangerously sinister and serious." His reasons are clear, and so is his criterion: Art is good when it expresses emotions. Carole Calo appraises Puryear as "one of the most exciting and influential sculptors working today." Her reasons are that he is independent, refuses to conform to the art marketplace, and overrides fashion; her implied criterion is that artists should be independent in their visions and not succumb to the pressure of what sells.

Criteria are rules for art making. They are "shoulds." They are "dos and don'ts." In critical writing, they are usually implied rather than stated explicitly by the critic. But they are usually easily uncovered as long as the critic provides reasons for his or her appraisals. Explicit, spelled-out criteria are more readily found in theoretical writings, aesthetics, or philosophies of art. Most of us carry around assumptions about what art should be: It would be a good critical exercise for anyone to attempt to be explicit about what he or she believes art should be or not be, do or not do.

TRADITIONAL CRITERIA

Art is judged by many different criteria, and, although it is an oversimplification, these criteria can be separated into four categories, or theories of art: realism, expressionism, formalism, and instrumentalism. These theories predate postmodernism. Realism, expressionism, and instrumentalism can be thought of as premodern, and

formalism is synonymous with modernism. Although we inherit these theories from the past, they can still be useful in thinking about contemporary art. Contemporary artists continue to make art within these traditions, and critics continue to be informed by traditional theories of art, even as both critics and artists update them with postmodernist influences.

Realism

A critic advocating realism as the major criterion of art would hold that the world, or nature, is the standard of truth and beauty and that the artist can do no better than try to accurately portray the universe in its infinite variety. Realism is as old as the ancient Greeks, backed by the authority and knowledge of Aristotle, rejuvenated during the Renaissance, and embraced at various times and places throughout the history of art. Realists show the world as they see it, as it ought to be, or as it ought not to be. Realism is closely related to idealism, often showing how things should be.

John Szarkowski, a former and influential curator of photography at the Museum of Modern Art in New York, wrote that the basic premise of realism is that "the world exists independent of human attention, that it contains discoverable patterns of intrinsic meaning and that by discerning these patterns, and forming models or symbols of them with the materials of his art, the realist is joined to a larger intelligence."

Linda Nochlin identifies and specifies realist criteria when she contemplates Chuck Close's painted portrait of Nancy Graves, *Nancy*:

This is a realist image in that it testifies at once to the existence of the subject in the "real" world beyond the painting and, at the same time, to the concrete, material presence of the acrylic on canvas: a testament to the labor that created this nonvirtuoso display of the artist's patient handwork. The austerity of the production—its lack of color, its stark presentation of image, its refusal of painterly self-indulgence or "personal sensibility"—is also part of the realist ethic. And its exactitude, the unflinching depiction of hairs, wrinkles, askew glance, the gleam on a random tooth, reminds us of the origin of portraiture in magic and memorial. 49

Nochlin's understanding of realist criteria is consistent with Szarkowski's. According to Nochlin, realist work has these characteristics: It acknowledges something outside itself in the world (its concerns are not limited to self-awareness, and it is not overly self-referential, as are many formalist works); the handling of materials is not overly self-indulgent (as can be the case with expressionist work); the artist's technique is subservient to the subject of the work; and the work is exact in depicting the subject.

Janet Fish is a contemporary painter working in the realist tradition (see Color Plate 17), and critic Robert Berlind in *Art in America* praises the realist art of Janet

Fish for never showing any technical strain: "Janet Fish's lavish still lifes propose a sort of hedonist sublime. For all the complexities of their gorgeous dishevelment there is never any technical strain or slowing the pace to wrestle some intractable optical phenomenon into painterly form. Rumpled pink satin is seen through a curvy, yellow-tinted glass bowl, and light projects through that bowl onto the cloth; a patterned blue-and-ocher material is seen through a green-tinted water pitcher, which also reflects a yellow wrapper. Working at a scale often three or four times life size, she notates a multiplicity of optical effects with a fluent, improvisatory performance that makes it all look easy." ⁵⁰ In his comments Berlind reinforces Nochlin's criterion that realist art in its technique ought not be overly self-indulgent and that it ought be subservient to its subject. If her work were strained, it would detract from the world outside itself to which it directly refers.

While Fish's realism is celebratory regarding aspects of daily life it shows, another contemporary realist, Walton Ford, makes paintings and prints indebted to nineteenth-century naturalist painting, referencing "rich white men who scoured the globe for 'specimens." According to Martha Schwendener in *Artforum*, "Ford splendidly shows how the two histories [nature and culture] are intertwined and how the treatment of animals and the extinction of various species serve as an analog—and possibly warning—for our own." ⁵¹

Expressionism

Expressionism (also called expressivism) is a popular and appealing theory of art asserting that "artists are people inspired by emotional experiences who use their skill to embody their emotions in a work of art, with a view of stimulating the same emotion in its audience." In 1800 Wordsworth, the romantic poet, characterized art as "the spontaneous overflow of powerful feeling."

Szarkowski contrasts realism and expressionism and writes this about expressionism (although he uses the term *romantic*): "The romantic view is that the meanings of the world are dependent on our own understandings. The field mouse, the skylark, the sky itself do not earn their meanings out of their own evolutionary history, but are meaningful in terms of the anthropocentric metaphors we assign to them." Expressionism favors artists and their sensibilities rather than nature. Artists' inner lives are potent, and their feelings about experiences are the source of their art. They use medium and form and subject matter to express their inner lives. It is their business to express themselves vividly so the viewer may experience similar feelings. Intensity of expression is much more crucial than accuracy of representation. Certainly expressionists are sensitive to form, but whereas the formalist sees art as being primarily about itself and other art, expressionists embrace art about life.

Art critic Barbara Rose praises Anselm Kiefer's paintings for being "conceptually and technically brilliant," and her criteria are expressionist. She refers to Kiefer's

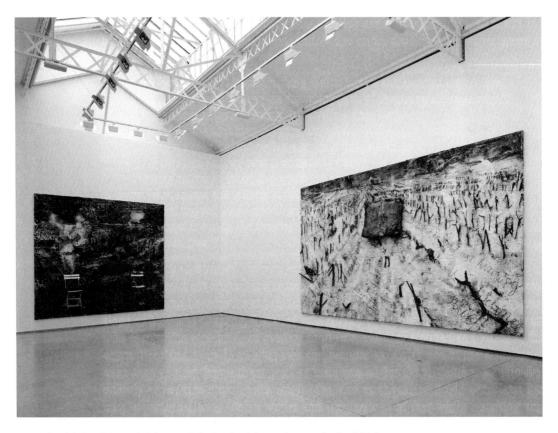

Anselm Kiefer, Für Paul Celan at Galerie Thaddaeus Ropac, Paris, 2006.

© Anselm Kiefer. Courtesy Galerie Thaddaeus Ropac, Paris/Salzburg. Photo by Charles Duprat. Courtesy of Gagosian Gallery.

concentration on Nazi Germany: "This is history painting that equates man the builder with man the destroyer; its epic sweep and cosmic energy deny the importance of the individual and negate the concept of the hero." She tells her readers about Kiefer's process of using sand and clay mixed with acrylic and shellac, and she draws interpretive inferences from his vivid use of media: "The grains of sand are numberless. Millions? How many millions? This century's tragic death toll eludes statistics." In his comments about a different exhibition of Kiefer paintings, critic Ken Johnson emphasizes the experience of viewing the work, an essential measure for expressionists: "Kiefer is indisputably a master of the awesome effect. The enormous bulk of his works, the vast scale of their imagery, the elephant-skin surfaces, the grand allusions to history and mythology, the profound brooding on death—all this can combine to produce a thrilling experience." 55

Robert Berlind, a critic reviewing an exhibition of Leon Golub's paintings (see Color Plate 6), also uses expressionist criteria. He interprets the subject of the paintings to be "Golub's massive complaints about the inevitability of pain, aging, indignity, and death." ⁵⁶

Expressionism emerged during the 1800s and continues, but was given new depth by the addition of cognitivism in twentieth-century art theory. Cognitivism asserts that art provides knowledge of the world in unique and powerful ways. Art is a special way of knowing. We can know the world through emotions, emotional intelligence, intelligence informed by emotions, and emotions informed by thought. We "celebrate some works for their profundity, their insights, into the human condition, for how they make us see the world anew; we criticize other works for their shallowness and their escapist pandering to people's illusions." Some works of art teach us in nontrivial ways, and their capacity to do so is an aesthetic value.

Formalism

Formalism is a theory of "art for art's sake," and the term *formalism* should not be confused with *form*. All art has form. The theory of formalism, however, asserts that form is the only criterion by which art should be judged. Formalists hold that aesthetic value is autonomous and independent of other values: According to them, art has nothing to do with morality, religions, politics, or any other area of human activity. In this view, the realms of art and social concerns are by their natures distinct, and the artist is alienated or separated from society.

The theory is new to art, introduced in this century, primarily through the writings of Clive Bell in the 1930s. To Bell it would not matter whether a crucifixion painting is of Jesus Christ or John Smith: It is not subject that counts, but form. For formalists, narrative content in art is a distraction from the aesthetic and should be ignored, and politics as the content of art is anathema. Formalism was given new impetus in the 1950s and 1960s by the influential criticism of Clement Greenberg, who championed abstraction of certain sorts, particularly minimalism. Formalist criticism grew up alongside New Criticism in literature and as a reaction against the excesses of biographical criticism, psychological criticism, and any other type of criticism that was thought to take primary attention away from the artwork or piece of literature itself. Formalism may well be viewed by future historians and critics as the contribution of the twentieth century. For example, in a tribute to Ad Reinhardt, a contemporary of Jackson Pollock and a preeminent formalist, Interview magazine praised his minimalist and austere monochromatic geometric abstractions and wrote, "Looking over his career, you realize that it's not simply as an influential abstract artist that Reinhardt will be remembered. He is something of a myth—his work is a vital sign of this century's art."58

Jackson Pollock is the preeminent formalist. After fifty years of familiarity with the work, Michael Fried was still stunned and awed while walking through the Museum of Modern Art's retrospective showing of Jackson Pollock's paintings. *Enchanted Forest*, one of the first drip paintings, is Fried's favorite, and his reasons are

based in formalist criteria: "There is something inexpressibly lyrical, even unchar-

Agnes Martin is a contemporary painter working within the strictures of formalism (see Color Plate 16). She articulates her criteria for her work with these thoughts: "My paintings have neither object nor space nor line nor anything—no forms. They are light, lightness, about merging, about formlessness, breaking down form. You wouldn't think of form by the ocean. You can go in if you don't encounter anything. A world without objects, without interruption, making a work without interruption or obstacle. It is to accept the necessity of the simple direct going into a field of vision as you would cross an empty beach to look at the ocean." 60

Gerrit Henry discusses Agnes Martin's paintings with formalism in mind; the critic faults her work for being too concerned with form and leaving out feeling: "Martin's work was, as always, lovely to look at, and even delicious to contemplate, but its overbearing neatness . . . made it, on reflection, seem unsatisfying, even contrived. As with so much minimal art, the search for perfection of an almost saintly sort excludes feeling and enshrines form. Where, as a popular song once put it, is the love?" Perhaps Henry strictly adheres to expressionist criteria and would say this about most formalist work, or perhaps he accepts formalism but is dissatisfied with this specific body of work.

Formalism should not be confused with form: Formalism is a theory of art, whereas form is a property of all works of art. All artists, realists, expressionists, and formalists are concerned with the form of their artworks, but formalists are exclusively interested in form. All art critics, whatever their theoretical assumptions, discuss the form of works of art, but formalist critics are concerned primarily with form, whereas an instrumentalist critic, for example, might look at the form of a work and judge its form by its effectiveness in moving one to political awareness and action. Critics who hold formalist views might opt to write mainly or exclusively about formalist work, or they might write about many kinds of work but apply formalist criteria to all of them, regardless of the intent of the work. As we have seen in Chapter 2, Hilton Kramer, for example, adheres to formalist criteria; he does not wish to write about art that is political, and when he does write about political art, he faults it because it is political. Michael Fried is a formalist critic, and when he writes about art that has not been made within the formalist aesthetic, premodern art, for example, he nevertheless is most interested in its formal aspects.

Instrumental Uses of Art

All art promotes values, and any artwork, whether it is realist, expressionist, or formalist, can be looked at to determine answers to these two questions: What is it for? What is it against? Art serves values larger than the aesthetic and issues bigger than art. The consequential or instrumental values of art have been philosophically argued in the West since the time of the ancient Greeks. Plato argued that it is necessary to restrict the artist in the ideal state on the grounds that art affects human behavior. Art that produces undesirable behavioral consequences must be excluded, and art that yields good behavioral consequences should be produced for the benefit of the populace. Leo Tolstoy, the Russian novelist and theorist, also held this view. For him, art was a force that should elicit the loftiest ethical behavior. For both Tolstoy and Plato, ethical and religious ideals determined aesthetic value. Vladimir Lenin argued that any art that does not serve the common cause should be condemned. For him, art was a tool, a shaper of political attitudes, and its function was social. An artwork's real value, Marxists insist, depends on its function in its social setting. Even Clement Greenberg, the dominant formalist who wants art to be judged autonomously of ethical values and political issues, believes that formalist art can liberate humankind from consumerist obsessions, "bad taste," and kitsch, to raise consciousness to a higher level than daily concern with material existence.⁶²

Political ends play prominently in discussion of today's art and can be explicitly seen in criticism of socially activist art. Douglas Crimp writes about the importance of considering audience when making art that is to influence change within society: "Success within the art world is not the primary goal of artists working within the context of AIDS activism, and communicating only to an art audience is a limited accomplishment. Thus cultural activism involves rethinking the identity of the artist as well as the role of production, distribution, and audience in determining a work's significance." Ann Cvetcovich, also writing about AIDS activism, stresses the need for persuasive art, arguing that if an artwork is only true and not persuasive, it will not be effective. AIDS activist artists must "not only provide information about safer sex, but eroticize it, acknowledging that telling people to use condoms may be useless if the presentation doesn't address the fear that safer sex interferes with sexual pleasure. AIDS activism thus questions not only whether the truth is represented but how truth is represented, and suggests that to be effective information must be both true and persuasive to its audience." 64

Critics often bring the consequences of art into play when they are writing about the work of underrepresented artists, such as that by African American and women artists. Writing about the exhibition "Contemporary African Artists," Frances DeVuono argues, "This was a long-overdue show. It was big enough and good enough to disabuse any remaining art chauvinists of the idea that contemporary art is the sole preserve of the developed nations of the West." Similarly, Curtia James writes in *Artnews* that "in a show of three installations, Maren Hassinger, Beverly

Curators conceive and mount some exhibitions for instrumentalist ends, such as "Facing History: The Black Image in American Art 1710–1940," curated by Guy McElroy for the Corcoran Gallery in Washington, D.C.: "How did portrayals of blacks reflect the prejudices of the society at large? Were better artists able to transcend stereotypes, or, like their lesser-known peers, did they only propagate them further?" In the exhibition catalog McElroy argues, "It's important for everyone—but especially for blacks and women—to become more sensitized to the insidious ways that images can work. That's the big point." 67

In an article discussing an exhibition about AIDS called "Not Alone," shown in Cape Town, South Africa, Steven Dubin, who often writes about museums, quoted a curator who said of the exhibition, "It was not about the market. It was not about commodity. It was about activism." He was implying that most art is about marketing the artworks as commodities. The exhibition is composed of subsections: "What is AIDS?" "Who lives, who dies?" "Why are condoms controversial?" "Are you afraid to touch?" "When was the last time you cried?" "Why a red ribbon?" After describing the show and many of its artworks, Dubin asks, "At the end of the day, do exhibitions such as these make any difference?" He concludes, optimistically, that what people see in the exhibition "might well prolong their lives." Similarly, Leon Golub, discussed in Chapter 3 and known as an activist, said, "Paintings don't change wars. They show feelings about wars." It is likely that he also believed that a change in feeling might bring about a change in action. However, the efficacy of activist art is difficult to determine, and various members of the art world and the larger society often call the value of activist art into question.

Some artists involve themselves in making art that does make positive physical changes in the world. Mel Chin is a prominent example of such an artist; Chin is pursuing the creation of activist, ecological artworks. He began Revival Field in 1990, an art project that actively reclaims toxic land outside St. Paul, Minnesota, into remediated green land that can support healthful life. With Revival Field, Chin devotes his artmaking to the regeneration of biotic and abiotic materials over time in an evolving environment. Revival Field uses selected plants such as sweet corn to extract heavy metals such as zinc and cadmium from a landfill's soil. During the growth cycle, the plants absorb and store toxic elements. The contaminated earth is divided into an intersecting X that is circumscribed by a circle within a larger square, a metaphorical target that pinpoints the cleanup. Plantings are scheduled for Revival Field until the site is detoxified. This contemporary ecological art project offers solutions to reconnect nature and culture through art, education, and community involvement, eschewing the creation of art as an individual pursuit. Art critic Jeffrey Kastner believes Chin's efforts have exceeded the metaphorical: "His synthesis of art, history, and science changes not only the viewers' conception of life on earth but ultimately also the earth itself."70

Chin is also organizing the "Fundred Dollar Bill Project," a collaborative art and science project uniting 3 million children with educators, scientists, health care professionals, designers, urban planners, engineers, and artists. After Hurricane Katrina, Chin went to New Orleans to work with scientists who found hazardous lead contamination in the soil. When 3 million drawings are collected, an armored truck, running on vegetable oil, will take the artworks to Washington, D.C., as a request of Congress for \$300 million of aid for New Orleans.

A group of artists are involved in what has been identified as "transactional aesthetics"—that is, artworks or situations constructed by artists that require people to actively engage in experiencing art. Public discourse is an integral element of their work. Rirkrit Tiravanija, for example, employs an "open-ended fluidity of projects and installations, as well as a softly spoken determination to dissolve the boundaries between the institution and its outside, artwork and daily life, audience and active participant." In recent years he has converted galleries into kitchens in which participants cook and eat curry meals, and opened a small grocery store inside a Swiss museum. "For Tiravanija the building process is as vital as the final structure itself, and in all cases the key ingredient is 'lots of people' without whose involvement the work remains incomplete."

Other Criteria

These four major categories do not exhaust the range of criteria available to critics. Originality, for instance, is an honored criterion of recent art. A critic compliments the paintings of Susan Rothenberg, for example, because the artist has managed to do something new and different with a very used subject: "Until Rothenberg revived it in the mid-70's, the horse had fallen out of favor as proper subject matter for painting. Its connotations were classical, monumental, and entirely too mythic for the late 20th century. Its ability to symbolize martial values and nobility of spirit had been rendered obsolete; as an aesthetic device it seemed, at best, corny. But Rothenberg's horse paintings worked—in fact, they worked remarkably well."⁷²

Craftsmanship is another criterion that is frequently used. For example, Michael Kimmelman, writing about the work of Bruce Nauman, says, "You see in Nauman's art the value he places on the inventively made object. This is clear in the odd and unhidden carpentry of some of his installations and in his waxworks, whose cast lines he leaves to show the process of their making. There is a sense in his work of labor as art, an oddly American notion of do-it-yourselfism that is clearly not about aesthetic bliss but about the beauties of science and craft." How Nauman makes the work is an essential part of the work and its meaning. We have also seen in writings about the work of Puryear that his craftsmanship is praised because it is not excessive and fussy. Craftsmanship is not an absolute quality for many critics, but a relative one; they look for objects that are appropriately crafted, and the appropriateness is contingent upon the expressive purposes of the objects.

CHOOSING AMONG CRITERIA

The critics quoted in this book are not of a single mind-set about criteria for judging art. Peter Plagens, for instance, has written that "political art ends up *preaching* to the converted—and preaching is the key word here."⁷⁴ Eleanor Heartney seems more tolerant of political art, but she too has difficulty with it. In a review of an installation about the homeless by Martha Rosler, Heartney asks, "How, for instance, does the socially concerned artist avoid merely aestheticising the victims of homelessness?"⁷⁵ Heartney ends up supporting Rosler's noble intent and attempt but concludes, "As it was, the gallery setting, with its preselected audience and social isolation, provided a constant reminder of the continuing gap between art and life. The real problems and the real solutions remained, and remain, out there—geographically only a few steps beyond the gallery door, but in practical terms, on another planet."

Donald Kuspit has also struggled with criteria for socially concerned art. In a review of Sue Coe's paintings (see Color Plate 5), he writes, "Granted, the world is a rotten, inhumane place. Blacks are oppressed and brutalized, the meat industry manipulates us almost as much as the military-industrial complex, and the United States is a neofascist aggressor; yet it is not the message in Sue Coe's art that interests me. All of her characteristic complaints would be propagandistic dross if it wasn't for her visionary aesthetic, which eloquently conveys the suffering she is at bottom obsessed with." Thus Kuspit accepts Coe's value positions and accepts her expressionism but praises her for her use of form. Her intellectual insights are not enough, nor is her passion; but when her insights, passion, and aesthetic vision combine, Kuspit admires her work. "Coe, I think, is torn between a wish to communicate instantaneously to as large an audience as possible, and thus to use a public and invariably clichéd language, and a desire to make 'high' art—that is, art so dense with visual substance and subtle meaning that it cannot be exhausted at first sight. When she manages to balance these impulses, she takes her place among expressionist masters, but when she makes images for 'the cause,' her works dwindle to militant cartoons, lacking even the saving grace of Daumier's wit."

Jan Zita Grover writes of a conflict over criteria with other critics on a state arts council while they were awarding grants to artists. To Grover was defending what she calls the "subcultural work"—the photographic work of Lynette Molnar titled Familiar Names and Not So Familiar Faces. It is a series of photomontages of the photographer and her female lover stripped into existing reproductions, such as a Marlboro cigarette ad, and the Ward and June Cleaver family of Leave It to Beaver. Grover writes that Molnar's "montage is deliberately not very convincing: it is quite obvious that the two figures have been imported from some other world and pastiched into these mainstream settings. The scale and repetitiveness of the same figures embracing in a variety of commercial settings enforce the artificiality of the insertion, producing a sense that this is an act of defiance, a clumsy and not altogether successful fusion of two different universes. Anyone living the life of an

Kara Walker, *Grub for Sharks*, A Concession to the Negro Populace (detail), 2004. Cut paper on wall. Courtesy of the artist and Sikkema Jenkins & Co.

informed outsider will recognize that this is precisely the position we occupy—culturally and politically, if not economically. Molnar's work struck me as a clever objectification of both the aspiration and reality of the uncloseted lesbian." The other two jurors objected in terms of what lay within the frame—namely what they considered technical flaws, formal deficiencies. Grover defended the montages because "these seeming limitations became challenges and virtues, given the paucity and distortions of most images depicting lesbians." Another juror responded that "we're judging photographs, not social revolutions." Grover was working from within a socially concerned frame of reference while the others were appealing to formal criteria such as craft.

With so many criteria, how is one to choose among them? The choices are difficult, but they must be made. One could hold an eclectic position and accept them all, but some of the criteria are contradictory or mutually exclusive. It would not be logically possible, for instance, to hold to both formalism and Marxist aesthetics. Formalism holds art to be autonomous, a world unto itself, separate from the social world and outside of moral parameters. Marxists, however, insists that moral issues are very pertinent to art making. This is not to say that Marxist critics would not have any formal demands on art. They would, but form alone would not be enough.

When one accepts particular criteria for art, further choices remain. An instrumentalist, for example, might see art that is clearly instrumental in purpose but still fault it on instrumentalist grounds. Such is the case with some art based in racial issues made by artists such as Kara Walker and Michael Ray Charles. Both artists are African American, and both deal aggressively with issues of race. Walker, for example, makes wall-size silhouettes of lurid antebellum scenes inhabited by what she calls "pickaninnies and nigger wenches." Charles paints minstrels, Aunt Jemimas, and Sambo images, one of which dribbles a basketball under the words "The NBA is tantastic." For the artists who make these images, they are clearly satiric. Most art critics understand them to be satiric: Ronald Jones, writing in Artforum, for example, sees them as "radically reinventing monstrous form to betray racism by its own hand."78 Henry Louis Gates, Ir., an African American social critic, defends the works by arguing that they are clearly postmodern critiques of the racist originals and that only the visually illiterate could mistake them as realistic portrayals. But others also note the danger of such images reinforcing rather than subverting the stereotypes. Betye Saar, an African American artist whose work also challenges stereotypes, sees Walker's work as reprehensible because she thinks it is a case of black self-degradation. Saar pointedly asks, "Can you imagine a Jewish artist doing satirical art about the Holocaust?" 79 Thus even when viewers agree that art is clearly instrumental and that it should be judged on social grounds, arguments will still ensue over the social effects of that art.

One might choose to be pluralistic and accept an artwork on its own grounds. That is, one would let the artwork influence which set of criteria should be used in judging it. A feminist work of art would be judged by instrumental criteria; a formalist piece on formal grounds; and so forth. The advantage to this position is that one would be very tolerant of a wide range of artworks. Many naive viewers of art hold only to realist criteria, and they narrowly dismiss most of the art of this century. This is unfortunate. If they were taught a broader range of criteria, they might be able to enjoy a wider range of artwork.

Some critics, however, are informed about and have considered many criteria for judging art but are still staunchly committed to a point of view and will hold only one set of criteria. Some critics will remain formalists, for instance, despite the severe limitations of formalism, which postmodernist writers have made apparent. Any critic who assumes a single critical stance has the security of a single point of view and a consistent way of viewing art. The danger for these critics, however, is one of rigidity. For a student of criticism, it would probably be wise and beneficial to try on and try out many different criteria on many works of art before deciding which criteria to embrace.

Maintaining a distinction between preference and value can be liberating. That is, a work I like may not be as good as another artwork I don't like. I may understand that one work of art is better than another, but I may still enjoy the former

Michael Ray Charles, Beware, 1994. Acrylic latex, oil wash and copper penny on paper, $44'' \times 30~1/4''$.

Courtesy of Michael Ray Charles and Tony Shafrazi Gallery.

more than the latter. I can like whatever I want to like. If we hold our preferences with confidence, then we might be in a better psychological position to critically and appreciatively attend to works that are beyond our range of tolerance.

It is also important not to confuse preference with value. Statements of preference are personal, psychological reports made by the viewer. Value statements are much stronger and need to be defended. There is no need to defend preferences. Aestheticians make the following distinctions: I may admire a work aesthetically that offends me religiously. I may buy a painting that is a poor investment or profit from a painting I loathe. I may appreciate something but prefer to look at something else, even though I can acknowledge that its aesthetic value is inferior.⁸⁰

Examining our preferences will yield insights into what is being valued and why. People writing criticism ought to be self-conscious of both their values and their preferences so they do not confuse the two.

PRINCIPLES FOR JUDGING ART

The following principles for judging art are offered as a summary of the important general points of this chapter. This set of principles is meant to be open-ended and nondogmatic. It can serve as a guide to formulating informed and responsible judgments of works of art.

A complete judgment consists of an appraisal, with reasons, that are based in criteria. Earlier in this chapter we read a clear and complete judgment of Frida Kahlo's oil painting *The Broken Column*. The judgment consists of an appraisal and reasons for the appraisal that are based in explicit criteria. The painting was judged to be one of the best paintings made in the first half of the twentieth century (appraisal) because it is "inventive" and conveys "a range of personal and universal meanings" (reasons), and these reasons are based in expressionist criteria that uphold art that expresses deeply felt emotion and significant ideas (criteria).

Judgments do not always contain explicit criteria: "Walton Ford's works are technically brilliant and visually spectacular. His detailed, life-size depictions of animals in watercolor and gouache are fascinatingly reminiscent of natural history drawings from past centuries . . ."81 This judgment contains an appraisal with reasons but does not (yet) identify criteria; but if we read the complete passage, the critic's criteria ought to emerge.

The objects of judgments are varied. Many aspects of art may be judged: How good is the exhibition? Which is the best work of art in an exhibition? How good is the artist, and what are his or her best works of art or best periods of production? How valuable is a particular movement or style? How good is the idea of a curator's for putting together an exhibition? How good is the art of a decade? Of what consequences is this art socially and morally? Should any art be censored ever?

Judgments are different from preferences. Anyone can like a work of art that they consider to be a "bad" work of art; no one has to like every "good" work of

163

art. When someone states that they like something, they are not logically bound to defend their preference. In matters of judging works of art, however, if one says that this is a "good" work of art, and that is a "bad" work of art, reasons are expected for such judgments and ought to be put forward by the one making them.

Judgments, like interpretations, should be persuasive arguments. Making judgments about the value of works of art is a task of formulating a set of reasons about the work to form a logical conclusion as to why it is judged to be worthy of critical appreciation (or not). Usually people who make judgments about works would like us to see and value the works the way they do. If they are effective in their arguments, they are persuasive: We are able to see the objects as they do, and we may even agree with their appraisals of them.

Judgments, interpretations, and descriptions are interdependent and inter-related. How one understands a work of art will influence how one judges it. In the previous chapter about interpretation, we saw that when some critics first interpreted the work of Jenny Holzer, they thought it to be shallow; therefore their judgments of it were negative. Because some critics of her work judged it to be shallow, they did not bother to interpret it at all. Their descriptions of her work carried negative rather than positive connotations.

Judgments offered without reasons are irresponsive and irresponsible. If one hears a judgment, one can expect to hear reasons for that judgment. If reasons are not given, the judgment ought not be accepted. Mere statements of appraisal without reasons have not taken the work into account—such judgments have skipped the processes of description and interpretation and are not responsive to the artwork. Throwing out mere statements of judgment without providing reasons for those judgments is irresponsible and ought not be counted as good criticism.

Published judgments are for audiences larger than the artists who made the works being judged. Professional critics judge art for an audience of readers that is considerably larger than the artist who made the work of art being judged. Critics wish to persuade readers to appreciate (or not) the artwork as they do and for their reasons. They would have us see as they see and enjoy as they enjoy (or not).

Some judgments should be taken more seriously than others. Because judgments are arguments that consist of appraisals and reasons based on criteria, it follows that some judgments will likely be better articulated than other judgments. Some judgments will be more persuasive because they are better informed by reasons. Some judgments will be better because they are grounded in sound criteria. Beware of judgments that consist only of statements of appraisal that are not accompanied by reasons or criteria; such statements should not be taken as adequate judgments. Be aware of statements that sound like judgments but are merely statements of personal preference.

Some criteria can be combined, and some are mutually exclusive. Criteria such as expressionism and realism can be combined. For example, Sue Coe's art of protest concerning animal rights is expressionistic and is made with representational

Solid judgments depend on accurate descriptions and informed interpretations. Judgments about artworks that are made without benefit of interpretive understandings are irresponsive to the art that is being judged and irresponsible. Informed interpretations, in turn, are based on accurate descriptive information about the work and the context of its making and its presentation. Faulty descriptions and misinterpretations should be seen as weakening one's judgments.

Feelings guide judgments. Judging a work of art, like interpreting a work of art, ought not be a coldly intellectual endeavor. Emotions feed thoughts, thoughts feed emotions, and both inform judgments. Feelings are essential to judging work according to expressionist criteria and can be influential in responding to works of art through any criteria. Unexamined feelings can also lead to premature judgments and faulty judgments, especially when one is confronted with art that is emotionally difficult for some reason. Is the reason for a strong emotional reaction in the work, or is the reaction based in my individual and idiosyncratic biography? Am I responding to the work or to my own past experience that is not part of the work?

Artworks, not artists, are the objects of judgments. Even though we read and hear comments about this artist being such and such, it ought to be the *artworks* of artists that are judged, not the artists themselves. Judgments directed at the artist are *ad hominem* arguments, directed wrongly at the person rather than at the work. It is logically and psychologically possible for people to both dislike an artist and value the artist's work, or to dislike a critic and agree with his or her critical positions.

Judgments, like interpretations, are communal decisions, and the community is self-corrective. This principle is an answer to the common and belligerent question, "Who gets to decide what's good art?" Certainly anyone and everyone can make judgments about art. The judgments that ultimately count, however, are those held by communities of inquirers. Communities, of course, are influenced by individuals; and communities, in turn, influence individuals. There are many different kinds of artistic communities with differing standards for judging what is good. The art world ultimately decides what ends up in art books and art museums; but the art world is informed by individual artists, critics, curators, historians, art teachers, collectors, and others who have strong interests in what works of art are worthy of collecting, protecting, teaching about, and saving for future generations. There is not always immediate consensus on what is good, but eventually the community "gets

Judgments, **like interpretations**, **should be personal as well as communal**. We seek artworks that are valuable to us individually, and this is a good thing. We do not want to blindly accept the canon of artworks passed to us through tradition as great works of art, but rather to examine them ourselves and to value them a lot or a little according to our own criteria for art and for life. We seek artworks that are personally inspiring to us while we also seek to understand what works of art are judged valuable by others and for what reasons.

Judgments should tell more about the artwork than they tell about the person judging. People's judgments are valuable to the extent that they inform us about the works they are judging and why they are judging them the way they are. We seek to hear reasons that clearly apply to the artwork and that inform us about the artwork. Judgments that tell a lot about the viewer and little about the artwork are not useful for art criticism, although they might be useful in getting to know the person making the judgment. Such sharing of the personal histories of viewers might be better suited for discussions other than critical art discussions.

Judgments of art are usually based in worldviews broader than the aesthetic. Strict formalists would not hold this principle to be true because they believe that art is unto itself and should be judged by aesthetic criteria alone. Many other viewers, though, judge art by standards broader than the aesthetic. A clear but extreme example of a judgment based in criteria other than aesthetic is that made in 1989 by the Ayatollah Khomeini of Iran, who judged *Satanic Verses*, the novel written by British author Salman Rushdie, to be blasphemous toward Islam. He condemned the author to death. The ayatollah's judgment was based on religious criteria rather than aesthetic criteria.

When faced with worldviews that impinge on judgments, we have four choices: (1) We can accept both the worldview and the judgment it yields. (2) We can reject both the worldview and the judgment. (3) We can accept the worldview but reject its application to the work in question. (4) We can reject the worldview and accept the judgment but for reasons other than those the worldview provides.

Judgments ought to be tentative and open to revision. Most critics do not make judgments with eternity in mind. Their judgments are usually tentative and open to revision. Critics writing about new works of art are generally aware that the criticism they write may be the first words published about a work of art, and most realize they cannot afford to be dogmatic or doctrinaire in their judgments of it.

Different judgments are beneficial because they highlight different aspects of works of art that we might otherwise overlook. We can apply different criteria to the same work of art and obtain multiple judgments of that work that might be helpful in increasing our understanding and appreciation of that work. We could answer these questions about any single work of art: What might a formalist appreciate in this work? An expressionist? A realist? How do the social consequences

of this work affect a determination of its value? Even using any single set of these criteria, different viewers are going to notice and appreciate different aspects of the work, and these can be enlightening to hear and might well increase our appreciation of the work in question.

Negative judgments can be stated kindly. This principle is especially pertinent to studio critiques in art classes. Negative judgments can be stated in a way that is respectful of others and their points of view. The principle also applies to professional critical writing. Critics ought to resist the urge to have power over another through unwarranted, meanly stated criticism.

Judgments, **like interpretations**, **should invite us to decide for ourselves and to think on our own**. Ultimately we want to form our own judgments. However, if our own judgments are informed by the considered and thoughtful judgments offered by others, our judgments may become better informed and more clearly articulated than otherwise. Our newly articulated judgments can contribute to the ongoing conversation about the value of works of art.

Writing and Talking about Art

THIS FINAL CHAPTER EMBODIES the ultimate purpose of the book: to help you write and talk about art better than you were able to do before you read it. Many art critics have been quoted throughout so you would have many positions to consider, several literary styles to read, and different ideological positions among which to choose. You should now be in a position to develop a critical voice of your own. Do you want to further feminist criticism? Would you like to publish in the popular press and influence large numbers of people? Are there certain types of art or aesthetic issues about which you feel passionate and about which you want readers to know?

The chapter assumes that you are serious about learning and writing. If you are not, you are likely wasting your time and that of anyone who has to read what you write. The writer Annie Dillard advises anyone who writes to "write as if you were dying. At the same time, assume you write for an audience consisting solely of terminal patients. That is, after all, the case."

Each chapter has included many references, and there is a lengthy bibliography at the end of the book. These references are provided to credit properly all the authors whose ideas were examined and, especially, to encourage you to read further. The quotations are brief and are used as examples to make various points. If you are intrigued by any of the quotes, pleased with the way someone writes, find the source in the library and read the critic's whole piece. Let these professional critics inspire your own critical thinking and writing.

Art critics are good models for those who want to engage in serious thought and writing about the art of our times. You probably identified with some critics, preferred some styles of writing, and felt closer to certain critical positions than to others—and now you can begin to articulate why. Because you have heard many voices, you are in a better position to further develop your own.

WRITING ART CRITICISM

Choosing What to Write about

If you are going to write art criticism, you have to have something to write about. You may be able to choose what you want, or you may have an assignment given by a professor or an editor. The critics quoted throughout the book work both ways: Some choose what they write about; others are given assignments or cover certain important exhibitions out of a sense of responsibility to their readers. It is usually easier to write about something you choose—you can avoid art you don't know enough about or aren't interested in. If you can choose, choose something you are passionate about or at least interested in. You might choose art that you love or art that you hate. You might choose art you know a lot about, or art you know little but want to learn more about.

If you are given an unappealing assignment by an editor or a professor, ask for a change by suggesting more interesting alternative topics. Your professors may be more flexible than you think. Professors want students to learn, and if you can convince them that you can learn more from your chosen topic than their assigned topic, they may be willing to accept your proposal. If your request is denied, you need to motivate yourself. You might even examine your lack of interest as a premise for the piece. And once you investigate the assigned topic, your initial reactions might change. Your changed feelings could be an organizing theme of your writing: Begin by describing your initial lack of interest and then explain how and for what reasons your feelings changed. If your initial reaction doesn't change, you might write a piece that is primarily negative, giving convincing arguments for your position. The point is you want to be emotionally and intellectually involved and committed to what you are expressing. Do whatever helps you motivate yourself to write honest and committed criticism.

SINGLE WORKS OF ART Are you writing about a single work of art, an exhibition by one artist, or a group show of several artists? Each of these presents its own challenges. If the assignment is to write about a single work of art, then get to know that work of art well. A single work of art is often part of a much larger body of work, and it is always embedded in a cultural context. The larger body of work and the culture in which it was made will inform you about that one piece.

SOLO EXHIBITIONS Many of the critics quoted in this book were writing about exhibitions, often analyzing single pieces to support their larger thesis about an artist or the exhibition. Critics usually write about exhibitions or large bodies of work. Historians are more likely to concentrate on a single work of art, trying to determine who made it and when, or what it might have meant to the people who saw it during the time and in the place in which it was made and shown. The critics quoted in Chapters 3, 4, and 5 have concentrated on bodies of work made by

such artists as Dale Chihuly, Deborah Butterfield, Romare Bearden, Frida Kahlo, and Martin Puryear. They had the advantage of being able to write about more than one work of art. This is an advantage because they had more to consider and could choose which pieces to examine and which to ignore. They didn't have to write about every piece or limit their comments to one artwork. They could compare and contrast several works by the same artist. However, they also had the challenge of making summary interpretive and evaluative statements about the lifelong careers of artists and whole bodies of work.

If you are writing about an exhibition by a single artist, you will probably want to provide an overview of the artist's accomplishments, pointing out stylistic similarities among the pieces that make the work distinctive. You might also consider whether the exhibition is a retrospective of a whole career of a living or deceased artist or an exhibition of works made during a particular period in the artist's career. You can determine if the artist's style has changed over time and, if so, describe how it evolved. Tell your reader if the work is by a professionally young or mature artist. Consider whether the work is a transition from or a continuation of a previous direction by the artist.

GROUP SHOWS Group shows can be challenging, depending on the number of artists in the exhibition. Some exhibitions may have fifty or more artists represented by one or two pieces each. Unless you are writing a long paper or a book, writing about every artist and every piece would be impossible. Even mentioning the names of all fifty artists would consume too much space. You will have to choose which artists and which pieces to concentrate on. Here are some strategies that may help: Look for interpretive themes that unite individual works; write about the best and the worst; describe the range of expression in the exhibition.

If the group show includes fewer artists, say six, then you are probably obligated to write something about the work of each, concentrating on those you feel to be most important or most interesting. If the number of artists is up to ten and you have a limited word count, then you will probably mention all but, again, concentrate on a few. Explain why these particular artists were brought together at this time in this exhibition, how they were selected, and by whom. Include the exhibition's title if it has one and any explicit theme. If there is no explicit theme, make a conjecture about why these works are being shown together. Always ask whether the exhibition curator has written a catalog or provided some statement of explanation. If the artists themselves chose to show their work together, you can consider how the works relate to each other.

Include and comment on the written opinions of curators and artists when they are available. Consider interviewing artists and curators. Unless you are doing a news story, however, your writing should be more than just quotations of what the artists and curators think about the work. Use their thoughts to provide context, but keep in mind that it is your own point of view about what they say that is of interest and importance.

Remember from Chapter 3 that description is criticism, not merely a prelude to criticism. Your readers may never see the art you are writing about, and your description may be their only access to it. You cannot count on having a photograph accompany your piece, but you always have your words. The main task in describing a work of art is to tell what it looks like. Describe accurately and with vivacity. Make the work come alive for your readers—give them a verbal image they can see. If you describe thoroughly and passionately, description may be all you need.

Chapter 3 discusses two major sources of descriptive data: internal and external. Internal information is based on what can be seen in the work itself and can be divided into three categories: subject matter, medium, and form. Subject matter refers to the recognizable people, places, or events in a work—the nouns of the work. The medium is the material of which the work is made. Form is how the artist shapes the subject with the medium. In nonobjective and nonrepresentational work, medium and form may be predominant, with no identifiable subject matter. Chapter 3 includes good descriptive examples of writing from many critics about many different types of art forms from performance art to glassmaking. You may want to refer to these.

External contextual information includes data about the time in which the piece was made—its social and intellectual milieu—other works by the same artist, and works by other artists of the same period. You can also place the work within a setting for your readers. Describe the gallery, the general tone of the exhibition, the dates during which the work was shown, and the number of pieces in the exhibition. Provide accurate information about titles, sizes, media. Provide information about who curated the exhibition and whether the work is for sale and in what price range. If biographical information about the artist would be helpful to your readers or helpful in defending your thesis about the work, then provide it. The test of what to include in description and what to ignore is relevance. Relevance refers both to what your readers need to know and to what you need to tell your readers so your thesis makes sense.

If you are assigned a descriptive paper by a professor, know whether you are expected to be descriptive only, or if you are allowed to color your descriptions with your preferences and values. If you are only to describe—not to make value judgments—then take care to avoid implied evaluations of positive or negative worth. If you are given free rein, let the reader know that you like (or dislike) the art. Also know if you can include external information.

Interpreting

Recall from Chapter 4 that interpretation of an artwork can be based on two types of information: internal evidence and external evidence. Internal evidence consists of what is in the work itself; it is drawn from a description of the work. External evidence consists of relevant information not within the work itself: the artist's other

The basic premise of interpretation is that works of art are about something. When you interpret, you present your understanding of the work in a way that is convincing, both by how you write and by the evidence you provide. You want to make the work as interesting to the reader as the work allows. Always present an artwork in its strongest rather than weakest light.

In a sense, all art is about other art—that is, influenced by and in dialogue with other art. At the same time, all art is affected by the culture in which the artist lives and, in turn, affects the culture in which it is shown. The interpretive goal is to make the art meaningful to your reader in terms of the art itself, the artist's other work, all art, and culture.

If you are writing about a new artist, you have advantages and disadvantages. One advantage is that any true thing you write is a contribution because you are one of the first to do so. A disadvantage is that you are starting the dialogue without benefit of an ongoing conversation about the artist. Much has already been written about an established artist, and your challenge in this case is to add something to the discussion.

If you are writing about the work of an artist who has already been written about, you can consult these other writings or develop your own interpretation. There are advantages and disadvantages to both approaches. Working on your own, without reading others' thoughts on the same topic, requires a certain amount of self-confidence and a willingness to take risks. If you trust yourself and trust that your insights are worthwhile, you will probably contribute to ongoing thought about the work. If you consult other writers, then you will need to go beyond what they have already written and contribute to the conversation. If you take the latter approach, you can add the points of view of these other critics to your own, thus giving your readers options among interpretations. And if you do take this course, be sure to fully credit all the others.

Throughout this book, we have examined several interpretive and ideological perspectives: psychoanalytical, semiotic, feminist, neo-Marxist, poststructuralist, modernist, postmodernist, and idiosyncratic worldviews. When you select art to write about, you might decipher the ideological basis of the artwork itself and adapt your criticism accordingly. If the art is clearly postmodern, for example, you can explain it in those terms and enlighten your reader about postmodernist theory. If you disagree with the ideology of the art, first explain what it is and then resist the ideology with reasonable arguments.

Judging

Responsible judgments include a clear assessment of the worth of an art object and reasons for the assessment based on reasonable criteria. Critics disagree about which exact criteria are appropriate for judging art. Types of criteria are realism,

You may, however, want to hold more narrowly to a particular set of criteria and judge all art, no matter what it strives to do, according to your chosen criteria. For example, because of the severe social problems in the world, you may want to measure all art by instrumental ends, favoring only art that attempts to make the world a better place in which to live. Thus you might reject formalist work as socially irrelevant and a waste of human energy and natural resources.

These are difficult choices: You may err on the side of aimless and contradictory eclecticism or narrow rigidity. Or perhaps you will be able to find some amicable middle ground.

When you judge art, you are not giving advice to artists but rather articulating to readers why you think something is good or not and on what basis. To judge is to risk the possibility of being demeaning to the artist by assuming a superior role or attitude. Such an approach will likely set you against artists, and them against you, in an antagonistic way. Antagonism is not in the spirit of good criticism. Criticism is meant to further rather than to end discourse about art; you want to further the discussion by inclusion rather than dismissive exclusions. Most often, critics' judgments are positive, telling readers why a work of art is meaningful and enjoyable. Resist finding minor faults in works of art—fault finding is petty—and argue for larger issues. Be generous to artists in your considerations of their art and be enthusiastic for your readers. The spirit of this book is one of curiosity because the purpose of criticism is to arouse curiosity and sometimes satisfy it.

Considering Assumptions

Infer the ideological basis of the art you are considering, and know and identify your own. What constitutes good art for the artist you are considering? What constitutes good art for you? Can you list your ten commandments of good art? Are there contradictions in your set? Are your assumptions and beliefs in consort with the art you are considering, or in conflict with them? Can you make both clear to your reader?

If the brief consideration in Chapter 2 of theoretical topics interested you, you would do well to take courses in aesthetics within a department of philosophy. You might also look into courses on recent literary theory and criticism, film theory and criticism, and women's studies, all of which are affecting art theory. You may have a penchant for writing feature-length articles of theoretical criticism rather than

reviews of particular exhibitions. You may want to write social theory based on artifacts. Some critics are concerned with larger issues and use works of art as examples of their theories. Others are content to write art journalism, or news about artists, rather than criticism. There is room for many approaches. Try several, find what you are comfortable doing, and do it as well as you can.

TECHNICALITIES AND PROCEDURES OF WRITING

Selecting a Style Manual

You can find style guides in libraries and bookstores. Style guides tell you how to footnote, how to present a bibliography, how to break your paper into sections. All journals and magazines have editorial styles that they follow. Your professor may require you to follow a certain style. If not, choose one of your own and follow it. Your selection can be arbitrary, but you might first find what style is generally preferred in your major area of study. If you are a psychology major, the American Psychological Association (APA) has a style manual that you may want to obtain and use. If you are an English major, your professors may prefer the University of Chicago style or the style of the Modern Language Association. Do not make up your own style—several have already been invented. If you plan on eventually writing a major paper, such as a senior thesis, a master's thesis, or a doctoral dissertation, find out which style your department or adviser expects and practice using it for your shorter papers so you become familiar with it.

Determining Word Count

Find out before you begin your project what length of paper or article you are expected to write. Do not even begin before you know. *New Art Examiner* wants reviews of fewer than 450 words. That might translate to only three or four paragraphs. A professor may want an end-of-term paper of twenty pages. You need to know the expected length and then make decisions accordingly. Some writers find it difficult to be succinct; others find it difficult to expand their thoughts over a number of pages.

Identifying Your Audience

Once you have decided on a topic, you have to decide on an audience or consider the reader for whom you are writing. If you are writing for a specific publication, make yourself familiar with that publication and with the range and type of writing it publishes. All magazines and journals have editorial staffs, and the addresses of their editorial offices are listed in the front matter of the publication. Sometimes this front matter includes a statement of publication policies and procedures, such as

whether the publication welcomes unsolicited manuscripts. You may contact editorial offices by telephone or letter and ask if they have printed guidelines for writers. You might even request a meeting or have a telephone conversation with an editor. You should not submit the same article to more than one publication at a time; if you do, inform each editor that you have sent the article to other publications for consideration.

At this point in your career, however, you are probably writing to fulfill a course assignment for a professor who will give your paper a grade. If that is the case, know what the professor is looking for before you begin. Ask questions about the assignment so that you are clear about the professor's expectations. Sometimes professors think they are clear about what they are assigning but they're not—your questions may help them further clarify the assignment. You may ask what the professor considers a good paper and, conversely, a weak paper. When writing for a professor, he or she—the grader—is your most important audience, but you might well imagine writing for your classmates in the course. They are the readers against whom you will likely be judged by your professor.

Getting details about an assignment from a classmate is risky business—it makes you dependent on the classmate's understanding of what the instructor wants. It is better to go directly to the instructor. If you are writing for publication, seek advice and clarification from the editor.

Getting Started

Get started the moment an assignment is given to you. See the art as soon as you can and let it sink in over the days or hours you have before you start writing. If it is a single work of art, get a photo of it or sketch it and carry it with you. Think about it over coffee in the morning and whenever else you can. If you are going to write about several works of art, photograph or sketch them and include notes. Obtain from the gallery or museum an "exhibition checklist" if one is available that lists artists, works, dates, and prices.

If you have choices, consider your options, then decide as early as you can what you are going to write about. If you can write about a number of artworks or a number of exhibitions, look at the artworks and the exhibitions and choose the one that most interests you or the one about which you have the most to say. Narrow your topic if you can or determine your approach. If you can choose your topic, do so early, even if your choice is somewhat arbitrary. The more interested you are in the topic, the more enjoyment you will have writing about it. Remaining undecided may be merely an avoidance technique that will not help you. If you can't decide among options, make an arbitrary choice by flipping a coin and go with the results.

Determine for yourself or ask your professor or editor if your criticism is to be based only on your own observations or if you can use external sources of

175

information. In other words, do you want and are you allowed to research what you are writing about? Research about contemporary art can take several directions. If the artist is at least somewhat established, other critics have already written about his or her work. You can search magazines, books, and the Internet for references to the work. If the artist has not been written about, you may choose to interview the artist, seeking to find out what he or she thinks about the work, where the ideas in the work originated, what he or she intended to express, and where the artist has been. If the artist is unavailable for an interview, he or she may have written an "artist's statement" to accompany the exhibition. The artist's insights are always interesting. Beware, however, of the intentionalist fallacy discussed in Chapter 4: The artist does not own the meaning of the work, and you should not let the artist dictate to you what the work means. Rather, take the artist's point of view about the work and test it against your own knowledge and intuitions.

Exhibition curators and gallery owners or directors also have information about the artists whose work they are showing, and they may be available for an interview. If you rely on their ideas, credit them in the text or in footnotes. Ultimately, however, no matter how many people you quote, you still have to present your own sense of the art to your reader.

If you choose not to do research or are not allowed to, then you will rely on your own observations of the work and on your knowledge and life experiences to present your descriptions, interpretations, and judgments. The evidence in this case will be your own observations and your knowledge of art and of life.

Taking Notes

No matter what or for whom you are writing, take notes. If you are writing about new art by a new artist, observe the work carefully, ask questions about it, think about it, and jot down your thoughts on paper, even if they seem random and unrelated. Note your first impressions and what triggers them. If you are writing about works of art in a gallery or museum, take many notes—more than you will need. Note everything that you find interesting and that you might use later when you are writing. If you do not take enough notes the first time, you may have to return to the place where the work is hanging. With deadlines, this could be a problem—museums have limited hours and most aren't open on Mondays, or you may find that the show has come down before you are through writing about it. If your note taking is thorough, you will probably have more notes than you can use. That is OK—it is better to have more than less information than you need.

If the work is by fairly prominent artists, there may be information about the artists' past works in the library. If you can find such information, you will be able to put new work into context with the older work. The *Art Index* is a useful reference for finding what has been written about artists or by critics.

Avoiding Plagiarism

Sloppy note taking can lead to unintentional plagiarism. Plagiarism is taking someone's ideas and presenting them as your own, or taking someone's words and not putting them in quotation marks or citing who wrote them. Plagiarism is theft of ideas and words and is taken seriously; it can have serious negative consequences for your career as a student and as a professional. When you take notes, be sure to put quotation marks around direct quotes so you know later that these are the exact words of another author; if you use them, keep them within quotation marks. If you are paraphrasing what someone else said, don't use quotation marks, but provide accurate bibliographical information, including author, publication and date of publication, publisher and place of publication if it is a book, and page numbers. If you take bibliographic notes in the format your style manual specifies, you won't have to correct them later when you use them in your footnotes and bibliography.

Making an Outline

Once you have gathered all the information and evidence for your writing, make an outline to organize your thoughts and formulate your argument. Outlines can be long, detailed, and formal, or short and informal. It depends on the way you prefer to work. The purpose of the outline is to structure your critical argument. The outline should have three major sections: the introduction, which clearly states your major claim; the body of the paper, in which you build support to back your claim; and the conclusion, in which you forcefully draw your ideas together, conclude, and summarize your argument.

Your outline should be logical. Writing criticism is formulating arguments, and arguments are built on logic and evidence. Your outline is not just a series of steps, but an ordered sequence of premises that lead to a conclusion backed by evidence. It is a map that shows you where you are going and how you are going to get there. Without such a map, you and your reader may wander about without direction, ending up with a lot of information that may be true but does not lead to a conclusion based on premises.

Once you have a sound outline, you can begin writing anywhere within the outline. You do not have to start at the beginning; you can start where you want, even with the conclusion. To build confidence and momentum, you might want to start with what you know best. An alternative strategy is to start with the hardest part; once you write it, the rest will be easy.

Writing

Write your first draft, following your outline, in whatever order you are comfortable with. As you write this first draft, do not worry if you don't have the exact wording you want, or if you need to think about something longer or are missing needed research—just leave a blank space and move on. Return to the inadequate words or blank space later and make changes and additions. Don't get stuck in any one spot. Keep pushing forward. If you have to interrupt or stop your writing, leave your work knowing exactly what you will write next when you return to it, even if you leave a sentence or paragraph half finished. This way, you can start up right away and move forward immediately—you don't want to have to start over every time you return to your writing.

Early in your paper, maybe even in the opening sentence, state your major claim or the thesis of your paper. Each paragraph should have an organizing idea. Write logically and clearly so that one sentence leads to the next and one paragraph leads to the following paragraph. Let your reader know your point of view about the art you are considering. If your paper is primarily interpretive, state the major theme you see in the work. If you are being judgmental, take a clear stand. Make a major claim that is clear and precise but also thought-provoking. All sentences and paragraphs should lead to your conclusion, which should be stated clearly at the end.

Consider the tone of your writing. Draw your reader into the art and into your ideas by expressing them in an interesting, evocative way. Being dogmatic will likely push your reader away. You might want the tone and pacing of your writing to match the tone and pacing of the artwork you are considering. Several of the critics quoted in this book matched their words to the work in poetic fashion; refer back to some of the writing about Chihuly's glass and Golub's paintings.

Rewriting

Consider your first draft as just that and plan on improving it. Always leave your-self time to think about what you have written and to revise it. Never turn in a first draft. Leave yourself time to get away from your writing so you can return to it with a fresh outlook and see it anew.

Check your first sentence to see if it will get your reader's attention. End strongly with a compelling closing sentence. Get rid of redundancies, and avoid offering points that may be true but that are irrelevant and thus distracting from your major thesis. Be sure your argument is clear and flows logically. Check the tone of your writing so it is consistent throughout and so you are pleased with it. Avoid sarcasm if you are judging art. Make sure your views are evident, but also make sure that you provide evidence for your positions. Polish your writing to get it just right. Be proud of what you are turning in to your professor or editor.

Common Errors and Writing Recommendations

The term *criterion* is singular, *criteria* is plural; *medium* is singular, *media* is plural. *Its* is possessive, *it's* means "it is." *There* refers to a place, *their* is possessive. Examples of singular possessive are the *artist's* colors, *Pollock's* drips, *Plagens's* criterion; plural possessive is the *artists'* colors.

Avoid the passive voice and write in the active voice. Your writing will be more forceful. For example, active: Holzer programmed the LED display; passive: The LED display was programmed by Holzer.

Keep present, past, and future tenses consistent throughout your writing. Works of art are usually referred to in the present tense because they exist; exhibitions are often discussed in the past tense because they are temporary.

Long sentences are not necessarily better than short ones. Whether long or short, make sure they are clear and easy to read.

Use gender-free language in your writing; avoid using pronouns such as *he* and *she* unless referring to a specific person. When possible, use plural pronouns such as *they*; it is preferable to writing *he and she* or *s/he*.

Write colorfully but avoid inflated language. If you don't fully understand something, say so. Do not try to cover up with obtuse verbiage what you don't understand. Critics can allow for the mystery of art; they are not expected to understand everything concerning the new art about which they are writing. Invite your reader to help solve the problem you are experiencing with the work.

Avoid qualifiers, or at least consider carefully before using them. Qualifiers such as *very* and *extremely* may weaken your writing rather than strengthen it. If you say that something is powerful, you do not need to say that it is *extremely* powerful. Too many qualifiers will make your writing seem gushy and will weaken your credibility. Avoid, too, qualifiers that make your statements too safe or too weak: *rather*, *little* (except regarding size), *pretty* (as in "pretty sure"), *somewhat*.

If you can obtain and use reproductions (color or black and white) in your paper or article, do so. Be sure to provide the artist's name, title of the piece in italics, medium, dimensions, and date of execution, in this order.

Consider whether headings will clarify your argument for your reader. Consult your chosen style guide for types and levels of headings.

Editing

Being a good writer also means being a good editor of your own writing. An editor assumes the role of a reader. Read what you have written as if you were a stranger to it.

First read it from the point of view of someone who would agree with you. Imagine specific people who might do so—your best friend, a brother or sister. Have you told them enough to allow them to visualize the art? Have you conveyed to them your enthusiasm for the art?

Then read it from the point of view of someone who would likely disagree with you. Have you presented your most convincing argument with sufficient evidence for your point of view? Will your intellectual adversaries have to admit, at least, that you presented a good argument, even though they might not accept your conclusion?

Once you have edited your paper and are proud of it, ask someone else to read it and make suggestions for improving it. All writing that appears in print has gone through an editorial process. This book, for example, before it got to your hands, went through considerable editing. I proposed the idea for this book to an editor. Before she and her publisher gave me the go-ahead to write it, she sent my proposal to a handful of professors around the country who might use such a book if it were published. They recommended that the book be written but offered suggestions they thought would make it better for their students.

As I wrote the book, I gave chapters of it to students in my criticism courses, and they commented on each chapter, pointing out sections they found unclear and identifying typographical errors. I made the changes they recommended. I also asked a trusted colleague to read the whole manuscript, and others to read sections; they, too, offered valuable suggestions for changes, which I made. I then sent the manuscript to my editor, who sent it to another handful of professors to see if they would want their students to read such a book. They approved of it but suggested changes. I made revisions. The manuscript then was given to a professional copy editor, who made detailed suggestions for changes that would improve its clarity, eliminate redundancy, and enhance its literary style. A designer then set the manuscript in the typeface you see. At this point, the publisher asked me to proofread galleys of the whole text, looking for any errors; the publisher also hired a proofreader to do the same. And after all this, there are probably still errors in the book—you may have already found some.

This laborious process of writing and editing is common. Read the acknowledgment sections of books on your bookshelf to see the variety of people authors credit and thank for their help. The point is that editing is important and you should go through the process with your own writing to help improve it. First, read your own work. Reading it aloud to yourself will help you find awkward phrases and incomplete sentences. Then, before you turn it in, have someone else read it. Choose someone in the class who knows the material and the assignment and ask him or her to read for substance—have this person assess the clarity of your writing, the logic of your argument, and the evidence you provide to support your conclusion. Then ask a roommate or a classmate to proofread it for spelling errors, poor grammar, and typographical mistakes, all of which hurt your credibility because they imply lack of respect, care, and concern for your reader and for how you regard your own work.

If writing is a problem for you and requires more help than a friend can provide, consider finding a tutor in the English department. Many universities have writing

laboratories staffed with people who provide free help for students experiencing difficulties in writing. You might even consider hiring an editor.

Ask your professors if they will accept and comment on preliminary versions of your paper. If so, you can have the benefit of their opinions before you submit the final paper and they grade it.

Adhering to Deadlines

Because editing and making revisions take time, you will not be able to begin writing your paper an hour before the class period in which it is due. If you are a serious student who wants to write good papers, you must plan ahead to leave yourself enough time to revise. Every paper you turn in should be at least a second, if not a third, version.

Turning in papers late will likely lower your grade. Missing editors' deadlines is professionally irresponsible and will not win you future favors.

SAMPLES OF WRITING

Following is a sampler of writings in response to assignments given in both art criticism classes and in art-making classes. All the samples but one (Kerry James Marshall's artist statement) are written by undergraduate or graduate students.

Writing Personal Responses

The following are three short papers, written by students in a college class about contemporary art, in response to the retrospective exhibition "Kara Walker: My Complement, My Enemy, My Oppressor, My Love," at the Fort Worth Contemporary Museum of Art, 2008. The students saw the exhibition outside of class at a time convenient to them and responded to an assignment for a brief personal reaction to the exhibition. The first essay is by an undergraduate senior art major, the second and third are by undergraduate seniors in art education, and the third is by a master's student in art and museum education at the University of North Texas.

Kara Walker Exhibit

Alanna Ezell

I went to the exhibit with an open mind, interested to find out what it was that offended so many people. I did my best not to be offended. Not only was I offended, I was disgusted. I can appreciate someone's struggle with racism. I can appreciate someone expressing things they have experienced. Call me stupid but I don't understand. Call me a prude but I actually felt dirty after leaving the exhibit. Why is it necessary to show two silhouettes of men giving each other head? I can honestly say I wanted to understand. I felt like she was trying to

speak for what long gone oppressed ancestors have gone through. I am all of that. I know the romantic ideal of the South isn't what really happened. My ancestors were "Florida Crackers." They were very poor people who lived off of what they grew. You don't see me showing them giving each other blowjobs, do you? What was so appealing about the exhibit that everyone else loved? Am I the sheltered redneck that cannot comprehend good art when I see it?

My Complement, My Enemy, My Oppressor, My Love

Kristi Rucker

This exhibition is displaying the oppression of slaves during Civil War times. The message is to show that blacks were seen and used as products. African American women were having mass-produced children, their bodies used as factories to produce workers for the fields. She has a hand puppet show showing children being thrown from the womb into the fields.

One of the most intriguing rooms was an add-on for Texas only. This room had pictures shown on the wall with overhead projectors. This forced viewers to be silhouettes on the wall. I walked in the room and froze. How was I a part of this exhibition or time period? Once I realized the intent I pondered how my ancestors were a part of this time in history, and how oppression was still going on today.

When traveling through this exhibition I was moved with emotion. The subjects and meanings are violent and sexual. I can't help but feel a part of this exhibition. I feel frustrated and angry that these situations occurred. I feel a personal connection with oppression of women. I am not a woman of color, so I have never truly had to confront those issues, but I do feel viewed as only a way to produce workers.

White on Black—the Kara Walker Exhibition

Lacy Blue

I'm a middle-class white girl from the South. My family came to Texas at the end of the Civil War when Moses Henry Blue, discharged from the Confederate Army at age 17, found his Alabama home and family destroyed and gone. He began to make the journey to Texas on foot so that he could reunite with friends from the war. The Blues have been here ever since. I come from a family rooted in the Southern Baptist tradition. I missed out on most of the hellfire and damnation sermons that I later learned were a stereotype of the church. As I became an adult I separated myself from its aggressive evangelicalism and strict conservatism.

Entering a room full of Walker's silhouettes was awe-inspiring and overwhelming. When I slowly read her narratives I felt belittled, embarrassed, and challenged. Her expressions of anger, even hate, were pointed directly at me and my familial background. Still, I could not help but admire the beauty of her

compositions, the sharpness of her lines, the stylized shadows that so obviously differentiated Black from White. I felt transcended to a time where black and white did not coexist; I felt that the shadows on the wall could be my own. Her work is so violent, gruesome, and blatantly obvious that Walker does not consider issues of racism to be a thing of the past.

Kara Walker seemed to be asking me to atone for the damage of my Alabama ancestors. She projected my shadow on the wall so I could feel the pain and humiliation of African American slaves, the mother nursing another woman's baby, the female slave sexual deviant, so that I would have to view myself as the fat white landowner, the sodomizer, and the shriveled infant simultaneously. I wanted to explain that I don't feel the hatred she projects through shadows.

I wondered if her art only helps to further segregate blacks and whites. Kara Walker is, after all, using their contrast to her advantage. I realize that every person who views the exhibition is casting their shadows. Walker's work unites races. Could we complement each other after all?

Kara Walker, My Complement, My Enemy, My Oppressor, My Love

Megan DiRienzo

I viewed Kara Walker's work with my friend and colleague who happens to be African American. That statement I just typed, "happens to be African American," reeks of the same awkward I-am-so-white-feeling I experienced as I stepped into Walker's exhibition. My feelings about being there with my friend were as ambiguous, shameful, and humorous as Walker's silhouettes. I wanted to ask my friend what she thought about the flat, demanding cuts in front of us, but couldn't bring myself to. Should I apologize? Should I try to laugh with her? Should I run out the front doors and back to my hometown in Pennsylvania where the only black people I ever knew were on TV? I was ashamed of myself and embarrassed that I didn't know how to relate to my friend or to the work in front of me.

"My Complement, My Enemy, My Oppressor, My Love" pointed right at me, screaming, "Hey, white girl! Think about how our histories as Americans are intertwined, but so disparate you can't even look your friend in the eye. And don't you dare use the old trick—My grandparents were late 19th century immigrants, so slavery has nothing to do with me. Jim Crow was hard at work when your grandpa got off the boat, so you're stuck with us, now face us!"

I faced *Darkytown Rebellion*. I laughed nervously to myself, imagining how terrible it would feel to have a ship's mast shoved right up my ass and out through the top of my head, and thinking I might even deserve it.

The black silhouettes in *Insurrection! Our Tools Were Rudimentary, Yet We Pressed On* had pinned me to the wall, accusing me of whiteness. Walker's work puts Caucasians on the spot, threatening, enlightening, and forcing good old fashioned white folks to see a side of themselves and their history that they would much rather forget, deny, or euphemize.

I kept telling myself I couldn't relate to Walker's work. None of my ancestors bore such terrible atrocities and discrimination, so to a white girl, the flat contrast and nightmarish fairytale imagery was terrifying and hilarious in a much different way than it would be to a black girl. I can't say how because I wasn't brave enough to ask. The next step is to ask. What's the worst that could happen? Kara Walker has already shown me the worst of it, so now it's a matter of moving away from the wall to ask my friend about what she thinks of our American history.

Each of these papers is written with honesty and passion. The writers read their papers aloud in class and granted permission to publish them here. Schools ought to be safe places where people can express themselves and agree and disagree with one another respectfully. Writing before speaking guarantees prior thought and usually results in more informed conversations about art and life.

The following paper is based on personal response combined with library research. When he wrote this paper, David Guion was a graduate student in arts policy and administration, enrolled in an art criticism course.²

Road Trip to Pittsburgh

David Guion

My friend Jim and I left Columbus on a Saturday morning for a road trip to Pittsburgh. I was interested in seeing the exhibition James Turrell: Into the Light and Jim wanted to tour the city and take in the architecture. I brought along guidebooks of Pittsburgh and I read out loud in the car so we could both be better informed about the city. I also brought along some rather theoretical art books that highlighted Turrell's work. I read aloud some passages from those books as well and reviewed the photographs, as the trip was about three hours and we had time to kill. I needed some reference point for the work we were about to see. It was an easy way to pass the time. The photographs of Turrell's work were so intriguing, even Jim was anticipating seeing the exhibition. With Jim's limited knowledge of contemporary art, I knew this might be a stretch to introduce him to this work. My fear was that he would be bored or simply not understand the conceptual framework. I had the same fear for myself.

The Mattress Factory, Setting a Context for Turrell's Work

We decided to stay overnight downtown at the Hilton on the "Golden Triangle," a strip of land that overlooks the Monongahela and Allegheny rivers. These two sprawling bodies of water form the Ohio River just south of the city. After reading the map, we determined that the Mattress Factory, an installation space for contemporary art where the exhibition was held, was about a twenty-minute walk from the hotel. We dropped off our things and ventured out into the "City of Bridges." After negotiating the map and locating various streets, we found ourselves in a relatively rundown neighborhood. Thirty minutes had passed by now

and we were still walking through brick-lined streets with homes and storefronts dating from the 19th and 20th centuries. We came upon the Mattress Factory unexpectedly.

As we learned from further reading, the Mattress Factory was founded in 1977 in a vacant Stearns and Foster warehouse located in Pittsburgh's north side. Artists rehabilitated the six-story industrial building for studio and living space, a co-op restaurant, and an experimental theater and gallery. In 1982, the museum began to focus programming on installation works that engage the architecture of the site and involve the community and region. Turrell was one of the first artists to create permanent installations for the museum.

We approached the renovated warehouse by a limestone gravel driveway that led up to an entrance, unmarked and unobtrusive. The Mattress Factory was partially ensconced in scaffolding. Construction equipment littered the area. To the left, in the gravel parking lot, we noticed what looked to be a temporary building, a tall square structure with corrugated aluminum siding. Since the Mattress Factory appeared as if it was in the midst of a renovation project, we gathered that the construction workers had built a temporary structure for architects to meet and house their plans. We didn't think much of the building and proceeded inside to view Turrell's work. I was hoping that this artwork extended beyond the minimalist label with which it is sometimes associated and that it wasn't too monotonous for Jim.

The Mattress Factory and Turrell were making a conscious choice to present this work in an alternative venue that was both experimental and less mainstream. It was consistent with many of the works Jim and I viewed in the catalogs and books highlighting Turrell's work. His art is often placed outside of the conventional museum venue—in homes, in alternative spaces, in venues such as a Friend's Meeting House in Houston, Texas, and in various lobby spaces at the Mondrian Hotel in West Hollywood, California. Turrell takes risks in presenting his work beyond the confines of the gallery so as to highlight our awareness, attention, and perception.

"James Turrell: Into the Light" filled four floors of the six-story building with Turrell's distinctive projection works, installations, drawings, and models of his ongoing project *Roden Crater Roden Crater* is a monolithic undertaking, which consists of a series of observation buildings built beneath the surface of a cinder volcano north of Flagstaff, Arizona.

The exhibition consisted of over 20 works that included permanent installations, new installations created specifically for the exhibition, smaller works in the corridor spaces, drawings, prints, and models of *Roden Crater* in the basement of the museum. Each work built upon Turrell's early explorations that began with a series known as Projection Pieces that are created by projecting a template of color onto the corner or wall of the gallery space. A special xenon projector with a 1200-watt bulb is used to create a clear hard-edged image of a geometric form that the mind completes as three-dimensional. In these early works Turrell begins

When you enter the gallery space, the glowing violet rectangle at the far end of the gallery appears to be a solid form. Viewing the work from afar, the rectangle appears to be a glowing television monitor or movie screen. Upon closer inspection, the rectangle is actually a cutout space in the gallery wall with fluorescent ultraviolet light emanating from behind the divided space. The walls behind the cutout rectangle are painted titanium white, a paint that contains metal and reflects the ultraviolet light to the degree that a fog or haze is created. The incandescent light within the gallery space creates the image in your mind that the wall is a solid form or screen.

Rise, 2002, introduces the element of time with what Turrell refers to as Shallow Space Constructions. In this series of works, Turrell adapts the architecture of the space occupied by the viewer. A false wall at the end of the gallery appears to float on a field of light. Combining artificial light (neon and fluorescent) and natural light, the work is constantly changing. While Jim and I were there the color and feel of the room had progressed from a foggy blue to a brighter pink. The change is almost imperceptible, and the idea of change over time is simply magnified as you are left to grapple with the changes you are witnessing. By introducing a variety of gases into the neon tubing—neon to produce red, hydrogen to produce purple, and mercury to produce blue—Turrell creates an installation that is never the same.

One of the most startling installations was *Big Red*, 2002. This work introduces the viewer to a *Ganzfeld* effect in which light is experienced as a consistent visual field. In normal atmospheric conditions, light is dispersed, reflected, and refracted from a multitude of surfaces; this is the nature of our atmosphere. This effect can be eliminated in a space that is carefully controlled for external and ambient light. In this installation the smooth surfaces of the gallery with recessed neon light create an intense red light that emanates from above the ceiling and below the floor. All ambient light is prevented from entering the space by its mere construction. With such concentrated color saturation, it is possible to lose one's orientation. The light in the space appears almost palpable, like a mist suspended in the air, a red fog. If it weren't for the few scuff marks on the white floor of the gallery space, that allowed for a hint at orientation, and the black doorway that Jim and I could escape to, like the exit in a funhouse, this would be clearly one of the most disorienting museum experiences on record.

Our next venture took us back out into the light of day and away from the formal gallery experience. At that point I began to understand the radical departure Turrell was making in moving beyond the confines of the gallery space and the museum. Associated with the Earth Art Movement, Turrell presents a new approach to conventional museum experiences with his installations entitled Skyspaces. Moving beyond the commercialization of art, he makes a social statement about the commodification of artworks and the gallery system in these

Skyspaces

In 1975 the first Skyspace was realized at the Villa Panza in Varese, Italy, entitled Skyspace I. Starting from models he created in his studio in California, Turrell proceeded to realize Skyspaces around the world, from New York City to West Cork, Ireland. Turrell explains that the idea of the Skyspace is to bring the space of the sky down to the plane of the ceiling (Noever, 1999). Though the space appears enclosed, the opening in the roof, also referred to in the literature as an aperture, is completely open to the sky. In inclement weather the rain and snow simply fall in, settling on the floor of the structure. It was a clear bright spring day when we visited *Unseen Blue*, but it was alluring to imagine the snowflakes or rain coming through and watching nature become one with the space. Turrell explains that in his Skyspaces a sense of closure at the juncture between aperture and ceiling appears to be a glassy film stretched across the opening, with an indefinable space beyond this transparency that changes with sky conditions and sun angles (Noever, 1999). The opening is made with a very thin knife-edge and is placed above the horizon so that the only thing a viewer sees through the aperture is the sky itself.

Experiencing Unseen Blue

Unseen Blue, 2002, is a wooden structure that stands alone in the parking lot, with corrugated aluminum siding covering the exterior of the building. It is nineteen feet six inches high and is twenty-five feet square. You approach the building via a ramp that wraps the building. The ramp, apparently designed with the physically challenged visitor in mind, creates a sort of promenade, an extended catwalk, or a runway that leads you to the doorway of the structure. Rather than simply entering the front of the structure directly through a doorway, the wraparound ramp provides an anticipatory element that heightens the excitement and adds to the illusive quality of what appears to be a rather unassuming building.

As Jim and I entered the doorway we noticed the intense blue on the ceiling almost immediately. The aperture that produces this intense blue, much clearer and defined than the sky outside the structure, is eleven and a half feet square. The rest of the structure is so minimal, that the benches along all four walls are unassuming and less of a feature. Only after your neck gets tired from looking up at the aperture, standing in the middle of the space, do you notice you can sit and observe the opening in more comfort and from different vantage points around

the room. The walls and ceiling are painted a matte white and the benches appear to be stained oak. Measuring seven feet high, the benches have a backrest that allows you to lean back and rest the head against wood and view the sky.

There is an intense or heightened awareness of the sky in *Unseen Blue*. The cutout in the ceiling becomes a focal point. Eventually you give in to the methodical staring and you sit down on one of the benches. You can view just the blue of the sky and notice the intensity as it is contrasted with the white of the ceiling. You begin to notice clouds floating by. A bird flew past at one point and startled me.

Turrell has discussed the incorporation of the sky in his work and the lines of science and art and how they seem to be inextricably tied together in his work:

The sky is actually part of our neighborhood and part of our visual sense of territory, which is wonderful. It was odd to me that we had to go to the moon, a lesser satellite, and then declare, "Now we're in space." I mean, we're in space now. But the fact is that we don't feel like we're in space now and that is a big effect. Because of fear of darkness we light the night sky and cut off access to inhabiting and living in this big territory. That is a profound psychological enclosure. (Giannini, 2002, p. 43)

Turrell and the Art World

As is apparent with his interview with Lennox, Turrell is profound in his writings and is astute at explaining the role of space and light in his work. It is often argued by critics that perception is the medium and light is the material in Turrell's art. The art world tends to grapple with this notion, as it is difficult to grasp the idea of perception as a medium. It would be much easier to consider the medium to be light. Artists and critics tend to approach his work differently than a scientist might approach his work.

I wondered if a skylight in a house would have the same effect, then realized that this was a unique structure, imbued with unique qualities by the artists. Intricately constructed, based on a series of Skyspace constructions dating over 25 years. It is masterfully crafted to heighten perception and awareness of the sky and the light from the sky, not just an additional opening in a house to provide natural light.

Light and Perception

At this juncture in the journey, I am wondering what I have gained in interpreting *Unseen Blue* and the overall exhibition. I think James Turrell has allowed me to reconsider light. I understand now that light is the result of something burning—the sun, an incandescent lightbulb, a fluorescent tube, a tungsten bulb, the red of a neon gas, the purple of hydrogen gas, or the blue of mercury gas. My perception of this light is not just external but internal. My brain is processing the color, the intensity of light, and the degree to which the rays meet my eyes and illumine the surfaces and space in front and around me. Working with and observing light is complex and tenuous.

Turrell not only takes us beyond the confines of our perception internally, allowing us to question what is unique to our view of the world, but makes us consider the vast space beyond our perception. With *Roden Crater* and his Skyspaces, Turrell takes us beyond the confines of the planet to the light of celestial bodies lighting our earth. We extend the confines of our own perceptions, the limits of our own atmosphere, and are asked to not only observe the light of the sun and the stars, but to consider them in new ways. We are asked to consider ourselves situated on a large ball spinning through space with a wide expanse of space outside of our day-to-day comfort level of comprehension.

Time

Turrell's work is not just about light, perception, and space. Time is a seminal theme. Turrell explains that his work involves the notion of "the opening of time" (Giannini, 2002). He suggests that he opens time in three ways. One way is to use how the eyes open as they adapt to levels of light. This use of time is most apparent in his projection work and his full-room installations. The second is in what Turrell calls the glazed-eye staring or overall sameness. This is evident in his constructions *Big Red* or what he calls his Wedgework series. An example of a Wedgework is the installation *Milk Run III*, 2002, at the Mattress Factory, where the light, situated at a variety of angles, is coming from behind a wall and creates a picture plane that is difficult to decipher unless one inspects the opening in the wall from which the light is emanating. The third way Turrell opens up time is change. In *Unseen Blue* this is evident as the artificial light in the space behind the benches is the same but the light outside changes, creating a dramatic effect at sunrise and sunset.

Who Is James Turrell: His Influences and in His Interests?

Where do all these ideas of time, space, light, and perception come from in Turrell's work? As I read in the car on the way to Pittsburgh about Turrell and his background, interests, and the connections he made to other influences in his life, I was able to gain more of an insight into these themes and his work. He was born in Los Angeles, California, in 1943. He obtained his pilot's license at the age of sixteen and has always been fascinated with aviation, the exploration of space, and the changing nature of the earth's atmosphere. He studied perceptual psychology at Pomona College taking classes in other scientific disciplines such as mathematics, geology, and astronomy. He received an M.A. from the Claremont Graduate School in 1973. All of these interests and studies have played key roles in his artistic process and creative endeavors.

From the age of six, his grandmother deeply influenced his approach to life and art as they both attended Quaker meetings. His parents were also Quakers. His grandmother suggested that he concentrate on the "light within" and that he "go inside to greet the light" (Herbert, 1998). In the silent Quaker meetings where

Back at the Hotel Room

After a long day of sightseeing I took the books out of the bag that I purchased at the Mattress Factory. Jim was watching television. Viewing the rivers outside the hotel window I sat and read a bit more about Turrell before bed. The catalog for the exhibition was particularly beautiful with its glossy photographs of the work, and Barbara Luserowski, director of the Mattress Factory, had key thoughts about the work I had not considered:

When you go to *Roden Crater* and walk into the spaces that Turrell has created there, you experience a sense of awe. There is an experience of being outside of yourself that helps put into perspective the realities of the world. You make an internal readjustment, spiritually, similar to what happens when you walk into a space like a French cathedral or when you lie on your back and look at the stars.

The light was the art. However, his work cannot be categorized as minimalist either. Minimalist work is what is in front of you and nothing else. But Turrell's work gives you more information and takes you to other places. (In Giannini, 2002, p. 5)

The Adventure of Being Transported

Reading more about Turrell's work, the various interpreter's views, and Turrell's thought-provoking explanations of his creative endeavors have allowed me to see that Jim and I took more than a tour of an exhibition that spring day in Pittsburgh. As I write about it, as I question the nuances of Turrell's work, I think it is more about a transformative quality of the work. Turrell took us to another space. The darkness and light, mysterious, confusing, and alluring is the nature of the work.

Jim and I talk about our adventures in Pittsburgh from time to time. There are many unresolved moments within the context of that adventure, that immersion in the world of perception. I think the experience was different for both of us, and yet equally profound. There is an internal awareness that grows when you sit and contemplate something or stand and stare at something and you don't really know what you are seeing. Perhaps this is the nature of interpreting something unfamiliar and strange.

I think something happened that day—an expansion, a freeing, a feeling beyond the confines of the space we inhabit. Can art change us? Can it allow us renewed awareness of the world around us? After viewing Turrell's work I can answer, "Yes it can, yes, an emphatic yes."

References

Giannini, C. (Ed.). (2002). *James Turrell: Into the light*. Pittsburgh, PA: Mattress Factory.

Herbert, L. M. (1998). Spirit and light and the immensity within. In Contemporary Arts Museum, Houston, *James Turrell: Spirit and light* (pp. 11–21). Houston, TX: Contemporary Arts Museum, Houston.

Noever, P. (Ed.). (1999). James Turrell: The other horizon. Vienna, Austria: Cantz.

Writing Short Responses to Works of Art

After silently watching a series of slides of the paintings of John Currin, students left class and wrote short responses to the work and posted them on the class Web site for their classmates to read.³ Writing one-paragraph spontaneous responses is a good way to free one's thinking and writing. Reading different responses to the same works of art enlarges one's individual perspective.

Time traveling Botticelli-esque nudes rematerialize on John Currin's canvas, looking slightly off-kilter as they re-acclimate to their new surroundings. His women seem plucked from *Birth of Venus* (1484–86) or *Primavera* (1482), and appear to be uncomfortable after the journey. Currin distorts their bodies; the women sheepishly smile, gazing vacantly from within strangely imagined backgrounds, and pining for a more agreeable host. A sinister undercurrent, not quite decipherable, begins to draw me closer. The curvilinear, yet angular nudes, are oddly positioned, adding to the general feeling that something is not quite right. Wide-eyed nymphet faces sit atop post-pubescent bodies; false innocence melding with well-used flesh. Currin gleefully corrupts Western idealized beauty, leaving me feeling disturbed and wishing the ladies a safe trip home.—Shari Savage

The seemingly benign brushstrokes of John Currin's paintings of female nudes, such as *The Pink Tree*, 1999, veil a harsh commentary on the objectification of women. The soft light and smiling faces are distinctly reminiscent of Botticelli's *Birth of Venus* (c. 1485) or *La Primavera* (c. 1482), yet the plump bellies and ample breasts seem intent on capturing the superficial male gaze. Once the viewer's eyes stray beyond the centerfold qualities, a more provocative and satirical story unfolds. The elongated, distorted limbs, perhaps reflective of the Mannerists, draws a more contemporary allusion to the heroin sheik, waif-like features of Kate Moss. The classic beauty of the Renaissance is quickly abstracted into a distorted reality.—Ross Schlemmer

John Currin's work is a great candidate for psychotherapy. In looking at his paintings, nothing quite fits, resulting in my nominating him for psychotherapy, as well as my inability to stop looking at them. Currin paints portraits and does so with an absolutely masterful technique—a throwback with a notable nod to the

John Currin, *The Pink Tree*, 1999.
© John Currin. Photo by Robert McKeever. Courtesy Gagosian Gallery.

192

What Do Critics Say about Currin?

Shari Savage

John Currin's paintings bother me. I can't see his work, most of it anyway, without feeling as though a sinister specter lurks nearby. I am bothered, and in the case of his more recent pornography-inspired series, disturbed. But, is his work good art? Is it even art? Both questions are asked whenever controversial sexualized subject matter is presented in a gallery setting. Sally Mann's, Robert Mapplethorpe's, and Lisa Yuskavage's work have faced these questions, too. Viewers divide when discussing Currin's work. I am conflicted; his paintings exhibit skill-fully rendered historical references; however, his subject matter tends to distract, leaves me disquieted, and confused. Making a call one way or another is difficult for me, so I want to look for others' interpretations and judgments to broaden my understandings. What do professional critics think?

Three art critics describe wrestling with similar issues when it comes to evaluating Currin's paintings. Michael Kimmelman of *The New York Times* writes that Currin's work can "put you off or turn you on at the same time" (2003). After engaging with Currin's work at a past exhibition, Ann Lauterbach gave him a pass, wanting to believe he held a "sympathetic gaze" when depicting women; however, over time her reading fell apart. Now she argues Currin "pushes us away as he draws us toward, like a roadside crackup, or tabloid headline" (2005). In *ArtReview* David Rappolt asks, "What's with all the sex?" He notes that *The Village Voice* called for a boycott of Currin's exhibition, and *Juggs* magazine (a men's

Whatever Currin means to say about women or his relationship with women through his paintings is important to some. Feminists are either troubled by his depictions of women, or see empowerment in Currin's themes. Some critics think the artist's intent is irrelevant to the discussion. Rappolt, however, is interested in intent or context, and while interviewing him in his studio asks Currin to address the pornographic turn in his recent series. The painter's answers range from admitted horniness, self-professed immaturity or tendency to revert back to his repressed schoolboy days, and finally to his obsession with "the golden age of porn during the mid-1970s, when they still let ugly or normal-looking people do it." But for all his nostalgia for amateur-looking porn, Currin is conflicted, too. Rappolt writes:

John Currin is embarrassed. His children can't come to his studio to look at his paintings, and when his parents come to his exhibition openings they don't want to comment on or discuss a number of his recent works. It's an awkward situation. Still, although he says he's embarrassed, he doesn't look particularly embarrassed about all this.

He's not blushing, fidgeting, sweating, or squirming in any way. He's sitting in a chair, looking a bit tweedy, in the middle of his Tribeca studio, sipping water in front of a large painting of a fleshy, curly-haired strawberry blonde stroking a man's erect penis (while he—the man in the painting, not Currin—reciprocates in kind). And he's calmly talking about how this, and other similarly themed works are going to constitute his next solo show at Sadie Coles HQ in London.

Rappolt notes that Currin's embarrassment does not extend to his financial success. Highly sought after, his paintings are hip, eagerly snapped up by the loft crowd, who show no embarrassment about hanging 1970s inspired porn on their exposed brick walls. High-level consumerism, Rappolt argues, seems fitting in this case because when distilled, Currin's work is nothing more than recycled cultural imagery, a pop culture primer upholding the idea that sex sells. Evidence of Currin's pop culture muses includes still shots from videos of 1970s porn, which litter the tables in his studio beside *Cosmopolitan* magazines. More telling, the artist uses the words *art* and *porn* interchangeably when talking about his new series, a speech act Rappolt reads as possibly calculated.

Calculated is a word Kimmelman might use when discussing Currin. He equates Currin to "a latter-day Jeff Koons," in both self-promotion and shock value, and finds the idea that people are split in their reactions to his paintings proof of his relevance. Like Rappolt, he points to the connections between the cultural narratives in Currin's paintings and the "cheap pathos that is in these vacant, ritual images, as there is also in magazine advertisements and pornography. But he nails the fake sentiments better than most." Kimmelman describes the recycled imagery Rappolt alludes to as "secondhand images culled from photographs mixed up with art historical quotations." He lists the quotations he's referring to: Goya, Lucian Freud, Dürer, Pontormo, Vermeer, Mantegna, Picabia,

Like Rockwell, Currin's skill as a painter is a discussion topic for critics, in that his skill is often overlooked because of his subject matter. Too saccharine or too smutty, both artists gain favor over time as their work gains in monetary value, fetching high prices at auction. Lauterbach, writing in *New England Review*, suspects Currin's self-promoted bad boy image garners attention, thereby overhyping the value of his works:

Currin's in-your-face rejection of ideology and theory-driven models for art experience is, I think, what has caused aestheticians like Peter Schjeldahl [of *The New Yorker*] to react with inebriated joy. Schjeldahl's *sine qua non* is pleasure, the delirium of a sensuous high from which, later, language and its conceptual demands ensue. Still a poet at heart, Schjeldahl wants to fall in love and tell about it in rapturous prose. And so Currin's combination of art historical savvy (where Schjeldahl and frères can strut their stuff), painterly finesse, and subversive topicality add up to a rave. Art critics of the world unite!

Lauterbach believes critics have set aside interpreting and illuminating, giving too much heed to Currin's celeb persona, fashionista lifestyle, and subsequent "market allure." He may capture our attention, she argues, but at what cost? Finding meaning in his work, Lauterbach writes, is something none of the critics "found a way to speak about . . . without separating, so to speak, the yolk from the egg." Like Kimmelman, she makes reference to the painter's use of high European techniques, historical quotation, and banal American illustration skill, but parts ways when it comes to declaring Currin imaginative or "vexing." Rappolt also refers to Currin's none too subtle borrowing from the European masters by calling it "potted history."

When describing Currin's paintings, the three critics use similar language. Lauterbach's terms include "creepy," "vacuous," "vapid," "puerile," and "vindictive." Kimmelman describes Currin's paintings as "creepy," "fetishistic," "suave and malevolent," "campy and debased." Rappolt uses the words "dead," "cartoony," and "kitschy."

The critics come to different conclusions, although none of them overly kind, when evaluating Currin's work. For Lauterbach, Currin's treatment of the female form is more "pop pornographer" than parody, "joyless, sarcastic, and glib." Rappolt declares Currin's paintings to be "all about overt display, they don't really seem to be displaying anything much at all . . . they seem strangely empty." Kimmelman, somewhat of a fan, believes "the final verdict is not in . . . it's not easy to make pictures that look strange to people today. We feel we have seen almost everything by now. Almost. We haven't seen the last of Mr. Currin."

Each critic mentions Currin's increasing value in the art world, as both a personality and painter, although even this remains a point of inquiry. Is he simply a family man looking to secure his family's economic place? A savvy

marketer who understands the complexities of the art game? A truly skilled painter whose subject matter engages some and enrages others? Kimmelman thinks Currin deserves to be heralded because his work is about "the pleasure of painting." Rappolt argues that Currin's work lacks a message; rather it's "just about painting," but he also describes it as "art in its most basic form." Is a painting with exemplary technical skill enough to qualify as good art? For Kimmelman it might be. For Rappolt—not entirely. Only Lauterbach issues a solid verdict about Currin's work when she writes, "We do not want to believe that someone as heralded as John Currin is a slick literalist of the imagination. A culture gets the artist, and the art, it deserves. The eagle soars over a destitute and cynical landscape."

After engaging with the different critics, I find myself knowing more about the artist than his art, as if he is the real story. If I understand Kimmelman, Lauterbach, and Rappolt correctly, this is perhaps the most I will get because Currin's paintings are not about anything except painting. Despite being message-deficient, his paintings make people talk, they challenge, amuse, disturb, and incite. That means something.

References

Kimmelman, M. (2003, November 21). With barbed wit aforethought. *The New York Times*, p. E31.

Lauterbach, A. (2005). John Currin, pressing buttons. *New England Review*, 26(1), 146–150.

Rappolt, D. (2008, April). Once more with feeling. ArtReview, 21, 50–59.

Writing an Artist's Statement

Artists, especially those in school, are expected at some time in their studies to write about their own work. These are commonly referred to as "an artist's statement" and are usually requisite for an exhibition. When well done, they open a door for the viewer of their work, inviting the viewer to walk in with an idea of what the work is about, but leaving room for the viewer to wander and wonder. An exemplary artist's statement follows. It is by a well-established artist, Kerry James Marshall, about a single painting of his called *Bang*.

Kerry James Marshall

Chicago, 2000

Bang continues the direction that I had started with *The Lost Boys* and *De Style*. History paintings are always made about grand themes and big events. The lives of black people in America are bracketed by big subjects of slavery, freedom, disenfranchisement, the political struggle for equality. These are the great black

Kerry James Marshall, *Bang*, 1994. Courtesy of the artist and Jack Shainman Gallery, NY.

cultural, social, and political issues. They are easy stories to choose, but there is another, less spectacular, less dramatic story that also needs to be represented: I mean the day-to-day ambivalence of black people about participating fully in the American dream. This story gets played out day by day, year by year, quietly, in backyards and homes all over the country.

So *Bang* is about celebrating Independence Day. It exposes one of the paradoxes of African America. Black people celebrate American holidays more vigorously than anybody—even the poorest are out barbecuing religiously on the days when you are supposed to be out barbecuing: the Fourth of July, Labor Day, Memorial Day. The title is written into the painting: HAPPY JULY 4—BANG! Two

young black boys and a girl are saluting the flag as if they are pledging allegiance. They are in a middle-class suburban neighborhood. The girl has a nimbus or halo, a small reference to the Statue of Liberty. Above their heads, a pair of doves carries a banner taken from a Revolutionary War poster: RESISTANCE TO TYRANNY IS OBEDIENCE TO GOD. Under their feet, another banner repeats the slogan on the back of the dollar bill: WE ARE ONE. Now, those phrases represent two aspects of American idealism: resistance and integration. The Revolution was fought to gain independence from the tyrannical rule of the British crown. If resistance to the oppressive disenfranchisement that the settlers suffered is a kind of obedience to God, then the parallel oppression and discrimination that black people experienced in America also required the same kind of resistance. During the civil rights movement, that struggle was staged with the hope of inclusion. These are the two poles of the black cultural revolution: resistance versus integration.

In the 1960s, during the civil rights movement and the black liberation struggle, there was a need to develop a protest art that could convey people's concerns directly. But it was often long on rhetoric and short on aesthetic appeal. It was about very strong political issues, but it wasn't very interesting to look at. Or it attempted to be completely involved in aesthetics, but was sort of meaningless. But there is a way to do both. Aimé Cesaire's poem *Notebook* of a *Return to the Native Land* showed me that you could be both incredibly political and poetic at the same time. I knew there was a way to get the same combination of politics and poetry in a painting. That's what I was after in *Bang*.⁴

Marshall wrote the statement six years after he made the painting. In the first paragraph he sets his large agenda; and in the following two paragraphs he applies this large theme to one work, writing from the general to the specific, enlightening us about both, without smothering our own reactions to the work. He writes clearly and directly, using first person singular. He also sets an art historical context for his work, saying how it is different from historical painting, and he offers the social context of race relations in the United States. He does not elevate the work into an intellectual stratosphere of vagueness. He enlightens us about the work rather than trying to impress us with his learnedness.

Marshall's statement is four paragraphs long, and about average in length, although no general rule about length applies. Pepón Osorio is an artist well known for his large-scale installations that evolve from interactions with neighborhood people with whom he works. He also teaches art at Tyler School of Art, Temple University. He has used a strategy with undergraduate artists to help them write artist's statements that hang next to their pieces in a gallery exhibition. First he asks them to write about their work in about nine pages; then rewrite those nine pages into three; and then rewrite those three into a one-page final statement. This technique is effective in getting student artists to consider their art broadly and thoroughly and then to successively make their statement more succinct to capture its essence with brevity.

Lynn Fleming, *The Here* + *Now*, 2009. Courtesy of Lynn Fleming.

Writing and Studio Critiques

Elliott Earls, acclaimed artist working in multimedia, and designer in residence and head of the 2D Design Department at Cranbrook Academy of Art, has devised a studio critique methodology that has produced good results among graduate design students in the program. Earls asks them to read *Criticizing Art* over the summer before coming to campus. When a student presents work for a critique during the year, the student hangs the work to be discussed in a gallery on Wednesday night, and writes a brief artist's statement for later use. Two other students write reviews of the work displayed, and illustrate their reviews with thumbnail images that they think relate to the work they are critiquing. On Friday, critique day, the group gathers in the gallery. Everyone looks at the work. The two writers read their reviews aloud. The artist reads an artist's statement. Discussion follows that is informed by *Criticizing Art*, the two reviews, the artwork, and the artist's statement. Following is a critical essay written by one student (Nicole) of another student's work (Lynne's) and then the artist's statement (Lynne's).

Ugly. Beautiful. Beautiful. Ugly.

Lynn is interested in making things despite them being ugly and the fascination with that. There is a moment in the process of perception, where the object continually teeters between beautiful and ugly, right and wrong. In its ambiguity between the two, there is an honest aesthetic.

Now here we are, looking at The Here + Now. Lynn has created a cryptic saying with vinyl tape on a piece of plywood. From far away, it looks as if she has painstakingly painted the type right onto the ply. However, as you get closer, you can see that it consists of very meticulously handled vinyl type. The tape has been cut and laid at perfect angles of 90 and 45 to create an almost calculator futuristic font. The type is minimalist and digital, yet crafted by the hand. It's apparent that it was not made on the computer once you start looking at the imperfections. But we will discuss that later. Playing with foreground/background, positive/negative allows the type to pop off the ply, even though it's as flat as the base she is putting it on. The forms originate from the cube. The tape is in colors deep blue, brown, white, and maroon. They come together to give you the feeling that maybe you aren't in 2009, but perhaps in your best friend's basement throwing darts or watching a movie with popcorn as a pubescent teen. You can relax but not put your feet up on the coffee table. It feels uncomfortable yet familiar. The plywood has a beautiful pattern to it—combining warm colors like vanilla and cream. This delicate patterning makes me forget the engineered origins.

In this minimalist piece, we are looking at 3 components. The tape, the wood, and the message. Let's start with the wood. A story of a man-made transformation, plywood bridges the gap from technology to nature. It fulfills a modern home's dreams.^a If plywood was good enough for the Eames' then it darn well be good enough for Lynn. It's totally middle class, cheap, attainable and there is probably a piece in everyone's garage at one point or another. Tape is another utilitarian material that's used in the everyday—a joiner and helper. You get things done with it. Here, the tape is paired with the perfect mate, plywood. There is a similarity of language in the tape and the ply. They are both household items you can pick up at the hardware store. They have a simplicity to them, however come together in projects to create much bigger things. The ply creates a good backdrop for the tape message. That's why these two materials work together. They are both everyday usual materials, cut from the same cloth.

A piece of wood represents a link with the deepest layers of the collective unconsciousness. Interestingly enough, a square, which the type was abstracted off of, is a symbol for body and reality. It projects the urge to bring into consciousness the basic factors of life that they symbolize.^b

Now we are left with the type. This progressive (futuristic) quality is in line with much of the work of the Dutch modernist designer, Wim Crouwel.

Both Crouwel's work, and Lynn's piece have angular forms that create letters. Pieces of the letter forms are obfuscated to create a three-dimensional quality. The Here + Now. I go to dictionary.com to look up first, the word "here." As a noun, it means this place, this world, this life, the present. As I scroll down, I check out idioms. Here and now. At the present moment; without delay; immediately, the immediate present. This is bringing everything into a little more focus for me. Maybe this is trying to start a dialogue about a culture that is always moving onto the next best thing. Maybe it's about how we are always going going going and not allowed to sit for a moment. My dad always used told me to stop and smell the roses as a little girl.

At first read, Lynn's message is finite. *The Here* + *Now.* Here I am, standing in the crit room, trying to review her work. It's telling me I can't go anywhere else but here. No escape . . . or maybe it's telling me to just keep on keepin' on. If you are in the immediate present, without delay, as the dictionary suggests, the wheel is turning and you aren't going to jump off. This sounds about right. The text works so well with its materials. The plywood and tape both mimic the idea of movement and process just as the text does. The modernist aesthetic of the letters proves to be as neutral as the plywood in letting the text speak for itself. The text is the essence of this piece. As a result, the plywood and tape continue to become more and more innocuous as you read into the words.

Lynn is playing with how we translate things. She's making us work hard for the money. What do we see? What do we get out of it? Ahh the aphorism. Not a new trick but a good one utilized by contemporary artists like Tracey Emin, Jenny Holzer, Mike Mills, and Ed Ruscha. All these artists use the power of language to prompt people to acknowledge and reflect. The strength of the message is also the weakness. The phrase leaves much to the viewer's imagination. It can be construed as too vague if looked at a glance. People want answers, but this piece gives none. The text is just a guide.

Indeed it is only a man's own fundamental thoughts that have truth and life in them. For it is these that he really and completely understands. To read the thoughts of others is like taking the remains of someone else's meal, like putting on the discarded clothes of a stranger.—Arthur Schopenhauer^c

Schopenhauer came to the conclusion that humans all want to think that their lives have meaning and we are directed by our free will. It's up to us to cull that meaning out of *The Here* + *Now*. This message can be whatever you want it to be, baby. However, it acts as a zeitgeist to move us onto the next thing. We have to have our own motivation to figure out what Lynn is trying to say with this piece. Nothing is spelled out. It's ordered, neutral, and quite possibly honest. It's presenting the message on a silver platter, or in a crystal ball if you will. Plain and simple. Or is it really that plain and simple?

Aphorisms are a huge part of our language. The phrases don't take a side either way. Just as a song does not set out to give you a solution, neither does an aphorism. Fredric Jameson describes postmodern culture as "schizophrenic." In a

contemporary sense, it relates to how people are becoming more and more passive and not wanting to stand for anything. There is an endless slippage of meaning. Thus, it's easier to leave much to be desired. Through aphorisms, one must use your own thought to form ideas instead of following another. In this piece, Lynn is just presenting and not informing. The viewer's the informant.

Cranbrook Slant

The Here + Now wants us to form our own conclusions. I think I have tripped over a meaning that is in this piece or in my own head. I see a relationship to the past coming into focus. I made a joke earlier about the Eames', plywood, and Lynn. Lynn's a smart cookie, and I think this piece could be a nod and commentary on the history and present of Cranbrook. She is reflecting on her time here thus far. It makes me think of how it's hard to escape the ghosts of this place. We come here to do our own thing, pave our own path, but it's difficult to not think about the people who have done so before us. What does it mean to say "the here and now," and to create type that looks like a homage of a Crouwel face? Is this piece grappling with the inability to be original and accepting this? The material relationship of the plywood and tape with the typographic futuristic nostalgia points me in this direction. It may seem contradictory to mention something as futuristic and reference an old designer; however, designers like Crouwel had the future in mind when creating work. Modernists designers were referencing the future (as odd as that is) while designers these days, such as Lynn, are informed by the past view of the future. Is The Here + Now a reaction against the work that has previously been made here at Cranbrook? It's going back to this mantra of the modernist/minimalist which Cranbrook 2D rejected so long ago in the 80's and 90's. The intentionally plain, inexpensively created piece is also a rejection of elitism in the conventional design world, while being ironic as a result of being so traditionally formal.

By using modernist and minimalist tools, Lynn tries to send out a message that is expressed by using rudimentary elements such as lines and planes organized in very particular manners. As architect Ludwig Mies van der Rohe said, "Less is more." While I think the materials are a good choice, the craftsmanship needs to be worked. From far away, all looks great. However, the closer you move up to the piece, you can see that some of the tape is peeling away at its edges due to sanding. This is detrimental to the seamless intent. Also distracting are the pencil marks that have remained. You can see the grid that was used to mechanically lay the tape down. A piece like this needs precision. And if the faint grid is meant to be intentional, then it needs to look more so. Right now though, it's a hindrance.

Aside from physical craft, Lynn has crafted her own aphorism for viewers to sit and ponder over. Not so much an original thought but in well-designed form, $The\ Here\ +\ Now\ may$ leave you standing there while time passes to figure out what you are really looking at. At first you thought it was just some words in tape

on some wood. But that's what is good about the piece. Equally confusing and clear at the same time. It makes you stop. Think. And then when you come out on the other end of it, you're better off. Or maybe not.

- ^a Ngo, Dung. Bent Ply. 2003.
- ^b Jung, Carl. Man and His Symbols. 1968.
- ^c Schopenhauer, Arthur. Essays of Schopenhauer. 2006.
- ^d Robinson, Dave & Groves, Jude. Introducing Philosophy. 1998.
- ^e Santayana, George. The Letters of George Santayana. 1955.
- ^f Kul-Want, Christopher & Piero. Introducing Aesthetics. 2007.
- g van der Rohe, Mies. The Presence of Mies. 1994.

Artist's Statement

Lynn Fleming

This past summer I lived a shadow life of Jacob Dahlgren, the Swedish artist for whom I house-sat. I slept in his bed, ate off his dishes, walked his dog, read his books, visited his summer house, had fikas with his neighbors, rode his bike to his studio to make . . . my work. Jacob is obsessed by stripes, geometric abstraction, and everyday materials. Recently I was at Home Depot and when I saw a display of colorful electrical tape I recognized its potential as an art material. I'm sure this is Jacob's influence manifest. I am interested in exploring how type can have a conversation with materials; I want to create areas of friction between form and material, between sign and signified.

Researching One's Own Art

The following and final essay is an example of a scholarly paper by a student artist reflecting on works of art as she was making them. She wrote the paper at the end of the first year of a two-year master of fine arts graduate program. Both her ideas about her work and her work itself were in process. Her essay is helpful to us as an example of writing about one's own work using critical strategies identified in this book. Her paper is also useful to her in conceptualizing and articulating what she is doing. Her essay and work interweave theory with practice, and she cites a range of authors and sources that inspire her thinking and her making. Her paper was a strong basis for an MFA thesis that she wrote in her second year in support of her final exhibition to fulfill graduation requirements.

Ceramic Work⁵

Janet Macpherson

Since I began working in clay, I have been interested in making work that demonstrates a personal response to my Catholic upbringing. I attended Catholic

Janet Macpherson, *St. Lucies*, 2009. Courtesy of Janet Macpherson.

schools all of my life, my father played the organ at our church, my very religious grandmother lived with me and my family when I was a child, and I have distinct memories of visits to my mother's parents' house where my grandparents would sit beneath a giant portrait of Jesus, saying the rosary in hushed, chanting voices that both scared and compelled me. These experiences have yet to leave my consciousness.

For the past decade I have been using Christian iconography and medieval hagiography juxtaposed with images from my childhood to create narratives in clay. I draw from sources such as Victorian anatomical drawings, icons, texts on medieval monsters, illuminated manuscripts, and the lives of Christian saints. Since beginning graduate school in ceramics last year, my interest has shifted to making figures as opposed to functional vessels, and I have been both collecting and sculpting objects from which to make molds.

I happened upon a 12-inch plaster statue of St. Lucy in a thrift store and made a complex twenty-part mold of her. In figuring out the undercuts, I paid little attention to where I placed the seam lines, and when I removed the first cast, I realized that I had seam lines in arbitrary places that were quite visible. Part of my interest in Christian martyrs is the idea of the saint as a deformed and fragmented body, and I realized that the seam lines that were left visible echoed this idea of the saint's body in pieces. During their martyrdom, saint's bodies are pulled apart, and often the part that is removed becomes emblematic of that saint and his or her hagiography. For example, St. Lucy had her eyes gouged out, and she carries her eyes on a plate as a remembrance of her sacrifice and selflessness. Similarly, St. Agatha is shown carrying her breasts on a plate after they were violently removed by her aggressors. Although God ultimately restores both St. Lucy's eyes and St. Agatha's breasts, and they are depicted in art as whole bodies, the image of these women holding the evidence of their dismemberment is powerful and evokes the idea of fragmentation that is so prevalent in Christian iconography.

In her book, *Visualizing Women in the Middle Ages*, Madeline Caviness discusses female martyrs within the context of sado-erotic spectacles that are enacted to satisfy the male gaze. Female bodies are stripped, tortured, and often sexually mutilated. It is interesting to me that the hagiographies of female martyrs have certain thematic similarities stated by Caviness in that the girls are "young, living devoutly with either Christian or pagan parents, when they become the object of desire of a man with political power . . . the refusal to marry is the first event of note, and the ensuing tortures occupy a large proportion of the texts, inviting serial illustration." (Caviness 89) The idea of women's bodies being beaten into submission is interesting to me as a feminist, as I have many negative associations with the Catholic Church as being hostile toward women's autonomy and especially reproductive rights. I am interested in channeling some of this into my work in ceramics through the use of female martyrs.

Torture and fragmentation of the saint's body lead me to the function of "the abject" in art, especially within the framework of medieval female martyrs. Caviness follows her discussion of the sado-erotic depiction of female martyrs with the contrasting idea that the body in pieces, demonstrated by emblematic images of the saint holding for example dismembered breasts or plucked out eyes, becomes de-eroticized as it is no longer a whole female body subject to a gaze, but is simply a collection of disassembled parts. Caviness cites Julia Kristeva and her philosophy of the abject as embodied in repulsive objects such as body fluids and wastes that are feared and rejected. "Such things keep one mindful of the vulnerable and fluctuating boundaries of the body . . . in death boundaries between self and other cease to exist." (Caviness 41) Kristeva states that "the corpse, the most sickening of wastes, is a border that has encroached upon everything. Fear of and fascination with this ultimate encroachment, a vortex of summons and repulsion, involve us in a cathartic discourse that integrates the abject into religion and art." (Caviness 41)

In *Powers of Horror*, Kristeva aligns the maternal body with the abject in her discussion of the Virgin Mary and "examines the confrontation with the maternal as the coming face to face with the un-nameable, the abject, that she sees as the base of all religions." (Jonte-Pace 10) I have begun a series of small casts of Mary

that I am deconstructing by carving into the plaster mold itself. The recessed areas of the mold become "tumors" on the surface of the statue. Kristeva discusses the connection between the inside and the outside of the body with regard to motherhood, as the child represents what was once inside the mother but is divided from it and connected simultaneously. The themes of the body in pieces, the visceral internal contents of the body, and the abject as a necessary aspect of human experience inform my ceramic work.

My interest in fragmented bodies encompasses the realm of monsters, most significantly Pliny's catalog of monstrous races that exist on the periphery of the "civilized" western world. These beings are monstrous in a medieval ontological understanding of humanity because they have too much of something, such as too many limbs, or they are lacking some important element like a head or a set of eyes. Hybrid beings such as dog headed men or the manticore (a creature that has the body of a lion with a human head) are also considered monsters as they disrupt that natural definition of what is human and what is animal.

According to Pseudo-Dionysius the Areopagite, whose writings on Christianity stem from the pre-Christian Platonic tradition of philosophical negation, monsters are necessary as a means to a closer understanding of God. This intellectual system of negation is based on a blurring of sign and signified. In the words of David Williams in his book *Deformed Discourse: The Function of the Monster in Medieval Thought and Literature*, "the more unwonted and bizarre the sign, it was thought, the less likely the beholder to equate it with the reality it represented . . . a purification of the naturally anthropomorphic human mind could be accomplished through the negation of every possible affirmation about God." The mind then encounters a "reality beyond negation and affirmation, a reality which is-not, finally knows God as a paradox." (Williams 4)

Monstrous images allow us to transcend the barriers of rational knowledge, which we need to do in order to understand the nature of God, and the "grotesque, enables the divinization of human intelligence by initiating a negation of all affirmative names." (Williams 5) In making hybrid animal/human entities I am trying to capture this idea of the symbiotic relationship between human and non-human, and I want the tension between the two to be apparent.

This medieval understanding of the monstrous in relation to God and humanity leads me to a postmodern discussion of the other. A deconstructionist reading of binary opposites such as light and dark, good and evil, human and non-human, male and female lends itself well to this idea of the boundaries between the two seemingly dichotomous concepts as blurred and ambiguous. One concept cannot exist without the other, and although they may seem to be in conflict they are actually interdependent and help to inform the other's meaning. Lacan discusses this idea of the other in his work regarding the Mirror stage, and in this idea he accepts the discord and fracture of the psyche that is only structured through recognition of the "other."

My work fits into a postmodern system because I draw from so many sources that are not necessarily cohesive and I can select text and image from varied sources

such as medieval hagiography, religious ceramic statuary, and German expressionist wood block prints. I am interested in the idea of blurred boundaries, and a deconstructionist view of binary opposites. My readings in existentialist philosophy during my undergraduate study remain crucial. I am struck by Nietzsche's exploration of the Apollonian and the Dionysian in his work The Birth of Tragedy and how one concept could not exist without the other. Nietzsche used this as a basis for understanding the human condition, and I felt an affinity. Kierkegaard's question of the teleological suspension of the ethical that is put forth in Problema 1 of Fear and Trembling explores the biblical story of Abraham and Isaac and the paradox of faith that exists in this situation. Kierkegaard explains that in the story, the individual must become more important than the universal since Abraham is essentially leaving the universal realm of the ethical in order to do God's will namely killing Isaac. For Kierkegaard, it is the absurd that allows this subversion of the ethical hierarchy to occur, and since it is absurd, it is paradox, and therefore unable to be mediated. (Hong 56) Exposure to existentialist philosophy through Nietzsche and Kierkegaard has informed how I think about concepts of faith, how we make meaning and absurdity, and I think that this has in turn influenced my reasons for wanting to be an artist and the making of the art itself.

I see my work within an expressionist and cognitive framework of art making. I am interested in R. G. Collingwood's demand that the artist must "transform his or her raw, inchoate feelings into communicative expressions. Through the process of making art and putting their feelings into physical form, artists come to better know themselves." (Barrett 61) This, in conjunction with the collaborative effort of the viewer, is what Collingwood feels makes a work of art. I align myself with this view based on my interest in making work that emerges from personal experience and is filtered through imagination, visual sources, and process to become something that makes reference to the world through what Nelson Goodman would explain as "denotation and exemplification." (Barrett, 64) I am curious about the way in which symbols can make references simultaneously in visual art, and this again exists within the realm of personal expression and viewer collaboration. Perhaps most challenging yet alluring to me is my interest in delving into psychoanalytic territory and mining very personal experiences to use in the making of my ceramic art. Although I hesitate, I believe that this is the direction that my work will take over the next year, and I am curious to see how mental images that have been buried manifest themselves in the physical world.

Works Cited

Barrett, Terry. Why Is That Art?: Aesthetics and Criticism of Contemporary Art. Oxford University Press, 2008.

Bynum, Caroline Walker. Fragmentation and Redemption: Essays on Gender and the Human Body in Medieval Religion. Zone Books, 1991.

Caviness, Madeline. *Visualizing Women in the Middle Ages*. University of Pennsylvania Press, 2001.

Jonte-Pace, Diane. "Situating Kristeva Differently: Psychoanalytic Readings of Women and Religion." *Body/Text in Julia Kristeva: Religion Women and Psychoanalysis*. Ed. David Crownfield. State University of New York Press, 1992. Kierkegaard, Soren. *Fear and Trembling*. Ed. Howard V. Hong and Edna H. Hong. Princeton University Press, 1983.

Williams, David. *Deformed Discourse: The Function of the Monster in Medieval Thought and Literature.* McGill-Queen's University Press, 1996.

Joel-Peter Witkin, *Leda*, 1986.
Courtesy of Catherine Edelman Gallery, Chicago.

Criticizing Criticism

The following paper is in response to a fourth paper assignment of the criticism course: Select a contemporary artist of your choice, find three critics who have written about the artist, and metacritically analyze their writings. When she wrote this paper, Kendra Hovey was a part-time, continuing education student (equivalent to a first-year master's student), taking courses for enjoyment. Her undergraduate degree is in philosophy. She had had no previous criticism courses or art courses but had had some photography courses. I think the clarity and sophistication of her thinking and writing need no further comment.

Reading Criticism: A Study of Three Critical Views on the Photographic Work of Joel-Peter Witkin

Kendra Hovev

Theoretically there are as many different ways of looking at a work of art as there are pairs of eyes. A painting, a photograph, a body of artistic work is not subsumed under a singular interpretation. Art critics prove this again and again by offering a number of differing viewpoints on the same piece of work. To find importance outside the sphere of one's own personal opinion, critics' viewpoints should not be mere assertions, but statements supported by reasons—reasons that should find evidence in the work being discussed. If the critic takes an evaluative stance, the critic needs to address the "why it is" as much as the "it is."

As a reader of criticism, it is important to pay attention not just to the judgment of "good" or "bad" or to the declaration, "it means this," but to pay equal attention to the "whys" and "becauses." The following is a discussion of three different critics on the work of one photographer. In considering the photographic work of Joel-Peter Witkin, these three critics provide interpretations, some widely different, some similar; and judgments, some largely negative, others positive. Each has a sensibility and a set of criteria by which they see and judge. Confronted with three persuasive views it becomes evident that as a reader it is important to both examine the success of an argument and to recognize the chosen criteria of the critic.

In the opening sentence of her review of Witkin's work, critic Susan Kandel simultaneously expresses both interest and biting judgment: "There is something profoundly exhilarating about a show that is extravagantly awful." The review appeared in the November 1989 issue of *Arts Magazine* and the show was at the Fahey/Klein gallery in Los Angeles. The reviewer admits that this work, in appealing to a fascination with perversity and the "truly terrible," is "immensely satisfying," but clarifies that this is the singular purpose of the work. In other words, the circus has made an unexpected stop at the Fahey/Klein, but if it is art that you want to see, she suggests, go somewhere else.

One entered the gallery and confronted a prominently positioned wall plaque reading, "Joel-Peter Witkin is interested in working with pathologists and anatomists and anyone who is or knows about unique [sic] individuals who wish to be

photographed," accompanied by Witkin's address in New Mexico; from that moment it was evident that the name of the game for Witkin was not art, but exploitation of the cheapest kind; exploitation not merely of his subjects—hermaphrodites, pedophiles, deformed individuals, fetuses, cadavers, and animals—but of his voyeuristic audience, primed by the media to crave gratuitous sex and violence, and only too thrilled to find it in the lofty setting of the art gallery.

Kandel's interpretation of the work as a parade of the perverse is mirrored in her description of the work. Like a jaded circus huckster, she leads us on a tour of the freak show: "Here we find a topless woman with two chicken feet affixed to her nipples; around the corner, masked Siamese twins in negligees, and a man hanging upside down from his testicles; across the room, a pair of severed male genitals perched on top of two skulls." She describes Witkin's technique of "scratching into the negative and printing with tissues and toners" as a failed attempt to "endow his images with the museum-validated look of vintage 19th-century photographs." Kandel's judgment is clearly negative, her reasoning is that this work is misplaced, she refers to Witkin as "P.T. Barnum with an MFA" implying that the art world has been duped. Witkin's work is not art but "racy nothings" attempting to legitimate itself with "aren't we clever references to the heavyweights of art history." For Kandel it "doesn't work." "Big deal," she says.

In her review Kandel provides two reasons for her judgment. The first, already mentioned, is the subject matter itself. For Kandel this "art" is immediately redefined as exploitation. It is unclear whether this is because there is something intrinsically exploitative in any depiction of this subject matter or just in the artist's method of searching out the subject matter. A second reason she provides for its demotion to the merely exploitative is that this work seeks only to appeal to the voyeuristic desires of the viewer: "Witkin's images are so rooted in a desperate materiality that eschews all suggestion, all enigma—key tokens of the surrealistic quality Witkin hankers after, but perpetually fails to achieve." Because Witkin's work has content only for the corporeal, it fails as art. According to Kandel this work exists only for our curious senses which are "assaulted by greater and greater displays of the dreadful." Although her definition of "exploitation" is an unclear one, Kandel does make the point that art cannot be exploitative and still be called art. The criteria that kick these photographs out of the ranks of art are based in Kandel's own theories about what defines art. The reader, in assessing the critic's opinion, should consider both her interpretation and her criteria. Her definition of art certainly leaves open many unanswered questions, such as: Can any depiction of Witkin's cast of characters be considered art or is such a depiction inherently exploitative? Is any work that appeals only to the senses, "to materiality," not art? And, are depictions *only* of the pretty as opposed to the dreadful also not art?

In an April 1986 review in *Flash Art*, critic Alfred Jan agrees with Kandel's assertion that Witkin's images extend into the perverse: "[Witkin] engages in the esthetics of excess that defies conventional standards of good taste." Jan acknowledges a judgment of the work such as Kandel's when he writes, "It would be tempting to write off all this Grand Guignol theatricality as self-indulgent

sensationalist exploitation." Jan even agrees that Witkin is "playing on our voyeuristic curiosity toward the Other." Jan, however, disagrees with Kandel when he calls all this, "art-worthy."

What Kandel terms "racy nothings" Jan calls "powerful images." According to Jan, "Witkin heightens awareness about the human condition (with consensual agreements from his models) by exorcising our subconscious fears and desires." Jan opens up a slot for Witkin in the annals of art history by aligning his content of choice with that of known artists who were also "concerned with sacrilegious nightmares," adding that Witkin's method is "even more effective." He, unlike Kandel, finds Witkin's technique to be successful, saying it "gives the final result a look of faded antiquity." In these works Jan finds important content where Kandel finds none. By ascribing to Witkin a purpose, that of "invok[ing] the power equal to that of a vision or thought just before death," Jan is ascribing to this work an interpretation that recognizes content beyond just the material.

Jan judges the work favorably because it meets two of his implied criteria. The first is that it holds psychological content that "heightens awareness," the second is that it is full of personal vision. For Jan these photographs express the artist's sensibility, they "build a personal, if eccentric, world vision." Considering the writings of both critics, their individual criteria are not necessarily opposed (though Jan introduces an expressionist criterion, not mentioned by Kandel) yet each hands down a very different judgment. Kandel, negative; Jan, positive. The source of this difference is in their very different interpretations of the work. To Kandel it is only a freak show, to Jan it looks like a freak show but is also a valuable journey of awareness into the irrational and the unknown.

A third critic also introduces the issue of exploitation, but with a definition different from the one we may glean from Susan Kandel's review. Cynthia Chris is unconcerned with the issue of whether Witkin's work is or is not art. In her article "Witkin's Others" in the 1988 spring issue of *Exposure*, Chris gives a fuller meaning to the idea of exploitation and asserts that more important than its inclusion or exclusion in art is its function in society. In a well-developed argument (admittedly she gets more time at the platform with 10 pages compared to Kandel and Jan's one), Chris states that Witkin's work is socially dangerous, and should be seen as such, because it displays the Other as different and judges the Other as "aberrant."

For Chris, these images are primarily about "representation," specifically, how the Other's "condition of being" is represented. "Witkin's photographs document his investigations of certain identities and practices; the transsexual, the androgyne, the fetishist, the sodomist, the masturbator, the homosexual, the masochist, and others whose sexuality is not encompassed by 'normal' heterosexuality." Ultimately, Chris says, the point of this investigation is to classify the listed behaviors as abnormal and thus allow the justification of their control. Witkin's images accomplish this by their method of portrayal which objectifies the models and those who share their characteristics, robbing them of both voice and point of view.

Chris describes Witkin's search for subject matter as a kind of anthropological pursuit, accusing him of reducing his subjects to a "shopping list" of attributes. She

holds that Witkin suggests these people are of use only through their "unique interests and collections . . . physical characteristics . . . ranging from unusually large genitals to the wounds of Christ." He then renders them passive in his imagery. One way Witkin does this is by burying them in "textual overlays," thus making them only actors in Witkin's own re-interpretations of narratives from art history. Utilizing the symbol of blindness as "metaphorical castration" found in the tale of Oedipus, Chris argues that the masks pulled over the subjects' eyes and the negative scratchings that obscure their faces also serve this purpose of objectification.

In effect, Witkin castrates his subjects; his scrawls on their faces are equivalent acts of violence. The eyes of the subject remain intact but the mask or the marks do interrupt access to the power of sight. No longer capable of looking back at the photographer, the model becomes effectively impotent, an object of the photographer's gaze. *Hermes* faces the viewer, but his ability to return the gaze, which is usually a feature of the frontal pose, is negated by the marks drawn over his eyes. He is left, literally, without a point of view.

The mask not only "robs the model" but "protects the viewer"; it, like the distance of the camera from the subject, confirms a separation between the one who is depicted and the one who views: "The viewer can look at the model without illusion of participation." In the end, for Chris, these images are not about transsexualism or additional behaviors; they are "about our relationship to the transsexual-as-Other." To categorize persons in this way is a form of oppression, it opens the door for the "normal" to participate in the "management of individuals whose behavior is considered aberrant." Chris concludes:

Witkin's crew of libertines . . . return to the status of documented, factionalized individuals who are to be corrected or controlled, divested of a voice, effectively castrated, diagnosed according to their perversions, and relegated to the mental institution, the prison, the redlight district, the freak show, the pornography industry, the gay ghetto, the closet, the art object—in short, to the margins of the culture into which all the oppressed are propelled—into the realm of the Other.

Chris's well-evidenced and carefully argued position relies a great deal on external information about the photographer's method of working, his personal life, and theories of oppression. Chris takes issue with the photographer, first, because of his search for subjects and second, because his viewpoint is from the outside. Like a "white actor in blackface" he temporarily plays out the role of his models' permanent lives and "like the white actor at the end of the minstrel show, Witkin washes off the Other." She accuses Witkin personally, as well as other photographers who have broached similar subject matter, for using "photography to visit the Other and to hold it up like a specimen at a safe distance. Neither speaks to us as the other, but always about the Other."

At the source of her argument is a theory about the relationship between representation and oppression. The reader should consider the source of her reasons with as much weight as the reasons themselves. One may agree with both her theory about oppression and her position that art is not immune to this type of

evaluation, but still disagree with her negative assessment of Witkin by arguing for a different interpretation of the work, one that makes the case that these images are not of objects but of subjects.

The writings of these three critics contain a range of differing interpretations and evaluations of one body of work. Basic to these differences, are the different sets of criteria the critics use to see and to judge. Where Susan Kandel finds no real content, both Alfred Jan and Cynthia Chris find commentaries about sexuality and religion (and in Jan's case a view of the dark side of the subconscious). The technique of scratching and toning that according to Jan invests the work with a nineteenth-century aura is nothing but a ruse to Kandel, while in the eyes of Cynthia Chris it is a tool used to blind and castrate the Other. Alfred Jan basically dismisses the issue of exploitation by acknowledging the models' consent; for Kandel and Chris it remains a primary issue, though with Kandel we are led to assume that the exploitation would be excused if she found in the work deeper and more complex content. Chris on the other hand solidly refuses to excuse the objectification. Her perspective is that of an instrumentalist primarily concerned with the function art serves in society and its consequences.

Here we have a small collection of evidence illustrating the many different ways in which one piece of art can be viewed. Each critic hopes to convince us to join their side or, at least, to engage us in the discussion.

TALKING ABOUT WORKS OF ART

Casual Conversation about Art

Much of our talk about art occurs in casual conversations with a friend or someone we are close to. These conversations can be enlightening. You can express what you feel about a work of art and get confirmation of what you see and what you say. If you trust the one you are speaking with, you can try out your ideas without fear of being ridiculed. You can hear what someone else has to say about the same work of art you have seen. Try to generate an interesting and enjoyable discussion and to keep the discussion going. Being a good conversationalist means being an attentive listener, encouraging someone to say more by showing your interest in what he or she has to say.

Casual conversations about art are too often evaluative and dismissive: "I don't like it. Do you?" Try to extend the conversation by providing reasons for your opinions, and seek reasons from the person with whom you are talking. If you feel put down or that you are not being listened to, you will probably end the discussion; similarly, if you dismiss what your friend is saying, you will also probably end that discussion or, at least, turn it into an uncomfortable argument rather than a friendly and tolerant disagreement. Disagreements can be enlightening and enjoyable if they are conducted with mutual respect, with both parties listening to each other, and if reasons for the disagreement are explained.

Organized Talk about Art

Formal talk about art often occurs in art classes, and such talk is often referred to as a *critique*. Studio professors often hold critiques with a class of art students while their work is in progress and also after the work is completed. The usual purpose of a critique is to improve the art being made. During critiques, artists are usually given a lot of advice, whether they want it or not, about how to change and improve their work. In this sense, critiques are different from published criticism. Critics do not attempt to improve the art about which they write. Nevertheless, critiques are a form of oral criticism that can be beneficial to artists and viewers alike, especially when they follow some of the principles of criticism presented in previous chapters.

Too rarely is work described during critiques. There is often an underlying and unidentified assumption that describing the work that is being critiqued is not necessary because it is there in front of everyone and everyone can see it. This is a false assumption. Everyone sees phenomena differently, based on their patterns of perception and their individual biographies. There is no one right way, and no complete way, to describe a complex work of art. Description depends to a certain extent on interpretation, and interpretation on description—and getting several descriptions from several individual viewers about the same work of art can be an enriching experience. If several viewers contribute their individual descriptions in their own chosen words, they can expand the group's perception of the work. If artists listen carefully to the several descriptions of their work, they can gain insights into what they have done and how others perceive it.

Too rarely is work interpreted during critiques. Usually everyone jumps over description and interpretation right to offering suggestions about how to improve the art—before they have even considered what it might be about. In critiques, interpretations are too often given by the artist whose work is being discussed. Then the critique is based on intentionalism and, specifically, the artist's intent. An artwork, however, does not necessarily mean what an artist means it to mean—it might mean more, or less, or something different. If artists insist that their art means only what they mean it to mean, then they are severely limiting the meaning of their own work. If the group allows artists to determine the meaning of their own works, then the group is denying its ability to add insights to those of the artists.

The focus of critiques is usually and predominantly the judgment of how good or bad the work is and how to make it better. Often the judgments are based on the artist's stated intent: "I tried to do this—how well did I do it?" Sometimes it is based on the teacher's intent: "I asked you to do this—how well did you do it?" Judgments based on intent, however, preclude judging the intent itself. If an artist's intent lacked merit to begin with, then, by achieving it, the artist still does not end up with a good work of art. Judgments based on intent tend to get very specific and ignore larger issues of criteria. A complete judgment ought to consist of a clear appraisal and reasons for that appraisal based on criteria. Several sets of criteria are discussed in Chapter 5.

One easy way to improve the intellectual quality of critiques and to expand the discussion to include more people and broader topics is to ask the artist whose work is being critiqued to remain a silent listener. This changes the usual critique by placing the burden of discussion on the viewers rather than on the artist, which is probably where the burden ought to be. It also precludes defensive and sometimes obstructionist statements by artists who feel put on the spot. The artists can stay in the background and take in what is being perceived about their works of art. They can check their intents against the group's perceptions. This could be a valuable experience for any artist.

Criticizing Works in the Public Domain

Discussing art with a group of viewers in a museum, gallery, or other public arena should take a different focus from the usual judgmental critique. The artist is not present, and you are not trying to tell the artist how to make the art better. You are most likely there to experience art, to appreciate it, and to talk about your experiences. The motivation to describe and interpret should be stronger because the directive to judge will be weaker.

The museum or gallery setting probably offers several works of art by the same artist or different artists, so the invitation to compare and contrast what you see is implicit. Check the range of dates of when the pieces were made. Also note how the pieces are hung—which is next to which and to what effect; speculate on why these decisions were made. Look for the exhibition's title, and consider its theme. Attempt to infer the curator's criteria for selecting these particular works of art.

Remember also the questions raised in Chapter 2 about art by educators who suspect institutions of being too limited in what they select and what they sanction: For whom was it created? For whom does it exist? Who is represented? Who is doing the telling? The hearing?

General Recommendations for Good Group Discussions

These recommendations apply to both the studio critiques of art you and your classmates have and to group discussions at public sites.

Try to understand the work through your own unique perspective and then share your understanding with others. Don't censor yourself. It is your professor's job to moderate the discussion; you do not need to keep yourself in check. Professors often dread conducting critiques or group discussions of any kind because their students won't talk, and they end up in the uncomfortable position of having to give a spontaneous lecture. When your professors, or perhaps tour guides in an art museum, ask what you think, they probably want to know and want you to talk.

If they are merely asking a rhetorical question and really want to lecture, you will see that soon enough. In the meantime, accept the challenge of contributing to the discussion.

Try to limit yourself to one point per utterance, rather than two or three. Beware of saying, "I have three points I'd like to make: First . . ." It is difficult for anyone to follow more than one point at a time. Introduce a single point, and then at a later time introduce another.

Be honest with and kind to one another; otherwise, no one will want to talk for fear of being dealt with harshly. If you disagree with someone's position, say so, but respectfully. First acknowledge that you heard what the other said, agree with parts of the position if you can, and then move the conversation forward. Always try to further a conversation rather than end it. Seek to find a word that will continue the conversation rather than wanting to have "the last word."

Avoid tendencies to be right; avoid tendencies to be dominated by others in the group. Know that others in the group share your sense of vulnerability when you are speaking in public. A psychologically safe environment needs to be established to have a good discussion; if people in the group do not feel safe, they will try to hide rather than talk. You will be denied their insights and will contribute to the censorship of their ideas.

A sense of curiosity is more appropriate to criticism and to art than a constant penchant to judge. The major principle guiding both written and spoken art criticism is that criticism is an ongoing discussion: You can add to it. You are part of a community of interested observers of art. With your help, the community—whether a group of friends at a bar, a class in a college, or a number of publishing authors—can be self-correcting. That is, no one of us has the single and complete right answer about any work of art; but as a group we may eventually correct our notions and together achieve more adequate answers to complex problems of art than any one of us could achieve individually.

Suggestions for Interactive Studio Critiques

The following suggestions are offered to anyone involved in group discussions about artworks made by the participants, or what are commonly called "studio critiques" or more simply "crits." The suggestions assume that critiques are interactive, that they can be run by both students and instructors, and that students and instructors actively participate with mutual goals. The suggestions are explicitly for group critiques. They may be useful for discussing finished work or work in process. Any group of artists may gather to discuss work. These suggestions are offered to everyone in a group crit:

- Determine a facilitator of the discussion.
- The facilitator should set the tone and direction of the discussion, keep it on topic, and help to move it along.

- The facilitator is one who stays in the background, as much as possible, so participants in the discussion discuss the art; that is, the facilitator ought not be a spontaneous lecturer to a group of listeners.
- A measure of a well-facilitated discussion is the relative invisibility of the facilitator and the dominance of the participants.
- Work to quickly build a psychologically safe environment.
- People need to feel safe before they will speak or speak honestly.
- Do not use sarcasm.
- Be an attentive and responsive listener.
- Do not ask rhetorical questions, to which you already know the answer, or questions that are disguised as declarative statements. Instead simply state an idea.
- Thank people who respond.
- Do not criticize responses; if you do, you will suppress further responses.
- Predetermine the purpose of the critique:
- To reinforce the learning objectives of an assignment? If so, make the purpose of the critique public—namely that the critique will be used to reinforce what is intended by the lesson assignment. List the goals and objectives of the assignment. Identify successfully completed assignments, with reasons in support of claims. Unsuccessfully completed assignments can be addressed, but remember that reasons are required for judgments.
- To admonish the lazy? Does the whole group need admonishment, or just a few individuals? If it is individuals, then talk to them individually. Regardless, be kind as well as direct and firm. Let everyone know the standards expected of the group.
- To motivate the whole group? To motivate an individual? If you want to reach an individual, do it privately. No one wants to be embarrassed in front of the group.
- To assert authority? To redirect attitudes? If so, then perhaps tell the participants directly that you feel a need to exert more influence on the group. Tell them you feel a responsibility toward certain content being learned. Be clear about what artistic outcomes are wanted and unwanted.
- To determine grades? If grades are implicitly or explicitly linked to critiques, it is likely that participants will be less than forthcoming for fear of lowering their own or someone's grade. Desire for good grades and peer pressure will militate against open communication. Separate grading from critiques.
- To celebrate students and the work they have done? If so, then defer any negative comments to another time. Be celebratory! Allow only positive comments from yourself and participants. Save any negative comments for another time and place.

- Is the critique to help the artist make better work? Determine whether or not giving advice to an artist is appropriate. Perhaps advice is unwarranted. Perhaps it is best to let artists determine what they "should" do to make their art better: it is, after all, the artists' own work and not the facilitator's or anyone else's in the group.
- Is the critique for the artist to become more articulate about his or her own work of art? If so, the artist becomes speaker, and perhaps unwontedly defender of his or her work. The discussion will revolve around the clarity of the artist's intentions in relation to what content the group perceives in the work being discussed.
- Consider if, when, and for how long the artist should speak during a critique of his or her work. In large part, the answer to this question depends on the purpose of the critique. Do you want to use the critique to have the maker be more articulate about what has been made? Then let the artist speak. If you are trying to help all of the participants become better critics of all imagery, limit the role of the artist whose work is being discussed.
- Determine the role that artistic intent will occupy during the critique.
- Will the parameters of the critique be determined by the intent of the artist who made the work?
- Will the parameters of the critique be determined by the intent of the assignment for the work?
- If the goal of a critique is to develop better critics, don't let the participants rely on the artist's intent to frame the conversation. The artist has already made the work; the artist has already put forth the results of artistic effort. Now let the interpreters do the work of interpreting what the artist has made.
- If intent is the basis of the discussion, these questions pertain: Does the statement of intent, in itself, make sense? Is it an intent worthy of pursuit? Is the intent accomplished in the work?
- If what the artist intends is not what shows up in the art, does that mean it is not good art?
- The facilitator of the critique needs to self-check whether he or she is dominating the discussion.
- It is perfectly all right to lecture, but lectures ought not be confused with interactive discussions.
- When the conversation lags, step in with a new question or a different strategy to get the conversation going again.

- Monitor whether you are talking more than you want, and adjust accordingly.
- If you ask a question, do not answer it. Wait for the participants to answer it. Wait as long as it takes. Do not resort to answering your own questions.
- Decide beforehand whether all the works available for the critique will be covered during the critique.
- You need not talk about every work in every critique. If you do this, critiques will be either very long or very shallow. Perhaps, rather than trying to talk about everyone's work every time, instead make sure that eventually everyone's work is covered over the length of a course.
- Announce beforehand that it is unlikely all work will be discussed in one time slot. Invite the participants to decide which works will be covered that day. Invite one-on-one discussions if there was not time to get to some who wanted their work covered.
- Decide whether the group of critiques will attempt to influence the artist to change the work, or to accept it as it is. You might want simply to accept the works of art as they are and not try to get the artists to "improve" them. Occasionally keep the critique descriptive and interpretive and let the artist just listen. Later the artist can decide if he or she thinks the work should be changed based on what was heard in the critique.
- Decide whether the critique will be primarily descriptive, interpretive, evaluative, theoretical, or a combination of these.
- Description itself constitutes criticism. If one of the goals of artistic learning is to help participants see, description is a good way to accomplish this.
- Critiques need not be judgmental; they can be limited to descriptive and interpretive insights.
- You might use a critique to consider theories of art by identifying assumptions about art that participants seem to have based on the work they have presented.
- Doing all of these activities all the time—describing, interpreting, judging, theorizing—in each critique is likely too much of a challenge for anyone.
- Work shown in critiques need not be a surprise. Ask the participants whose
 work is to be discussed to turn in work well before the critique so participants have time to consider what might be most pertinent to discuss, what
 questions to raise, and what topics to cover.
- Try new ways. Drop what does not work. Try something else. Keep yourself and others motivated. If you are engaged, it is likely that other participants are too.
- What is the mood or tone of the discussion as it is winding down? A critique that leaves participants eager to make new work is likely a successful critique. If this seems not to be the case, consider redirecting the discussion before it ends.⁷

Notes

Preface

- These first two ideas are similar to goals for education stated more generally by R. S. Peters, a philosopher of education.
- 2. Deborah Ambush, Robert Arnold,
 Nancy Bless, Lee Brown, Malcolm
 Cochran, Alan Crockett, Susan DallasSwann, Arthur Efland, Ron Green,
 Sally Hagaman, Richard Harned, Bill
 Harris, Georg Heimdal, James Hutchens, K. B. Jones, Marcus Kruse, Peter
 Metzler, Lynette Molnar, Susan Myers,
 A. J. Olson, Stephen Pentak, Sarah
 Rogers, Richard Roth, Larry Shineman,
 Amy Snider, Robert Stearns, Patricia
 Stuhr, Sydney Walker, Pheoris West.
- 3. Morris Weitz, Hamlet and the Philosophy of Literary Criticism (Chicago: University of Chicago Press, 1964).

Chapter 1 • About Art Criticism

- Robert Rosenblum, quoted by Deborah Drier, "Critics and the Marketplace," Art & Auction, March 1990, 172.
- 2. Rene Ricard, "Not about Julian Schnabel," *Artforum*, 1981, 74.
- 3. Rosalind Krauss, quoted by Janet Malcolm, "A Girl of the Zeitgeist—I," *New Yorker*, October 20, 1986, 49.

- 4. Lucy Lippard, "Headlines, Heartlines, Hardlines: Advocacy Criticism as Activism," in *Cultures in Contention*, ed. Douglas Kahn and Diane Neumaier (Seattle: Real Comet Press, 1985), 242.
- 5. Ricard, "Not about Julian Schnabel," 74.
- 6. Saul Ostrow, "Dave Hickey," in *Speak Art!* ed. Betsy Sussler (New York: New Art Publications, 1997), 42.
- 7. Rosenblum, quoted in Drier, "Critics and the Marketplace," 73.
- 8. Jeremy Gilbert-Rolfe, "Seriousness and Difficulty in Criticism," *Art Papers*, November–December 1990, 9.
- 9. Malcolm, "Girl of the Zeitgeist—I," 49.
- 10. Peter Plagens, "Peter and the Pressure Cooker," in *Moonlight Blues: An Artist's Art Criticism* (Ann Arbor: UMI Press, 1986), 119.
- 11. Ibid., 126.
- 12. Ibid., 129.
- 13. Ibid.
- 14. Dave Hickey, "Air Guitar," in Air Guitar: Essays on Art and Democracy (Los Angeles: Art Issues Press, 1997), 163.
- 15. Patricia C. Phillips, "Collecting Culture: Paradoxes and Curiosities," in *Breakthroughs: Avant-Garde Artists* in *Europe and America*, 1950–1990, Wexner Center for the Arts (New York: Rizzoli, 1991), 182.

- 16. A. D. Coleman, "Because It Feels So Good When I Stop: Concerning a Continuing Personal Encounter with Photography Criticism," in Light Readings: A Photography Critic's Writings 1968–1978 (New York: Oxford University Press, 1979), 254.
- 17. Gilbert-Rolfe, "Seriousness and Difficulty," 8.
- Linda Burnham, "What Is a Critic Now?" Art Papers, November–December 1990, 7.
- 19. Hickey, quoted in *Speak Art! The Best of BOMB Magazine's Interviews with Artists*, ed. Betsy Sussler (New York: New Art Publications, 1997), 42–43.
- 20. Plagens, "Peter and the Pressure Cooker," 129.
- 21. Malcolm, "Girl of the Zeitgeist—I," 49.
- 22. Plagens, "Peter and the Pressure Cooker," 126.
- 23. Gilbert-Rolfe, "Seriousness and Difficulty," 9.
- 24. George Steiner, quoted by Gilbert-Rolfe, "Seriousness and Difficulty," 10.
- Pat Steir, quoted by Paul Gardner, "What Artists Like about Art They Like When They Don't Know Why," Artnews, October 1991, 119.
- Steven Durland, "Notes from the Editor," High Performance, Summer 1991, 5.
- 27. Ibid.
- 28. Lucy Lippard, "Some Propaganda for Propaganda," in Visibly Female: Feminism and Art Today, ed. Hilary Robinson (New York: Universe, 1988), 184–94.
- 29. Bob Shay, quoted by Ann Burkhart, "A Study of Studio Art Professors' Beliefs and Attitudes about Professional Art Criticism" (Master's thesis, The Ohio State University, 1992).
- 30. Ibid.
- 31. Pheoris West, quoted by Burkhart.
- 32. Tim Miller, "Critical Wishes," *Artweek*, September 5, 1991, 18.

- 33. Georg Heimdal, quoted by Burkhart, "A Study of Studio Art."
- 34. Susan Dallas-Swann, quoted by Burkhart.
- 35. Richard Roth, quoted by Burkhart.
- 36. Kay Willens, quoted by Burkhart.
- 37. Robert Moskowitz, quoted by Gardner, "What Artists Like," 120.
- 38. Claes Oldenburg, quoted by Gardner, 121.
- 39. Tony Labat, "Two Hundred Words or So I've Heard Artists Say about Critics and Criticism," *Artweek*, September 5, 1991, 18.
- 40. Lippard, "Headlines," 184-94.
- 41. Patrice Koelsch, "The Criticism of Quality and the Quality of Criticism," *Art Papers*, November–December 1990, 14.
- 42. Roberta Smith, quoted in Drier, "Critics and the Marketplace," 172.
- 43. Rosenblum, quoted in Drier, 172.
- 44. Wendy Beckett, *Contemporary Women Artists* (New York: Universe, 1988).
- 45. David Halpern, ed., Writers on Art (San Francisco: North Point Press, 1988).
- 46. Charles Simic, *Dime-Store Alchemy* (New York: Ecco Press, 1992).
- 47. Ann Beattie, *Alex Katz by Ann Beattie* (New York: Abrams, 1987).
- 48. Gerrit Henry, "Psyching Out Katz," *Artnews*, Summer 1987, 23.
- 49. Rosenblum, quoted in Drier, "Critics and the Marketplace," 173.
- 50. Newsweek, October 21, 1991.
- 51. For a fuller discussion of the role of ideology in art criticism, see Elizabeth Garber, "Art Criticism as Ideology," *Journal of Social Theory in Art Education* 11 (1991), 50–67.
- 52. Mutandas: Between the Frames: The Forum, exhibition catalog (Columbus, Ohio: Wexner Center for the Visual Arts, 1994), 60.
- 53. Suzi Gablik, *Conversations before the End of Time* (London: Thames and Hudson, 1995), 283–86.

- 54. Hilton Kramer, in Gablik, Conversations before the End of Time, 127.
- 55. John Coplans, A Self-Portrait (New York: DAP, 1997), 134.
- 56. Hickey, 110.
- 57. Ibid., 112.
- 58. Ibid., 111.
- 59. Ibid., 112-13.
- 60. Peter Plagens on the New York Lineup, *Artforum*, January 1999 http://www.artforum.com/preview.html>.
- 61. James Elkins, "Art Criticism," in *Dictionary of Art*, Vol. 2, ed. Jane Turner (New York: Grove Dictionaries, 1966), 517–19.
- 62. L. Grassi and M. Pepe, *Dictionary Della Critica D'Arte*, cited by Elkins, "Art Criticism," 517–19; Lionello Venturi, *History of Art Criticism* (New York: Dutton, 1964; first published 1936).
- 63. This information about Vasari is compiled from Julian Kliemann, "Vasari," in *Dictionary of Art*, Vol. 32, 10–24.
- 64. Kliemann, 21.
- 65. Quoted by Kliemann, 18.
- 66. Angelica Goodden, "Diderot, Denis," in *Dictionary of Art*, Vol. 8, 864–67.
- 67. Denis Diderot, *Salons* (1759–81), 4 vols., ed. J. Adhémar and J. Seznec (Oxford: Oxford University Press, 1957–67; rev. 1983).
- 68. Baudelaire, quoted by Elkins, "Art Criticism," 517.
- 69. Baudelaire, quoted by Venturi, 247.
- 70. Baudelaire, quoted by Venturi, 248.
- 71. Nicole Savy, "Baudelaire," in *Dictionary of Art*, Vol. 3, 392–93.
- 72. Deborah Solomon, "Catching Up with the High Priest of Criticism," *The New York Times*, Arts and Leisure, June 23, 1991, 31–32.
- 73. Garber, "Art Criticism as Ideology," 54–55.
- 74. Solomon, "Catching Up," 32.
- 75. Adam Gopnik, "The Power Critic," *New Yorker*, March 16, 1998, 74.

- 76. Ibid.
- 77. Clement Greenberg, quoted by Peter G. Ziv, "Clement Greenberg," *Art & Antiques*, September 1987, 57.
- 78. Ziv, "Greenberg," 57.
- 79. Tom Wolfe, *The Painted Word* (New York: Farrar, Straus, and Giroux, 1975).
- 80. Solomon, "Catching Up," 31.
- 81. Kenneth Noland, quoted in Ziv, "Greenberg," 57–58.
- 82. Ziv, "Greenberg," 57.
- 83. Ibid.
- 84. Greenberg, quoted in Ziv, "Greenberg," 58.
- 85. Ibid., 87.
- 86. Florence Rubenfeld, *Clement Greenberg: A Life* (New York: Scribner's, 1998).
- 87. The information about Lawrence Alloway is drawn from the work of Sun-Young Lee, "A Metacritical Examination of Contemporary Art Critics' Practices: Lawrence Alloway, Donald Kuspit and Robert-Pincus Wittin for Developing a Unit for Teaching Art Criticism" (Ph.D. dissertation, The Ohio State University, 1988).
- 88. Lawrence Alloway, "The Expanding and Disappearing Work of Art," Auction, October 1967, 34–37; Alloway, "The Uses and Limits of Art Criticism," in Topics of American Art since 1945 (New York: W. W. Norton, 1975); Alloway, "Women's Art in the Seventies," in Network: Art and the Complex Present (Ann Arbor: UMI Press, 1984); Alloway, "Women's Art and the Failure of Art Criticism," in Network: Art and the Complex Present (Ann Arbor: UMI Press, 1984).
- 89. Alloway, quoted by Lee, "A Metacritical Examination."
- 90. Ibid.
- 91. Hilton Kramer, *The Triumph of Modernism: The Art World 1987–2005* (New York: Ivan R. Dee, 2006).
- 92. Anthony Lewis, "Minister of Culture," The New York Times Book Review, Sunday, December 31, 2006, p. 16.

- 93. Suzi Gablik, Conversations before the End of Time, 107–8.
- 94. David Ross, quoted by Gablik, 108.
- 95. Edgar Allen Beem, *Maine Art Now* (Gardiner, ME: The Dog Ear Press, 1990), 209.
- 96. Ibid.
- 97. Hilton Kramer, The Twilight of the Intellectuals: Culture and Politics in the Era of the Cold War (Chicago: Ivan R. Dee, 1999); Hilton Kramer, Abstract Art: A Cultural History (New York: Free Press, 1994); Hilton Kramer, The Age of the Avant-Garde: An Art Chronicle of 1956–1972 (New York: Farrar, Straus, and Giroux, 1973); Hilton Kramer, The Revenge of the Philistines: Art and Culture 1972–1982 (New York: Free Press, 1984).
- 98. Ibid.
- 99. Lucy Lippard, Mixed Blessings (New York: Pantheon Books, 1991); On the Beaten Track: Tourism, Art, and Place (New York: New Press, 1999).
- 100. Meyer Raphael Rubinstein, "Books," *Arts Magazine*, September 1991, 95.
- 101. Hilton Kramer, quoted by Lippard in "Headlines," 242.
- 102. Lippard, "Some Propaganda," 186.
- 103. Ibid., 194.
- 104. Lippard, "Headlines," 243.
- 105. Hal Foster, Rosalind Krauss, Yve-Alain Bois, and Benjamin Buchloh, Art since 1900: Modernism, Antimodernism, Postmodernism (New York: Thames & Hudson, 2004).
- 106. Arlene Raven, *Crossing Over: Feminism* and Art of Social Concern (Ann Arbor: UMI, 1988).
- 107. Ibid., xvii.
- 108. Ibid., xiv.
- 109. Ibid., xviii.
- 110. Donald Kuspit, quoted in Raven, *Crossing Over*, xv.
- 111. Raven, Crossing Over, 165.
- 112. Ibid., 167.

- 113. Coleman, "Because It Feels So Good," 204.
- 114. Kuspit, quoted by Mark Van Proyen, "A Conversation with Donald Kuspit," *Artweek*, September 5, 1991, 19.
- 115. Mutandas, 62.
- 116. Hickey, 166.
- 117. Smith, quoted in Drier, "Critics and the Marketplace," 172.
- 118. Alloway, quoted by Lee, "A Metacritical Examination," 46.
- 119. Ibid., 48.
- 120. Robert Pincus-Witten, quoted in Lee, "A Metacritical Examination," 96.
- 121. Ibid., 97.
- 122. Ibid., 105.
- 123. Ziv, "Greenberg," 58.
- 124. Smith, quoted by Drier, "Critics and the Marketplace," 172.
- 125. Joanna Frueh, "Towards a Feminist Theory of Art Criticism," in *Feminist Art Criticism: An Anthology*, ed. Arlene Raven, Cassandra Langer, and Joanna Frueh (Ann Arbor: UMI Press, 1988), 58.
- 126. Ibid., 60-61.
- 127. Arthur Danto, quoted by Elizabeth Frank, "Art's Off-the-Wall Critic," *New York Times Magazine*, November 19, 1989, 73.
- 128. Peter Plagens, "Max's Dinner with André," *Newsweek*, August 12, 1991, 61.
- 129. Edmund Feldman, "The Teacher as Model Critic," *The Journal of Aesthetic Education* 7, no. 1 (1973), 50–57.
- 130. Marcia Eaton, Basic Issues in Aesthetics (Belmont, CA: Wadsworth, 1988), 113–20.
- Harry Broudy, Enlightened Cherishing (Champaign-Urbana: University of Illinois Press, 1972).
- 132. Morris Weitz, Hamlet and the Philosophy of Literary Criticism (Chicago: University of Chicago Press, 1964), vii.
- 133. Andy Grundberg, "Toward Critical Pluralism," in *Reading into Photography:* Selected Essays, 1959–1982, ed. Thomas

134. John Coplans, quoted in Malcolm, "A Girl of the Zeitgeist—I," 52.

Barrow et al. (Albuquerque: University

of New Mexico Press, 1982), 247-53.

- 135. Ibid., 49.
- 136. Ibid., part II, 51.
- 137. Ibid., 52.
- 138. Marina Vaizey, "Art Is More Than Just Art," *New York Times Book Review*, August 5, 1990, 9.
- 139. Eaton, Basic Issues, 122.
- 140. Kay Larson, quoted by Amy Newman, "Who Needs Art Critics?" *Artnews*, September 1982, 60.
- 141. Mark Stevens, quoted by Newman, "Who Needs Art Critics?" 57.
- 142. Harry Broudy, "Some Duties of a Theory of Educational Aesthetics," *Educational Theory* 1, no. 3 (1951), 198–99.
- 143. Chuck Close, quoted by Gardner, "What Artists Like," 119.
- 144. Marcia Siegel, quoted by Irene Ruth Meltzer, "The Critical Eye: An Analysis of the Process of Dance Criticism as Practiced by Clive Barnes, Arlene Croce, Deborah Jowitt, Elizabeth Kendall, Marcia Siegel, and David Vaughn" (Master's thesis, The Ohio State University, 1979), 55.

Chapter 2 • Theory and Art Criticism

- Steven Best and Douglas Keller, Postmodern Theory: Critical Interrogations (New York: Guilford Press, 1991), 3.
- 2. Chika Okeke-Agulu, "Questionnaire," October 1, 30, 2009, 45.
- 3. Best and Keller, Postmodern Theory, 24.
- 4. Robert Atkins, *Art Spoke: A Guide to Modern Ideas*, *Movements, and Buzzwords*, 1848–1944 (New York: Abbeville Press, 1993), 139.
- 5. Atkins, Art Spoke, 176.
- Karen Hamblen, "Beyond Universalism in Art Criticism," in Pluralistic Approaches to Art Criticism, ed. Doug Blandy and Kristin Congdon (Bowling

- 7. Robert Atkins, *Art Speak: A Guide to Contemporary Ideas*, *Movements, and Buzzwords* (New York: Abbeville Press, 1990), 81.
- 8. Philip Yenawine, *How to Look at Modern Art* (New York: Abrams, 1991), 20.
- 9. Harold Rosenberg, quoted by Howard Singerman, "In the Text," in *A Forest of Signs: Art in the Crisis of Representation*, ed. Catherine Gudis (Cambridge: MIT Press, 1989), 156.
- 10. Barnett Newman, quoted by Singerman, "In the Text," 156.
- 11. Frank Stella, quoted by Singerman, 157.
- 12. Atkins, Art Speak, 99.
- 13. Tom Wolfe, *The Painted Word* (New York: Farrar, Straus, and Giroux, 1975).
- 14. Tom Wolfe, From Bauhaus to Our House (New York: Farrar, Straus, and Giroux, 1982).
- Charles Jencks, The Language of Postmodern Architecture (New York: Pantheon, 1977).
- 16. Arthur Danto, Beyond the Brillo Box: The Visual Arts in Post-Historical Perspective (New York: Farrar, Straus, and Giroux, 1992).
- 17. Atkins, Art Speak, 65.
- 18. Danto, Beyond the Brillo Box, 9.
- Eleanor Heartney, "A Consecrated Critic," Art in America, July 1998, 45–47.
- 20. Yenawine, How to Look, 124.
- 21. Ibid.
- 22. Mario Cutajar, "Goodbye to All That," *Artspace*, July–August 1992, 61.
- 23. Cornel West, quoted by Thelma Golden in "What's White?" in 1993 Biennial Exhibition catalog, Whitney Museum of American Art, New York City, 27.
- 24. Hamblen, "Beyond Universalism," 7–14.

- 25. Wanda May, "Philosopher as Researcher and/or Begging the Question(s)," *Studies in Art Education* 33, no. 4 (1992), 226–43.
- Craig Owens, "Amplifications: Laurie Anderson," *Art in America*, March 1981, 121.
- Lucy Lippard, "Some Propaganda for Propaganda," in Visibly Female: Feminism and Art Today, ed. Hilary Robinson (New York: Universe, 1988), 184–94.
- 28. Barbara Kruger, "What's High, What's Low—and Who Cares?" *The New York Times*, September 9, 1990, 43.
- 29. Robert Storr, "Shape Shifter," *Art in America*, April 1989, 213.
- 30. Harold Pearse, "Beyond Paradigms: Art Education Theory and Practice in a Postparadigmatic World," *Studies in Art Education* 33, no. 4 (1992), 249.
- 31. Barrett, *Why Is That Art?* (New York: Oxford, 2008), 56.
- 32. Diarmuid, ed., *Art: Key Contemporary Thinkers* (Oxford, England: Berg, 2007).
- Michael Hatt and Charlotte Klonk, Art
 History: A Critical Introduction to Its Methods (Manchester, England: Manchester University Press, 2006), 175.
- 34. Much of this material about Lacan is condensed from Barrett, *Why?*, ibid., 156–157.
- 35. Museo de Arte Contemporáneo de Castilla y León, http://musac.es/index_en.php?ref=23300, retrieved February 6, 2010.
- 36. Guerrilla Girls, http://www.guerrillagirls .com/interview/faq.shtml, retrieved January 15, 2010.
- 37. Hilde Hein, "The Role of Feminist Aesthetics in Feminist Theory," *The Journal of Aesthetics and Art Criticism* 48, no. 4 (1990), 281–91.
- 38. Anita Silvers, "Feminism," *The Oxford Encyclopedia of Aesthetics*, p. 163 . . .
- 39. Kristin Congdon, "Feminist Approaches to Art Criticism," in

- Pluralistic Approaches to Art Criticism, ed. Blandy and Congdon, 15–31.
- 40. Elizabeth Garber, "Feminism, Aesthetics, and Art Education," *Studies in Art Education* 33, no. 4 (1992), 210–25.
- 41. Simone de Beauvoir, quoted in Hein, "The Role of Feminist Aesthetics," 282.
- 42. Hilton Kramer, quoted by Edward M. Gomez, "Quarreling over Quality," *Time*, Special Issue, Fall 1990, 61.
- 43. Ibid., 61-62.
- 44. Rosalind Coward, quoted by Jan Zita Grover, "Dykes in Context: Some Problems in Minority Representations," in *The Contest of Meaning*, ed. Richard Bolton (Cambridge: MIT Press, 1989), 169.
- 45. Georgia Collins and Renee Sandell, "Women's Achievements in Art: An Issues Approach for the Classroom, *Art Education*, May 1987, 13.
- 46. Lucy Lippard, "No Regrets," *Art in America*, June/July 2007, 76.
- 47. John Berger, *Ways of Seeing* (London: Penguin Books, 1972).
- 48. Jean-Paul Sartre, quoted by Hein, "The Role of Feminist Aesthetics," 290.
- 49. Griselda Pollock, "Missing Women," in *The Critical Image*, ed. Carol Squiers (Seattle: Bay Press, 1990), 202–19.
- 50. Jan Zita Grover, "Dykes in Context: Some Problems in Minority Representations," in *The Context of Meaning*, ed. Richard Bolton (Cambridge: MIT Press, 1989), 163–202.
- 51. Personal correspondence with the author, February 22, 1993.
- 52. Lippard, ibid., 75.
- 53. Michael Kimmelman, "An Improbable Marriage of Artist and Museum," *The New York Times*, August 2, 1992, 27.
- 54. Museum for Contemporary Arts, Baltimore, 1992.
- 55. Karen Hamblen, "Qualifications and Contradictions of Art Museum Education in a Pluralistic Democracy," in *Art*

- in a Democracy, ed. Doug Blandy and Kristin Congdon (New York: Teachers College Press, 1987), 13–25.
- Mason Riddle, "Hachivi Edgar Heap of Birds," New Art Examiner, September 1990, 52.
- 57. Meyer Raphael Rubinstein, "Hachivi Edgar Heap of Birds," *Flash Art*, November–December 1990, 155.
- Lydia Matthews, "Fighting Language with Language," *Artweek*, December 6, 1990, 1.
- Daina Augaitis, "Prototypes for New Understandings," *Brian Jungen* (Vancouver: Vancouver Art Gallery, 2010), 5.
- David Bailey, "Re-thinking Black Representations: From Positive Images to Cultural Photographic Practices," Exposure 27, no. 4 (1990), 37–46.
- 61. This treatment of postcolonialism is a reiteration from Terry Barrett, *Why Is That Art?* (New York: Oxford University Press, 2008).
- 62. Michael Hatt and Charlotte Klonk, *Art History: A Critical Introduction to Its Methods* (Manchester, England: Manchester University Press, 2006), 221.
- 63. May, "Philosopher as Researcher," 231–32.
- 64. Lisa Duggan, "Making It Perfectly Queer," *Art Papers* 16, no. 4 (1992), 10–16.
- 65. Louise Sloan, quoted in Duggan, "Making It Perfectly Queer," 14.
- Douglas Crimp with Adam Rolston, *AIDS Demo Graphics* (Seattle: Bay Press, 1990).
- 67. Walter Robinson, "Artpark Squelches Bible Burning," *Art in America*, October 1990, 45.
- 68. Ralph Smith, "Problems for a Philosophy of Art Education," *Studies in Art Education* 33, no. 4 (1992), 253–66.
- 69. Michael Brenson, "Is 'Quality' an Idea Whose Time Has Gone?" *The New York Times*, July 22, 1990, 1, 27.

Chapter 3 • Describing Art

- 1. Astrid Mania, "Mona Hatoum," in Hans Werner Holzwarth, ed., 100 Contemporary Artists (Los Angeles: Taschen, 2010), 268.
- 2. Laura Steward Heon, "Grist for the Mill," *Mona Hatoum: Domestic Disturbance* (North Adams, MA: MASS MoCA, 2001), 13.
- 3. Doug Harvey, *LA Weekly*, January 10, 2002, http://www.markryden.com/press/laweekly.html, retrieved December 20, 2009.
- 4. Gary Faigin, "Review of Mark Ryden at the Frye Museum," broadcast December 2004, KUOW FM Seattle, http://www.garyfaigin.com/ reviews/2004/2004-12.html, retrieved December 20, 2009.
- Holly Myers, "Mark Ryden's Return to Nature," in Mark Ryden, The Tree Show (Los Angeles: Michael Kohn Gallery, 2007), 13–14.
- Peter Schjeldahl, "Uncluttered: An Olafur Eliasson Retrospective," *The New Yorker*, http://www.newyorker.com/arts/critics/artworld/2008/04/28/080428 craw_artworld_schjeldahl, retrieved January 20, 2010.
- 7. Lucy Lippard, "No Regrets," *Art in America*, June/July 2007, 78.
- 8. David Cateforis, "Anselm Kiefer," in Compassion and Protest: Recent Social and Political Art from the Eli Broad Family Foundation Collection, ed. Patricia Draker and John Pierce, exhibition catalog (New York: Cross River Press, 1991), 46.
- Waldemar Januszczak, "Is Anselm Kiefer the New Genius of Painting? Not Quite!" Connoisseur, May 1988, 130.
- Frances Colpitt, "Kiefer as Occult Poet," Art in America, March 2006, 109.
- 11. Gary Keller, Mary Erickson, and Pat Villeneuve, *Chicano Art for Our*

- Millennium (Bilingual Press: Tempe, AZ, 2004), 97.
- 12. Galerie St. Etienne, "Elephants We Must Never Forget, Essay," 2008, http://www.gseart.com/exhibitions. asp?ExhID=508, retrieved January 4, 2010.
- Gerald Marzorati, "Night Watchman," *Artforum* XLIII, no. 3 (November 2004), 23.
- 14. Holland Cotter, "Leon Golub, Painter on a Heroic Scale, Is Dead at 82," *The New York Times*, August 12, 2004, C14.
- Raphael Rubinstein, "Leon Golub (1922–2004)," Art in America, October 2004, 41.
- 16. David Cateforis, "Leon Golub," in *Compassion and Protest*, 32–35.
- 17. Ed Hill and Suzanne Bloom, "Leon Golub," *Artforum*, February 1989, 126.
- Rosetta Brooks, "Leon Golub: Undercover Agent," Artforum, January 1990, 116.
- 19. Robert Berlind, "Leon Golub at Fawbush," *Art in America*, April 1988, 210–11.
- 20. Pamela Hammond, "Leon Golub," *Artnews*, March 1990, 193.
- 21. Ben Marks, "Memories of Bad Dreams," *Artweek*, December 21, 1989, 9.
- 22. Robert Storr, "Riddled Sphinxes," *Art in America*, March 1989, 126.
- 23. Margaret Moorman, "Leon Golub," *Artnews*, February 1989, 135.
- Robert Berlind, "Leon Golub at Ronald Feldman," *Art in America*, February 1999, 107.
- 25. Joshua Decter, "Leon Golub," *Arts Magazine*, March 1989, 135–36.
- 26. Deborah Yellin, "Deborah Butterfield," *Artnews*, April 1991, 154.
- 27. Donna Brookman, "Beyond the Equestrian," *Artweek*, February 25, 1989, 6.
- 28. Richard Martin, "A Horse Perceived by Sighted Persons: New Sculptures by

- Deborah Butterfield," *Arts Magazine*, January 1987, 73–75.
- 29. Kathryn Hixson, "Chicago in Review," *Arts Magazine*, January 1990, 106.
- Marcia Tucker, "Equestrian Mysteries: An Interview with Deborah Butterfield," Art in America, June 1989, 203.
- 31. "Ceramics and Glass Acquisitions at the V. & A.," *Burlington Magazine*, May 1990, 388.
- 32. Andrea DiNoto, "New Masters of Glass," *Connoisseur*, August 1982, 22–24.
- 33. Robert Silberman, "Americans in Glass: A Requiem?" *Art in America*, March 1985, 47–53.
- 34. Gene Baro, "Dale Chihuly," *Art International*, August–September 1981, 125–26.
- 35. Ron Glowen, "Glass on the Cutting Edge," *Artweek*, December 6, 1990.
- Linda Norden, "Dale Chihuly: Shell Forms," Arts Magazine, June 1981, 150–51.
- David Bourdon, "Chihuly: Climbing the Wall," Art in America, June 1990, 164.
- 38. Marilyn Iinkl, "James Carpenter–Dale Chihuly," *Craft Horizons*, June 1977, 59.
- Penelope Hunter-Stiebel, "Contemporary Art Glass: An Old Medium Gets a New Look," Artnews, Summer 1981, 132.
- 40. Peggy Moorman, "Dale Chihuly," *Artnews*, March 1984, 212.
- 41. Barbara Rose, "The Earthly Delights of the Garden of Glass," in *Chihuly Gardens* & Glass (Portland, OR: Portland Press, 2002), http://www.chihuly.com/essays/ rosegarden.html, June 24, 2007.
- 42. John Howell, "Laurie Anderson," *Artforum*, Summer 1986, 127.
- 43. Ann-Sargeant Wooster, "Laurie Anderson," *High Performance*, Spring 1990, 65.
- 44. "Laurie Anderson," *The New Yorker*, May 21, 2007, 10.

- 46. Bill Viola, Bill Viola: The Passions, retrieved from Emergence, The Getty, http://www.getty.edu/art/gettyguide/art ObjectDetails?artobj=201607, January 3, 2010.
- 47. Michael Duncan, "Bill Viola: Altered Perceptions," *Art in America*, March 1998, 63–67.
- 48. Dierdre Boyle, "Post-Traumatic Shock: Bill Viola's Recent Work," *Afterimage*, September/October 1996, 9–11.
- 49. Annette Grant, "Art, Let 7 Million Sheets of Paper Fall," *The New York Times*, April 11, 2004, http://www.nytimes.com/2004/04/11/arts/art-let-7-million-sheets-of-paper-fall.html, retrieved January 9, 2010.
- 50. Joseph Thompson, in "Ann Hamilton Work to Open in MASS MoCA's Massive Building 5 Gallery on December 13," MASS MoCA Web site, http://www.massmoca.org/event_details.php?id=42, retrieved January 9, 2010.
- 51. MASS MoCA, "Ann Hamilton, *corpus*," ibid.
- 52. MASS MoCA, Press Release, http://www.massmoca.org/press_ releases/11_2003/11_13_03.html, retrieved January 10, 2010.
- 53. Sarah Rogers-Lafferty, "Ann Hamilton," in *Breakthroughs: Avant-Garde Artists* in *Europe and America*, 1950–1990, Wexner Center for the Visual Arts, The Ohio State University (New York: Rizzoli, 1991), 208–13.
- 54. Kirsty Bell, "Charles Ray," in Hans Werner Holzwarth, ed., 100 Contemporary Artists (Los Angeles: Taschen, 2010), 502.
- 55. Holgar Lund, "Chris Ofili," in Hans Werner Holzwarth, ed., 100 Contemporary Artists (Los Angeles: Taschen, 2010), 442.

- Cecelia Alemani, "Kehinde Wiley," in Hans Werner Holzwarth, ed., 100 Contemporary Artists (Los Angeles: Taschen, 2010), 648.
- 57. Astrid Mania, "Wangechi Mutu," in Hans Werner Holzwarth, ed., 100 Contemporary Artists (Los Angeles: Taschen, 2010), 404.

Chapter 4 • Interpreting Art

- 1. Roni Feinstein, "Dogged Persistence," *Art in America*, May 2007, p. 179.
- 2. Kim Hubbard, "Sit, Beg... Now Smile!" *People*, September 9, 1991, 105–8; Elaine Louie, "A Photographer and His Dogs Speak as One," *The New York Times*, February 14, 1991, B4.
- 3. Michael Gross, "Pup Art," *New York*, March 30, 1992, 44–49; Louie, "Photographer and His Dogs"; Brooks Adams, "Wegman Unleashed," *Artnews*, January 1990, 150–55.
- 4. William Wegman, *Man's Best Friend* (New York: Abrams, 1982); introduction by Laurance Wieder.
- 5. Martin Kunz, "Introduction," in William Wegman, ed. Martin Kunz (New York: Abrams, 1990), 9.
- 6. Peter Weiermair, "Photographs: Subversion through the Camera," in William Wegman, ed. Kunz, 45.
- 7. Craig Owens, "William Wegman's Psychoanalytic Vaudeville," *Art in America*, March 1983, 101–8.
- 8. Robert Fleck, "William Wegman, Centre Pompidou," *Flash Art,* Summer 1991, 140.
- 9. D. A. Robbins, "William Wegman's Pop Gun," *Arts Magazine*, March 1984, 116–21.
- 10. Kevin Costello, "The World of William Wegman—The Artist and the Visual Pun," *West Coast Woman*, December 1991, 16.
- 11. Owens, "William Wegman's Psychoanalytic Vaudeville."

- 12. Jean-Michel Roy, "His Master's Muse: William Wegman, Man Ray, and the Dog-Biscuit Dialectic," *The Journal of Art*, November 1991, 20–21.
- Roberta Smith, "Beyond Dogs: Wegman Unleashed," *The New York Times*, March 10, 2006, Arts and Design, 1.
- Jerry Saltz, "A Blessing in Disguise: William Wegman's Blessing of the Field, 1986," Arts Magazine, Summer 1988, 15–16.
- Jeremy Gilbert-Rolfe, "Seriousness and Difficulty in Criticism," Art Papers, November–December 1990. 8.
- Nick Obourn, "Jenny Holzer, Whitney Museum of American Art," Art in America, May 2009, 149.
- 17. Museum of Contemporary Art, Chicago, "Jenny Holzer: Protect Protect," http:// www.mcachicago.org/exhibitions/ exh_detail.php?id=179#_self, accessed December 5, 2009.
- 18. Gilbert-Rolfe, "Seriousness and Difficulty," 10.
- 19. Robert Hughes, "A Sampler of Witless Truisms," *Time*, July 30, 1990, 66.
- 20. Peter Plagens, "The Venetian Carnival," *Newsweek*, June 11, 1990, 60–61.
- 21. Michael Brenson, "Jenny Holzer: The Message Is the Message," *The New York Times*, August 7, 1988, 29.
- 22. Candace Mathews Bridgewater, "Jenny Holzer at Home and Abroad," *Columbus Dispatch*, August 5, 1990, sec. F, 1–2.
- 23. Grace Glueck, "And Now a Word from Jenny Holzer," *The New York Times Magazine*, May 26, 1991, 42.
- 24. Diane Waldman, *Jenny Holzer*, (New York: Abrams, 1989); exhibition catalog, Guggenheim Museum, New York.
- 25. Jenny Holzer, "Truisms," in *Blasted Allegories: An Anthology of Writings by Contemporary Artists*, ed. Brian Wallis
 (New York: The New Museum of
 Contemporary Art, 1987), 107.
- 26. Waldman, Jenny Holzer, 10.

- 27. Ann Goldstein, "Baim-Williams," in A Forest of Signs: Art in the Crisis of Representation, ed. Catherine Gudis (Cambridge: MIT Press, 1989).
- 28. Hal Foster, "Subversive Signs," *Art in America*, November 1982, 88–92.
- 29. Holland Cotter, "Jenny Holzer at Barbara Gladstone," *Art in America*, December 1986, 137–38.
- 30. Joan Simon, "Voices, Other Formats," Jenny Holzer (Chicago: Museum of Contemporary Art, 2009), 11.
- 31. Obourn, "Jenny Holzer."
- 32. Francine Prose, *Elizabeth Murray Paintings* 1999–2003 (New York: PaceWildenstein), 11.
- 33. Roberta Smith, "Elizabeth Murray, 66, Artist of Vivid Forms, Dies," *The New York Times*, August 13, 2007, Art and Design, 13.
- Deborah Solomon, "Celebrating Painting," *The New York Times Magazine*, March 31, 1991, 21–25.
- 35. Robert Hughes, *Nothing If Not Critical*, (New York: Knopf, 1990).
- Jude Schwendenwien, "Elizabeth Murray," New Art Examiner, October 1988, 55.
- 37. Robert Storr, "Shape Shifter," *Art in America*, April 1989, 210–20.
- Ken Johnson, "Elizabeth Murray's New Paintings," Arts Magazine, September 1987, 67–69.
- 39. Nancy Grimes, "Elizabeth Murray," *Artnews*, September 1988, 151.
- 40. Janet Kutner, "Elizabeth Murray," *Artnews*, May 1987, 45–46.
- 41. Gregory Galligan, "Elizabeth Murray's New Paintings," *Arts Magazine*, September 1987, 62–66.
- 42. Nelson Goodman, *Languages of Art*, (Indianapolis: Hackett, 1976); Arthur Danto, *Transfiguration of the Commonplace*, (Cambridge: Harvard, 1981).
- 43. Thomas McEvilley, Art & Discontent: Theory at the Millennium (Kingston, NY: McPherson, 1991).

- 45. Richard Marshall and Robert Mapplethorpe, 50 New York Artists, (San Francisco: Chronicle Books, 1986), 94.
- 46. Curtia James, "New History," *Artnews*, October 1990, 203.
- 47. Mark Van Proyen, "A Conversation with Donald Kuspit," *Artweek*, September 5, 1991, 19.
- Pamela Hammond, "A Primal Spirit: Ten Contemporary Japanese Sculptors," Artnews, October 1990, 201–2.
- Marcia Eaton, Basic Issues in Aesthetics, (Belmont, Calif.: Wadsworth, 1988), 120.

Chapter 5 • Judging Art

- 1. Jens Astoff, "Walton Ford," in Hans Werner Holzwarth, ed., *100 Contemporary Artists* (Los Angeles: Taschen, 2010), 194.
- 2. Roberta Smith, "Kristin Baker," Surge and Shadow, April 14, 2007, B29.
- 3. Peter Schjeldahl, "Man of the World: A Gabriel Orozco Retrospective," *The New Yorker*, December 21, 28, 2009, 146.
- 4. Jeet Heer, "Word Made Fresh," *Bookforum*, September/October/November 2009, 35.
- 5. Peter Plagens, "Frida on Our Minds," *Newsweek*, May 27, 1991, 54–55.
- 6. Hayden Herrera, "Why Frida Kahlo Speaks to the 90's," *The New York Times*, October 28, 1990, 1, 41.
- 7. Joyce Kozloff, "Frida Kahlo," *Art in America*, May/June 1979, 148–49.
- 8. Kay Larson, "A Mexican Georgia O'Keeffe," *New York Magazine*, March 28, 1983, 82–83.
- 9. Michael Newman, "The Ribbon around the Bomb," *Art in America*, April 1983, 160–69.
- Jeff Spurrier, "The High Priestess of Mexican Art," Connoisseur, August 1990, 67–71.

- Georgina Valverde, quoted in Robert Bersson, Worlds of Art, (Mountain View, Calif.: Mayfield, 1991), 433.
- Meyer Raphael Rubinstein offers another story in "A Hemisphere of Decentered Mexican Art Comes North," Arts Magazine, April 1991, 70.
- 13. Angela Carter, *Frida Kahlo*, (London: Redstone Press, 1989), Introduction.
- 14. Serge Fauchereau, "Surrealism in Mexico," *Artforum*, Summer 1986, 88.
- 15. Peter Schjeldalh, "All Souls: The Frida Kahlo Cult," *The New Yorker*, November 5, 2007, 92–94.
- Robert Hughes, "Martin Puryear," Time, July 9, 2001.
- 17. Neal Menzies, "Unembellished Strength of Form," *Artweek*, February 2, 1985, 4.
- Ann Lee Morgan, "Martin Puryear: Sculptures as Elemental Expression," New Art Examiner, May 1987, 27–29.
- Kenneth Baker, "Art Review: Martin Puryear Sculptures at SFMOMA," San Francisco Chronicle, November 8, 2008, E1.
- Nancy Princenthal, "Intuition's Disciplinarian," *Art in America*, January 1990, 131–36.
- 21. Carole Gold Calo, "Martin Puryear: Private Objects, Evocative Visions," *Arts Magazine*, February 1988, 90–93.
- 22. Peter Schjeldahl, "Seeing Things," *The New Yorker*, November 12, 2007, 94.
- 23. Donald Kuspit, "Martin Puryear," *Artforum*, 2002.
- 24. Hughes, "Martin Puryear."
- 25. Suzanne Hudson, "Martin Puryear," *Artforum*, May 2008, 374.
- 26. Kuspit, "Martin Puryear."
- 27. Schjeldahl, "Seeing Things," 95.
- 28. Colin Westerbeck, "Chicago, Martin Puryear," *Artforum*, May 1987, 154.
- 29. Judith Russi Kirshner, "Martin Puryear, Margo Leavin Gallery," *Artforum*, Summer 1985, 115.
- 30. Joanne Gabbin, "Appreciation 26: Romare Bearden, *Patchwork Quilt*,"

- in Worlds of Art, by Robert Bersson (Mountain View, CA: Mayfield, 1991), 450–51.
- 31. Michael Brenson, "Romare Bearden: Epic Emotion, Intimate Scale," *The New York Times*, March 27, 1988, 41, 43.
- 32. Peter Plagens, "Unsentimental Journey," *Newsweek*, April 29, 1991, 58–59.
- 33. Barrie Stavis, quoted by Margaret Moorman, "Intimations of Immortality," *Artnews*, Summer 1988, 40–41.
- 34. Elizabeth Alexander, review of Romare Bearden: His Art and Life, by Myron Schwartzman, The New York Times Book Review, March 24, 1991, 36.
- 35. Nina ffrench-frazier, "Romare Bearden," *Artnews*, October 1977, 141–42.
- Myron Schwartzman, "Romare Bearden Sees in a Memory," *Artforum*, May 1984, 64–70.
- Ellen Lee Klein, "Romare Bearden," Arts Magazine, December 1986, 119–20.
- Davira S. Taragin, "From Vienna to the Studio Craft Movement," *Apollo*, December 1986, 544.
- 39. Nancy Princenthal, "Romare Bearden at Cordier & Ekstrom," *Art in America*, February 1987, 149.
- 40. Mildred Lane, "Spotlight Essay, Romare Bearden *Black Venus*," Kemper Museum of Contemporary Art, February 2007, http://www.kemperart.org/, accessed January 3, 2010.
- 41. Eleanor Heartney, "David Salle: Impersonal Effects," *Art in America*, June 1988, 121–29.
- 42. David Rimanelli, "David Salle," *Artforum*, Summer 1991, 110.
- 43. Laura Cottingham, "David Salle," Flash Art, May–June 1988, 104.
- 44. Robert Storr, "Salle's Gender Machine," *Art in America*, June 1988, 24–25.
- 45. Jed Perl, "Tradition-Conscious," *The New Criterion*, May 1991, 55–59.
- 46. A. M. Homes, "Vito Acconci," *Artforum*, Summer 1991, 107.

- 47. Mary Jane Aschner, "Teaching the Anatomy of Criticism," *The School Review* 64, no. 7 (1956), 317–22.
- 48. John Szarkowski, Mirrors and Windows: American Photography since 1960, (New York: Museum of Modern Art, 1978), 9.
- Linda Nochlin, "Four Close-Ups (and One Nude)," Art in America, February 1999, 66.
- Robert Berlind, "Janet Fish at Borgenicht," Art in America, December 1995, http://findarticles.com/p/articles/mi_m1248/is_n12_v83/ai_17860710/, accessed January 24, 2010.
- 51. Martha Schwendener, "Walton Ford," *Artforum*, January 2003.
- 52. Gordon Graham in Terry Barrett, *Why Is That Art?* (New York: Oxford University Press), p. 57.
- 53. Ibid.
- 54. Barbara Rose, "Kiefer's Cosmos," *Art in America*, December 1998, 70–73.
- Ken Johnson, "Anselm Kiefer at Marian Goodman," Art in America, November 1990, 198–99.
- Robert Berlind, "Leon Golub at Ronald Feldman," *Art in America*, February 1999, 107.
- 57. Berys Gault in Barrett, Why Is That Not?, 57.
- 58. "Ad Reinhardt," Interview, June 1991, 28.
- 59. Michael Fried, "Optical Illusions," *Artforum*, April 1999, 97–101.
- 60. Agnes Martin, Writings, (New York: DAP, 1991), 7.
- 61. Gerrit Henry, "Agnes Martin," *Artnews*, March 1983, 159.
- Terry Barrett, Why Is That Art? (New York: Oxford University Press, 2008), 139.
- Douglas Crimp, AIDS: Cultural Analysis/ Cultural Activism, (Cambridge: MIT Press, 1988), 18.
- 64. Ann Cvetcovich, "Video, AIDS, and Activism," *Afterimage*, September 1991, 8–11.

- 66. Curtia James, "New History," *Artnews*, October 1990, 203.
- 67. Guy McElroy for the Corcoran Gallery in Washington, D.C.
- 68. Steven Dubin, "Art and Activism: Do Not Go Gentle," *Art in America*, December 2009, 66.
- Leon Golub, Wall text, Museum of Contemporary Art, Chicago, January 2009.
- 70. Satorimedia, http://www.satorimedia.com/fmraWeb/chin.htm, accessed February 5, 2010.
- 71. Kirsty Bell, "Rirkrit Tiravanija," in Hans Werner Holzwarth, ed., 100 Contemporary Artists (Los Angeles: Taschen, 2010), 584.
- 72. Janet Bell, "Susan Rothenberg," *Artnews*, May 1987, 147.
- 73. Michael Kimmelman, Portraits: Talking with Artists at the Met, the Modern, the Louvre, and Elsewhere, (New York: Random House, 1998), 110.
- 74. Peter Plagens, "Max's Dinner with André," *Newsweek*, August 12, 1991, 60–61.
- 75. Eleanor Heartney, "Martha Rosler at DIA," *Art in America*, November 1989, 184.
- 76. Donald Kuspit, "Sue Coe," *Artforum*, Summer 1991, 111.
- 77. Jan Zita Grover, "Dykes in Context: Some Problems in Minority Representations," in *The Contest of Meaning*, ed. Richard Bolton (Cambridge: MIT Press, 1989), 163–202.

- 78. Ronald Jones, "Crimson Herring," *Artforum*, Summer 1998, 17–18.
- 79. Pamela Newkirk, "Pride or Prejudice," *Artnews*, March 1999, 115–17.
- 80. Margaret Battin, John Fisher, Ronald Moore, and Anita Silvers, *Puzzles about Art: An Aesthetics Casebook*, (New York: St. Martin's Press, 1989).
- 81. Jens Astoff, "Walton Ford," in Holzwarth, ed., 100 Contemporary Artists, 194.

Chapter 6 • Writing and Talking about Art

- 1. Annie Dillard, *The New York Times Book Review*, May 28, 1989, 1.
- 2. Department of Art Education, The Ohio State University, Professor Terry Barrett.
- 3. Art Education 795, Art Writing, Spring Quarter, 2008, Department of Art Education, The Ohio State University, Professor Terry Barrett.
- Kerry James Marshall, Kerry James Marshall (New York: Abrams, 2000), 119.
- 5. Janet Macpherson, "Janet Macpherson: Ceramic Work," course paper for Art Education 840, Professor Terry Barrett, The Ohio State University, 2009.
- Terry Barrett, "A Comparison of the Goals of Studio Professors Conducting Critiques and Art Education Goals for Teaching Criticism," Studies in Art Education 30, no. 1 (1988), 22–27.
- 7. Adapted from Terry Barrett, "Tentative Tips for Better Crits" (Boston: College Art Association, November 19, 2003).

Bibliography

- Adams, Brooks. "Wegman Unleashed." *Art News*, January 1990, 150–55.
- Alexander, Elizabeth. Review of *Romare*Bearden: His Life and Life, by Myron
 Schwartzman. The New York Times Book
 Review, March 24, 1991, 36.
- Alloway, Lawrence. "The Expanding and Disappearing Work of Art." *Auction*, October 1967, 34–37.
- ——. "Women's Art and the Failure of Art Criticism." In *Network: Art and the Complex Present*. Ann Arbor: UMI Press, 1984.
- ——. "Women's Art in the Seventies." In Network: Art and the Complex Present.
 Ann Arbor: UMI Press, 1984.
- Aschner, Mary Jane. "Teaching the Anatomy of Criticism." *The School Review* 64, no. 7 (1956), 317–22.
- Atkins, Robert. Art Speak: A Guide to Contemporary Ideas, Movements, and Buzzwords. New York: Abbeville Press, 1990.
- ——. Art Speak: A Guide to Modern Ideas, Movements, and Buzzwords, 1848–1944. New York: Abbeville Press, 1993.
- Bailey, David. "Re-thinking Black Representations: From Positive Images to Cultural Photographic Practices." *Exposure* 27, no. 4 (1990), 37–46.

- Baker, Kenneth. "Ann Hamilton." *Artforum*, October 1990, 178–79.
- Barnet, Sylvan. *A Short Guide to Writing about Art.* 3rd ed. Glenview, IL: Scott, Foresman, 1989.
- Baro, Gene. "Dale Chihuly." Art International, August/September 1981, 125–26.
- Barrett, Terry. "A Comparison of the Goals of Studio Professors Conducting Critiques and Art Education Goals for Teaching Criticism." *Studies in Art Education* 30, no. 1 (1988), 22–27.
- Bass, Ruth. "Miriam Schapiro." *Artnews*, October 1990, 185.
- Battin, Martin, John Fisher, Ronald Moore, and Anita Silvers. *Puzzles about Art: An Aesthetics Casebook*. New York: St. Martin's Press, 1989.
- Beattie, Ann. *Alex Katz.* New York: Abrams, 1987.
- Beckett, Wendy. Contemporary Women Artists. New York: Universe, 1988.
- Beem, Edgar Allen. *Maine Art Now.* gardiner, ME: Dog Ear Press, 1990.
- Bell, Janet. "Susan Rothenberg." *Artnews*, May 1987, 147.
- Berger, John. *Ways of Seeing*. London: Penguin, 1972.
- Berlind, Robert. "Leon Golub at Fawbush." *Art in America*, April 1988, 210–11.
- ——. "Leon Golub at Ronald Feldman." *Art in America*, February 1999, 107.

- Bersson, Robert. Worlds of Art. Mountain View, CA: Mayfield, 1991.
- Blandy, Doug, and Kristin Congdon, eds. *Art in a Democracy*. New York: Teachers College Press, 1987.
- ———. Pluralistic Approaches to Art Criticism. Bowling Green, Ohio: Popular Press, 1991.
- Bloom, Suzanne, and Ed Hill. "Leon Golub." *Artforum*, February 1989, 126.
- Bourdon, David. "Chihuly: Climbing the Wall." *Art in America*, June 1990, 164–66.
- Boyle, Dierdre. "Post-Traumatic Shock: Bill Viola's Recent Work." *Afterimage*, September/October 1996, 9–11.
- Brenson, Michael. "Is 'Quality' an Idea Whose Time Has Gone?" *The New York Times*, July 22, 1990, 1, 27.
- —... "Jenny Holzer: The Message Is the Message." The New York Times, August 7, 1988, 29.
- ——. "Romare Bearden: Epic Emotion, Intimate Scale." The New York Times, March 27, 1988, 41.
- Bridgewater, Candace Mathews. "Jenny Holzer at Home and Abroad." *Columbus Dispatch*, August 5, 1990, sec. F, 1–2.
- Brookman, Donna. "Beyond the Equestrian." *Artweek*, February 25, 1989, 6.
- Brooks, Rosetta. "Leon Golub: Undercover Agent." *Artforum*, January 1990, 116.
- Broudy, Harry. Enlightened Cherishing. Champaign-Urbana: University of Illinois Press, 1972.
- ——. "Some Duties of a Theory of Educational Aesthetics." *Educational Theory* 30, no. 3 (1951), 198–99.
- Burkhart, Ann. "A Study of Studio Art Professors' Beliefs and Attitudes about Professional Art Criticism." Master's thesis, The Ohio State University, Columbus, 1992.
- Burnham, Lynda Frye. "Running Commentary." *High Performance*, Summer 1991, 6–7.
- -----. "What Is a Critic Now?" *Art Papers*, November/December 1990, 7–8.
- Calo, Carole Gold. "Martin Puryear." *New Art Examiner*, February 1988, 65.

- ——. "Martin Puryear: Private Objects, Evocative Visions." Arts Magazine, February 1988, 90–93.
- Carter, Angela. Introduction. *Frida Kahlo*. London: Redstone Press, 1989.
- "Ceramics and Glass Acquisitions at the V. & A." Burlington Magazine, May 1990, 388.
- Chambers, Karen. "Pluralism Is a Concept." *U&lc*, Fall 1991, 36–40.
- Cokes, Tony. "Laurie Anderson at the 57th Street Playhouse." *Art in America*, July 1988, 120.
- Coleman, A. D. "Because It Feels So Good When I Stop: Concerning a Continuing Personal Encounter with Photography Criticism." In Light Readings: A Photography Critic's Writings 1968–1978, ed.
 A. D. Coleman. New York: Oxford University Press, 1979.
- Compassion and Protest: Recent Social and Political Art from the Eli Broad Family Foundation Collection. New York: Cross Rivers Press, 1991.
- Congdon, Kristin. "Feminist Approaches to Art Criticism." In *Pluralistic Approaches to Art Criticism*, Ed. Doug Blandy and Kristin Congdon, 15–31. Bowling Green, Ohio: Bowling Green State University Popular Press, 1991.
- Coplans, John. *A Self-Portrait*. New York: DAP, 1997.
- Corn, Alfred. "Lucien Freud, *Large Interior*, W. 9." *Artnews*, March 1990, 117–18.
- Costello, Kevin. "The World of William Wegman—The Artist and the Visual Pun." *West Coast Woman*, December 1991, 16.
- Cotter, Holland. "Donald Lipski." *Artnews*, October 1990, 184.
- ———. "Jenny Holzer at Barbara Gladstone." *Art in America*, December 1986, 137–38.
- Cottingham, Laura. "David Salle." *Flash Art*, May–June 1988, 104.
- Crimp, Douglas. *AIDS: Cultural Analysis/ Cultural Activism.* Cambridge: MIT Press, 1988.
- Crimp, Douglas, and Adam Rolston. *AIDS Demo Graphics*. Seattle: Bay Press, 1990.

- Curtis, James. "New History." *Artnews*, October 1990, 203.
- Cutajar, Mario. "Goodbye to All That." *Artspace*, July/August 1992, 61.
- Cvetcovich, Ann. "Video, AIDS, and Activism." *Afterimage*, September 1991, 8–11.
- Danto, Arthur. Beyond the Brillo Box: The Visual Arts in Post-Historical Perspective. New York: Farrar, Straus, and Giroux, 1992.
- Transfiguration of the Commonplace. Cambridge: Harvard University Press, 1981.
- Decter, Joshua. "Leon Golub." *Arts Magazine*, March 1989, 134–35.
- Dery, Mark. "From Hugo Ball to Hugo Largo: 75 Years of Art and Music." *High Performance*, Winter 1988, 54–57.
- DeVuono, Frances. "Contemporary African Artists." *Artnews*, Summer 1990, 174.
- Diderot, Denis. *Salons* (1759–81). Edited by J. Adhémar and J. Seznec. 4 vols. Rev. ed. Oxford: Oxford University Press, 1983.
- Dillard, Annie. *The New York Times Book Review*, May 28, 1989, 1.
- DiNoto, Andrea. "New Masters of Glass." Connoisseur, August 1982, 22–24.
- Drier, Deborah. "Critics and the Marketplace." *Art & Auction*, March 1990, 172–74.
- Duncan, Lisa. "Making It Perfectly Queer." *Art Papers* 16, no. 4 (1992), 10–16.
- Duncan, Michael. "Bill Viola: Altered Perceptions." *Art in America*, March 1998, 63–67.
- Durland, Steven. "Notes from the Editor." *High Performance*, Summer 1991, 5.
- Eaton, Marcia. *Basic Issues in Aesthetics*. Belmont, CA: Wadsworth, 1988.
- Editors. "Ad Reinhardt." *Interview*, June 1991, 28.
- Efland, Arthur. A History of Art Education: Intellectual and Social Currents in Teaching the Visual Arts. New York: Teachers College Press, 1990.
- Failing, Patricia. "Invisible Men: Blacks and Bias in Western Art." *Artnews*, Summer 1990, 152–55.

- Fauchereau, Serge. "Surrealism in Mexico." Artforum, Summer 1986, 88.
- Feldman, Edmund. "The Teacher as Model Critic." *Journal of Aesthetic Education* 7, no. 1 (1973), 50–57.
- ——. Varieties of Visual Experience. 3rd ed. Englewood Cliffs, NJ: Prentice-Hall, 1987.
- ffrench-frazier, Nina. "Romare Bearden." *Artnews*, October 1977, 141–42.
- Fleck, Robert. "William Wegman, Centre Pompidou." Flash Art, Summer 1991, 140.
- Flood, Richard. "Laurie Anderson." *Artforum*, September 1988, 80–81.
- Foster, Hal. "Subversive Signs." *Art in America*, November 1982, 88–92.
- Frank, Elizabeth. "Art's Off-the-Wall Critic." *The New York Times Magazine*, November 19, 1989, 73.
- Fried, Michael. "Optical Illusions." *Artforum*, April 1999, 97–101.
- Frueh, Joanna. "Towards a Feminist Theory of Art Criticism." In *Feminist Art Criticism: An Anthology*, ed. Arlene Raven, Cassandra Langer, and Joanna Frueh. Ann Arbor: UMI Press, 1988.
- Gablik, Suzi. Conversations before the End of Time. London: Thames and Hudson, 1995.
- Galligan, Gregory. "Elizabeth Murray's New Paintings." Arts Magazine, September 1987, 62–67.
- Garber, Elizabeth. "Art Criticism as Ideology." *Journal of Social Theory in Art Education* 11 (1991), 50–67.
- ——. "Feminism, Aesthetics, and Art Education." *Studies in Art Education* 33, no. 4 (1992), 210–25.
- Gardner, Paul. "What Artists Like about the Art They Like When They Don't Know Why." *Artnews*, October 1991.
- Gerrit, Henry. "Agnes Martin." *Artnews*, March 1983, 159.
- Gilbert-Rolfe, Jeremy. "Seriousness and Difficulty in Criticism." *Art Papers*, November–December 1990, 8–11.
- Gill, Elizabeth. "Elizabeth Murray." *Artnews*, October 1977, 168.

- Gitlin, Michael. "Deborah Butterfield." Arts Magazine, February 1987, 107.
- Glowen, Ron. "Glass on the Cutting Edge." *Artweek*, December 6, 1990.
- Glueck, Grace. "And Now a Word from Jenny Holzer." *The New York Times Magazine*, December 3, 1989, 42.
- ——. "The Pope of the Art World." *The New York Times Book Review*, May 26, 1991, 15.
- Goldstein, Ann. "Baim-Williams." In A Forest of Signs in the Crisis of Representation, ed. Catherine Gudis. Cambridge: MIT Press, 1989.
- Gomez, Edward M. "Quarreling over Quality." *Time*, Special Issue, Fall 1990, 61–62.
- Goodman, Nelson. *Languages of Art.* Indianapolis: Hackett, 1976.
- Gopnik, Adam. "The Power Critic." *New Yorker*, March 16, 1988, 74.
- Grimes, Nancy. "Elizabeth Murray." *Artnews*, September 1988, 151.
- Gross, Michael. "Pup Art." New York, March 30, 1992, 44–49.
- Grover, Jan Zita. "Dykes in Context: Some Problems in Minority Representations." In *The Contest of Meaning*, ed. Richard Bolton. Cambridge: MIT Press, 1989.
- Grundberg, Andy. "Toward Critical Pluralism." In *Reading into Photography:*Selected Essays, 1959–1982, ed. Thomas Barrow, Shelley Armitage, and William Tydeman, 247–53. Albuquerque:
 University of New Mexico Press, 1982.
- Gudis, Catherine, ed. *A Forest of Signs in the Crisis of Representation*. Cambridge: MIT Press, 1989.
- Hagen, Charles. "William Wegman." *Artforum*, June 1984, 90.
- Halpern, David, ed. Writers on Art. San Francisco: North Point Press, 1988.
- Hamblen, Karen. "Beyond Universalism in Art Criticism." In *Pluralistic Approaches to Art Criticism*, ed. Doug Blandy and Kristin Congdon, 7–14. Bowling Green, Ohio: Bowling Green State University Popular Press, 1991.
- "Qualifications and Contradictions of Art Museum Education in a Pluralistic

- Democracy." In *Art in a Democracy*, ed. Doug Blandy and Kristin Congdon, 13–25. New York: Teachers College Press, 1987.
- Hammond, Pamela. "Leon Golub." *Artnews*, March 1990, 193.
- ——. "A Primal Spirit: Ten Contemporary Japanese Sculptors." *Artnews*, October 1990, 201–2.
- Handy, Elizabeth. "Deborah Butterfield at Edward Thorp." Art in America, April 1987, 218.
- Hartney, Mick. "Laurie Anderson's *United States*." *Studio International*, April/May 1983, 51.
- ——. "Leon Golub." *Artnews*, March 1990, 193.
- Heartney, Eleanor. "Art and the Public." *Art Papers*, November–December 1990, 15–16.
- ——. "A Consecrated Critic." *Art in America*, July 1998, 45–47.
- ——. "David Salle: Impersonal Effects." *Art in America*, June 1988, 121–29.
- ——. "Jenny Holzer." *Artnews*, March 1990, 173.
- ----. "A Little Too High Minded." *Artnews*, December 1990, 159.
- ——. "Martha Rossler at DIA." *Art in America*, November 1989, 184.
- ——. "Sue Coe." *Artnews*, December 1989, 158.
- Hein, Hilda. "The Role of Feminist Aesthetics in Feminist Theory." *The Journal of Aesthetics and Art Criticism* 48, no. 4 (1990), 281–91.
- Henry, Gerrit. "Agnes Martin." Artnews, March 1983, 159.
- -----. "Psyching Out Katz." *Artnews*, Summer 1987, 23.
- ——. "William Wegman." *Artnews*, April 1986, 154.
- Herrera, Hayden. "Why Frida Kahlo Speaks to the 90's." *The New York Times*, October 28, 1990, 1.
- Hickey, Dave. "Air Guitar." In Air Guitar: Essays on Art and Democracy. Los Angeles: Art Issues Press, 1997.
- Hill, Ed, and Suzanne Bloom. "Leon Golub." *Artforum*, February 1989, 126.

- Hixson, Kathryn. "Chicago in Review." *Arts Magazine*, January 1990, 106.
- ——. "Chicago in Review." *Arts Magazine*, November 1990, 123.
- Holmes, A. M. "Vito Acconci." *Artforum*, Summer 1991, 107.
- Holzer, Jenny. *Survival Series*. Buffalo, NY: Albright Knox Gallery, 1991.
- "Truisms." In Blasted Allegories: An Anthology of Writings by Contemporary Artists, ed. Brian Wallis, 107. New York: The New Museum of Contemporary Art, 1987.
- Howell, John. "Laurie Anderson." *Artforum*, Summer 1986, 127.
- Hubbard, Kim. "Sit, Beg... Now Smile!" *People*, September 9, 1991, 105–8.
- Hughes, Robert. *Nothing If Not Critical*. New York: Knopf, 1990.
- ——. "A Sampler of Witless Truisms." *Time*, July 30, 1990, 66.
- Hunter-Stiebel, Penelope. "Contemporary Art Glass: An Old Medium Gets a New Look." *Artnews*, Summer 1981, 132.
- Iinkl, Marilyn. "James Carpenter—Dale Chihuly." *Craft Horizons*, June 1977, 59.
- James, Curtia. "New History." *Artnews*, October 1990, 203.
- Januszczak, Waldemar. "Is Anselm Kiefer the New Genius of Painting? Not Quite!" *Connoisseur*, May 1988, 130–33.
- Johnson, Ken. "Anselm Kiefer at Marian Goodman." *Art in America*, November 1990, 198–99.
- ——. "Being and Politics." *Art in America*, September 1990, 155–60.
- ——. "Elizabeth Murray's New Paintings." *Arts Magazine*, September 1987, 67–69.
- Jones, Ronald. "Crimson Herring." *Artforum*, Summer 1998, 17–18.
- ——. "David Salle." *Flash Art*, April 1987, 82.
- Joselit, David. "Lessons in Public Sculpture." *Art in America*, December 1989, 131–34.
- Kachur, Lewis. "Lakeside Boom." *Art International*, Spring 1989, 63–65.
- Katz, Vincent. "Janet Fish at D. C. Moore." *Art in America*, March 1999, 99.
- Kimmelman, Michael. "An Improbable Marriage of Artist and Museum." *The New York Times*, August 2, 1992, 27.

- ———. Portraits: Talking with Artists at the Met, the Modern, the Louvre, and Elsewhere. New York: Random House. 1998.
- Kirshner, Judith Russi. "Martin Puryear, Margo Leavin Gallery." Artforum, Summer 1985, 115.
- Klein, Ellen Lee. "Romare Bearden." *Arts Magazine*, December 1986, 119–20.
- Koelsch, Patrice. "The Criticism of Quality and the Quality of Criticism." *Art Papers*, November–December 1990, 14–15.
- Kozloff, Joyce. "Frida Kahlo." *Art in America*, May/June 1979, 148–49.
- Kramer, Hilton. *Abstract Art: A Cultural History*. New York: Free Press, 1994.
- The Age of the Avant-Garde: An Art Chronicle of 1956–1972. New York: Farrar, Straus, and Giroux, 1973.
- The Revenge of the Philistines: Art and Culture 1972–1982. New York: Free Press, 1984.
- ——. The Twilight of the Intellectuals: Culture and Politics in the Era of the Cold War. Chicago: Ivan R. Dee, 1999.
- Kruger, Barbara. "What's High, What's Low—and Who Cares?" *The New York Times*, September 9, 1990, 43.
- Kunz, Martin, ed. William Wegman. New York: Abrams, 1990.
- Kuspit, Donald. "Sue Coe." *Artforum*, Summer 1991, 111.
- Kutner, Janet. "Elizabeth Murray." *Artnews*, May 1987, 45–46.
- Labat, Tony. "Two Hundred Words or So I've Heard Artists Say about Critics and Criticism." Artweek, September 5, 1991, 18.
- Larson, Kay. "A Mexican Georgia O'Keeffe." *New York*, March 28, 1983, 82–83.
- Lee, Sun-Young. "A Metacritical Examination of Contemporary Art Critics'
 Practices: Lawrence Alloway, Donald Kuspit, and Robert Pincus-Witten for Developing a Unit for Teaching Art Criticism." Ph.D. diss., The Ohio State University, Columbus, 1988.
- Lewis, James. "Joseph Kosuth." *Artforum*, December 1990, 134.
- Lichtenstein, Therese. "Artist/Critic." *Arts Magazine*, November 1983, 40.

- Lippard, Lucy. "Headlines, Heartlines, Hardlines: Advocacy Criticism as Activism." In *Cultures in Contention*, ed. Douglas Kahn and Diane Neumaier. Seattle: Real Comet Press, 1985.
- ——. *Mixed Blessings*. New York: Pantheon Books, 1991.
- On the Beaten Track: Tourism, Art, and Place. New York: New Press, 1999.
- ——. "Some Propaganda for Propaganda." In Visibly Female: Feminism and Art Today, ed. Hilary Robinson, 184–94. New York: Universe, 1988.
- Louie, Elaine. "A Photographer and His Dog Speak as One." *The New York Times*, February 14, 1991, B4.
- Malcolm, Janet. "A Girl of the Zeitgeist—I." *New Yorker*, October 20, 1986, 49–87.
- ———. "A Girl of the Zeitgeist—II." *New Yorker*, October 27, 1986, 47–66.
- Marks, Ben. "Memories of Bad Dreams." *Artweek*, December 21, 1989, 9.
- Marshall, Richard, and Robert Mapplethorpe. 50 New York Artists. San Francisco: Chronicle Books, 1986.
- Martin, Agnes. Writings. New York: DAP, 1991.
- Martin, Richard. "A Horse Perceived by Sighted Persons: New Sculptures by Deborah Butterfield." *Arts Magazine*, January 1987, 73–75.
- Matthews, Lydia. "Fighting Language with Language." *Artweek*, December 6, 1990, 1.
- May, Wanda. "Philosopher as Researcher and/or Begging the Question(s)." *Studies in Art Education* 33, no. 4 (1992), 226–43.
- McElroy, Guy. Facing History: The Black Image in American Art 1710–1940. Corcoran Museum, Washington, D.C.
- McEvilley, Thomas. "New York: The Whitney Biennial." *Artforum*, Summer 1991, 98–100.
- Meltzer, Irene Ruth. "The Critical Eye: An Analysis of the Process of Dance Criticism as Practiced by Clive Barnes, Arlene Croce, Deborah Jowitt, Elizabeth Kendall, Marcia Siegel, and David Vaughn." Master's thesis, Ohio State University, Columbus, 1979.

- Menzies, Neal. "Unembellished Strength of Form." *Artweek*, February 2, 1985, 4.
- Meyer, Raphael Rubinstein. "A Hemisphere of Decentered Mexican Art Comes North." *Arts Magazine*, April 1989, 70.
- Miller, Robert. "Deborah Butterfield." *Artnews*, March 1987, 149.
- Miller, Tim. "Critical Wishes." *Artweek*, September 5, 1991, 18.
- Moorman, Margaret. "Intimations of Immortality." *Artnews*, Summer 1988, 40–41.
- ——. "Leon Golub." *Artforum*, February 1989, 126.
- Morgan, Ann Lee. "Martin Puryear: Sculpture as Elemental Expression." *New Art Examiner*, May 1987, 27–29.
- Mutandas: Between the Frames: The Forum. Exhibition catalog. Columbus, Ohio: Wexner Center for the Visual Arts.
- Newkirk, Pamela. "Pride or Prejudice." *Artnews*, March 1999, 115–17.
- Newman, Michael. "The Ribbon around the Time Bomb." *Art in America*, April 1983, 160–69.
- Nochlin, Linda. "Four Close-Ups (and One Nude)." *Art in America*, February 1999, 66.
- Norden, Linda. "Dale Chihuly: Shell Forms." Arts Magazine, June 1981, 150–51.
- Ostrow, Saul. "Dave Hickey." In *Speak Art!* ed. Betsy Sussler. New York: New Art Publications, 1997.
- Owens, Craig. "Amplifications: Laurie Anderson." *Art in America*, March 1981, 120–23.
- ——. "William Wegman's Psychoanalytic Vaudeville." Art in America, March 1983, 101–8.
- Pagel, David. "Still Life: The Tableaux of Ann Hamilton." Arts Magazine, May 1990, 56–61.
- Pearse, Harold. "Beyond Paradigms: Art Education Theory and Practice in a Postparadigmatic World." *Studies in Art Education* 33, no. 4 (1992), 244–52.
- Perl, Jed. "Tradition-Conscious." *The New Criterion*, May 1991, 55–59.
- Phillips, Patricia C. "Collecting Culture: Paradoxes and Curiosities." In *Break-throughs: Avant-Garde Artists in Europe*

- *and America*, 1950–1990. Wexner Center for the Arts. New York: Rizzoli, 1991.
- Plagens, Peter. "Frida on Our Minds." *Newsweek*, May 27, 1991, 54–55.
- ———. "Max's Dinner with André." Newsweek, August 12, 1991, 60–61.
- ——. "Peter and the Pressure Cooker." Moonlight Blues: An Artist's Art Criticism. Ann Arbor: UMI Press, 1986.
- ——. "Unsentimental Journey." Newsweek, April 29, 1991, 58–59.
- ——. "The Venetian Carnival." *Newsweek*, June 11, 1990, 60–61.
- Pollock, Griselda. "Missing Women." In *The Critical Image*, ed. Carol Squiers, 202–19. Seattle: Bay Press, 1990.
- Princenthal, Nancy. "Intuition's Disciplinarian." *Art in America*, January 1990, 131–36.
- —. "Romare Bearden at Cordier & Ekstrom." Art in America, February 1987, 149.
- Prud'homme, Alex. "The Biggest and the Best?" *Artnews*, February 1990, 124–29.
- Raven, Arlene. Crossing Over: Feminism and Art of Social Concern. Ann Arbor: UMI Press. 1988.
- Reveaux, Tony. "O Superwoman." *Artweek*, July 26, 1986, 13.
- Ricard, Rene. "Not about Julian Schnabel." *Artforum*, 1981, 74–80.
- Riddle, Mason. "Hachivi Edgar Heap of Birds." New Art Examiner, September 1990, 52.
- Rimanelli, David. "David Salle." *Artforum*, Summer 1991, 110.
- Robbins, D. A. "William Wegman's Pop Gun." *Arts Magazine*, March 1984, 116–21.
- Robinson, Walter. "Artpark Squelches Bible Burning." *Art in America*, October 1990, 45.
- Ronk, Martha C. "Top Dog." *Artweek*, May 3, 1990, 16.
- Rose, Barbara. "Kiefer's Cosmos." *Art in America*, December 1998, 70–73.
- Rosen, Michael. *The Company of Dogs*. New York: Doubleday, 1990.
- Roy, Jean-Michael. "His Master's Muse: William Wegman, Man Ray, and the Dog-Biscuit Dialectic." *The Journal of Art*, November 1991, 20–21.

- Rubenfeld, Florence. *Clement Greenberg:* A Life. New York: Scribner's, 1998.
- Rubinstein, Meyer Raphael. "Books." *Arts Magazine*, September 1991, 95.
- ——. "Hachivi Edgar Heap of Birds." *Flash Art*, November/December 1990, 155.
- ——. "A Hemisphere of Decentered Mexican Art Comes North." Arts Magazine, April 1991, 70.
- Saltz, Jerry. "A Blessing in Disguise: William Wegman's Blessing of the Field, 1986." Arts Magazine, Summer 1988, 15–16.
- Schwartzman, Myron. *Romare Bearden: His Life and Life.* New York: Abrams, 1993.
- ——. "Romare Bearden Sees in a Memory." Artforum, May 1984, 64–70.
- Shottenkirk, Dana. "Nancy Spero." *Artforum*, May 1991, 143.
- Silberman, Robert. "Americans in Glass: A Requiem?" *Art in America*, March 1985, 47–53.
- Simic, Charles. *Dime-Store Alchemy*. New York: Ecco Press, 1992.
- Singerman, Howard. "In the Text." In A Forest of Signs: Art in the Crisis of Representation, ed. Catherine Gudis, 156. Cambridge: MIT Press, 1989.
- Smith, Ralph. "Problems for a Philosophy of Art Education." *Studies in Art Education* 33, no. 4 (1992), 253–66.
- Smith, Roberta. "Outsider Art Goes Beyond the Fringe." *The New York Times*, September 15, 1991, 1, 33.
- Sofer, Ken. "Reviews." *Artnews*, October 1987, 134.
- Solomon, Deborah. "Catching Up with the High Priest of Criticism." *The New York Times*, Arts and Leisure Section, June 23, 1991, 31–32.
- ——. "Celebrating Painting." *The New York Times Magazine*, March 31, 1991, 21–25.
- Spurrier, Jeff. "The High Priestess of Mexican Art." *Connoisseur*, August 1990, 67–71.
- Storr, Robert. "Elizabeth Murray." New Art Examiner, October 1988, 55.
- ——. "Riddled Sphinxes." *Art in America*, March 1989, 126.
- ——. "Salle's Gender Machine." *Art in America*, June 1988, 24–25.

Sussler, Betsy, ed. Speak Art! The Best of BOMB Magazine's Interviews with Artists. New York: New Art Publications, 1997.

Szarkowski, John. *Mirrors and Windows: American Photography since 1960.* New York: Museum of Modern Art, 1978.

Tallman, Susan. "Guerrilla Girls." *Arts Magazine*, April 1991, 21–22.

Taragin, Davira S. "From Vienna to the Studio Craft Movement." *Apollo*, December 1986, 544.

Tucker, Marcia. "Equestrian Mysteries: An Interview with Deborah Butterfield." *Art in America*, June 1989, 203.

Turner, Jane, ed. *Dictionary of Art.* New York: Grove Dictionaries, 1966.

Vaizey, Marina. "Art Is More Than Just Art." The New York Times Book Review, August 5, 1990, 9.

Valverde, Georgina. In *Worlds of Art* by Robert Bersson. Mountain View, CA: Mayfield, 1991.

Van Proyen, Mark. "A Conversation with Donald Kuspit." *Artweek*, September 5, 1991, 19.

Venturi, Lionello. *History of Art Criticism*. 1936. New York: Dutton, 1964.

Waldman, Diane. *Jenny Holzer*. New York: Abrams, 1989.

Watson, Gray. "Jenny Holzer." Flash Art, March/April 1989, 120–21.

Wegman, William. *Cinderella*. New York: Hyperion, 1993.

——. *Man's Best Friend*. New York: Abrams, 1982.

Weitz, Morris. Hamlet and the Philosophy of Literary Criticism. Chicago: University of Chicago Press, 1972.

Westerbeck, Colin. "Chicago, Martin Puryear." Artforum, May 1987, 154.

Westfall, Edward. "Deborah Butterfield." *Arts Magazine*, February 1987, 107.

Wexner Center for the Arts. Breakthroughs: Avant-Garde Artists in Europe and America, 1950–1990. New York: Rizzoli, 1991.

Wolfe, Tom. From Bauhaus to Our House. New York: Farrar, Straus, and Giroux, 1982.

——. *The Painted Word*. New York: Farrar, Straus, and Giroux, 1975.

Wooster, Ann-Sargeant. "Laurie Anderson." High Performance, Spring 1990, 65.

Yau, John. "William Wegman." Artforum, October 1988.

Yellin, Deborah. "Deborah Butterfield." *Artnews*, April 1991, 154.

Yenawine, Philip. *How to Look at Modern Art.* New York: Abrams, 1991.

Ziv, Peter G. "Clement Greenberg." *Art & Antiques*, September 1987, 57–59.

Index

"aboutness," 119-120 Acconci, Vito, Adjustable Wall Bra, 148 active voice, 178 ACT UP. 63 Adjustable Wall Bra (Acconci), 148 Afterimage, 88 After Walker Evans #7 (Levine), 39-41 AIDS, 63, 155, 156 Albers, Josef, 143 Alexander, Elizabeth, 144 Allegory of the Four Elements (Ryden), 67, Color Plate 3 Alloway, Lawrence, 19-20, 25 Anderson, Laurie, 84-87 Empty Places, 84-85 Andre, Carl, 98 appraisals, 149, 162 Aristotle, 150 arrogance, 3-4 Artforum, 1, 3, 12, 84 Art in America, 87, 106 artists, critics and, 6-8 artist statement, 195-197 Art Monthly, 10 Artnews, 115 Art/Public (Perjovski), 2 ArtReview, 192 Artscribe, 10 Arts Magazine, 115, 116 Artweek, 81 Ashberry, John, 10 Ash Flower (Kiefer), 70 Ashton, Dore, 24 assumptions, considering, 172-173 Astoff, Jens, 127 Atkins, Robert, 33 audiences critics and, 8-9 identification of, 173-174

Bailey, David, 59–60 Baker, Kristin, 127 Bang (Marshall), 195-197 Baro, Gene, 81 Baudelaire, Charles, 16, 25 Baziotes, William, 19 Bearden, Bessye, 143 Bearden, Romare "Of the Blues," 144 "Of the Blues/Second Chorus," Patchwork Quilt, 141-142, Color Plate 15 Quilting Time, 145 Beattie, Ann, 10 Beauvoir, Simone de, 48, 50 Beckett, Wendy, 10, 38 Bell, Clive, 34, 153 Benjamin, Walter, 38 Berger, John, 54 Berlind, Robert, 74, 76-77, 150-151, 152-153 Beware (Charles), 161 Big Red (Turrell), 185 biographical information, 92, 124 Bite Your Tongue (Golub), 73, Color Plate 6 Black Lime Soft Cylinder with Golden Lip Wrap (Chihuly), Color Plate 8 Bloom, Suzanne, 74 Blue, Lacy, 181-182 Bochner, Mel, 98 Book of Genesis Illustrated, The (Crumb), 127, 128–129 Bop (Murray), Color Plate 13 Bourdon, David, 82-83 Bourgeois, Louise, 118 Boyle, Deirdre, 88 Brenson, Michael, 142-143 Bridgewater, Candace, 104, 110 Brillo Box (Warhol), 15, 36, 37 Broken Column, The (Kahlo), 135, Color Plate 14

Brooks, Rosetta, 74, 76

Baldessari, John, 96

Buchloch, Benjamin, 11, 22 Buried Secrets (Viola), 88 Burnham, Linda, 4 Butler, Judith, 56 Butterfield, Deborah, 77-80 Installation, 78 Untitled (Red), Color Plate 7 Calo, Carole, 137, 139-141, 149 Can You Hear Me? (Murray), 118 Carter, Angela, 136 Castelli, Leo, 12 casual conversation, 212 Cateforis, David, 68, 74 Caviness, Madeline, 204 Chaotoc Lip (Murray), 115 Charles, Michael Ray, 160 Beware, 161 Chicago, Judy, 49 Chihuly, Dale, 80-84 Black Lime Soft Cylinder with Golden Lip Wrap, Color Plate 8 Pilchuck Basket series, 82-83 Childhood (Salle), 146 Chin, Mel, 156-157 "Fundred Dollar Bill Project," 157 Revival Field, 156 Chris, Cynthia, 210 Christo, 10 Clark, T.J., 18 Close, Chuck, 29, 150 Coe, Sue, 72, 158 The Jangaweed, Color Plate 5 coherence, in interpretation, 123 Coleman, A.D., 4, 24 collage, 68 judgment of, 141-146 Collingwood, R.G., 206 Collins, Georgia, 53 colonialism, 61

Colpitt, Frances, 70

community

Broudy, Harry, 26, 28

Buchanan, Beverly, 156

David, Jacques Louis, 34 Davis, Angela, 53 Daybed (Hatoum), 66, 67 Deadeve (Purvear), 138 deadlines, 180 Decter, Joshua, 77 Delacroix, 16 De Saussure, Ferdinand, 32 description circularity of, with interpretation, 94 context and, 72, 92-93 as criticism, 90 decisions in, 91 evaluation and, 93-94

external information and, 93 interpretation and, 93-94 of performance art, 84-87 relevance of, to larger idea, 94 subject matter and, 66-68, 91

"Electronic Signs" (Holzer), Emergence (Viola), 87, Color Plate 9 Empty Places (Anderson), 84-85

evaluation, description and, 93-94 Ezell, Alanna, 180-181

factual description, 90-91 Falgin, Gary, 66 Familiar Names and Not So Familiar Places (Grover), 158 Fauchereau, Serge, 136 feelings in interpretation, 121-122 in judgment, 164 Feinstein, Roni, 95 Feldman, Edmund, 26 feminism, 47-57

Nan's Kitchen, Color Plate 17

Fish, Janet, 150-151

Flash Art, 147 Fleck, Robert, 98 Fleming, Lynn, The Here + Now. 198-201 Ford, Walton, 127, 151 form, 70-71, 92, 154 formalism, 153-154 Foster, Hal, 22, 106 Foucault, Michel, 62 Four Horsemen of the Apocalypse (Pfeiffer), Color Plate 1 Frankenthaler, Helen, 17, 18, 21, 49 Frederick Serving Fruit (Wilson), 57 French-Frazier, Nina, 144 Freud, Sigmund, 31, 45-46 Fried, Michael, 22, 153, 154 Friedan, Betty, 48 Frueh, Joanna, 25, 54 Fry, Roger, 34 Fujii, Chuichi, 125 "Fundred Dollar Bill Project" (Chin), 157 Funney/Strange (Wegman), 99, 101 Für Paul Celan (Kiefer), 152

Gabbin, Joanne, 141-142 Gablik, Suzi, 11, 20 gallery, 214 Galligan, Gregory, 116-117 Garber, Elizabeth, 49, 50, 51, 56 García, David Anthony, Requiem, 71, Color Plate 4 Gates, Henry Louis, Jr., 160 gays, 62-63 gender, 50 Gilbert-Rolfe, Jeremy, 3, 4, 5, 102, 103.104 Gilligan, Carol, 54 glass, 80-84 Glowen, Ron, 81, 82 Glueck, Grace, 104, 106, 108, 110 Goldstein, Ann, 106, 107-108 Golub, Leon, 21, 72-77, 152-153, Bite Your Tongue, 73, Color Plate 6 Interrogation II, 75 "Night Scenes," 76 Prisoners (III), 75 Gomez, Edward, 51 Goodman, Nelson, 119 Gopnik, Adam, 17 Grant, Annette, 88 Graves, Nancy, Nancy, 150 Greenberg, Clement, 14, 17-19, 22, 25, 27, 35, 153, 155 Greer, Germaine, 48 Grimes, Nancy, 115 Gross, Terry, 8 Grosz, George, 142 group discussions, 214-215 group shows, 169

Grover, Jan Zita, 55, 158

Grub for Sharks (Walker), 159

Guerrilla Girls, 47–48 Guion, David, 183–190

Haacke, Hans, 21 Halpern, David, 10 Hamblen, Karen, 42, 58 Hamilton, Ann. 88-90 corpus, 88-89, Color Plate 10 Hammond, Pamela, 74 Harlem Renaissance, 142 Harridan, Newton, 11 Harvey, Doug, 66 Hassinger, Maren, 155-156 hate, 1-3 Hatoum, Mona Daybed, 66 Homebound, 66 Paravent, 66 Heap of Birds, Hachivi Edgar, 58-59 Heartney, Eleanor, 38, 146-147, 158 Heer, Jeet, 128 Heimdal, George, 7 Hein, Hilde, 48, 50, 51, 55 Henry, Gerrit, 154 Here + Now, The (Fleming), 198-201 Herrera, Hayden, 129, 132-134 Hickey, Dave, 3-4, 12, 13 High Performance (magazine), 5, 84 Hill, Ed, 74 history, of art criticism, 14-15 Hixson, Kathryn, 79 Holzer, Jenny, 102-112, 125 "Electronic Signs," 110-111 Inflammatory Essays, 107-108 Laments, 103, 109-110 The Living Series, 108 Lustmord, 110 "Protect Protect," 103, 110 Purple, Color Plate 12 "Redaction Paintings," 110 Under a Rock, 108-109 The Survival Series, 108 Truisms, 103, 105, 106-107, 108 Homebound (Hatoum), 66 Homes, A.M., 148 homosexuals, 62-63 Hovey, Kendra, 208-212 Howell, John, 84 Hudson, Suzanne, 138 Hughes, Langston, 143 Hughes, Robert, 8, 103, 114, 137-138 humility, 3-4 Huxley, Aldous, 10

identification, of audience, 173–174 linkl, Marilyn, 82 Inflammatory Essays (Holzer), 107–108 In killing fields sweet butterfly ascend (Mutu), Color Plate 2 Installation (Butterfield), 78 installations, describing, 88–90 instrumental uses of art, 155–157 interactive studio critiques, 215–218 interpretation

artist vs. art in, 124 biographical interpretation in, 124 as communal, 126 complexity of, 95 correctness of, 122 description and, 93–94 differences in, 122 feelings and, 121–122

importance of, 95 judgment and, 163, 164 judgments of, 123 meaning vs. significance in, 126 as non-exhaustive, 125

objects of, 124 as persuasion, 120 principles of, 119–126 quality of, 121

quality of, 121 worldview and, 122 in writing, 170–171 Interrogation II (Golub), 75

James, Curtia, 124, 155–156

James, Henry, 10
Jan, Alfred, 209–210
Jangaweed, The (Coe), Color Plate 5
Januszczak, Waldemar, 70, 93
Jencks, Charles, 36
Jenney, Neil, 96
Jensen, Bill, 21
Johns, Jasper, 19
Johnson, Ken, 115, 152

audience for, 163 of collage, 141–146 as communal, 164–165 craftsmanship and, 157 criteria in, 149, 162, 163–164 description and, 163, 164 differences in, 165–166

appraisals in, 149, 162

judgment

feelings and, 164 formalism in, 153–154 instrumental uses of art and, 155–157

expressionism in, 151-153

of interpretation, 123 interpretation and, 163, 164 irresponsible, 163 judge in, 165

kindness in, 166 negative, 146–147, 166 objects of, 162, 164 opposing, of same work,

148–149 originality and, 157 of painting, 129–137 personal nature of, 165 as persuasive, 163 preference vs., 162–163 principles for, 162–166 realism in, 150–151
reasons in, 149
revision of, 165
of sculpture, 137–141
as tentative, 165
weight of, 163
worldview and, 165
writing, 171–172
Julius, Anthony, 20
Jungen, Brian, 59

Kahlo, Frieda, 52, 129-137 The Broken Column, 135, Color Plate 14 My Birth, 132 Self-Portrait, 130 Two Nudes in a Forest, 130 Kandel, Susan, 208-210 Kant, Immanuel, 30 Kastner, Jeffrey, 156 Katz, Alex, 10, 21 Kiefer, Anselm, 68, 91, 151-152 Ash Flower, 70 Für Paul Celan, 152 Killian, Nicole, 198-201 Kimmelman, Michael, 157, 192, 193 kindness, in judgment, 166 Klein, Ellen Lee, 144 Kline, Yves, 143 Koelsch, Patrice, 9 Koons, Jeff, 41 Kozloff, Max, 12, 27, 134-135 Kramer, Hilton, 11, 20-21, 148, 154 Krasner, Lee, 118 Krauss, Rosalind, 1, 4, 18, 22, 27 Kristeva, Julie, 204 Kruger, Barbara, 43 Untitled, 51 Kunz, Martin, 97 Kushner, Robert, 96 Kuspit, Donald, 24, 27, 28, 125, 158 Kutner, Janet, 115

Labat, Tony, 8 Lacan, Jacques, 32, 45-46 Lacy, Suzanne, 21 Laments (Holzer), 103, 109-110 Lane, Mildred, 145 Langer, Sandra, 54 Larson, Kay, 28, 135 Lauerbach, A., 194 Leda (Witkin), 207 Levine, Sherrie, 39 After Walker Evans #7, 39-41 Levi-Strauss, Claude, 32 LeWitt, Sol, 98 Lichtenstein, Rov. 18, 19 Lincoln, Abraham, 147 Lippard, Lucy, 2, 5-6, 8-9, 21-22, 43, 52, 56–57, 68 Littleton, Harvey, 82 Living Series, The (Holzer), 108 Louis, Morris, 17, 18, 104

love, 1–3 Lustmord (Holzer), 110

Macpherson, Janet, 202-206 St. Lucies, 203 Madonna, 130 Mailer, Norman, 10 Malcolm, Janet, 3, 4 Malpede, John, 11 Manet, Edouard, 34 Man Ray (dog), 96-97 manual, style, 173 Mapplethorpe, Robert, 9 market, critics and, 12-14 Marshall, Kerry James, 195-197 Bang, 195-197 Martin, Agnes, 154 Unittled #18, Color Plate 16 Martin, Richard, 78-79 Marx, Karl, 31 Marxist criticism, 44-45 Marzorati, Gerald, 73 Matisse, Henri, 21 Matthews, Lydia, 59 McElroy, Guy, 156 McEvilley, Tom, 27, 119 medium, 68-70, 92 Meier, Richard, 10 Menzies, Neal, 137, 138 Mesa-Bains, Amalia, 21 Michelangelo, 15 Michelson, Annette, 22 Mile Run III (Turrell), 188 Miller, Tim, 6 Millet, Kate, 48 minority stereotyping, 59-60 modernity, 30-33 Modotti ,Tina, 135 Molnar, Lynette, Familiar Names and Not So Familiar Places, 158 Mondrian, Pat. 39 Moorman, Margaret, 76, 83 Morgan, Ann Lee, 137, 140, 141 Morris, Robert, 98 Moskowitz, Robert, 7 Motherwell, Robert, 17 Moto, Wangechi, 53 multiculturalism, 57-60 Murray, Elizabeth, 112-119 Bop, Color Plate 13 Can You Hear Me?, 118 Chaotic Lip, 115 My Manhattan, 116, 120 Pompeii, 115 museum, 214 Mutu, Wangechi, 93 In killing fields sweet butterfly ascend, Color Plate 2 My Birth (Kahlo), 132 Myers, Holly, 66 My Manhattan (Murray), 116, 120

name substitution, 60 Nancy (Graves), 150

Nan's Kitchen (Fish), Color Plate 17 National Public Radio, 8 Nauman, Bruce, 96, 157 negative judgments, 146-147, 166 Nevelson, Louise, 131 New Art Examiner, 114 New Criterion, 11, 20, 148 New Criticism, 153 Newman, Barnett, 19, 35 Newman, Michael, 135 Newsweek (magazine), 3, 8, 10 New York Times, 9, 17, 20 Nietsche, Friedrich, 206 "Night Scenes" (Golub), 76 Nochlin, Linda, 150 Noland, Kenneth, 17 note taking, 175-176

objectification, 60 Obourn, Nick, 103 October (journal), 1, 11, 22 Ofili, Chris, 92 "Of the Blues" (Bearden), 144 "Of the Blues/Second Chorus" (Bearden), 144 O'Keeffe, Georgia, 18, 52, 131 Okeke-Agulu, Chika, 31 Oldenburg, Claes, 7, 19 Olitski, Jules, 17 Olmedo, Dolores, 135 opposite judgments, 148-149 Orientalism, 61 originality, 157 Orozco, Gabriel, 128 outlining, 176 Owens, Craig, 98-100

Paravent (Hatoum), 66 Partisan Review, 18 passive voice, 178 Patchwork Quilt (Bearden), 141-142, Color Plate 15 Pearse, Harold, 44 performance art, describing, 84-87 Perjovski, Dan, Art/Public, 2 Perl, Jed, 148-149 personal responses, 180-190 persuasion, 120, 163 Pfeiffer, Paul, 46 Four Horsemen of the Apocalypse, Color Plate 1 Phillips, Patricia, 4 photography, 37, 41, 95-102 Pilchuck Basket series (Chihuly), 82-83 Pincus-Witten, Robert, 25 Pink Tree, The (Currin), 190, 191 Piper, Adrian, 21, 123 Plagens, Peter, 3, 5, 8, 13, 26, 103, 129-132, 136, 143-144 plagiarism, 176 Plato, 14, 155

Pollock, Griselda, 55

Pollock, Jackson, 17, 21, 70, 143, 153-154 Pompeii (Murray), 115 Poons, Larry, 17 pornography, 55 postcolonialism, 60-62 postmodernity, 30-33, 39-44 poststructuralism, 32-33 Powell, Mary Claire, 54 preference, judgment vs., 162-163 Princenthal, Nancy, 137, 139, 145 Prisoners (III) (Golub), 75 Prose, Francine, 112 "Protect Protect" (Holzer), 103, 110 Pseudo-Dionysius the Areopagite, psychoanalytic criticism, 45-46 public domain, criticism in, 214 Purple (Holzer), Color Plate 12 Puryear, Martin, 137-141, 149 Deadeye, 138

queer theory, 62–63 Quilting Time (Bearden), 145

Raphael, 15 Rappolt, David, 192 Rauschenberg, Robert, 19 Raven, Arlene, 23-24 realism, 150-151 reasons, 149 "Redaction Paintings" (Holzer), 110 Red Toy (Wegman), Color Plate 11 Reed, Lou, 85 Reinhardt, Ad, 153 Requien (García), 71, Color Plate 4 Revival Field (Chin), 156 rewriting, 177 Ricard, Rene, 1, 2 Richards, I.A., 35 Riley, Bridget, 49 Rimanelli, David, 147 Rise (Turrell), 185 Rivera, Diego, 130, 142 Robbins, D.A., 100-101 Robeson, Paul, 143 Rockwell, Norman, 194 Rollins, Tim. 11 Rose, Barbara, 22, 83-84, 151-152 Rosenberg, Harold, 35 Rosenblum, Robert, 1, 9, 10 Rosenquist, James, 19 Ross, David, 20 Roth, Richard, 7 Rothenberg, Susan, 124, 157 Rothko, Mark, 104 Roy, Jean-Michel, 100 Rubenfield, Florence, 19 Rubinstein, Meyer Raphael, 73, 136 Rucker, Kristi, 181 Ruscha, Ed, 96 Ryden, Mark, 66 Allegory of the Four Elements, 67, Color Plate 3

talking about art, 212-218

Said, Edward, 61 Time (magazine), 8 Funney/Strange, 99, 101 Salle, David, 18, 42, 146-147 Tintoretto, 10 Red Toy, Color Plate 11 Tiravanija, Rirkrit, 157 Sworded, 96 Childhood, 146 Weiermair, Peter, 98 topic choice, 168-169 Saltz, Jerry, 13, 101, 102 traditional criteria, 149-157 Weimeraners, 97 Samaras, Lucas, 12 Weitz, Morris, 26 "transactional aesthetics," 157 Sartre, Jean-Paul, 10, 54 Transfiguration of the Commonplace West, Cornel, 42 Savage, Shari, 192-195 West, Pheoris, 6 (Danto), 119 Schapiro, Miriam, 49 Westerbeck, Colin, 140 Schjeldahl, Peter, 13, 68, 128, Trotsky, Leon, 130, 131 Weston, Edward, 39 137, 139 Truisms (Holzer), 103, 105, 106-107, 108 White, Minor, 123 Schnabel, Julian, 18 Schwartzman, Myron, 144 Tsinhnahjinnie, Hulleah, 53 Wiley, Kehinde, "The World Stage: Africa, Lagos-Dakar," 93 Schwenden, Martha, 151 Tucker, Marcia, 79-80 Schwendenwien, Jude, 114 Turrell, James, 183-190 Willens, Kay, 7 Williams, David, 205 Self-Portrait (Kahlo), 130 Big Red, 185 Wilmarth, Christopher, 21 Mile Run III, 188 Serra, 98 Rise, 185 Wilson, Fred, 57-58 Serrano, Andres, 9 Skyspaces, 186 Frederick Serving Fruit, 57 Shaw, George Bernard, 10 Witkin, Joel-Peter, 208-212 Unseen Blue, 186-187 Shay, Bob, 6 "Two Hundred Words or So I've Leda, 207 Sherman, Cindy, 135 Heard Artists Say about Wolfe, Tom, 18, 36 short responses, 190-197 Silberman, Robert, 81 Critics and Criticism" Wooster, Ann-Sargeant, 84-85 word count, 173 Simic, Charles, 10 (Labat), 8 Skyspaces (Turrell), 186 Two Nudes in a Forest (Kahlo), 130 "World Stage, The: Africa, Lagos-Dakar" (Wiley), 93 Sleep (Warhol), 97 worldview Sloan, Louise, 62 Under a Rock (Holzer), 108-109 Unseen Blue (Turrell), 186-187 interpretation and, 122 Smith, David, 18 Smith, Ralph, 64 Untitled (Kruger), 51 judgment and, 165 Smith, Roberta, 9, 25, 101, 112, 127 Untitled #18 (Martin), Color Plate 16 Writers on Art (Halpern), 10 Smithson, Robert, 98 Untitled (red) (Butterfield), Color writing active voice in, 178 sociocultural information, 92 Plate 7 Solomon, Deborah, 17, 85, 112, Updike, John, 10 artist statement, 195-197 113-114 Vaizey, Marina, 28 assumptions in, 172-173 audience identification in, Solomon R. Guggenheim value, of criticism, 28-29 173-174 Museum, 19 Valverde, Georgina, 135-136 deadlines and, 180 Spero, Nancy, 21 Vasari, Giorgio, 15 Ventilator (Eliasson), 68, 69 editing and, 178-180 Spurrier, Jeff, 135 errors in, 178 St. Lucies (Macpherson), 203 Venturi, Lionello, 14 getting started in, 174-175 Stein, Gertrude, 10 video, 87-88 Steiner, George, 5 Village Voice (newspaper), 4, 13, 192 note taking and, 175–176 Steir, Pat, 5 Viola, Bill, 87-88 outlining, 176 passive voice in, 178 Stella, Frank, 35 Buried Secrets, 88 personal repsonses, 180-190 Stevens, May, 21 The Crossing, 88 Stieglitz, Alfred, 18 Emergence, 87, Color Plate 9 plagiarism in, 176 Storr, Robert, 44, 114, 117, 118, 147 rewriting, 177 samples of, 180-190 structuralism, 32 Waldman, Diane, 105, 109 short responses, 190-197 studio critiques, 198-202, 215-218 Walker, Alice, 53 style manual, 173 Walker, Kara, 160, 180-181, studio critiques, 198-202 style manual and, 173 subject matter, 66-68, 91 181-182, 182-183 word count in, 173 Survival Research Laboratories, 63 Walker, Ken, Grub for Sharks, 159 Survival Series, The (Holzer), 108 Warhol, Andy, 19, 36 Sworded (Wegman), 96 Yarowsky, Anne, 10 Brillo Box, 15, 36, 37 Szarkowski, John, 150, 151 Sleep, 97 Yellin, Deborah, 77 Yenawine, Philip, 39, 41 Way, Wanda, 43

Wegman, William, 95-102, 123, 125